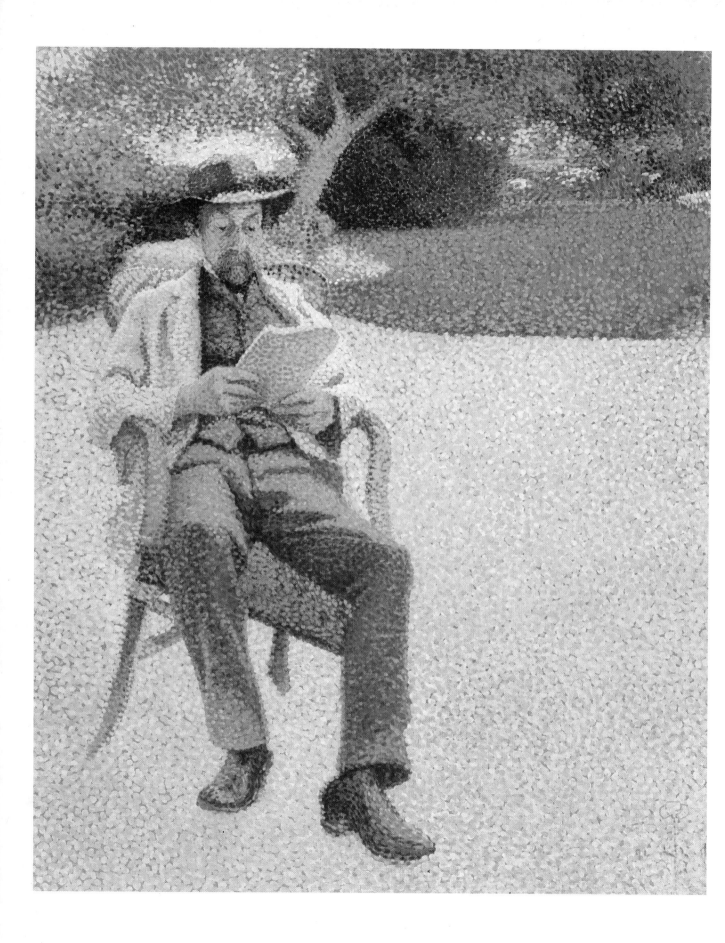

The Aura of Neo-Impressionism:

The W. J. Holliday Collection

Ellen Wardwell Lee

Artists' Biographies by Tracy E. Smith

Indianapolis Museum of Art
Indiana University Press

Editor: Debra Edelstein
Designer: Marcia K. Hadley
Photographer: Robert Wallace

ISBN: 0-936260-04-1 cloth
ISBN: 0-936260-05-X paper
Library of Congress Catalog Card Number: 82-84036

This catalogue and the exhibition on which it is based
would not have been possible without the generous sup-
port of several agencies, which we gratefully acknowl-
edge here:
 Research and editorial costs have been funded, in part,
by a grant from the Andrew W. Mellon Foundation.
 Additional support for the production of this cata-
logue has been provided by a grant from the National
Endowment for the Arts, a federal agency, Washington,
D.C.
 Support for the exhibition and this catalogue has also
been provided by the Indiana Arts Commission and the
Institute of Museum Services, a federal agency that
offers general operating and program support to the
nation's museums.

On the cover: Detail, Paul Signac, *Entrance to the Port of Honfleur*

Frontispiece: Henry van de Velde, *Père Biart Reading in the Garden*

Contents

Preface

Collections of art museums grow slowly. Works are acquired one at a time or in small groups, and over a period of years and with luck, great collections are formed. In its hundred-year history, the Indianapolis Museum of Art has indeed been lucky, and we can now boast extensive collections of quality and richness in many areas. But rarely in our distinguished history has an entire collection of worldwide importance come into our care, in a single stroke enhancing the Museum's collections beyond our wildest expectations. The W. J. Holliday bequest of ninety-six paintings by the followers of Seurat is such a stroke, and with it the Museum's holdings of European paintings of the late nineteenth and early twentieth centuries have been significantly enriched.

W. J. Holliday was a collector in every sense of the word. He brought to his collecting the passion, knowledge, taste, and commitment that are the characteristics of all true collectors. This collection, which focuses on a major though brief chapter in the history of art, was one of several Mr. Holliday formed in succession over many years. When he began this collection in the mid-1950s, Mr. Holliday intended to build a collection of Impressionist pictures. He very quickly realized that prices for important Impressionist works of art had already gone way beyond the means of most collectors and that the very best works were out of the market in museum or private collections. However, one unique aspect of later Impressionism, Neo-Impressionism, had been overlooked. These were the extraordinary, light-filled pictures painted in the pointillist technique and based on the theories of Georges Seurat. Once the idea took hold in his mind, Mr. Holliday went at collecting these works with dedication and skill; and while he had the advice of dealers and experts, he himself became an expert. Relying as all great collectors on his own skill, judgment, and taste, he formed a comprehensive collection that defines the history of this "school" from its formation in the 1880s through its passing in the twentieth century.

While the exhibition is intended to present the Holliday Collection to the public and to demonstrate how extensively it adds to the Museum's distinguished holdings, the catalogue has the equally important objective of documenting the history of the movement through the works of the eighty-five artists represented in the collection. One of the largest of its kind in the world, the collection lends itself to such scholarly scrutiny. The resulting catalogue offers new insights into and a fuller definition of the movement.

The exhibition and catalogue are the results of nearly four years' work involving many people on the staff of the Museum and many people outside the Museum. To all those who so generously shared their knowledge with us go our many thanks for their help and support. While it is impossible in this preface to acknowledge each contributing staff member individually, I would like to express my appreciation to some of those most closely connected to this project. For all their talent, enthusiasm, and just plain hard work, many thanks to the Museum's conservators, especially chief conservator Martin Radecki and paintings conservators David Miller and John Hartmann; photographer Robert Wallace; and the editor and designer of Museum publications, Debra Edelstein and Marcia Hadley. I am also grateful to Sherman O'Hara, chief preparator, and his staff for the outstanding installation of the exhibition; Helen Ferrulli, director of education, and her talented staff for the excellent programs that accompany the exhibition; the public relations staff; and, indeed, the entire Museum team, whose cooperation and support have made this outstanding exhibition and catalogue possible.

But my special thanks must go to Ellen Lee, associate curator, who as maestro so brilliantly coordinated the efforts of everyone involved with the exhibition and catalogue and who was responsible for every detail of this project. This has truly been Ellen's "show," and words can hardly convey the breadth of her devotion to this project or the depth of our gratitude to her for this extraordinary achievement. With care and concern and with intelligence and purpose, Ellen has documented each of the pictures in the collection and in the process has amassed a body of new knowledge about the Neo-Impressionist movement and its impact. Under the pressures of deadlines and through the inevitable but no less frustrating blind alleys of research, Ellen has brought determination and exemplary intelligence to a difficult task. I know I speak for all of us at the Museum, for our public, and for the community of scholars when I say to Ellen that simple thanks are hardly enough to express our deep appreciation for a job not just well done, but done superbly.

I would also like to add thanks here to Mrs. W. J. Holliday for sharing her knowledge and enthusiasm with us and for providing so much personal insight and information about the collection. This kind of information adds that human dimension which makes the Holliday Collection not just an assemblage of pictures but a living entity.

Robert A. Yassin
Director

Acknowledgements

In the three years that have elapsed since I first began to study the Holliday Collection, there have been countless occasions when my colleagues have devoted that extra measure of their time and skills to this project. Their efforts have helped to generate the results—and the spirit—crucial to the successful resolution of such a large undertaking. And now one of the most satisfying aspects of completing this catalogue is having the opportunity to permanently acknowledge the individuals who worked to bring *The Aura of Neo-Impressionism* into print. My thanks go first to Museum director Robert A. Yassin for his steady advice and encouragement and for making available to me the talents of such a capable staff. Bob has consistently put the Museum's full support behind the research, presentation, and publication of the Holliday Collection.

One of my greatest advantages in pursuing this project was having Tracy E. Smith as an assistant. Tracy came to the Museum in March 1981, and she quickly demonstrated the judgment, thoroughness, and enthusiasm that made her a valuable addition to the Museum. Tracy was responsible for the preparation and writing of the artists' biographies. A tireless researcher, she also helped me compile the complex documentation of this large and varied collection and handled many of the endless administrative details required to coordinate our research. Tracy has now returned to graduate studies, and her capabilities—and good nature—are sorely missed.

Writing is a very solitary experience, and when an author first entrusts her manuscript to an editor, she is very fortunate if she encounters an individual with sensitivity as well as rigorous standards. Such was my experience with Museum editor Debra Edelstein. Debbi combines a scrutinizing eye for detail with the capacity to grasp the effect of the whole. For her ability, as well as for her willingness to help me address any facet of catalogue preparation, she has both my respect and my promise of chocolates and flowers for many birthdays to come. This catalogue has also benefited from the taste and experience of Marcia K. Hadley, designer of Museum publications. She has transformed miles of type and stacks of photographs into a consistent design format. With skill and with grace under deadline pressure, Marcia has supervised the catalogue production, conferring with all the typesetters, color separators, printers, and binders involved in the complexities of publishing.

To meet the challenge of capturing on paper the distinctive effects of Neo-Impressionist pictures, the Museum could not have had anyone more qualified than our photographer, Robert Wallace. Bob produced all the color plates and black and white illustrations of the collection. His talent, organization, and perfectionism transformed what could have been one of the publication's most vexing problems into the beautiful and accurate reproductions that enhance this catalogue.

The participation of the Museum's conservation department added a whole new dimension to this project. Since early in 1980, I have had the privilege of working closely with chief conservator Martin Radecki, associate conservator David A. Miller, and assistant conservator E. John Hartmann, Jr. After thoroughly examining every painting, they embarked on a program designed to achieve the best condition and appearance for each picture in the collection. As David Miller's technical statement suggests, the cleaning of these pictures is critical to our perception of the Neo-Impressionists' finely orchestrated harmonies and meticulous brushwork. Yet the conservators' contributions go well beyond the actual treatment of these works. With their knowledge of painting techniques and diagnostic equipment, they have provided information that would have been otherwise inaccessible to me. Infra-red lenses, x-rays, pigment analyses, and experienced eyes have expanded the scope of my research. The conservators also responded enthusiastically to the intriguing questions posed by Neo-Impressionist frames, and they played an integral role in the discussion and actual labor of reframing several of the pictures. Our collaboration has made my job more stimulating and more enjoyable, as I was continually buoyed by their professionalism and intellectual curiosity.

I would also like to acknowledge Museum librarian Martha Blocker, who tracked down the many new books and the long series of interlibrary loans necessary for our research. I am grateful to Pamillia Cavosie, administrative assistant; Janet Feemster, curatorial secretary; and Dorothy Meyer, for typing the manuscript and the great volume of correspondence demanded by the project.

My special thanks are reserved for the Museum's senior curator, Dr. Anthony F. Janson. Tony became the project's unofficial advisor and from the earliest stages has generously contributed his time and expertise to this study. From individual attributions to philosophies of entire aesthetic systems, Tony has helped me review my work and focus my thinking. At virtually every phase of my research and writing, I have benefited from his intellect, his common sense, and his humor.

During the course of this project, I have had the pleasure of getting to know Mrs. W.J. Holliday. She has always shown the greatest interest in and enthusiasm for our research, and has graciously provided the personal touch that enlivens the documentation of a private collection.

Finally, I want to thank the many individuals in Europe and America who have responded to our requests for information. Anne Thorold, of the Pissarro Family

Archive, Ashmolean Museum, Oxford, was especially helpful in documenting the Pissarro paintings. Over the last two years, she has never failed to provide thorough and prompt answers to my questions. In the course of this project, I often sought the help of Professor Robert L. Herbert of Yale University, and he also patiently responded to each of a wide variety of inquiries. To the other scholars, curators, librarians, gallery owners, and artists' family members whose knowledge and good will led to many of the discoveries recorded in this catalogue, go my sincere thanks. Many of these individuals are cited in the footnotes, but I would also like to acknowledge: Arthur G. Altschul, New York; Alfred Aufhauser, New York; Joseph Baillio, Wildenstein and Co., New York; Galerie Alain Blondel, Paris; Françoise Cachin, Musée d'Orsay, Paris; Sue Canning, University of North Carolina at Greensboro; Marie-Jeanne Chartrain-Hebbelinck, Musées Royaux des Beaux-Arts de Belgique, Brussels; Iris Krenzis Cohen, Hammer Galleries, New York; Micheline Colin, Musées Royaux des Beaux-Arts de Belgique, Brussels; Isabelle Compin, Musée du Louvre, Paris; Anne Distel, Musée d'Orsay, Paris; Paul Eeckhout, Museum voor Schone Kunsten, Ghent; Jean Forneris, Musée des Beaux-Arts Jules Chéret, Nice; Oscar Ghez, Petit Palais, Geneva; Gilbert Gruet, Bernheim-Jeune & Cie., Paris; A.M. Hammacher, Brussels; Luke Herrmann, University of Leicester; Stephen Higgons, Toulon; Eric Hild, Musée de l'Annonciade, Saint-Tropez; Norman Hirschl, Hirschl & Adler Galleries, Inc., New York; William I. Homer, University of Delaware, Newark; Michel Hoog, Palais de Tokyo, Paris; Suzanne Houbart, Musées Royaux des Beaux-Arts de Belgique, Brussels; Nicole d'Huart, Musée d'Ixelles, Brussels; Daniel Janicot, Conseil d'Etat, Paris; Samuel Josefowitz, Lausanne; Dr. Ulrike Köcke, Museum Folkwang, Essen; Barbara LaMont, Vassar College Library, Poughkeepsie; Francine-Claire Legrand, Musées Royaux des Beaux-Arts de Belgique, Brussels; Christopher Lloyd, Ashmolean Museum, Oxford; Mlle. Van Louven, Cabinet des Estampes, Bibliothèque Royale de Belgique, Brussels; Daniel Malingue, Paris; Harry Tatlock Miller, Redfern Gallery, London; Meyer Miller, New York; Pierre Mommen, Brussels; Martha Op de Coul, Rijksbureau voor Kunsthistorische Documentatie, The Hague; Mme. Guy Pogu, Paris; Timothy Pringle, Richmond Gallery, London; John Rewald, New York; Claude Robert, Paris; Anne Roquebert, Etablissement Public du Musée du XIXe Siècle, Paris; Eugène Rubin, Freiburg; Polly Rubin, Sotheby's, New York; Ryerson Library, The Art Institute of Chicago; M.R. Schweitzer, New York; Geraldine Stanley, Sotheby's, London; Maurice Sternberg, Chicago; Jacqueline Stewart, Alex Reid and Lefevre, Ltd., London; Mme. E. Thévenin-Lemmen, Toulon; Martha Ward, California Institute of Technology, Pasadena; Jean Warmoes, Bibliothèque Royale de Belgique, Brussels; Dick Weston, Las Vegas; G. Weynans, Galerie L'Ecuyer, Brussels; Jean Willems, Brussels; M. et Mme. Wittamer-de-Camps, Brussels.

Ellen W. Lee
Associate Curator of Painting and Sculpture

Introduction

In 1890, when Georges Seurat stated the theories and techniques fundamental to his painting, he began with one simple sentence: "Art is harmony."[1] It is ironic, then, that both in its development and in its reception, Seurat's art has been surrounded by paradox. In formulating the Neo-Impressionist aesthetic, Seurat sustained the spirit of many of the French Academy's classical traditions, but he wed them to the era's most up-to-date scientific discoveries. Though he rejected the spontaneity and fleeting sensations that intrigued the Impressionists in favor of a more enduring, permanent image of the world, he still tried to capture on canvas the elusive effects of real light. And while Seurat often chose mundane subjects from everyday life, he and his followers quickly became the favorites in Symbolist literary circles. Even Seurat's pictorial technique was grounded in contrast, since opposites on the color wheel were the basis for his harmonies. Finally, Seurat's express purpose was to put the art of painting on a rational basis, yet his works often have a poetry that defies rational analysis.

It is into this realm of apparent contradictions, esoteric theory, and straightforwardly beautiful works of art that Mr. and Mrs. W.J. Holliday entered when they began to build their collection. Bringing all the attributes and appetites of the experienced collector to the task, Mr. Holliday traveled to galleries and auction houses throughout Europe and America in pursuit of examples of the Neo-Impressionist influence. From 1957 to 1971, he assembled a group of ninety-six pictures representing eighty-five different artists and spanning more than seventy-five years of painting.

Holliday's thorough search led him from works by acknowledged Neo-Impressionists like Paul Signac, Maximilien Luce, and Théo van Rysselberghe, to the less familiar terrain of artists such as Jean Metzinger or Auguste Herbin, who experimented with the style for only brief periods in their careers. Since Seurat's true followers were restricted to a small group, it is not surprising that in a collection representing eighty-five artists, there are several painters who borrowed his decorative pointillist technique without applying the theory behind it. There are also works which, eluding even the broadest of Neo-Impressionist categories, entered the collection through that prerogative of the private collector to acquire a picture simply because it suits his taste.

While this liberal interpretation of a theme might appear to dilute the impact of the collection, it is actually a source of its strength and appeal. Mr. Holliday's achievement lies not only in the individual merits of some of the purest examples of Neo-Impressionism, but also in the synergistic result of assembling such a rich variety of the style's interpretations. Viewed as a whole, the collection suggests the extensive influence of Seurat's style and represents what could legitimately be called the Neo-Impressionist "aura." The pictures range in date from a student work by Seurat from the late 1870s to echoes of the style in the mid-twentieth century. They represent artists from France, Belgium, Germany, Holland, and America who responded with varying degrees of faithfulness to the allure of Neo-Impressionism.

This catalogue is intended to update and revise two earlier publications on the Holliday Collection: *Homage to Seurat* prepared by William E. Steadman of the University of Arizona Art Gallery, Tucson, in 1968; and *Recent Additions to the W.J. Holliday Collection*, produced by the Indianapolis Museum of Art in 1971. The new catalogue also includes all other Neo-Impressionist works in the Indianapolis Museum of Art's permanent collection. This expansion permits the inclusion of Seurat's masterful Gravelines seascape and makes the catalogue a complete guide to this segment of the Museum's holdings. This new publication is needed not only to document what is now the largest public collection of Neo-Impressionist works in America, but also to reflect the enormous amount of scholarship devoted to the subject since the original catalogue was issued. Robert Herbert's landmark exhibition, *Neo-Impressionism*, presented by the Solomon R. Guggenheim Museum in 1968, defined the full context of the movement and provided a wealth of material on its artists. In 1970, a volume entitled *The Neo-Impressionists* combined the knowledge of several authorities in the field and provided thorough biographies of the movement's key figures. In the last decade, several monographs and one-man shows have brought individual artists to light, while in 1979 and 1980 major exhibitions such as *Post-Impressionism: Cross-Currents in European Painting* at the Royal Academy of Arts, London and *Belgian Art: 1880-1914* at the Brooklyn Museum, have underscored Neo-Impressionism's prominent role in late nineteenth-century painting.

The objective of this catalogue is to present an accurate survey of the Holliday Collection, both by close examination of the individual paintings and their artists as well as by consideration of the larger context of Neo-Impressionism. In the process, many of the apparent conflicts in Neo-Impressionism will no doubt appear. If, as Seurat has also observed, "harmony is the analogy of opposites,"[2] then many of the analogies that resolve those contradictions should also surface. Perhaps only Seurat's ultimate mystique, the conflict between his scientific methods and his spiritual effects, will resist explanation.

Notes

[1] Letter from G. Seurat to Maurice Beaubourg, August 28, 1890. A transcript of his statement of theory and technique follows on p. 12.
[2] Letter from G. Seurat to M. Beaubourg, August 28, 1890.

Seurat's Statement of Theory

Letter from Georges Seurat to Maurice Beaubourg, August 28, 1890*

Aesthetic

Art is Harmony.
Harmony is the analogy of opposites, the analogy of similar elements, of *tone*, of *color*, and of *line*, considered according to their dominants and under the influence of lighting, in gay, calm, or sad combinations.

The opposites are:
For tone, a more $\begin{Bmatrix} \text{luminous} \\ \text{light} \end{Bmatrix}$ against a darker one.

For color, the complementaries, $\begin{cases} \text{red-green} \\ \text{orange-blue} \\ \text{yellow-violet} \end{cases}$ i.e., a certain red opposed
to its complementary, etc.

For line, those forming a right angle.

Gaiety of tone is the light dominant; of *color*, the warm dominant; of *line*, lines above the horizontal.

Calmness of tone is the equality of dark and light; of color, the equality of warm and cool; and of line, the horizontal.

Sadness of tone is the dark dominant; of color, the cool dominant; and of line, downward directions.

Technique

Granting the phenomena of the duration of the light-impression on the retina, synthesis necessarily follows as a resultant. The means of expression is the optical mixture of tones, of colors (of the local color and the color of the illuminating light: sun, oil lamp, gas, etc.), that is to say, of the lights and their reactions (shadows), in accordance with the laws of *contrast*, gradation, and irradiation.

The frame is in a harmony opposed to that of the tones, colors, and lines of the picture.

*A photograph of this letter first appeared in R. Rey, *La Renaissance du sentiment classique*, Paris, 1931. It is also reproduced in J. Rewald, *Georges Seurat*, New York, 1943, fig. 41, p. 61; and H. Dorra and J. Rewald, *Seurat: L'Oeuvre peint, biographie et catalogue critique*, Paris, 1959, fig. 37, p. XCIX.

Neo-Impressionism

One hundred years ago France was at the threshold of the modern era. The effects of the industrial revolution were unmistakable, as factories rose on the outskirts of Paris and a new urban working class developed. Technological progress brought obvious symbols like the Eiffel Tower, but it also put many laborers and craftsmen out of work. The same era that bred a new confidence in the achievements of science left many citizens disillusioned with the established order and the position of the working man. Artists responded to their modern age with contemporary subject matter and a search for new pictorial modes. Academic values and the Impressionist sensibility persisted, but many painters were exploring new methods—and fresh rationales—for their art. From this milieu, Georges Seurat built the framework of the Neo-Impressionist aesthetic.

Almost a century has elapsed since Georges Seurat first exhibited the monumental painting that became the standard-bearer of the Neo-Impressionist movement. Words like "bedlam," "scandal," and "hilarity" were used to describe the commotion aroused by *A Sunday Afternoon on the Island of La Grande Jatte* (The Art Institute of Chicago) in 1886. The controversial canvas drew criticism so varied that it is now hard to believe that one picture could provoke such conflicting commentary.[1] Critics disagreed about the young artist's motivation: what one reviewer dismissed as a hoax, another regarded as a sincere effort. Seurat's color scheme was alternately criticized for dull, dusty effects and praised for its transparent atmosphere. And the startling new dotted brush strokes were compared to wafers, fly specks, and "the whole vocabulary of dermatological disease."[2]

Most of the visitors—artists and critics, as well as the general public—to that first display of Seurat's new style marshalled all the negative feelings aroused by the first exhibition of Impressionism twelve years earlier. With their networks of tiny dots, the pictures of Seurat and his first followers were a radical departure from the nineteenth-century idea of how paintings were "supposed" to look. The notion of building pictures out of small spots baffled and even irritated observers. These works had neither the mirror-smooth finish of Neo-Classical paintings nor the individualized, bravura handling of Romanticism. The broad, impetuous brushwork of the Impressionists had been scandalous in its freedom and richness, but the technique of Seurat and his group was controversial for the opposite reasons. The regularity of the brush strokes made the act of painting appear too mechanical, and the artists' association with scientific theories drew the style even further

from the romantic conception of the creative process. Adding to the confusion was the fact that many viewers could not distinguish between the works of Seurat and those of his followers.

Despite the largely negative response to Seurat's new method, Neo-Impressionism was one style of the era that did not receive its name at the pen of a hostile critic. Unlike Impressionism or Fauvism, the term was coined by a spirit kindred in artistic ideals and social philosophy. In the autumn of 1886, author Félix Fénéon first used the expression "Neo-Impressionism" to describe Seurat's art.[3] A frequent contributor to French and Belgian journals, Fénéon was an active member of the Symbolist literary circle that stepped forward to become the painters' eloquent defenders. Upon seeing *La Grande Jatte* at the last Impressionist exhibition in 1886, Fénéon was moved to interview its intense young artist. When he produced a review of Seurat's art, it was written with a clear understanding and undeniable appreciation of the painter's methods and objectives.

Why did Fénéon christen Seurat's new style "Neo-Impressionism"? Meaning simply a new Impressionism, his choice of words refers to what Seurat and his followers were emulating, as well as to what they rejected. Not only did Seurat's group sympathize with the Impressionists' struggle for critical acceptance and their efforts to exhibit outside the sanctions of the juried salons, they also admired their devotion to recording the effects of sunlight and the brighter pigments which that required. For Seurat, where the Impressionist idiom broke down was in its commitment to capturing the fleeting sensations of nature. To make these glimpses of the world their true subjects, the Impressionists were compelled to paint rapidly, wielding broad strokes rather than methodically composing their pictures. By the mid-1880s, even some of the original Impressionists were uncomfortable with the lack of structure resulting from the spontaneous handling of their canvases. Seurat set out to form an aesthetic that would retain, and even extend, the Impressionists' attention to color in natural light but would replace their ephemeral visual effects with a sense of underlying and enduring form. Seurat transcribed what he considered the lasting essence of reality. Another Symbolist literary figure, Gustave Kahn, expressed the distinction quite succinctly, concluding that Seurat "tried to convey a more permanent image of a landscape rather than its momentary appearance."[4]

Fénéon's term, which draws upon the nature of Seurat's relationship to his predecessors, became the movement's official title, but other names inevitably arose to label his methods. "Divisionism," frequently used interchangeably with "Neo-Impressionism," refers to the practice of applying separate strokes of pigment to the

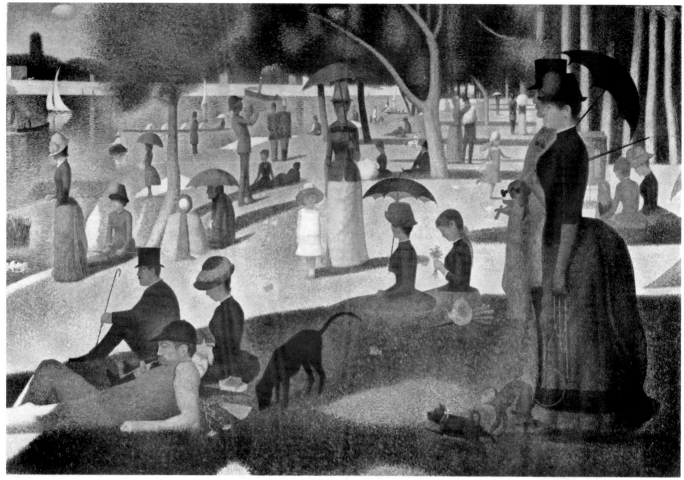

Fig. 1 Georges Seurat, *A Sunday Afternoon on the Island of La Grande Jatte*, Collection of The Art Institute of Chicago.

canvas according to a systematic division of color. "Pointillism," which cannot claim the theoretical basis of Neo-Impressionism, refers only to the technique of painting in small, uniform dots and was an expression the artists disliked. Seurat preferred the term "chromoluminarism," a reference seldom used today, which emphasized the color and light studies central to his artistic program. Finally, there is "Post-Impressionism," an umbrella term that encompasses Seurat's style as well as others developed in the late 1880s and 1890s in response to Impressionism.[5]

Seurat and his colleagues were prominent figures in this Post-Impressionist era, when new styles and their attendant manifestoes would make the late nineteenth century one of the richest epochs in the history of French art and thought. While relying on many of the traditions of the past, the Neo-Impressionists wanted to create an art whose methods and subjects were distinctly of their own time. Fascinated by the beauty of the landscape and the seashore, they were also drawn to modern urban scenes. Rapt observers of color and light, they sought principles that explained their perceptions. And in the process of creating their own contemporary art, they developed attitudes fundamental to modern painting.

History

Georges Seurat, Paul Signac, and other future Neo-Impressionists met for the first time in 1884. The occasion was the formation of the "Indépendants," an exhibition group offering an alternative to the juried salons of the French Academy. Much more resulted, however, than the stormy launching of a controversial new exhibition society. To the catalytic exchange of ideas that ensued between Seurat and Signac, Seurat brought a rigorous classical training and a growing knowledge of optical theory, while Signac contributed his enthusiasm for the Impressionist palette, purged of all earth tones.

In the autumn of 1885, Seurat and Signac became acquainted with Camille Pissarro and his son Lucien, and the elder Pissarro became the first convert to the new aesthetic. Camille Pissarro's affiliation with Seurat must have been a particularly persuasive affirmation of the young artist's innovative methods, for as the eldest of the Impressionists and a participant in each of their exhibitions, Pissarro was regarded as a staunch Impressionist. And it was Pissarro who provided historians with one of the most succinct distinctions between the two schools when he compared his new "scientific" Impres-

sionism to the "romantic" Impressionism of his former colleagues.[6]

Pissarro's confidence in the work of his young friends led him to the heated negotiations that allowed them to participate in the eighth and final exhibition of the Impressionist group, held in Paris during May and June, 1886. There the world had its first look at Neo-Impressionism's first exemplar, Seurat's *A Sunday Afternoon on the Island of La Grande Jatte*. And there it should have been clear that the unity of the Impressionist outlook was crumbling and that in the paintings of Seurat, Signac, and the Pissarros, a fresh sensitivity was at work.

By the time of the second exhibition of the Société des Artistes Indépendants late in the summer of 1886, other artists were attracted to the new technique, and Seurat's aesthetic was on its way to becoming a distinct force in the Post-Impressionist era. Louis Hayet, who had conducted his own color research in the early 1880s, was in contact with Seurat and the Pissarros by 1886. As the movement gained momentum, the soldier-artist Albert Dubois-Pillet joined the group, followed in 1887 by Charles Angrand, Maximilien Luce, and Léo Gausson. Signac, already familiar with many of the Symbolist writers, became the liaison between critics and colleagues, and the Indépendants became the forum of Neo-Impressionism, enjoying even the reclusive Seurat's steady support.

Early in 1887, Seurat's notorious *La Grande Jatte* traveled to Brussels for the annual salon of the avant-garde Belgian group, Les Vingt. Les Vingt, or "The Twenty," was founded late in 1883 as an exhibition society committed to showing "an independent art, detached from all official connections."[7] Their annual shows, held from 1884 through 1893, included the work of the twenty members as well as that of twenty "invités" selected each year from progressive artists in Europe, England, and America. Seurat and Camille Pissarro participated in 1887 as the guests of this cosmopolitan group. The appearance in Brussels of Seurat's monumental canvas can be credited to a few open-minded individuals guiding Les Vingt and the Belgian review *L'Art Moderne*. Octave Maus, the group's secretary, poet-critic Emile Verhaeren, and painter Théo van Rysselberghe had seen Seurat's picture in Paris at the last Impressionist exhibition the previous summer. A carefully planned campaign, complete with Félix Fénéon's lucid stylistic explanations, was mounted in the pages of *L'Art Moderne* to prepare the public for their first glimpse of Seurat's sensation.[8] Greeted in Brussels by a spirited but less tumultuous critical reception, *La Grande Jatte* struck a responsive chord in progressive Belgian painters, who would make Brussels second only to Paris as a center for Neo-Impressionism. The imported aesthetic quickly became a favored style at Les Vingt, and paintings by French Neo-Impressionists became regular features of their exhibitions.

A number of prominent members of Les Vingt exemplify the enthusiastic Belgian response to Neo-Impressionism. Willy Finch, working in the style by 1887,

was the first to attempt divisionism.[9] By the summer of 1888, Henry van de Velde was adeptly manipulating the technique, and Théo van Rysselberghe was soon committed to the method. Van Rysselberghe, the best known of the Belgian Neo-Impressionists, sustained the style for the longest period and successfully applied it to portraiture. By 1890 the movement had also attracted Georges Lemmen. During the summer of 1892, it was Henry van de Velde and another Vingtiste, Jan Toorop, who were instrumental in presenting a special exhibition of Les Vingt at The Hague. There Dutch artists were exposed to the work of the leading French and Belgian Neo-Impressionists, and by 1894 Holland had a small band of divisionists that included Toorop and Johan Joseph Aarts at The Hague as well as H. P. Bremmer and Jan Vijlbrief in Leiden.

The Neo-Impressionist Aesthetic: Light and Color

At the heart of the "new Impressionism" pioneered by Seurat was a specific aesthetic program that blended elements of tradition with a decidedly modern sensibility. To reform the Impressionists' spontaneous approach to painting, Seurat did not just retreat into the studio to plot more meticulous compositions. As a product of the academic training of the Ecole des Beaux-Arts, Seurat had acquired a taste for the fine draughtsmanship of J.-A.-D. Ingres, the simplified forms of Egyptian art, and the harmony of the Antique. His emphasis on stable, well-ordered pictures is therefore not surprising. Yet other aspects of Seurat's new program lay more strategically in the character of his time. Reflecting the era's confidence in the achievements of science, Seurat looked to recent explanations of optics and color perception as the rational basis for his new methods. He replaced the impetuous handling and intuitive color sense of the Impressionists with disciplined, uniform brushwork and colors selected according to his interpretation of optical theories. After Seurat's death, Belgian poet Emile Verhaeren mused about the artist's motivation, "Perhaps he thought that the scientific and positivist spirit of his time demanded within the realm of the imagination a more clear and solid tactic for the conquest of beauty."[10]

What did Seurat want his pictures to look like? Merely stating that Seurat wished to restructure the improvisatory nature of Impressionism and that he sought methods based on scientific truth does not communicate the effect he hoped to achieve in his finished paintings. Seurat was actually seeking a way to make the physical substance of oil paint generate the luminosity and radiance of real light. He also wanted to create color harmonies capable of both brilliance and nuance, intensity and subtlety.

Simply stated, Seurat's entry into the realm of science focused on the way the eye sees and the way colored light, as well as colored pigment, behaves. Since 1876 he had been studying the principles of color theory, read-

ing the treatises of French scientists Michel Chevreul and Charles Blanc, and making detailed notes on Eugène Delacroix's manipulation of color relationships. Seurat's research was placed on an even firmer scientific footing in 1881 with his discovery of a book entitled *Modern Chromatics,* by Ogden Rood.[11] This American physicist based his findings on color and perception upon laboratory experiments and calculations derived from scientific instruments.

Seurat and his Neo-Impressionist colleagues readily acknowledged the information that science placed at their disposal. In 1887, Pissarro even granted that "we could not pursue our studies of light with much assurance if we did not have as a guide the discoveries of Chevreul and other scientists." He added, "I would not have distinguished between local color and light if science had not given us the hint; the same holds true for complementary colors, contrasting colors, etc."[12] While writers friendly to the movement appeared to take comfort in the Neo-Impressionists' association with science, they were frequently called upon to defend the painters against the charge that they had subordinated art to science. Félix Fénéon argued that science was only a tool to educate the eye and to sharpen perception and could never serve as a replacement for artistic judgment. The critic summarized his position in one sentence: "Mr. X can read optical treatises until eternity, but he will never create *La Grande Jatte.*"[13] Even Ogden Rood maintained that rules alone did not produce agreeable color schemes: painters still need the "natural feeling for what may be called the poetry of colour."[14] And when their methods are compared to other painting conventions, it becomes even more clear that the Neo-Impressionists did not forsake the domain of art for scientific formulae. Their application of laws governing color perception is no more scientific, nor any less creative, than the practice of painters since the Renaissance who have used optical theories to guide their handling of perspective and spatial recession.

In his study of the scientific principles of color mixture, Ogden Rood isolated a fact that became the cornerstone of Seurat's theoretical framework: the difference between colored light and colored pigment. Rood made a major contribution simply by determining that the distinction exists, but he also specified the differences in their behaviors and the subsequent effect on the painter's craft. Paint pigments lack the purity and power of light and thus they must be governed by different laws.[15] A few examples illustrate that the material substance of colored paint indeed performs differently from rays of colored light. Mixing the pigments of primary colors yellow and blue yields green, but combining yellow and blue beams of light produces a gray-white light. And more to the point for Neo-Impressionist practice, when the three primaries or any pair of complementaries of colored pigments are mixed together, the result is a dark, neutral tone. When beams of the primary or complementary colors of light intersect, however, they produce

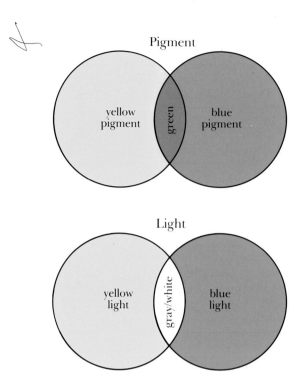

Fig. 2 Diagram illustrating the difference between the mixture of colored light and colored pigment.

white light. Ultimately, blending all the colors of paint pigment yields a muddy grayish-brown tone, while combining all the colored lights in the spectrum creates a pure white light.

These comparisons led the Neo-Impressionists to conclude that the traditional method of mixing pigments on the artist's palette also leads to duller, muddied colors. In order to generate more luminous effects, Seurat and his followers opted for applying unblended pigments directly to the canvas from the paint tube. These pure hues, painted in the form of small dots, then reflect chromatic light, which blends in the eye of the viewer, creating the desired color effect without sacrificing vibrancy. This method of blending color, known as *mélange optique,* was the basic principle of the new aesthetic. According to *mélange optique,* or optical mixture, the separate dots of pigment are blended on the retina as colored light. To the Neo-Impressionists, the canvas became a preparation ground where pure particles of color, arranged according to specific rules, should trigger certain luminous color reactions when set in motion by the act of viewer perception.

This theory of mixing color by the eye rather than the brush, taken to extremes, has given rise to the idea that when perceived at the proper distance, the small dots of Neo-Impressionist paintings fuse into an even surface. Viewers of these pictures are often told to look for a blending of the canvases' divided hues and stippled strokes. Despite this persuasively simple explanation, in actual observation the separate colors persist even well beyond the normal viewing distance. While they do not totally merge, the discrete points of color do seem to

posite. This phenomenon can be demonstrated by staring at a square of red paper in bright sunlight, then switching abruptly to look at a square of white paper and noting the sensation of green that appears. What the Neo-Impressionists did, and this simple fact is often overlooked, was to anticipate this sequential optical effect by painting both the color and its complement in adjacent areas of the canvas. This type of contrast, most obvious at the edges of colored areas, is often seen in the subtle halos or silhouettes that surround the figures in Neo-Impressionist portraits.

To engineer these contrasting harmonies, the Neo-Impressionists typically worked with blue as the opposite of orange, red opposite green, and yellow opposite violet. These colored pairs are the pigmentary complementaries, and as suggested earlier, they are not the same as the complementary colors of light. That there are two sets of opposites, or complementaries, can be confusing to those analyzing the Neo-Impressionists' contrasts. Given the painters' emphasis on the mixture of colored light, one might well expect a reliance on the spectral opposites. Robert Herbert has clarified this point, noting that early in the movement Seurat and Signac did experiment with the complementaries of light rays, opposing, for example, purple with green. By about 1887, however, they reverted to the more traditional pigmentary opposites, such as red and green, having concluded that their pigments could not behave as spectral or prismatic colors since they generate reflected, not pure radiant, light.[17] Seurat's statement of aesthetics of 1890 clearly cites the pigmentary opposites as the basis for his contrasting harmonies.

A common misconception about the color structure of Neo-Impressionist paintings pertains to the blending of color. It is often assumed that if Seurat wanted to paint a landscape with green grass, he placed several blue dots next to several yellow dots to achieve a green mixture. But as Signac commented to a colleague who misunderstood his method, "But no, dear Maître, when I want a green, I use a green, and when I want a violet, I use a violet. . . . Division, contrast are not this at all! It is both simpler and more complex—and, especially, more useful."[18] In actual practice, the Neo-Impressionist painter obtained the green effect by applying unmixed green pigment directly from the paint tube. The artist was not even restricted to one shade of green but could vary both hue and value to suggest the gradations that exist in any field of green grass. These gradations, or orchestrations of related hues, are the other element of Neo-Impressionist harmonies, and they contribute to the flickering effect of the painted surface. To indicate the presence of direct sunlight, the Neo-Impressionist painter typically added dots of orange, yellow-orange, and yellow to the green grass.[19] In the field's shaded areas, points of blue and violet represent the cooler tints of indirect light and are also the color opposites required to complement the oranges and yellows of the adjacent sunny areas. The shaded portions of the field also have

reddish-purple tints that oppose the sunstruck greens.

This example alone should dispel the myth that the Neo-Impressionists were confined to working with red, yellow, and blue, the primaries of colored pigments. At times, Seurat's palette included as many as eleven different hues,[20] each of which could also be mixed with its neighbor on the chromatic wheel, or with any amount of white, the only palette blending the painters condoned. The Neo-Impressionist palette was limited, however, to colors derived from the solar spectrum, thereby excluding black or any earth colors. This restriction was based on Sir Isaac Newton's observation that as white light passes through a prism, it divides into all of the colors of the visible spectrum, which does not include earth colors or black.

The Neo-Impressionist Aesthetic: Frames

The Neo-Impressionists' careful orchestration of colored effects did not end with the selection and distribution of pigments. Technical and aesthetic considerations also governed the presentation and mounting of their canvases. Seurat's group rejected the use of varnishes because these surface glazes could disrupt the reflective properties of the pigments. With their tendency to yellow, the varnishes also threatened the color relationships within their pictures. (See conservator David Miller's statement about the effects of varnish on the perception of Neo-Impressionist pictures.) The Neo-Impressionist painters preferred to put their canvases behind glass. Louis Hayet even experimented with encaustic compounds, seeking a medium for his pigments that would resist change over time.

Concern for sustaining their color harmonies also extended to the choice of frames. The Neo-Impressionist painters believed that gilded moldings were incompatible with the orange and gold tints of their pictures. Like the Impressionists, Seurat and his followers avoided traditional gold moldings and favored simple white frames. They used the white frame to protect the picture's color harmonies and to separate the canvas from its surrounding environment. These frames were generally broad and flat, without the depth or the ornate trim that could cast shadows upon the picture's surface.

Very few of these frames survive today, and our knowledge of them comes primarily from contemporary accounts in correspondence and reviews. In his letters of the 1880s, Camille Pissarro writes of his struggles to use white frames in spite of the objections of his dealer, Durand-Ruel, and certain exhibition societies. In his treatise on Neo-Impressionism, Signac comments that these "modest and logical" frames, which exalt the saturation of tints without disturbing their harmony, were banned by the official and pseudo-official salons of France.[21] An indisputable record of the use of white frames is Seurat's large figure painting of 1886-88, *The Models* (The Barnes Foundation, Merion, Penn.). The picture's setting is Seurat's own atelier, and it shows *La*

move toward each other, setting up an oscillation, or vibration of color, that suggests the shimmer of real light. As Robert Herbert explains the perception of the small dots of color intended for optical mixture:

> The eye struggles toward a resolution of the several colors, but stops short of a final, single result. In so doing, it is subjected to a vibration of colored particles in which their separate identities are preserved, but intensely activated by the texture and by interaction with the other colors.[16]

In this context, "vibrant" becomes a most appropriate adjective for Neo-Impressionist painting, describing not only the brilliant colors, but also the slight trembling of the picture's lustrous surface. The effect is indeed one of luminosity, one of Seurat's primary objectives.

While Neo-Impressionist theory did call for optical blending, total optical mixture is not actually possible in painting. The dots of pigment do emit colored light, but they are not light sources and therefore do not behave in the same manner as radiant light. Thus the chromatic light reflected from the painted surface cannot be as pure as that radiating from a prism. Furthermore, the blending of component light colors into whole light is the work of a prism and cannot be performed by the human eye.

The Neo-Impressionists' rigorous dotted technique was not just the vehicle for the optical mixture they wished to generate. The small spots of color that have become the style's most conspicuous feature also permitted great variety and nuance of chromatic effect. Through their use of fine points, the Neo-Impressionists could divide even small passages into an infinite range of related or contrasting colors. The stippled facture was also suited to the precise lines and the carefully engineered structures of their compositions. Taming the broad, impetuous strokes of the Impressionists, Seurat and his coterie opted for a methodical application of consistent brushwork. If there was some political posturing involved in replacing the Impressionists' individualized handling with a less personal treatment befitting the new mechanical era, there was also the practical consideration that thick patches of paint sometimes dry unevenly, or mix with other pigments, producing the duller tones the Neo-Impressionists wished to avoid.

Since the Neo-Impressionists condemned most palette mixtures, they used pigments that were broken down into their pure, constituent hues. Without the option of physically blending their pigments, the painters had to choose and distribute their colors carefully in order to achieve specific harmonic effects. Seurat and his group acknowledged that the Impressionists had already begun to divide their colors, but they faulted their predecessors for selecting their pigments in a more intuitive fashion based on random observation of nature. Here Seurat's confidence in the utility of science again asserted itself. He and his colleagues divided their colors

systematically, according to fixed laws governing the contrast, intensity, and gradation of color.

A brief summary of some of the principles that guided the Neo-Impressionists' choice and placement of colors should dispel some of the mystery about their color arrangement. First, Seurat and his followers, like the Impressionists before them, saw the local or actual color of an object in nature as only one aspect of representing its appearance on the canvas. Also taken into consideration were the qualities of the natural or artificial light of the particular setting and the shadows and reflections cast by the surroundings. The artists tried to give equal pictorial emphasis to each passage of the scene, creating a consistent screen of color across the surface of the canvas.

As the Neo-Impressionists pursued the luminous effect of light, they sought clear, vivid harmonies based on the behavior of color in nature. Fundamental to their color schemes is the contrast of hues, especially complementaries, or opposites on the color wheel. The basic principle governing the painters' division of color is simultaneous contrast. According to this law, applying two colors side by side heightens their differences; and if the colors happen to be complementaries, their juxtaposition creates unusual vibrancy. Although Seurat's stippled technique made it easier to employ the principles of contrast, it should be noted that the complementary colors were seldom juxtaposed dot by dot but were applied in adjoining areas of the canvas. The other important principle, successive contrast, refers to the sensation that occurs when one intense color fatigues the eye and produces a surrounding after-image of the color's op-

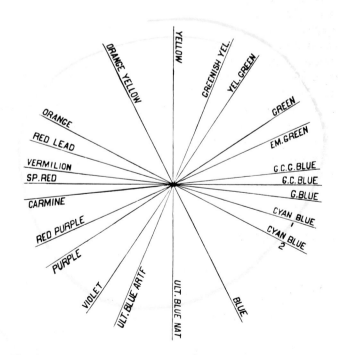

Fig. 3 Ogden Rood's contrast-diagram, from *Modern Chromatics* or *Students' Text-Book of Color*. Based on experiments with polarized light, Rood's pairings of complementary colors differ from the pigmentary opposites.

Grande Jatte, mounted in a broad white frame, hanging on the studio wall.

Seurat was soon dissatisfied with the plain white frame, however, and began to extend the dotted treatment of his canvases to their wood frames. Reflecting upon Seurat's varied experiments with framing techniques, Gustave Kahn reports that his friend was never completely content with his solutions. Kahn offered a useful perspective on Seurat's efforts, observing:

> A painting is a painting. But it is also a slice of nature, and confronting the conventions of painting Seurat felt many of the anxieties that troubled Mallarmé *vis-à-vis* the structure of a book and the succession of its pages, with little accord between the separate poems and the imposition of a strong connection between the unrelated items.[22]

For Seurat, the frame was the bridge between his "slice of nature" and the "unrelated" environment around it.

Establishing the chronology of Seurat's development of the stippled frame is difficult, since he frequently returned to earlier works to apply his latest framing methods. In June 1887, Camille Pissarro wrote to Signac that he had visited Seurat's studio, where work on *The Models,* and its startling new frame, was progressing. Though Pissarro was not specific about the technique, he did distinguish it from the plain white frame and pronounced the new treatment an "indispensable complement" to various atmospheric conditions.[23] In April 1888, Félix Fénéon singled out Seurat's frames for uncharacteristically negative criticism. While he approved of tinting them with small dots of pigment corresponding to adjacent hues on the canvas, Fénéon complained that Seurat went too far when he imagined that the frame actually surrounded the specific landscape depicted on the canvas. For in these cases, Seurat dotted the frame with orange or blue, depending upon whether the frame would exist in the shadow or sunlight of his picture.[24] Fénéon's remarks, however, indicate that the frames were still predominantly white, and the shortage of additional commentary suggests that this particular treatment was short-lived.

Around 1889 Seurat began the regular use of another element in the presentation of his canvas, the painted border. With this innovation, Seurat began to insulate and enhance his harmonies on the flat surface of the picture itself. Stippled directly on the canvas in colors that varied according to the adjacent hues, this narrow band was another attempt to ease the break between the luminous, harmonious life of the picture and the world around it. The Belgian Neo-Impressionists, specifically Van Rysselberghe, Lemmen, and Finch, adopted Seurat's border treatments. The borders were usually meant to accompany rather than substitute for the painted frames, and the unfortunate loss of most Neo-Impressionist frames deprives modern viewers of the proper effect of the two devices used together.

The best surviving example of Seurat's framing techniques is *Le Crotoy, Looking Downstream* (The Detroit Institute of Arts), painted in 1889. This composition presents both the painted border and the original painted frame. Their colors are applied in direct contrast to the landscape's harmonies, as combinations of blue, red, and orange blanket both border and frame, and all trace of the white or stippled white frame has now disappeared. In this context, Seurat's vibrant frame hardly plays a subsidiary role in the picture's total effect. Seurat pursued this approach for his four Gravelines seascapes painted during the summer of 1890, but none of their frames has survived. It seems that he sustained the use of contrasting colors but made the dominant tint of the borders and frames a deep, or ultramarine, blue (see fig. 4, p. 31). The border of his last painting, *The Circus,* 1890-91 (Musée du Louvre, Paris), as well as several which he repainted on earlier works, demonstrates this shift to a darker blue band. After Seurat's death, Signac commented on the impact of these colorful, contrasting frames on Seurat's late works: "Saw again the paintings of Seurat in his mother's living room. The last seascapes of Crotoy and of [word missing, probably Gravelines], in their colored frames, make marvels there. It is like soft and harmonious light glowing on these walls."[25] Camille Pissarro, no longer a member of the Neo-Impressionist group, was less enthusiastic about Seurat's Gravelines marines and their dark perimeters: "All his pictures are framed in chromatic colors and the ensemble gives the effect of an intense blue and violet stain; I find this disagreeable and discordant, it is not unlike the effect of plush."[26]

Though the white frame is generally regarded as the most common Neo-Impressionist framing device, it is clear that as Seurat's last refinement of the technique, his colored frames and borders of 1889-91 deserve greater prominence in the study of Neo-Impressionist painting. Works from the early 1890s by Signac, Van Rysselberghe, Finch, and Lemmen indicate that Seurat's colleagues also borrowed his innovation of contrasting frames dominated by deep blue tints. Françoise Cachin has suggested that the frames with wide contrasting panels, usually of dark ultramarine blue, used by Seurat and his friends were inspired by the bands of printer's ink commonly found above and below the prints of Hokusai and Hiroshige.[27] In any case, the cool tones of the dark frames enhance the canvases' luminosity. There were also variations on the white and colored frames, exemplified by Signac's treatment for his large canvas *In the Time of Harmony* (City Hall of Montreuil). His design called for narrow planks tinted with complementary hues on the interior, surrounded by a broader white frame.[28]

If the Neo-Impressionists' experiments with painted frames did not already suggest it, Seurat's famous declaration of theory and technique confirms that the frame and its articulation had become indispensable elements in their aesthetic program. In the brief statement that

presents the fundamentals of his art, Seurat devotes the final sentence to this issue: "The frame is in a harmony opposed to that of the tones, colors and lines of the painting."[29] As Seurat attempted to integrate his tones, colors, and lines into the larger visual arena in which they must exist, there is no doubt that the frame was their essential complement.

The Neo-Impressionist Aesthetic:
Expression of Line and Color

The notoriety of the Neo-Impressionists' colored dots and the complexity of their harmonies should not overshadow the compositional element of their artistic program. Given Seurat's express intention to add structure to the amorphous pictures of the Impressionists, neglecting the role of line and geometry would misrepresent the goals and the impact of the movement. Contemporary critics certainly recognized the new order and clarity of their pictures; and in this century, artists like the Cubists and Purists were inspired by the organization and intellectual rigor of their formal arrangements. For Seurat himself, interest in design and pattern took on added importance later in his career, when he began to explore the expressive potential of painting's formal components.

Between 1884 and 1886, Seurat formulated most of his methods for creating luminosity and vibrant harmonies. From 1887 until his death in 1891, he was preoccupied with the expressive qualities of line, direction, and color. This later interest did not contradict or supplant Seurat's earlier thinking. Rather, it co-existed with his growing belief that there were not only rules governing the perception of color and light, but also basic principles for establishing a unified system of pictorial expression. In his intense scrutiny of his craft, Seurat concluded that the abstract components of art—line, color, and tone—have more than descriptive, pictorial value: they possess an emotive capability that communicates itself even subconsciously to the viewer.

Just as Seurat turned to physical laws for his methods of color division, he sought comparable principles to explain the expressive potential of lines and angles. A pivotal point in the development of his ideas came with his introduction to the brilliant young scientist and aesthetician, Charles Henry, at the last Impressionist exhibition in 1886. Henry was already looking to science and mathematics for keys to the emotive power of forms. In one of his first publications, which he ventured to title *A Scientific Aesthetic* (1885), Henry postulated that there are physiological and psychological explanations for why certain lines and directions strike the viewer as agreeable or displeasing.

According to Henry, lines moving upward and to the right convey gaiety, horizontal lines communicate a sense of calm, and lines turning downward and to the left connote sadness. Henry maintained that directional movement was the basis for translating the effects of

such lines. To explain the pleasing, energetic sensations of lines moving upward and to the right (known as dynamogenic), he maintained that those lines or motions are natural and comfortable to humans, comparable to the propensity to turn a pencil sharpener outward and clockwise to the right. As Herbert summarized Henry's application, when a viewer perceives those upward-turning lines, they are "agreeably associated with his unconscious mental movements."[30] Conversely, Henry regarded the lines that travel downward and to the left as inhibitory and enervating, and they can be compared to the feeling of awkwardness experienced in trying to turn the pencil sharpener in the opposite direction.

Henry's findings fortified Seurat's thesis that there could be a scientifically demonstrable set of rules for the expressive roles of line, color, and tone in painting. While his goal may sound ambitious, the emotional states he attempted to explain were of the most general nature: gaiety, calmness, and sadness. Seurat assigned feelings of gaiety to lines above the horizontal and qualities of sadness to downward lines. Perhaps the easiest way to test these assertions is to consider the universal interpretation of the upward-turning lines of a smiling face or the downward curves of a frowning one. While this example may seem simplistic, the Dutch painter-theorist Humbert de Superville, whose ideas were known to the Neo-Impressionists, used diagrams of lines and angles of the human face to illustrate his conclusions about the expressive effects of line.[31] In fact, Seurat's remarks devoted to linear elements in his 1890 statement of aesthetics closely parallel Humbert de Superville's ideas.

The Neo-Impressionists were also intrigued by Charles Henry's research on the expressive power of color. Henry provided texts, demonstrations, and lectures on the effects of color on the observer, fortifying with physiological explanations his theory that gay colors are the warm hues of red, orange, and yellow, while the cool hues of green, blue, and violet are the sad colors. The next step toward a fully integrated theory of pictorial expression was to establish the correspondence between the feelings inspired by colors and those by lines. Henry succeeded in coordinating those associations and furnished artists with diagrams of his "index" of expression. His schematic wheels or circles matched the gay and sad colors to the appropriate linear movement. Drawing upon

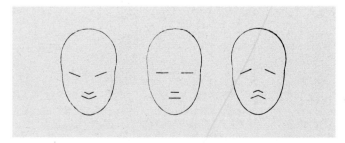

Fig. 4 Schematic drawings of the human face, illustrating the emotive value of lines, from Humbert de Superville, *Essai sur les signes inconditionnels dans l'art.*

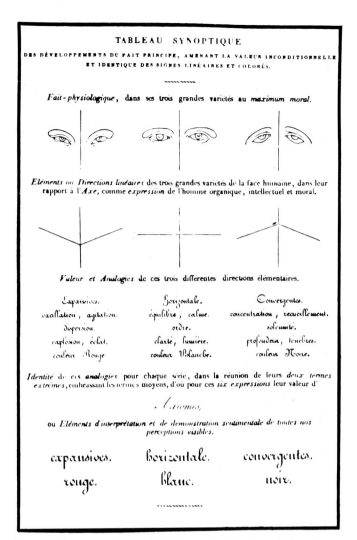

Fig. 4a Humbert de Superville's "Synoptic Table," correlating the expressive effects of line and color.

the theories and research of Henry and a few other scientist-aestheticians, Seurat completed his aesthetic formula, linking the emotive qualities of warm and cool colors and tones with those of lines to achieve a unified expression of gaiety, calmness, or sadness. Through this

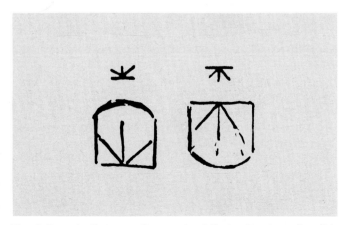

Fig. 5 Seurat's diagrams of gay and sad linear directions, from his letter to Maurice Beaubourg, August 28, 1890.

concordance of visual elements, Seurat sought to establish the ultimate harmony of his pictures.

If the Neo-Impressionists' reliance on perceptual laws and harmonic theories provoked the criticism that science had intruded too far into the realm of painting, their attempts to systematize the expressive capacity of art were guaranteed to be regarded as an inappropriate manipulation of the artistic process. Again, the Symbolist writers, a group from whom one might well expect vehement protection of the ineffable mystique of a work of art, were the Neo-Impressionists' eloquent defenders. In an 1891 article, Félix Fénéon described the role of Henry's findings in the Neo-Impressionist approach, "He [Signac] knows well that a work of art is inextricable. Moreover, nowhere did Henry claim to furnish artists with the means of mechanically creating a somewhat complex beauty."[32] Seurat and his colleagues affirmed that the formulas were only a starting point for the painter and hardly a substitute for imagination or artistic intuition.

While the intrinsic expressive qualities of line and color have received less attention in the study of Neo-Impressionism, this aspect of the aesthetic provided a vital legacy for artists of the twentieth century. For in Seurat's approach lies the realization of the autonomy of art's formal elements. As Fénéon observed, "Seurat knows well that a line, independently of its topographical role, possesses a measurable abstract value."[33] Seurat's interpretation of the decorative and expressive *raison d'être* of line and color was a crucial step toward "legitimizing" the existence of a fully abstract art.

Neo-Impressionism and Symbolism

It is this belief in the expressive capacity of color and line that brings the Neo-Impressionist and the Symbolist painters to an intriguing intersection of viewpoints before they embark on separate but parallel routes. The Neo-Impressionists shared with the Symbolists a confidence in the ability of painting to communicate emotions or states of mind independent of their images of the natural world. For both groups, the expression of moods or ideas took precedence over copying nature. As Symbolist Albert Aurier expressed this liberation from the close imitation of nature:

> The artist will also always have the right . . . to exaggerate, to attenuate, to deform these directly significant characters (forms, lines, colors, etc.) not only according to his individual vision, not only according to the form of his personal subjectivity (such as happens even with realistic art), but also to exaggerate, attenuate and deform them according to the needs of the Idea to be expressed.[34]

The pivotal difference between the two outlooks lay in the Neo-Impressionists' search for scientific explanations for predictable emotional reactions to various colors

and shapes. For the Symbolist painters, no such uniform system was required. Their interpretations were individualized and did not have to correspond to a specific stimulus. While all the painters still created pictures based on representational images, the Symbolists maintained, for example, that the artist was not bound to make the colors in his paintings correspond to those found in nature. Paul Gauguin and Vincent van Gogh were two of the most famous proponents of the idea that the artist could assign his own personal interpretation to the emotional significance of colors.

It is curious that the Symbolist authors had their first close association not with their Symbolist counterparts in painting, but with the Neo-Impressionists. Writers such as Félix Fénéon, Gustave Kahn, Paul Adam, and Emile Verhaeren supported the Neo-Impressionist artists with a body of lucid and eloquent documentation. In 1886 both Neo-Impressionist painting and literary Symbolism emerged as identifiable movements. Since in 1886 Seurat's aesthetic was largely devoted to optics and structure rather than to expression and interpretation, it is all the more surprising that he and his friends were adopted with such alacrity by the Symbolist critics. The Neo-Impressionists' departure from the anecdotal objectivity of the Impressionists for an art that attempted to present the essence of a superior, enduring reality appealed to the Symbolists' sensibilities.

The poets and painters also held common views on the expressive function of line and color. Like the Neo-Impressionists, Gustave Kahn was influenced by Henry's analysis of dynamogenic and inhibitory impulses.[35] The poet observed that Seurat's "experiments in line and color were in many respects exactly analogous to our theories of verse and phrase."[36] The fresh modernity of the Neo-Impressionist outlook, as well as their shared distaste for the bourgeoisie's reluctance to accept new artistic ideas, cemented the bond with the Symbolist writers. Yet the Neo-Impressionists were not the only painters endorsed by the Symbolists, and the individual authors showed considerable variety in the pictures and the artists they favored.[37] After 1891, when Seurat died and the movement faltered, several Symbolists shifted their support to Gauguin and the painters of the Nabi group.

The Neo-Impressionists and Anarchism

Neo-Impressionist painters and Symbolist authors shared more than an outlook on artistic expression: Seurat's followers and their friends among the literati held similar social and political views. Unlike the Impressionists (with the notable exception of Camille Pissarro), these painters were far from apolitical. Most members of the original group of Neo-Impressionists, as well as the writers like Félix Fénéon, Gustave Kahn, and Emile Verhaeren who were their most enthusiastic critics, were committed Anarchists. Their conviction took the form of a pronounced sympathy for the working man and a vehement rejection of bourgeois taste and the standards of the established government.

The Anarchist position in France during the final years of the nineteenth century was not just a nihilistic attitude condemning the existing order. On the contrary, the movement was motivated by a utopian vision of the future. The form of Anarchism subscribed to by many of the intellectuals of late nineteenth-century France is more accurately referred to as "Anarchist-Communism," as it advocated the collective ownership of the means of production by small, local groups. The movement's intellectual leader, Pierre Kropotkin, recognized the evils of urban industrialization, but he did not endorse an escapist retreat to a pre-industrial era. Though he retained a romantic attachment to the countryside, he included the machine and the achievements of modern technology in his plan for the harmonious society of the future.[38]

Sensitive to the inequities of the current social system, the artists-anarchists aspired to a more comfortable life, free from exploitation, for all workers. Conscious of their own unprivileged position, they looked to the day when there would be recognition for the value of the creative work of painters and writers. The corrupt and ineffective administration of the Third Republic did little to relieve the abuses to which the artists and authors objected. Although the Neo-Impressionists undertook little overt political activity, they did not deny the fact that violence was a viable method for the disruption of the old order. Fénéon even acknowledged that bombings made more effective publicity than pamphlets.[39] Fénéon and Maximilien Luce were both imprisoned in the wave of arrests that followed the assassination of President Sadi Carnot in 1894, and Camille Pissarro fled to Belgium. Luce was eventually released, and Fénéon brought to trial but acquitted. As John Rewald has so aptly characterized the artists devoted to the Anarchist movement, "They were idealists, not agitators. . . . The writers and painters who professed extremist views were anarchists with all the altruism of their hearts, the purity of their souls, and the elegance of their demeanors."[40]

On the surface, the association of Anarchists and Neo-Impressionists might appear an unlikely liaison. The idea that the same mentality that follows rigorous artistic techniques and fixed principles could also advocate the rejection of systems of authority might at first seem paradoxical. Though there is no required correlation between an artist's moral values and his aesthetics, this correspondence nevertheless often exists, and it is tempting to look for a conceptual unity underlying the two approaches. For the Neo-Impressionists, a common element in their art and their politics was a positive attitude toward science. Just as they saw recent scientific discoveries as the legitimate basis for their methodology, the painters identified with a movement that incorporated industrial progress into its hopes for the future of society. The capacity of science to serve the artist in his search for expression had its parallel in the potential of

technology to supply the means for a utopian existence.

The Neo-Impressionists' willingness to confront the realities of modern life is reflected in their choice of subject matter. Particularly during the 1880s, Seurat, Signac, Luce, Dubois-Pillet, and others depicted views of working-class neighborhoods, factories, and industrial sites on the outskirts of Paris. Even when Seurat traveled to the coast to paint luminous seascapes, he often chose the homelier, unpicturesque motifs.[41] Maximilien Luce's scenes from the notorious *Pays Noir* of Belgium's mining district are more pointed commentaries on the effects of the industrial revolution.

While scenes from the modern era were basic to their repertoire of subjects, the Neo-Impressionists seldom painted pictures with overt political messages. One outstanding exception is Paul Signac's monumental canvas, *In the Time of Harmony* (City Hall of Montreuil), of 1893-95. Its didactic intent is borne out by Signac's initial choice for its title, *In the Time of Anarchy*.[42] The painting is not a slice of contemporary life but a utopian vision of people co-existing in the comfortable, compatible future. But more typically during the 1890s, as artists like Signac, Cross, and Angrand turned increasingly to formal and abstract issues, they were less inclined to clothe their political convictions in paintings of explicit content.[43] As Signac summarized their position:

> Justice in society, harmony in art; the same thing. The anarchist painter is not someone who paints anarchist scenes, but he who, without desire for money or any recompense, fights with all his individuality against bourgeois and official conventions by his personal contribution. Subject matter is nothing, or at least only one part of the work of art, no more important than the other elements—colors, drawing, composition.[44]

The artists did, however, provide illustrations for Anarchist publications. Luce, the Pissarros, Signac, Angrand, and Cross executed drawings and lithographs that, if not openly propagandistic, were at least sympathetic to the position of the common man.[45]

Another manifestation of the Neo-Impressionists' social awareness was their involvement with the growth of the applied arts in Europe. Nowhere was this more evident than in Belgium, where divisionist painters were enthusiastic leaders in the revival of decorative arts and crafts. Belgian artists were receptive to William Morris and the message of the English Arts and Crafts movement, and there was a strong impetus to make art accessible to all people. When the Art Section of the Belgian Worker's Party was founded in 1891, its platform read, "In the future, we hope, art will be everywhere. Not only will it formulate in magnificent fashion the generous aspiration toward an ideal, but it will come down to the ordinary things of daily life and will accompany all human activity."[46] Les Vingt, perennially alert to fresh artistic concepts, featured examples of the applied arts in its 1891 salon, and the emphasis on decorative arts and crafts continued in subsequent exhibitions of Les Vingt and its successor, La Libre Esthétique.

Belgian Neo-Impressionists Willy Finch, Georges Lemmen, and Henry van de Velde were in the forefront of this trend. Finch broadened his interests to include ceramics, and his pieces figured in the Les Vingt show of 1891. Georges Lemmen began his work in the ornamental arts in the early 1890s, during the same period that he adopted divisionism. Henry van de Velde provided the most extreme example of the rising importance of the applied arts. As Van de Velde began to paint divisionist pictures in 1888, he was involved with the study of socialist doctrines, and one might speculate that the Neo-Impressionists' progressive politics enhanced the aesthetic's appeal to the young artist. By the early 1890s, however, Van de Velde was questioning the validity of creating easel paintings, unique works that could be enjoyed by only a few people, when decorative arts and household objects could reach a much wider audience. By 1894 he had given up painting, which was "scarcely consistent with [his] social aspirations,"[47] to devote himself to applied arts and architecture. And in France at this time, Signac wanted to devise tools for artisans that would improve the quality of their products.[48] The artists' actions and attitudes reflected an eagerness to face the challenges of the day with the knowledge and the technical skill of the modern era.

Neo-Impressionism After Seurat

The critical period of Neo-Impressionism was limited to only half a decade: from 1886, the year of Seurat's first exhibition of *La Grande Jatte*, to 1891, the year of his death. In this brief period, Seurat succeeded in codifying his analysis of the laws of perception and in establishing a system of expression based on the interpretation of colors and lines. For several reasons, some anticipated and others unpredictable, the Neo-Impressionist movement began a rather abrupt decline in the early 1890s.

Unexpected, of course, was the death of Seurat at the age of thirty-one. The year before, in 1890, both the Neo-Impressionists and the Société des Artistes Indépendants suffered a loss in the death of artist and loyal member Albert Dubois-Pillet. During the same period, the reclusive Louis Hayet detached himself from the group and Charles Angrand retreated to his native Rouen, where he devoted the next decade of his career to exquisite black and white drawings. Less surprising is the fact that by the end of the 1880s, several artists wearied of Neo-Impressionism's methodical technique and began to drift back into more individual painting styles. The most notable loss from the group was that of the venerable Camille Pissarro, who concluded that the rigorous methods of Neo-Impressionism robbed his pictures of the spontaneity necessary for his personal expression. His son Lucien also defected from the group and settled in England in 1890. Maximilien Luce, whose handling of Neo-Impressionism had always been rather

idiosyncratic, also opted for a more Impressionist style and painted only a few Neo-Impressionist pictures after the turn of the century. Léo Gausson's enthusiasm waned, and from 1896 he pursued a life of public service in France and abroad.

In Belgium, the other stronghold of Neo-Impressionism, the peak of the movement endured a few years longer, but artists there also drifted away from the style. Georges Lemmen's Neo-Impressionist activity was over by about 1895, and even Théo van Rysselberghe's divisionist handling had relaxed by late in the century. Henry van de Velde made an abrupt turn away from Neo-Impressionism in specific and painting in general to devote his energies to the applied arts. For Willy Finch, work in the decorative arts grew at the expense of his painting. By the middle of the 1890s, the movement had lost its initial momentum, but its future was left in the able hands of Paul Signac and Henri Edmond Cross.

The continuity of the Neo-Impressionist movement can be largely attributed to Paul Signac. His outgoing nature made him a diplomatic spokesman for the style, and at his home in Saint-Tropez, he introduced a new generation of aspiring painters to the principles of the movement. In 1898, Signac's manifesto on divisionism, *From Eugène Delacroix to Neo-Impressionism,* first appeared in serial form in *La Revue Blanche.* Published as a book in 1899, this treatise played a pivotal role in the regeneration of the Neo-Impressionist aesthetic. It provided younger painters with artistic precedents as well as with lucid explanations of the Neo-Impressionist methodology. Though the author stressed the division of color at the expense of the role of the small dot, his position was consistent with the paintings he produced during this period and indicated the direction the style would take in its second phase.

Signac's paintings and writings during the decade of the 1890s show that he experienced the dilemma inherent in Seurat's aesthetic philosophy. Signac's diaries, as well as the letters of Cross and Angrand, are filled with references to the tension of choosing between transcribing the images provided by nature and composing pictures based on the artists' own arrangement of colors and shapes. Recognizing the intrinsic decorative and expressive value of lines and colors, independent of their representational function, led artists to question their imitation of nature's motifs. In his diary, Paul Signac expresses the conflict of an artist who believes in the primacy of color and line but who is still moved by the allure of nature: "One should not allow oneself to be diverted by nature from one's ideal any more than one should do without nature and deprive oneself of all the beautiful, rare and varied [images] that it offers."[49]

Indicative of his growing conviction, Signac turned increasingly to composing his pictures in the studio. He indulged his desire to paint directly from nature by executing spontaneous oil sketches and watercolors on the site and making notations for future works. The paintings he then produced in the studio display freer brushwork, more individual color harmonies, and more active surface patterns than the works of Neo-Impressionism's early years. By 1898 he had clarified his position and the new direction for the movement was set:

> The strongest colorist will be the one who will create the most. To strain to copy nature is to deprive oneself of 99 out of 100 subjects and harmonies which the free painter can treat. How limited is that which one may copy—how unlimited is that which one may create![50]

A comment made the next year shows how Signac had made naturalistic and formal concerns compatible: "It is always the same lesson; to take from nature some elements of composition, but to handle them to one's liking."[51]

For both Cross and Signac, handling these elements to their liking often meant working with the curvilinear shapes of Art Nouveau. In several of their landscape and figural scenes of the 1890s, the attention to surface design took the form of the rhythmic patterns of the Art Nouveau movement, then at the height of its popularity. In Belgium also, the threads of Neo-Impressionism were entwined with the tendrils of Art Nouveau. Divisionist painter Georges Lemmen produced designs based on the style's curling plant motifs. And when Henry van de Velde abandoned Neo-Impressionism to devote himself to the applied arts, he became one of Europe's leading representatives of Art Nouveau.

Spurred by the polemics and the dedication of Paul Signac, Neo-Impressionism reemerged in the twentieth century with new strength and distinct stylistic changes. Consistent with the trend of the 1890s was a new emphasis on decorative design and color. The canvases of divisionism's second phase were characterized by more intense harmonies, less systematic brushwork, and complex compositions. The small points used by Seurat had grown into rectangles, or bricks, often compared to the tesserae that compose mosaics. While a uniform small dot was not the only way to achieve vibrant color effects, it was the best vehicle for optical mixture. The more cumbersome brush stroke of these later works could not possibly blend in the eye of the viewer or convey nuances of tone. This shift in style marked a shift in artistic direction: Signac and Cross pursued their interest in vibrant color combinations at the expense of the luminous effects originally sought by the Neo-Impressionists. Concern for capturing the behavior of natural light and color was replaced by the search for bolder harmonies and decorative patterns that would satisfy the artists' individual sensibilities. In spite of Signac's steady leadership of the movement and the continued use of bright, divided colors, the enhanced priority of abstraction, and the pictorial changes that attended it, suggest that this later stage of Neo-Impressionism could easily be considered a distinct style warranting its own separate title.

The second period of Neo-Impressionism coin-

cided with the rise of Fauvism. Many of the painters who came to be known as Fauves experimented with Neo-Impressionism and used the vibrant color harmonies of Cross and Signac as stepping stones to their own expressive use of color. Henri Matisse, for example, was already well acquainted with Signac's treatise on divisionism when he spent the summer of 1904 in Saint-Tropez in the company of Cross and Signac. The following winter, he painted his purest Neo-Impressionist work, *Luxe, calme et volupté* (Musée du Louvre, Paris). His friend Derain experimented with Neo-Impressionist methods during the same period. The future Cubists Braque and Metzinger were also drawn to the brilliant colors, decorative patterns, and abstract construction that typified later Neo-Impressionism. Before creating the simultaneous discs of Orphism that constitute one of the most dynamic responses to Chevreul's color theory, Robert Delaunay, like his friend Metzinger, built orderly compositions with large rectangles of throbbing color. The greatest concentration of this activity occurred during the years 1904 to 1907. Indeed, the walls of Paris exhibition halls showed so many examples of Neo-Impressionism's new vitality that in 1905 the critic Charles Morice complained, "The group of pointillists and confetti-ists has not diminished. . . . On the contrary, new adherents are coming to them."[52]

With the exception of Signac and Cross, the most influential names associated with the revival of Neo-Impressionism are those who experimented in this mode before moving to Fauve, Cubist, and Expressionist styles. Yet the Neo-Impressionist legacy is also represented by a second generation of artists, such as Lucie Cousturier, Jeanne Selmersheim-Desgrange, Edouard Fer, and Henri Person, who were inspired by the divisionist aesthetic and pursued its principles without attempting to translate them into new movements. Clustered around Paul Signac in the vicinity of Saint-Tropez, they are another indication that during the twentieth century, the stronghold of Neo-Impressionism had moved from Paris, the Channel coast, and Brussels, to the Mediterranean shore.

Neo-Impressionism and the Holliday Collection

In a statement written for an exhibition of his collection in 1969, Mr. Holliday commented that he had tried to assemble pictures that illustrated the broad impact of Neo-Impressionism. Indeed, his search went beyond the immediate circle of Seurat's colleagues to diverse artists who responded to various facets of the Neo-Impressionist aesthetic. Each piece in the collection, therefore, does not bear the same relation to the stylistic and theoretical foundation of Neo-Impressionism. Yet as a group, these works suggest that the complete story of any movement is not told exclusively through the products of its leading practitioners; the related works also contribute to a realistic picture of how new philosophical and pictorial ideas are absorbed into the vocabulary of painting.

The nucleus of the collection is composed of works by members of Seurat's coterie who exhibited with him at the Société des Artistes Indépendants during the peak years of Neo-Impressionist activity. Landscapes by Charles Angrand, Léo Gausson, and Louis Hayet painted between 1886 and 1889 suggest the stylistic latitude available even to divisionists. In its subject, handling, and harmonies, Maximilien Luce's Parisian street scene, *La Rue Mouffetard,* represents one of the artist's most thoroughly Neo-Impressionist efforts. Seurat's most loyal follower, Paul Signac, is represented by an oil from the late 1890s that points to the movement's new direction in the twentieth century. While Lucien Pissarro was one of the group's original members, his landscape in the Holliday Collection was painted nearly twenty-five years after he abandoned the serious application of divisionist principles. The works by Hippolyte Petitjean are just as difficult to classify in the Holliday Collection as they are within the movement as a whole, yet one of his luminous pointillist watercolors does stand as a lyrical representation of his unique approach to Neo-Impressionism. And Seurat himself is represented by *The Channel of Gravelines,* part of the Museum's collection since 1945. This canvas is a sublime example of the seacoast pictures that hold such an important place in his oeuvre.

The Holliday Collection encompasses the work of many of Seurat's contemporaries who experimented with his technique without becoming members of the Neo-Impressionist group. These works frequently raise questions about the distinctions that separate Impressionism from Seurat's systematic handling. Among the pictures in this segment of the collection, Henri Delavallée's landscape displays the most successful application of Seurat's theories. The paintings of Emile Schuffenecker and Daniel de Monfreid reveal a flirtation with divisionism on the part of artists more commonly associated with Paul Gauguin's following. Georges Lacombe is principally known as a Nabi sculptor and painter, but his forest scenes of 1905 to 1907 reveal his explorations of Neo-Impressionist handling and luminous effects. Achille Laugé conscientiously pursued divisionist principles, but his residency in the south of France effectively cut him off from most Neo-Impressionist activity or attention. In America, Thomas Meteyard used luminous hues and a divided facture to paint the sunstruck coast of Cape Cod. Even artists like Ernest Laurent, Henri Martin, and Henri Le Sidaner, who maintained firm ties to the more traditional world of official art, adapted variations of Seurat's divided brushwork for their fashionable portraits, mural commissions, or landscapes.

Works by Seurat's followers in Belgium and Holland represent the single most outstanding area of the Holliday Collection. The works date from the first half of the 1890s, when Neo-Impressionism thrived in the Low Countries. That Mr. Holliday accumulated so many fine examples from this chapter of the movement is itself an accomplishment, since most of these artists practiced divisionism for only a brief period and their pictures are not numerous. Henry van de Velde's portrait of Père

Biart is one of a limited number of Neo-Impressionist paintings he produced before turning to architecture and decorative arts. In Georges Lemmen's arresting picture of two young girls, the collection has one of the artist's most accomplished works as well as a textbook example of the divisionist reliance on complementary harmonies. From the stillness and simplicity of Théo van Rysselberghe's seascape to the silence and clutter of George Morren's parlor scene, Mr. Holliday's selections document these painters in the prime of their Neo-Impressionist activity. A rare painting by the little-known artist Jan Vijlbrief marks the first wave of Dutch response to Neo-Impressionism. Ferdinand Hart Nibbrig is another obscure but talented representative of divisionism in Holland, and Paul Baum exemplifies the interest stimulated in Germany by Neo-Impressionist exhibitions and publications at the turn of the century.

The Holliday Collection's depth in Belgian art goes beyond the works of the movement's most prominent figures. At the avant-garde exhibition forum of Les Vingt, artists Willy Schlobach and Anna Boch were exposed to French Neo-Impressionism, but Schlobach's seascape adds a sprinkling of pointillist dots to a primarily Impressionist conception, and the vibrant colors and loose brush strokes of Boch's canvas have more in common with the freer handling of the Fauve era. Landscapes by A.-J. Heymans, Modest Huys, and Léon de Smet are typical of the works that can be linked to Neo-Impressionism, but they have their most direct rapport with Luminism, the Belgian counterpart of French Impressionism. Fernand Verhaegen, who belongs to the generation that succeeded the original group of Neo-Impressionists, is represented by one of the few pointillist canvases he painted at the beginning of his career. The paintings of Jean vanden Eeckhoudt, and to a lesser extent Médard Verburgh, document the period of bold color and fragmented brushwork that preceded the constructivist orientation of their best known work.

The Holliday pictures also trace the resurgence of Neo-Impressionism in the early twentieth century. Paul Signac, the figure primarily responsible for the movement's continuity, is represented by two works on paper. Paintings by two of his protégés, Lucie Cousturier and Jeanne Selmersheim-Desgrange, display the heightened harmonies, rectangular brushwork, and active surface patterns that characterize the Neo-Impressionist renaissance. Landscapes by Edouard Fer, Henri Person, and Louis Gaidan also hint at the breadth of interpretation open to artists inspired by Paul Signac. Jean Metzinger's coastal scene is an important early work that typifies the Neo-Impressionist "internship" served by many painters who eventually became Fauves or Cubists.

While the geometry and ordered compositions of Seurat's era set an inspiring precedent for painters refining the Cubist aesthetic, Jean Metzinger provides the collection's strongest example of the historical link between later Neo-Impressionism and Cubism. In the Holliday Collection there are several other works that suggest an affinity between the two movements, for many of the artists who responded to the divisionist approach also experimented with the language of Cubism. André Léveillé, for example, is represented by an accomplished pointillist landscape from very early in his career; yet in his maturity, he developed a Cubist style and even produced portraits that retain the movement's faceted planes and sharp angles. Paul-Elie Gernez's picture is an exuberant display of vibrant patches of color, but one of the basic motifs of his later work was ponderous, volumetric nudes formed by interlocking planes. For both Marevna and Yvonne Canu, the sequence was reversed, and their interest in Cubism preceded their first divisionist efforts. Even Arthur Segal, whose "Equivalence" paintings and geometric articulations of the picture plane show elements of a Cubist orientation, acknowledged a Neo-Impressionist influence in his career. While these artists are not the major figures of either movement, the correspondence of their outlooks indicates that the divisionist experience was fundamental to many twentieth-century artists who emphasized formalist concerns in their search for a personal style.

This association between Neo-Impressionism and Cubism is part of an intriguing aspect of the Holliday Collection that cuts across distinctions of nationality, date, or handling: rare pointillist works by artists who established their reputations in other styles. Auguste Herbin, creator of the purely abstract pictures conceived according to his "Plastic Alphabet," was producing brightly colored divisionist landscapes in the opening years of the century. And Christian Rohlfs, who became a leading figure of German Expressionism, came under the influence of Neo-Impressionism early in his career and painted a number of divisionist works. Together with the works of Metzinger, Gernez, and Léveillé, these examples suggest the wide variety of artists whose early experiments in color and design took form in variations of Neo-Impressionism.

Since the origin of the movement, there have also been painters who borrowed the pointillist facture without adopting a systematic division of color. In the Holliday Collection, artists as diverse as Bernard Boutet de Monvel in France, Enrico Reycend in Italy, and Reginald St. Clair Marston in England have used different kinds of discrete brush strokes, which do not figure in the articulation of color, to animate their surface design or to add luster to their canvases. While other pieces in the collection may illustrate the influential role of the Neo-Impressionist theory or method, these works demonstrate the technique's enduring decorative appeal.

The Holliday Collection reveals the widespread and long-lasting influence of a movement whose heyday and revival were confined to only a few years. Through these pictures, the Neo-Impressionist aura can be traced from its development in reaction to the day's most progressive style, to its "alliance" with scientific principles and its effect on generations of painters. From the perspective of nearly a century, it becomes clear that the Neo-

Impressionists' emphasis on the formal elements of color and line created a fertile ground for the growth of abstract art. A greater familiarity with these pictures also makes it clear that the Neo-Impressionists' association with science does not detract from the legitimacy of their works of art any more than it compromises the creative process. Even the most thorough analysis of theory and technique, however, does not completely explain the Neo-Impressionists' expression. Their version of the continuing dialogue between art and reality is the appeal—and the challenge—of **The Aura of Neo-Impressionism.**

Ellen W. Lee

Notes

The following abbreviations are used throughout the notes.

Herbert, Neo-Impressionism for Herbert, R. L. *Neo-Impressionism.* New York: The Solomon R. Guggenheim Museum, 1968.

Post-Impressionism, Royal Academy for *Post-Impressionism: Cross-Currents in European Painting.* London: Royal Academy of Arts, 1979.

Rewald, Post-Impressionism for Rewald, J. *Post-Impressionism from van Gogh to Gauguin.* New York: Museum of Modern Art, 3rd ed., 1978.

Rewald, Signac Diary, with volume and page numbers, for Rewald, J., ed., "Extraits du journal inédit de Paul Signac." I (1894-1895), *Gazette des Beaux-Arts,* 6th ser., XXXVI, 1949, pp. 97-128 (trans. pp. 166-174); II (1897-1898), *Gazette des Beaux-Arts,* 6th ser., XXXIX, 1952, pp. 265-284 (trans. pp. 298-304); III (1898-1899), *Gazette des Beaux-Arts,* 6th ser., XLII, 1953, pp. 27-57 (trans. pp. 72-80).

Sutter, ed., The Neo-Impressionists for Sutter, J., ed., *The Neo-Impressionists.* Translated by C. Deliss. Neuchâtel, London, and Greenwich, Conn., 1970.

[1] See Rewald, *Post-Impressionism,* pp. 84-88, and H. Dorra and J. Rewald, *Seurat: L'Oeuvre peint, biographie et catalogue critique,* Paris, 1959, pp. 157-163, for information on specific critics and their remarks on *La Grande Jatte.*

[2] S. Faunce, "Seurat and 'the Soul of Things,'" in *Belgian Art: 1880-1914,* The Brooklyn Museum, 1980, p. 44.

[3] F. Fénéon, "L'Impressionnisme aux Tuileries," *L'Art Moderne,* VI, 38, September 19, 1886, p. 302.

[4] G. Kahn, "La Vie artistique," *La Vie Moderne,* IX, 15, April 19, 1887, p. 229; quoted in R. Herbert, "Seurat's Theories," in Sutter, ed., *The Neo-Impressionists,* p. 40.

[5] Invented a quarter-century after the phenomenon it was meant to describe, this general term was coined in 1910 by the English critic Roger Fry to name an exhibition representing artists from Van Gogh to Picasso and from Gauguin to Matisse. Fry later conceded that he considered the name "as being the vaguest and most noncommital." See A. Bowness, "Introduction," in *Post-Impressionism,* Royal Academy, pp. 9-12.

[6] J. Rewald, ed., *Camille Pissarro: Letters to His Son Lucien,* New York, 1943, pp. 74, 84.

[7] "Les Vingt," *L'Art Moderne,* November 11, 1883, p. 361; quoted in J. Block, "Les XX: Forum of the Avant-Garde," in *Belgian Art: 1880-1914,* The Brooklyn Museum, 1980, p. 19.

[8] See Block, p. 27, for an account of the *L'Art Moderne* commentaries and the critical response to *La Grande Jatte.*

[9] "Petite Chronique," *L'Art Moderne,* July 24, 1887, p. 239; quoted in Block, p. 27.

[10] E. Verhaeren, "Georges Seurat," *La Société nouvelle,* April 1891, p. 436; quoted in W. I. Homer, *Seurat and the Science of Painting,* Cambridge, Mass., 1970, p. 241.

[11] Originally published as *Modern Chromatics,* the title of Rood's book was later changed to *Students' Text-Book of Color.* The French edition of Rood's book was called *Théorie scientifique des couleurs.* See Homer, pp. 244-249, for a careful analysis of specific scientists' contributions to Seurat's aesthetic.

[12] Rewald, ed., *Camille Pissarro: Letters to His Son Lucien,* p. 99.

[13] Fénéon, "L'Impressionnisme aux Tuileries," p. 302 (trans).

[14] O. N. Rood, *Students' Text-Book of Color,* New York, 1881, p. 316; quoted in Homer, p. 275, note 78.

[15] Robert Herbert explains the distinction very simply and clearly in *Neo-Impressionism,* pp. 17-18.

[16] R. Herbert, "Seurat's Theories," in Sutter, ed., *The Neo-Impressionists,* pp. 30-31.

[17] Herbert, *Neo-Impressionism,* p. 188.

[18] Rewald, Signac Diary, I, p. 169.

[19] Both Félix Fénéon and Robert Herbert have chosen the example of the sunny landscape to explain the Neo-Impressionist division of color. For a more thorough analysis, see Herbert, *Neo-Impressionism,* p. 18, and F. Fénéon, "Signac," *Les Hommes d'Aujourd'hui,* VIII, 373, 1890, unpaginated.

[20] Homer, pp. 146-149.

[21] P. Signac, *D'Eugène Delacroix au néo-impressionnisme,* Paris, 1899, rept. 1964, p. 51.

[22] G. Kahn, "Au temps du pointillisme," *Mercure de France,* CLXXI, April 1, 1924, p. 14 (trans).

[23] Letter from Camille Pissarro to Paul Signac, June 16, 1887; quoted in H. Dorra and J. Rewald, p. XXII.

[24] F. Fénéon, "Le Néo-Impressionnisme, à la IVᵉ Exposition des Artistes Indépendants," *L'Art Moderne,* VIII, 16, April 5, 1888, p. 122. Despite the fact that Fénéon's remarks were made on the occasion of the fourth exhibition of the Indépendants, it is unlikely that the kind of frames he criticized actually appeared in that salon. For in 1888, Seurat's only entries were *The Models* and *The Parade* (The Metropolitan Museum of Art, New York). Since the first picture is an indoor scene and the second a nighttime setting, Seurat could not have colored his frames according to the position of the sun.

[25] Rewald, Signac Diary, I, p. 170.

[26] Rewald, ed., *Camille Pissarro: Letters to His Son Lucien,* p. 156, regarding Seurat's paintings at the Indépendants exhibition of 1891.

[27] Cachin suggests that this technical detail, added by the printer rather than the artist, must have had a strong decorative effect, enhancing, by contrast, the landscape's luminosity. F. Cachin, "Les Néo-Impressionnistes et le Japonisme, 1885-1893," in *Japonisme in Art,* An International Symposium, Tokyo, 1980, p. 228.

[28] Its original frame no longer exists, but the artist's correspondence in the Octave Maus archives in Brussels records his precise specifications. M.-J. Chartrain-Hebbelinck, "Les lettres de Paul Signac à Octave Maus," *Bulletin,* Musées Royaux des Beaux-Arts de Belgique, Brussels, 1969, 1-2, p. 80, plate III; and Rewald, Signac Diary, I, p. 172.

[29] Letter from G. Seurat to M. Beaubourg, August 28, 1890, see transcription on p. 12.

[30] Herbert, *Neo-Impressionism,* p. 22. See also R. Herbert, "Seurat's Theories," in Sutter, ed., *The Neo-Impressionists,* pp. 34-35 for a more detailed explanation of these theories.

[31] D. P. G. Humbert de Superville, *Essai sur les signes inconditionnels dans l'art,* Leyden, 1827-1832.

[32] F. Fénéon, "Paul Signac," *La Plume,* September 1, 1891, p. 299; quoted in Homer, p. 239.

[33] F. Fénéon, "Exposition des Artistes Indépendants à Paris," *L'Art Moderne*, IX, 43, October 27, 1889, p. 339 (trans).

[34] A. Aurier, "Symbolisme en Peinture: Paul Gauguin," *Mercure de France*, March 1891; quoted in Rewald, *Post-Impressionism*, p. 448.

[35] According to Herbert, these principles were expounded in Henry's book of 1888 entitled *Cercle chromatique*, in which he submitted language and music to an interpretation comparable to his study of color. Rewald, *Post-Impressionism*, p. 166, note 30.

[36] G. Kahn, *Les Dessins de Seurat*, Paris, introduction; quoted in Rewald, *Post-Impressionism*, p. 146.

[37] Rewald, *Post-Impressionism*, pp. 146-147.

[38] R. L. Herbert and E. W. Herbert, "Artists and Anarchism: Unpublished Letters of Pissarro, Signac and others," *Burlington Magazine*, CII, 692, November 1960, pp. 472-482, and CII, 693, December 1960, pp. 517-522.

[39] Rewald, *Post-Impressionism*, p. 141.

[40] Rewald, *Post-Impressionism*, pp. 140-141.

[41] Herbert, *Neo-Impressionism*, p. 123.

[42] C. Bock, *Henri Matisse and Neo-Impressionism, 1898-1908*, Studies in the Fine Arts: The Avant-Garde, Ann Arbor, Michigan, 1980, p. 74.

[43] Signac's full title, *In the Time of Harmony. The golden age is not in the past, it is in the future*, was based on an idea in the writings of the Anarchist leader Malato. See M.-T. Lemoyne de Forges, *Signac*, Paris, Musée du Louvre, 1963, p. 57.

[43] R. Herbert and E. Herbert, "Artists and Anarchism," pp. 478-482.

[44] Unpublished manuscript, Signac archives; quoted in Bock, p. 75.

[45] R. Herbert and E. Herbert, "Artists and Anarchism," p. 478.

[46] J. Destrée and E. Vandervelde, *Le socialisme en Belgique*, Paris, 1898, p. 235; quoted in J.-G. Watelet, "Art Nouveau and the Applied Arts in Belgium," in *Art Nouveau Belgium/France*, Houston, Rice Museum, 1976, p. 121.

[47] Fonds Henry van de Velde, Bibliothèque Royale de Belgique, Brussels, Chapter I, Part II, Autobiographical manuscripts, no. 79 (trans).

[48] R. Herbert and E. Herbert, "Artists and Anarchism," p. 481.

[49] Rewald, Signac Diary, I, p. 174.

[50] Rewald, Signac Diary, II, p. 302.

[51] Rewald, Signac Diary, III, p. 80.

[52] C. Morice, "XXIᵉ Salon des Indépendants," *Mercure de France*, April 15, 1905; quoted in Bock, p. 80, note 61.

Conservation of Neo-Impressionist Paintings

The Neo-Impressionist painting technique as developed by Georges Seurat and practiced by Paul Signac and others depended upon established optical laws of additive mixture and simultaneous contrast to create the desired color effects. Since paint and pigments can only simulate the appearance of colored light, the purity of the hues and their unhampered reflection of light were as crucial to the artists' working method as they are to our proper perception of the paintings today.

Many of the Neo-Impressionists were aware of the limitations of varnish as a protective coating and rejected its use on their paintings. Signac commented in his diary on April 22, 1899 how poor some of Monet's paintings looked, the values having changed due to varnishing, and how others were glorious with "the purity of the tints still untarnished by varnish."[1] Those Neo-Impressionist paintings that acquired a varnish coating had them applied by restorers or dealers who did not realize how destructive it would be to our perceptions of the artists' theory and technique.

Natural resin varnishes, such as Dammar and Mastic, yellow considerably with age. This shifts the color relationships within any type of painting but completely distorts the appearance of Neo-Impressionist canvases. The "Old Master glow" of yellow-brown varnish is totally inappropriate for the divisionist technique. The glossy, glass-like surface created by those varnishes alters the relative saturation of the different pigments, making porous dark greens and blues appear almost black. These varnishes also refract light in a manner that does not allow each dot or stroke of color to assert its proper hue, value, and intensity (chroma) as individuals or in relation to each other. The angle of viewing a glossy surface is very critical. If viewed from the wrong position, the resulting glare causes the intensity of the colors to drop off, sometimes to a point where all one sees is white light. Given the color relationships at the core of Neo-Impressionist theory, it is, as Jean Sutter noted, "criminal to apply varnish to Neo-Impressionist paintings."[2]

Sutter has also pointed out that a "matt effect was sought by all painters using pure hues,"[3] no doubt because a matt, unvarnished paint surface yields the same value and intensity of color from all viewing angles and avoids the distortion caused by yellowing of a varnish layer. Since the Neo-Impressionists did not varnish their pictures, they were displayed either unprotected or behind glass. Louis Hayet even developed his own paints to simulate the encaustic (wax) paintings of the ancient Greeks, as he was impressed with how fresh the colors and surfaces appeared despite centuries of exposure, without protection from varnish or glass.

The shunning of protective varnishes, however, resulted over the years in paintings ingrained with dirt and grime. Even those works framed behind glass were not sufficiently protected. Sooty, gray dirt and yellow nicotine deposits from tobacco smoke are as effective a deterrent to our proper perception of the divisionist technique as a discolored, glossy varnish. Besides significantly dulling the colors, the dirt tends to accumulate in the interstices (hollows) of the brush strokes and canvas weave, creating patterns that really do not exist, exaggerating texture, and negating the effects of exposed ground color, which was intended to be seen as part of the design.

In addition to the usual tasks of consolidating flaking paint and repairing tears, the painting conservators were therefore faced with the task of returning those pictures slathered with varnish or buried under decades of dirt and grime to a state where the vibrancy of their color relationships would be unhampered by these later accretions. The goal in the treatment of these paintings was to remove as much of these accretions as possible without causing any damage to the original paint. Many of the paintings had to be cleaned dot by dot under the magnification of the binocular microscope. The paintings cannot tolerate partial or uneven cleaning because the color relationships are so precise that putting any area out of balance with the rest creates planes and color harmonies the artist never intended. Much of the work entailed removing modern glossy varnishes that had not yet yellowed but had completely changed the character of the paintings, unequally saturating colors and obscuring subtle transition tones. Paintings whose varnish was removed had to be revarnished because of the documented effects of varnish removal.[4] New, non-yellowing, synthetic polymer varnishes have been applied in ways that protect the paint films; yet they are invisible to the non-expert eye and give the appearance of a fresh, unvarnished surface. In keeping with the artists' intentions, those pictures which had never been varnished and which required only dirt removal were not varnished after cleaning. They are displayed behind special non-reflecting glass that is not visible under normal gallery conditions.

Minor cleaning significantly improved the appearance of many of the paintings treated by the conservators. The differences in the paintings before and after treatment were often too subtle to record accurately via photographs during the process, but they became visually apparent once the colors regained their vibrancy. Two of the more dramatic examples of how distorting varnish and dirt, and how gratifying their removal, can be to Neo-Impressionist paintings were Maximilen Luce's *La Rue Mouffetard* and Georges Seurat's *The Channel of Gravelines*. The Luce had been previously restored and varnished. The very yellowed varnish completely al-

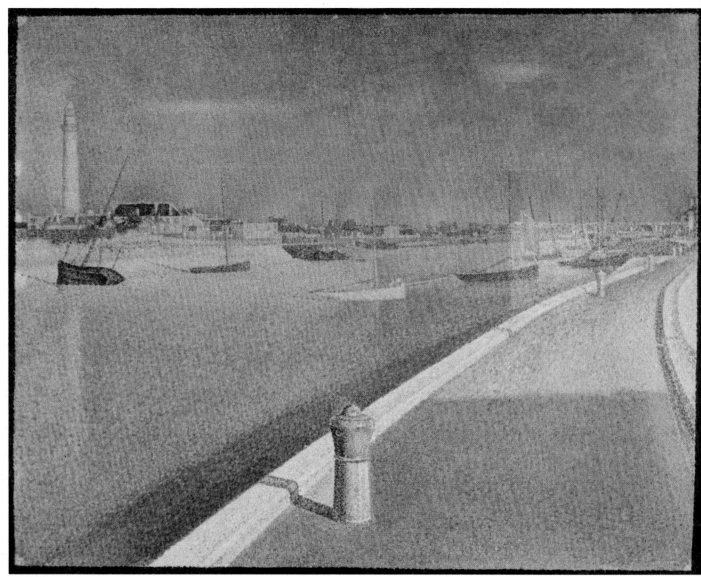

Fig. 1 Georges Seurat, *The Channel of Gravelines, Petit Fort Philippe,* during cleaning.

tered the appearance of the painting: its predominantly cool blue and purple tonality appeared as a warm orange. This change destroyed the planes of the painting and prevented the bright orange and green fruits and vegetables from achieving the prominence that contemporary writers had discussed.[5] The thick, glossy varnish also masked the texture of the brushwork, prohibiting the tapestry-like surface from reflecting light in the intended shimmering manner. The accompanying illustrations show the Luce painting during the process of varnish removal. The Seurat, fortunately, is in pristine condition. It was unvarnished and unlined but was, although framed behind glass, encrusted with years of dirt and grime. Through dirt removal, the painting regained a luminosity that exceeded all expectations.

The examination and treatment of the Museum's collection of Neo-Impressionist paintings gave further in-

sight into the precision of the artists' theories and the ways in which time and human intervention altered their vision. Hopefully, the paintings now appear much as they did at the time of their creation.

David A. Miller
Associate Conservator of Paintings

Notes

[1] L. Nochlin, *Impressionism and Post-Impressionism, 1874-1904,* Sources and Documents series, Englewood Cliffs, 1966, p. 130.

[2] Sutter, ed., *The Neo-Impressionists,* p. 115.

[3] Sutter, ed., *The Neo-Impressionists,* p. 115.

[4] N. Stolow, "Solvent Action: Some Fundamental Researches in the Picture Cleaning Problem," in *On Picture Varnishes and Their Solvents,* Cleveland, 1971, pp. 45-111.

[5] J. Christophe, "Maximilen Luce," *Les Hommes d'Aujourd'hui,* VIII, 376, 1890.

Fig. 2 Maximilien Luce, *La Rue Mouffetard*, after cleaning of lower right quadrant.

Fig. 3 Detail, Maximilien Luce, *La Rue Mouffetard*. Two squares in center show areas where dirt and varnish had not yet been removed.

Fig. 4 Conservator's rendering of a Neo-Impressionist frame, shown here on the lower left corner of Seurat's *The Channel of Gravelines, Petit Fort Philippe*.

Catalogue of the Collection

Author's Note

This catalogue has been organized by dividing the pictures of the Holliday Collection into three separate groups. The first category is reserved for the works of Seurat and his followers in France, Belgium, and Holland who painted Neo-Impressionist pictures during the movement's critical years from 1886 to 1895. Excluded from this group are artists such as Lucien Pissarro who are generally associated with the movement but who are not represented in this collection by pure Neo-Impressionist works. The second, and by far the broadest, section of the catalogue contains paintings by artists influenced to varying degrees by Neo-Impressionist technique or theory. Crossing distinctions of nationality, date, and handling, this classification includes Seurat's contemporaries, second-generation followers of the movement, and artists still experimenting with the style today. The Museum's six other Neo-Impressionist pictures, which are not part of the Holliday bequest, are also divided between these two groups. In the last category are works of less significance that are peripheral to the study of the Neo-Impressionist impact. Within each section, the entries are arranged alphabetically by artist. All paintings by the same artist are grouped together chronologically, even when some of their works could be classified in a different section. An alphabetical index of all artists represented in the catalogue can be found on page 210.

Cataloguing

All titles appear first in English. Translations of titles are included when they were specifically assigned by the artist or when the name has become identified with the piece through exhibition or publication. Dimensions are provided in inches and centimeters, with height preceding width. Only inscriptions made by the artist have been recorded, unless otherwise noted. The colorman stamp indicates the name or trademark of the supplier of the artist's materials, whenever their identification has been stamped, stenciled, or otherwise labeled on the reverse. These references have not been transcribed in their entirety; only the name and city of the colorman are recorded. The number following the credit line is the Museum's accession number.

Notes

References used frequently in the text appear in the notes in abbreviated form. Full bibliographic citations for these sources are listed in the abbreviations key concluding the author's note. When "(trans)" appears at the end of a note, it indicates that the quotation is my translation from the original French.

Provenance

The first entry is always the earliest known element in the history of ownership, though in many instances it was not possible to trace the provenance all the way back to the artist. Any other gap in the succession of collections is indicated by an ellipsis (. . .). Transactions were by purchase unless relationships cited between owners suggest transferral by gift or inheritance. "Art market" refers to an unidentified gallery, as opposed to "public sale," which indicates an unspecified auction. The location of each gallery, auction, or individual is provided whenever this documentation exists; though for all references to Mr. Holliday's ownership, the word Indianapolis has been omitted.

Exhibitions

All known references to the exhibition and publication of each picture are listed. When an exhibition was accompanied by a catalogue, its full citation is provided in the exhibition section and is not repeated under literature.

The abbreviations HC 1968-69 and HC 1969-70 refer to two separate exhibition tours of large segments of the Holliday Collection. HC 1968-69 was entitled *Homage to Seurat* and was presented at the University Art Gallery, University of Arizona, Tucson, December 1, 1968-January 1, 1969; the California Palace of the Legion of Honor, San Francisco, January 23 through February 1969; and at the Utah Museum of Fine Arts, University of Utah, Salt Lake City, March 16-April 13, 1969.

HC 1969-70 was called *The Circle of Seurat* and traveled to the Museum of Fine Arts, St. Petersburg, Florida, November 18-December 28, 1969; Columbia Museum of Art, Columbia, South Carolina, January 7-February 8, 1970; Lowe Art Gallery, University of Miami, Coral Gables, Florida, February 15-March 15, 1970; and Cummer Gallery of Art, Jacksonville, Florida, March 25-April 19, 1970. This series of exhibitions was accompanied by a brief catalogue of the same title.

In addition, every piece in the Holliday Collection was included in an exhibition, also entitled *Homage to Seurat*, at the Indianapolis Museum of Art, June 22-August 29, 1971. This reference has not been repeated in the exhibition section for each entry.

Literature

The Holliday Collection was catalogued by William E. Steadman in 1968 under the title *Homage to Seurat* and published by the University of Arizona Press at Tucson. In 1971, the Indianapolis Museum of Art produced *Recent Additions to the W. J. Holliday Collection* as a supplement to the original catalogue. Since the information in

The Aura of Neo-Impressionism: The W. J. Holliday Collection supersedes that of the previous two publications, they have not been recorded in the literature section. Comments in the texts citing previous attributions are references to the pictures' classifications in these earlier catalogues.

Abbreviations

The following abbreviations are used throughout the notes of this publication.

Herbert, *Neo-Impressionism* for Herbert, R. L. *Neo-Impressionism*. New York: The Solomon R. Guggenheim Museum, 1968.

***Post-Impressionism*, Royal Academy** for *Post-Impressionism: Cross-Currents in European Painting*. London: Royal Academy of Arts, 1979.

Rewald, *Post-Impressionism* for Rewald, J. *Post-Impressionism from van Gogh to Gauguin*. New York: Museum of Modern Art, 3rd ed., 1978.

Rewald, Signac Diary, with volume and page numbers, for Rewald, J., ed., "Extraits du journal inédit de Paul Signac." I (1894-1895), *Gazette des Beaux-Arts*, 6th ser., XXXVI, 1949, pp. 97-128 (trans. pp. 166-174); II (1897-1898), *Gazette des Beaux-Arts*, 6th ser., XXXIX, 1952, pp. 265-284 (trans. pp. 298-304); III (1898-1899), *Gazette des Beaux-Arts*, 6th ser., XLII, 1953, pp. 27-57 (trans. pp. 72-80).

Sutter, ed., *The Neo-Impressionists* for Sutter, J., ed., *The Neo-Impressionists*. Translated by C. Deliss. Neuchâtel, London, and Greenwich, Conn., 1970.

E.W.L.

I

Charles Angrand
French 1854-1926

Originally trained as a schoolteacher, Charles Angrand enrolled in the Rouen art academy in the 1870s. There he studied with Gustave Morin and Philippe Zacharie and produced naturalistic works with light colors and well-defined outlines. These early paintings, influenced by Manet and Bastien-Lepage, earned him the reputation of an "enfant terrible" among his classmates and professors.

From 1882 to 1896, Angrand lived in Paris. With a steady income assured by a teaching post in mathematics, he participated in the city's flourishing avant-garde circles. In 1884 he helped found the Société des Artistes Indépendants, where he exhibited annually until his death. Angrand was a close friend of many of the Indépendants and of the Symbolist writers Félix Fénéon, Gustave Kahn, and Emile Verhaeren.

The evolution of Angrand's Neo-Impressionist style began during his early years in Paris and was first evidenced in 1884 by short brush strokes and bright colors. By 1887, as a result of his first-hand knowledge of Seurat's theories, Angrand was painting with small dots of divided hues. His transition to Neo-Impressionism was then complete, and Angrand was deservedly touted as one of the leaders of the new ideology. Divisionism freed Angrand to concentrate on the formal elements of his works. As Signac observed, "He declares that it is the search for nature that paralyzes us, that we know quite enough to draw a dog which will not resemble a donkey—and that this is sufficient. The rest, the arrangement of lines and colors, alone should preoccupy us."[1]

Angrand worked in a divisionist manner until 1891, when he virtually abandoned painting for conté crayon and charcoal drawings. These black and white works, with themes such as "Mother and Child," are conceived in broad, stylized forms indebted to the earlier drawings of Seurat. Angrand's new style was well received by his contemporaries, including Signac.

Angrand retired to Normandy in 1896, deliberately retreating from the intellectual and artistic life of Paris. Although his last thirty years were passed in relative isolation, he never stopped drawing or reading treatises on aesthetics and maintained a steady correspondence with other Neo-Impressionist painters, especially Paul Signac, Henri Edmond Cross, and Maximilien Luce. For brief periods during 1901 to 1908, he returned to oils, applying uniform square strokes of color that link him to Neo-Impressionism's second phase. In 1910 Angrand renewed his interest in color and in the ensuing years also produced numerous chalk drawings recalling Daumier and Millet.

Path in the Country, ca. 1886
Chemin à la campagne
oil on canvas, 8⁹⁄₁₆ x 15¾ (21.7 x 40.0)
unsigned[2]
The Holliday Collection 79.232

With this rural landscape scene, Charles Angrand reaches the threshold of a mature Neo-Impressionist aesthetic. While *Path in the Country* differs dramatically from the peasant subjects that occupied the young painter from 1883 to 1885, it does not yet display the full commitment to Neo-Impressionism

evident in his work by 1887. Its brushwork, composition, and approach place the Holliday painting in the year 1886.[3]

Earlier pictures such as *In the Garden*, 1884 (Private Collection) and *The Artist's Mother Sewing*, 1885 (Petit Palais, Geneva) have active surface patterns characterized by varied brushwork or choppy, slicing strokes. By contrast, *Path in the Country* is based upon flatter, square-shaped touches, yet its uniform handling is still far from the distinct, fine point that identifies Angrand's fully developed brand of Neo-Impressionism.

In the Holliday painting, Angrand applies the principles of division of color in a random and tentative fashion rather than on a systematic basis. Dots of orange and rose dapple the green and yellow-green foliage, but the entire sky is colored by the repetition of a single blue tint. Instead of shading the curving path with discrete touches of violet and yellow, the artist has blended these pigments with the road's local color. The landscape's bright, saturated hues show Angrand's obvious awareness of the Impressionist palette, but the broad areas of flat color in the Holliday canvas suggest a schematic approach to the overall distribution of color rather than close attention to the variations of light and atmosphere.

The composition of *Path in the Country* marks the transition from the busy, more complex formats of Angrand's figural subjects to the spare construction of his Neo-Impressionist works. With its simplified composition and high horizon line, the Holliday painting relates directly to two pictures dated 1886: *The Seine, In the Morning, Saint-Ouen* (Samuel Josefowitz Collection, Lausanne) and *Western Railway at Its Exit from Paris* (Private Collection), the most famous example of Angrand's nascent Neo-Impressionism. A sense of geometry rather than genre now animates Angrand's work. This turn to empty or sparsely populated landscapes where the human element is drastically reduced anticipates Angrand's later shift of emphasis from representation to abstract, decorative concerns. In a letter of 1889 in which he refers to his works from 1886 as "intermediate," Angrand acknowledges his "present preoccupations of technique and esthetic" in order to "show ... how little interest I have in the story-telling or genre element of these pictures."[4] In the construction of *Path in the Country* are the seeds not only of Angrand's emerging Neo-Impressionism, but also of his change from the "search for nature" to the "arrangement of lines and color."[5]

Notes

[1] Rewald, Signac Diary, I, p. 169.

[2] The painting is recorded as no. 33 *The Sunny Path (La route ensoleillée)* in the roster of Angrand's work compiled by his nephew, Pierre Angrand. Letter from P. Angrand to E. Lee, September 7, 1982.

[3] I am indebted to Bogomila Welsh-Ovcharov for providing illustrations and advice about Angrand's early works.

[4] Letter from Angrand, addressee unknown, March or April, 1889, Angrand archives; quoted in Herbert, *Neo-Impressionism*, pp. 29, 31.

[5] Rewald, Signac Diary, I, p. 169.

Provenance: Paris, Galerie l'Oeil; New York, Hammer Galleries (through Ignace Hellenberg, Paris), 1965; W. J. Holliday, 1965.

Exhibitions: HC 1968-69; HC 1969–70.

Charles Angrand, *Path in the Country*

Léo Gausson

French 1860-1944

After studying engraving in Paris with Théophile Chauvel, Léo Gausson entered the print shop of Eugène Froment in the mid-1870s. There he befriended Maximilien Luce and Cavallo-Peduzzi. After losing their jobs to a new printing process in 1883, the three young artists seriously began painting and shared studios in Paris and Lagny.[1]

Gausson's painting career was limited to the years 1886 to 1900. With Luce and Cavallo-Peduzzi, he experimented with the color theories and divisionist technique of Seurat and exhibited annually with the Indépendants beginning in 1887. Gausson worked in a Neo-Impressionist manner only briefly, and from 1890 to the end of the century, his canvases reveal the influence of Nabi and Symbolist painters.

Gausson traveled extensively throughout France, cultivating friendships with other painters and exhibiting in the progressive salons of Le Barc de Boutteville, Rose + Croix, and Les Vingt, as well as with the Indépendants. After 1896, however, he virtually abandoned all painting and exhibition activities. Instead, he published an anthology of verse, illustrated poetry by his friend Adolphe Retté, designed posters, and executed a number of engravings after the paintings of Millet.

From 1901 to 1908 Gausson spent most of his time in Africa. He served as a colonial administrator and journeyed across the continent. Gausson then returned to Paris, where he was employed in minor government posts, and eventually retired to Lagny.

Barges on the Marne at Lagny, ca. 1888
Chalands sur la Marne à Lagny
oil on panel, 8¼ x 13¾ (21.0 x 34.9)
signed lower left: Leo Gausson
The Holliday Collection 79.248

Barges on the Marne at Lagny belongs to that brief period from 1886 to 1890 when Gausson was a member of Seurat's coterie, but the small panel does not exhibit a rigorous use of Neo-Impressionist principles. For this riverside scene, the artist has drawn upon a variety of different types of brushwork, with thick, broken strokes in the foreground, a stippled pointillist facture for the distant trees, and a smooth application of paint in the sky. While the green grass of the river bank is flecked with strokes of yellow, orange, and blue, Gausson does not pursue a systematic division of color in this composition.

Gausson's paintings from 1886 to 1890 do not present a steady, clear-cut progression in style. The artist often changed the size of his stroke and the handling of his pigments as he explored the new aesthetic. This diversity often makes the dating of Gausson's work problematic, but fortunately the Holliday panel is known to be one of eight paintings that Gausson exhibited at the salon of the Société des Artistes Indépendants in March of 1888.[2] Reviewing the exhibition, Jules Christophe referred to the "peaceful barges on the blue Marne."[3] Though the Holliday panel was formerly catalogued as *Barges on the Seine*, Pierre Eberhart of the museum at Lagny-sur-Marne has confirmed that the painting's site is the river Marne at Lagny, where Gausson, a native of the area, often painted.[4]

This small landscape is the result of careful construction.

Gausson interrupts the low horizon line and the broad, flat proportions of the barges with the forceful verticals of the boats' masts. These lines are echoed by the prows of the barges and the poles flying the French flags in the left distance. Examination of the panel by infra-red reflectography reveals the artist's preparations and alterations. A thorough pencil underdrawing, sometimes detectable by the naked eye, outlines the entire composition. Also visible through the infra-red lens but overpainted in the finished product is a small boat, set perpendicular to the shore in front of the barges. Removing this element leaves the foreground unobstructed and maintains the axis set by placing the barges parallel to the river bank.

The barges with their cargo of barrels and the glimpse of the chimney and factory buildings on the far right are indications that Gausson, too, was receptive to subjects of contemporary everyday life. Like many of his Neo-Impressionist colleagues, he incorporates scenes of labor and the signs of industrial growth into his landscape motif. With this panel, Gausson joins Albert Dubois-Pillet, Georges Lemmen, and his friend Camille Pissarro in depicting the commercial activity of the riverside.[5]

Notes

[1] J. Sutter distinguishes their activities in the 1880s by referring to them as the "Lagny Group" in his essay "The Lagny-sur-Marne Group," in Sutter, ed., *The Neo-Impressionists*, pp. 147-148.

[2] I am indebted to Madame Hanotelle and Pierre Eberhart of the Musée Gatien-Bonnet, Lagny-sur-Marne, for the information on this exhibition and its critical review. Letters from P. Eberhart to E. Lee, January 28 and August 9, 1982.

[3] J. Christophe, "Le Néo-impressionnisme au Pavillon de la ville de Paris," *Journal des Artistes*, May 6, 1888.

[4] Letter from P. Eberhart to E. Lee, January 28, 1982.

[5] See Herbert, *Neo-Impressionism*, p. 55 for references to comparable works by Dubois-Pillet, Pissarro, and Lemmen.

Provenance: Paris, Galerie André Maurice; New York, Hammer Galleries, 1962; W. J. Holliday, 1962.

Exhibitions: Paris, Pavillon de la ville de Paris, *4ᵉ Exposition de la Société des Artistes Indépendants*, March 22-May 3, 1888, no. 273 as *Les bateaux;* New York, Hammer Galleries, *Seurat and His Friends*, October 30-November 17, 1962, no. 34; HC 1968-69; HC 1969-70.

Literature: J. Christophe, "Le Néo-impressionnisme au Pavillon de la ville de Paris," *Journal des Artistes*, May 6, 1888; J. Sutter, ed., *The Neo-Impressionists*, Neuchâtel, London, and Greenwich, Conn., 1970, p. 198 (reprod.).

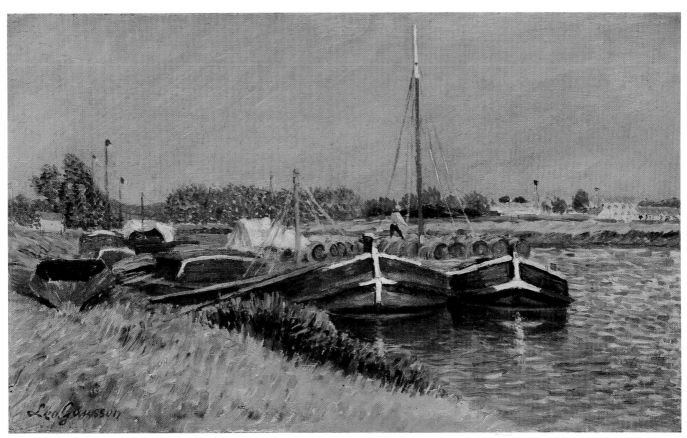

Léo Gausson, *Barges on the Marne at Lagny*

Louis Hayet
French 1864-1940

Louis Hayet could not afford formal training in the arts and was virtually self-taught. From 1878 to 1886, he traveled throughout Normandy and around Paris working as a *peintre-décorateur*. As part of his self-prescribed course of study, Hayet read optical and color theories, particularly those of Chevreul. By 1883 his investigations had resulted in watercolors utilizing pure primary colors and fragmented brush strokes. Three years later, after encounters with Signac, Seurat, and the Pissarros, he adopted a divisionist technique and began to construct chromatic circles in order to explore color contrasts and harmonies. While serving in the military from 1886 to 1887, Hayet continued his research through correspondence with the Pissarros and by devising increasingly elaborate color charts.

From 1887 to 1890, Hayet enjoyed a period of intense artistic activity, during which he produced a large body of Neo-Impressionist works considered to be the finest of his career. These include canvases utilizing experimental encaustic mixtures and paintings on thin cloth, which were probably meant to be viewed in front of a background of primary hues.

In 1890 Hayet began to withdraw from the French art world. Temperamental and extremely moody, he resigned from the Indépendants and renounced the divisionist technique. By 1895 he had ended his close friendship with the Pissarros. He lived thereafter in relative artistic isolation, broken only by occasional commissions for stage designs and, after the turn of the century, by a renewed interest in color theory. Hayet painted very little during the last fifteen years of his life and died in obscurity.

Hayet rarely exhibited: his only one-man shows were staged from 1902 to 1904 in Parisian stores and restaurants that he himself rented. He participated in the Indépendants' salons during his brief period of membership, but also exhibited at Les Vingt in 1890 and with Le Barc de Boutteville eight times between 1894 and 1897.

the composition. The somewhat ambiguous horizontal structures appear to be sections of walls projecting from taller buildings. A similar sense of geometry exists in many of Hayet's vistas, as earth and sky are partitioned in an orderly articulation of the picture plane. In two later series of paintings, many of which are now lost, Hayet further explored the abstract qualities of compositions restricted to treetops, clouds, and skies.[2]

In medium and size, *Landscape* is typical of Hayet's Neo-Impressionist oeuvre. It is an example of his extensive experiments using encaustic as a binder. Chemical tests indicate that the medium is not purely encaustic mixed with pigment; like other works of the period, another material, perhaps oil or resin, has been added to the compound.[3] The small format is also common for Hayet, as he produced few large-scale divisionist pieces.

Hayet's standard signature calls for a capital "H." The lower case "h" in the Holliday picture can be explained by paint losses in and around the deep blue pigment of the signature. The losses, which are visible through photo-enlargements and the microscope, removed the upper right bar of the "H." Unfortunately, the inscription below the signature is unreadable.

Notes
[1] This picture was formerly catalogued as *Paysage parisien*, but its precise locale is difficult to identify. While Paris was one of the artist's prime subjects in 1889, collector Guy Dulon has also suggested Hayet's native Pontoise as a plausible site. Letter from Dr. G. Dulon to E. Lee, January 22, 1982.

[2] J. Sutter, "Louis Hayet 1864-1940," in Sutter, ed., *The Neo-Impressionists*, p. 115.

[3] The examination and tests were conducted by IMA painting conservator David Miller.

Provenance: Purchased from the artist's son, Georges Hayet, by Guy Pogu (Galerie de l'Institut), Paris; W. J. Holliday, 1965.

Exhibitions: HC 1968-69; HC 1969-70.

Literature: R. Herbert, *Neo-Impressionism*, New York: The Solomon R. Guggenheim Museum, 1968, p. 61.

Landscape, ca. 1889
encaustic (?) on layered cardboard, 7¹¹⁄₁₆ x 10⁹⁄₁₆ (19.5 x 26.8), irregular
signed lower right: L. hayet/(illegible inscription)
The Holliday Collection 79.251

Hayet produced this landscape during his brief but intense Neo-Impressionist period in the closing years of the 1880s. At this time, he characteristically used a short, comma-shaped stroke rather than a dotted facture. On the basis of the similar arcing brushwork in two compositions dated 1889, *Vegetable Market* (Arthur G. Altschul Collection, New York) and *Paris, the Tree-lined Avenue* (Private Collection), the Holliday picture can also be assigned to that year.

In this modest composition, formal elements seem to be the artist's primary concern. Framing a glimpse across the treetops, Hayet abdicates a focal point of interest in favor of an anonymous slice of French terrain.[1] His real subjects are the play of space and texture and the contrast between the blue and rose sky and the green, orange, and blue flecks of foliage. Hayet's choppy brushwork creates an active surface rhythm whose current is broken only by the horizontal bands that cross

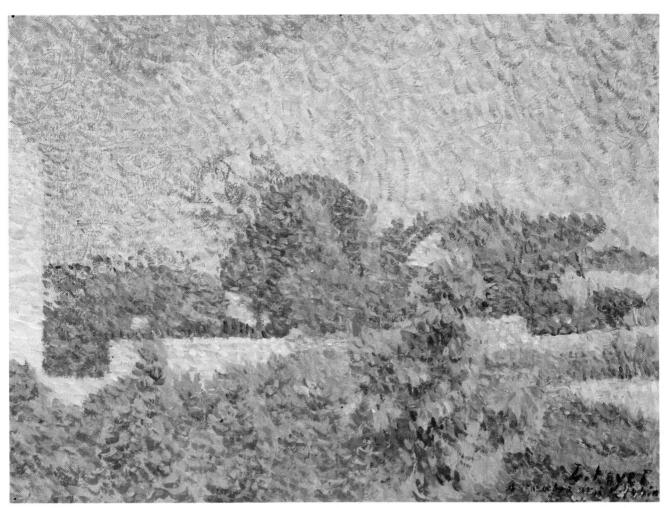

Louis Hayet, *Landscape*

Georges Lemmen
Belgian 1865-1916

The son of an architect, Georges Lemmen received his introduction to aesthetics at home. He found academic training restrictive and attended a drawing school in Saint-Josse-ten-Noode only briefly. Lemmen's earliest paintings date from the mid-1880s, when he began exhibiting in Brussels and Ghent. Primarily domestic interiors and portraits, these canvases recall works by Fernand Khnopff, Dürer, and Holbein.

Lemmen became a member of Les Vingt in 1888 and first exhibited in the group's salon of 1889. In the same year, he began participating in shows with the Indépendants in Paris. During 1889 Neo-Impressionism was the predominant aesthetic in both groups, and Lemmen adopted divisionism shortly after this strong dual exposure.

He painted according to Seurat's theories from 1890 to 1895, but from 1895 to 1900 Lemmen modified his approach with looser brush strokes and less rigorous color division. He continued to favor interior and figure themes over landscapes. After the turn of the century, Lemmen's canvases bore few traces of Neo-Impressionism. Instead, he used a subdued brown and mauve palette to portray Intimist domestic scenes and voluptuous nudes recalling the works of Vuillard and Bonnard.

Along with fellow Vingtistes Henry van de Velde and Willy Finch, Lemmen was also a central figure in the Belgian arts and crafts movement. His involvement with the decorative arts officially began in 1891, when he designed the cover for Les Vingt's exhibition catalogue. In the following years, Lemmen created typefaces, book illustrations, posters, textiles, and wallpapers, but never relinquished his painting career. During the last ten years of his life, Lemmen was honored by one-man shows at the Galerie Druet in Paris and at the Galerie Giroux in Brussels.

The Two Sisters or **The Serruys Sisters,** 1894
Les deux soeurs or *Les soeurs Serruys*
oil on canvas, 23⅝ x 27⁹⁄₁₆ (60.0 x 70.0)
 with painted frame: 26¹³⁄₁₆ x 31⁷⁄₁₆ (68.1 x 79.8)
signed with stenciled monogram lower left of canvas and
 lower right of frame: Ⓛ
dated on upper stretcher bar: août-sept. 1894
stamped with monogram on reverse and on upper stretcher
 bar: Ⓛ
colorman stamp on central vertical stretcher bar: Félix
 Mommen, Bruxelles
The Holliday Collection 79.317

Georges Lemmen's double portrait is a prime example of the enthusiasm and the understanding with which Belgian painters responded to the Neo-Impressionist aesthetic. Not long after his first appearance as an exhibiting member of Les Vingt in 1889, Lemmen began to paint according to divisionist principles. *The Two Sisters* was executed in 1894, during the period of the artist's most intense Neo-Impressionist activity.

In its heavy reliance on complementary colors, *The Two Sisters* represents one of the most direct applications of the laws of contrast fundamental to Neo-Impressionist harmonies. The picture's compelling presence is due as much to the artist's bold use of color as to the psychological overtones expressed in many of his portraits. The schema is dominated by the warm red of the girls' dresses and the blue of the backdrop, while uniform dots of orange and green are distributed across both color zones. Within this restricted range, Lemmen has repeatedly demonstrated the law of simultaneous contrast. A basic tenet of divisionism, this theory holds that applying complementary hues to adjacent areas intensifies their differences and stimulates a brilliant effect on the canvas. In *The Two Sisters*, the red and orange pigments of the dresses find their complements in the green and deep blue dots of the background. The same principle prevails, though with less impact on the overall color scheme, in the yellow hues of the brass vase, which is surrounded by clusters of violet dots. In his distribution of pigments, Lemmen goes beyond the standard Neo-Impressionist practice of juxtaposing complements in adjacent passages: he also juxtaposes the contrasting hues dot by dot within the same passage. Hence, orange and blue dots coexist in the background, while both green and red pigments are used to color the dresses.

Lemmen also employs contrasting colors to create a sense of spatial relief for his figures. The girls are silhouetted by a subtle but perceptible halo of deep blue that separates them from the background. Implementing the principle that the interaction of two opposites is always the most intense along the edges of the colored areas, Lemmen has applied thin borders of orange along the elder girl's sleeve and on the top of her head in order to complement the adjacent blue tones of the halo. By manipulating his opposites in this manner, Lemmen illustrates the other basic law of complements, that of successive contrast. This theory holds that when the eye is fatigued by one color area, it sees an after-image or halo of the opposite hue. Lemmen anticipates that optical effect by providing the blue aureole as the "after-image" of the orange tints at the edges of his figures. The resulting silhouette, common

Georges Lemmen, *The Two Sisters* or *The Serruys Sisters*

Fig. 1 Georges Lemmen, *Portrait of Madame Lemmen,* Collection of Madame Henri Thévenin-Lemmen, Toulon

to Neo-Impressionist compositions, occurs in other works by Lemmen, such as his *Self-Portrait,* 1890 (Samuel Josefowitz Collection, Lausanne).

The Holliday canvas bears a painted frame, unique in Lemmen's oeuvre, which continues the dialogue of complementaries. Like Seurat's painted frames and borders, its colors vary in response to the adjacent hues on the canvas. At lower center, just under the red tints of the dresses, the frame has a concentration of green dots, but near the cooler zones of the painting's background, flecks of deep pink appear on the perimeter. The dots become more sparse toward the outer edge of the frame, creating the impression that the frame functions as the mediator between the canvas and the surrounding space.

The composition of *The Two Sisters* is closest to Lemmen's *Portrait of Madame Lemmen* (Collection of Madame Thévenin-Lemmen, Toulon) of 1895, where subsidiary elements are also restricted to a rather fragile chair and a still-life arrangement (fig. 1). By 1894 Lemmen had demonstrated his commitment to the decorative arts, and designs such as his title page for the periodical *L'Art Moderne* display the artist's fondness for the

winding vegetal forms of Art Nouveau. In the portrait of his wife, the subtle turns of her neckline, back, and wispy curls are woven into a design directly based on the integration of curving forms. In *The Two Sisters,* however, Lemmen's decorative impulse is confined to the ornate pattern of the tablecloth, and only the curvilinear handles of the vase and a few twisting tendrils of money plant betray his affinity for Art Nouveau patterns.

Like Théo van Rysselberghe, Lemmen was that rare Neo-Impressionist artist for whom portraits and figure studies played a larger role than landscape subjects. Most of Lemmen's figural work was drawn from the close circle of his domestic life, and the two young girls in the Holliday picture were identified as members of a Belgian family named Serruys who were close friends of the artist and his wife. Lemmen reportedly painted this portrait while vacationing at their home in Menin, near the French border.[1] One of the children, Yvonne Serruys, became a sculptress of some repute, exhibiting in both Paris and Brussels. She was often thought to be one of the girls in Lemmen's picture. However, since Yvonne Serruys was born on

March 26, 1873, she would have been twenty-one when this portrait was painted and thus too old to be one of the sitters. The painting can still be tied to the Serruys family, thanks to the birth records maintained in their native Menin. Records in the burgomaster's office indicate that Yvonne was the eldest of three daughters and two sons. Berthe Serruys, born in 1882, and Jenny, born in 1886,[2] must be the young sisters of twelve and eight who posed for Lemmen in 1894. The portrait apparently remained in the Serruys family until its sale by the younger sister less than twenty years ago. This would account for the conspicuous absence of such an important painting from all exhibitions of Lemmen's work prior to 1966.

Lemmen also made a conté crayon drawing of the older sister (J.-C. Bellier Collection, Paris) wearing the same dress but presented in full profile.[3] As the drawing is dated October 1894 and the canvas was executed during the preceding months of August and September, the drawing cannot be a preparatory study for the finished portrait and its relationship to the painting is not clear.

Lemmen's two young subjects project a commanding presence. Part of their effect can be explained by the dynamic use of color and the detailed rendering of their faces, which, like many of Lemmen's likenesses, recall the precise portraits of the Northern Renaissance tradition.[4] Yet there is also a psychological undercurrent animating the Serruys portrait. Difficult to interpret and easy to exaggerate, the picture's emotive quality is elusive. The sitters are not portrayed as vacuous young models but as distinct individuals whose attention does not appear to be focused on the same object. One girl's gaze engages the observer while the other's is directed elsewhere outside the canvas, leaving their interaction unclear. In its handling and in its impact, *The Two Sisters* has an arresting quality that makes it one of the Neo-Impressionist movement's most unusual portraits.

Notes

[1] Statement on certificate of authentication, signed by Pierre Lemmen, the artist's son.

[2] Letter from Paul Isebaert, burgomaster, Menin, Belgium, to E. Lee, September 16, 1982. A contemporary review of Yvonne Serruys' sculpture also comments that she was the eldest of five children. A. M. de Poncheville, "Yvonne Serruys," *Gand Artistique*, II, 8, August 1923, p. 185.

[3] I am grateful to Jane Block, University of Wisconsin at Milwaukee, for information about this drawing as well as general information on the artist.

[4] Herbert, *Neo-Impressionism*, p. 171; J. Block, in *Belgian Art 1880-1914*, The Brooklyn Museum, 1980, p. 118.

Provenance: Menin, Belgium, Serruys Family; Paris, Jenny Serruys Bradley; Paris, René de Gas and Galerie Daniel Malingue; London, Kaplan Gallery, 1966; New York, Hammer Galleries, 1967; W. J. Holliday, 1969.

Exhibitions: London, Kaplan Gallery, *A Selection of Impressionist and Post-Impressionist Paintings, Watercolors, Pastels, and Drawings*, 1966 (reprod.); London, Kaplan Gallery, *Recent Acquisitions: French Impressionist Paintings*, April 12-May 27, 1967, no. 14 (reprod.); New York, Hammer Galleries, *40th Anniversary Loan Exhibition*, November 7-December 7, 1968, p. 34 (reprod.).

Literature: *Apollo*, LXXXIII, February 1966, p. xvii (reprod.); *Connoisseur*, CLXI, 648, February 1966, p. v (reprod.); *Art Journal*, XXVII, 1, Fall 1967, p. 89 (reprod.) as *Les filles de l'artiste;* R. Herbert, *Neo-Impressionism*, New York: The Solomon R. Guggenheim Museum, 1968, p. 169; J. Sutter, ed., *The Neo-Impressionists*, Neuchâtel, London, and Greenwich, Conn., 1970, p. 204 (reprod.).

Maximilien Luce

French 1858-1941

The long and productive career of Maximilien Luce embraced some of the era's critical artistic and political movements. From 1872 to 1885, Luce pieced together an education under various artists and craftsmen. After an apprenticeship with wood engraver H. T. Hildebrand, he studied at the Académie Suisse and with D. N. Maillart, Auguste Lançon, and Charles Carolus-Duran. From 1876 to 1886, Luce worked intermittently in the print shop of Eugène Froment, where he and fellow workers Léo Gausson and Cavallo-Peduzzi engraved plates for French periodicals. In 1883 Luce's position was rendered obsolete by the zincography print process and his painting career commenced in earnest. He shared studios in Paris and Lagny with Gausson and Cavallo-Peduzzi and together they became intrigued with the experiments of Seurat. By 1885 Luce had begun his own tentative divisionism. At the Indépendants two years later, he showed full-blown Neo-Impressionist paintings that established him as one of the leaders of the movement.

While Paul Signac served as Neo-Impressionism's aesthetic spokesman and theoretician, Luce embodied the movement's Anarchist ideals in his life and work. He depicted Parisian streets bustling with everyday activities of the working class and produced illustrations for leading Anarchist journals, including *La Révolte*, *Le Père Peinard*, and *Les Temps Nouveaux*. During the 1890s, Paris was convulsed by terrorism, and in 1894 Luce was imprisoned as an Anarchist sympathizer. After his release, he published a series of lithographs on prison life. In 1895 Luce made the first of several trips to the Belgian mining region of the Sambre Valley. By 1900 Luce's political involvement waned and he was using a loose, Impressionist brushwork with little trace of divisionism. He still drew upon the Parisian cityscape for motifs, but he also painted more lighthearted landscapes, floral still lifes, and bathing scenes.

Luce was included in nearly all exhibitions dedicated to Neo-Impressionism in France and frequently participated in the salons of Les Vingt and La Libre Esthétique in Brussels. He played a major role in the Société des Artistes Indépendants, serving as vice-president from 1901 and, following the death of Signac in 1935, as president. Luce was under contract with Bernheim-Jeune in Paris and regularly exhibited in one-man shows from the end of the nineteenth century.

La Rue Mouffetard, 1889-90
oil on canvas, 31⅝ x 25³⁄₁₆ (80.3 x 64.0)
signed lower right: Luce
The Holliday Collection 79.311

Maximilien Luce painted views of Paris throughout his career, but this Left Bank market scene offers one of the artist's purest expressions of Neo-Impressionism. Luce had fully developed his divisionist manner by 1887 and was considered a principal member of the group. At the 1890 Salon des Indépendants, he exhibited a particularly impressive body of works, which included *La Rue Mouffetard*. Later that year, his prominence was acknowledged by a biography in *Les Hommes d'Aujourd-hui*, a weekly Parisian periodical that had already featured Seurat, Signac, and Dubois-Pillet in its series on Neo-Impressionism. This picture was one of the few paintings to figure in the article, for certainly the author was scanning the colorful activity of *La Rue Mouffetard* when he wrote:

> In the spring, a bright Sunday morning, the bottom of the rue Mouffetard, near Saint-Médard, in view, the brightly painted goings and comings of the ascending street, the big, loud, posters of the tall walls, the gaudy color scheme of the little shops, the range of greens and orange in the carts of the street vendors, the varied skirts of the housewives, two somber and peaceful guardians of the peace . . .[1]

Luce's brand of pointillism was less uniform than that of Seurat: his touches vary in shape, direction, and impasto as they compose the energetic rhythms appropriate to his lively subject. Lest there be any doubt about the artist's attention to variations of light, the shadows cast by the setting sun (contrary to the article's description, it is late afternoon rather than morning) are clearly delineated along the upper stories of the buildings lining the right side of the street. In accordance with Neo-Impressionist theory, yellow and rose predominate in the facades bathed in sunshine, while in the large shaded area, Luce's more characteristic purple and blue hues prevail. A contrapuntal harmony has been created by the relationship of the orange and green pigments that animate the foreground.

The Neo-Impressionist tenet of firm compositions is satisfied by the stable forms of the buildings that lock into the canvas' vertical format. Their dominant position is emphasized by the artist's elevated viewpoint, which allows for the full rise of the structures but truncates the foreground figures. (Luce must have taken the liberty of raising his vantage point slightly, since the city square at the base of the street slopes up toward the viewer, but not sufficiently to permit Luce's particular view. None of the buildings on the square would afford his perspective up the street.) Indeed, the contrast of the bustling movements of this faceless crowd enhances the buildings' permanence. A preliminary sketch (Hôtel George V, Paris, May 25, 1976, no. 201) in pastel and colored pencil differs significantly only in the placement of figures.

Luce's choice of subject suits the Neo-Impressionists' interest in contemporary urban life and his own deep concern for the working man. The rue Mouffetard is a busy artery of a working-class neighborhood located, as the large sign suggests,

Maximilien Luce, *La Rue Mouffetard*

not far from the Panthéon. In the same district were the offices of *La Révolte,* the Anarchist publication to which Luce often contributed illustrations. He returned to this locale, viewed from the opposite direction, for a picture dated 1896 (Sotheby's, London, April 15, 1970, no. 36).

Today the rue Mouffetard has changed little; it is still a popular market district, its curving street and individual buildings clearly recognizable. The biggest alteration occurs in the colorful posters—once the scene of the artist's pointillist *tour de force,* they now lie beneath a coat of white paint. As a critical example of Luce's work, *La Rue Mouffetard* remains an important historical, thematic, and stylistic document of Neo-Impressionism and one of the masterpieces of the Holliday Collection.

Note
[1] J. Christophe, "Maximilien Luce," *Les Hommes d'Aujourd'hui,* VIII, 376, 1890 (trans.).

Provenance: Normandy, Private Collection; Paris, Palais Galliera, sale, December 10, 1966, no. 20; New York, Hammer Galleries, 1966; W. J. Holliday, 1969.

Exhibitions: Paris, Pavillon de la ville de Paris, *6ᵉ Exposition de la Société des Artistes Indépendants,* March 20-April 27, 1890, no. 493; New York, Hammer Galleries, *Summer Exhibition: Recent Acquisitions,* June-September 1967, no. 18 (reprod.); New York, The Solomon R. Guggenheim Museum, *Neo-Impressionism,* February 9-April 7, 1968, no. 41 (reprod.); New York, Hammer Galleries, *40th Anniversary Loan Exhibition,* November 7-December 7, 1968 (reprod.); HC 1969-70.

Literature: J. Christophe, "Maximilien Luce," *Les Hommes d'Aujourd'hui,* 376, 1890; *Apollo,* LXXXV, June 1967, p. lxxxvi (reprod.); *Art Journal,* XXVI, Summer 1967, p. 405 (reprod.); "Art Across the USA: Outstanding Exhibitions," *Apollo,* LXXXVIII, December 1968, p. 494 (reprod.); J. Sutter, ed., *The Neo-Impressionists,* Neuchâtel, London, and Greenwich, Conn., 1970, p. 193 (reprod.); A. Janson, *100 Masterpieces of Painting,* Indianapolis: Indianapolis Museum of Art, 1980, pp. 192-195 (reprod.); "La chronique des arts: principales acquisitions des musées en 1979," *Gazette des Beaux-Arts,* 6th ser., XCV, March 1980, supplément, p. 45 (reprod. no. 232).

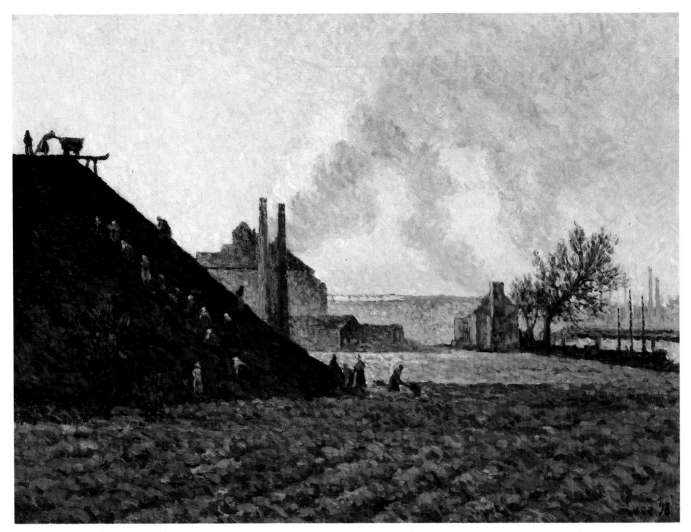

Maximilien Luce, *A Slag Heap Near Marchiennes*

A Slag Heap Near Marchiennes, 1898
Un terril près de Marchiennes
oil on canvas, 21½ x 28¾ (54.6 x 73.0)
signed and dated lower right: Luce 98
inscribed on upper stretcher bar: 10 un terril près
 Marchiennes
Gift of Mr. and Mrs. B. Gerald Cantor 71.204.2

The second picture by Luce in the Museum's collection marks an interval of eight years and is distinguished from *La Rue Mouffetard* by a relaxation of Luce's pointillist style and an intensification of his social themes. Formerly catalogued as *The Slag Heap at Charleroi*, the picture was more specifically identified as Marchiennes by an inscription on the stretcher. Marchiennes is one of several towns in the Sambre River valley, located in southern Belgium's famous Black Country, the *Pays Noir*. A key area for European mining and iron production, this industrial center tapped Luce's already well-developed sensitivity to the conditions of the working man.

Luce first visited the region in 1895. He had been invited to Brussels to participate in the salon of La Libre Esthétique, Belgium's annual avant-garde exhibition. Political conditions in France also made it an opportune moment for an Anarchist to escape government reprisals for the rash of terrorist activity in Paris from 1892 to 1894. Luce had already spent several

weeks of the summer of 1894 in Mazas prison during the wave of arrests following the assassination of French President Sadi Carnot in June of that year.

Luce traveled to the Black Country several times in the closing years of the century. Deeply moved by the landscapes he found "so terrible and so beautiful,"[1] Luce produced dozens of canvases that record industry's effect on the land and its laborers. In *A Slag Heap Near Marchiennes* the composition is securely anchored by the looming mound of mining refuse and the tall verticals of the furnace smokestacks. The position of the workers, small and anonymous in the landscape, is dramatized by the almost anecdotal note of the silhouette of a woman straining to push a coal cart at the edge of the slag heap. Instead of the billowing clouds which might occupy the Impressionists' skies, Luce has presented the smoky air of the Black Country atmosphere.

In this canvas of 1898, the tight dots of pointillism have been replaced by broader strokes and looser handling. The turn to a freer, more Impressionist brushwork is typical of Luce's stylistic evolution in the late 1890s, as he moved away from the practices of Neo-Impressionism. The color scheme is no longer based on a systematic division of hues or the luminosity of sunlight, but is dominated by a cooler palette drawn from the blues, purples, greens, and roses that Luce saw in this landscape of industry. In a letter of 1895 to his friend Henri Ed-

mond Cross, Luce himself describes the change in his handling of color: "As for color, I see only little application for divisionism, I follow my instinct."[2]

A Slag Heap Near Marchiennes marks a distinct chapter in the life and work of Maximilien Luce. It was among thirty-one Belgian scenes featured in his one-man show at Durand-Ruel in 1899. The following year, the painting appeared at La Libre Esthétique, where Luce's works were almost exclusively confined to industrial themes. Commenting on his entries for the year 1900, Madeleine Maus, chronicler of Brussels' avant-garde exhibitions, was moved to write, "Never has the painter seemed to have been so profoundly or poetically inspired as by the theme of the Borinage."[3] With their emphasis on the conservation of human and natural resources, Luce's Belgian paintings retain a surprisingly contemporary pertinence.

Notes

[1] Letter from Luce to Henri Edmond Cross, 1896, quoted in R. Rousseau, "Maximilien Luce et la Belgique, un Néo-Impressionniste au Pays Noir," *Maximilien Luce,* Charleroi, Palais des Beaux-Arts, 1966, unpaginated (trans).

[2] Letter from Luce to Henri Edmond Cross, 1895, quoted in Rousseau.

[3] Borinage is another term for the region around Charleroi. M. O. Maus, *Trente années de lutte pour l'art, 1884-1914,* Brussels, 1926, rept. 1980, p. 244 (trans).

Provenance: Paris, Palais Galliera, sale, May 25, 1971, no. 44; Beverly Hills, Mr. and Mrs. B. Gerald Cantor, 1971.

Exhibitions: Paris, Galerie Durand-Ruel, *Exposition Maximilien Luce,* October 16-November 1, 1899, no. 10; Brussels, Musée Moderne, *7e Exposition de la Libre Esthétique,* March 1-31, 1900, no. 179.

Literature: "Numéro spécial, le guide 1972 des ventes publiques à Paris," *Connaissance des Arts,* 1972, p. 69 (reprod.); A. Janson, *100 Masterpieces of Painting,* Indianapolis: Indianapolis Museum of Art, 1980, p. 194 (reprod.).

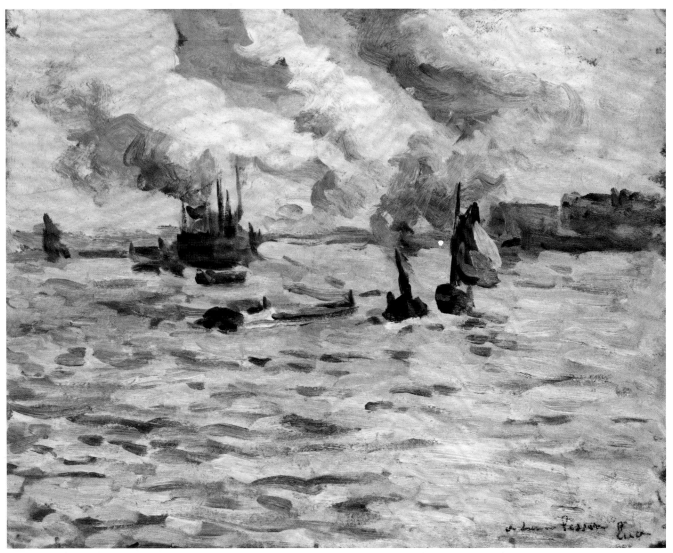

Maximilien Luce, *The Estuary*

The Estuary, 1907
oil on paper mounted to cardboard, 10⅜ x 13¹/₁₆ (26.4 x 33.2)
inscribed and signed lower right: a Lucien Pissarro/Luce
The Holliday Collection 79.266

This vibrant oil sketch is the product of a tour of Holland that Luce made with Dutch painter Kees van Dongen in 1907. His two-month sojourn resulted in a series of paintings, drawings, and engravings of several Dutch cities and harbors. Entitled simply *The Estuary*, the scene is the busy port of Rotterdam, where the Nieuwe Maas River flows into the North Sea. Jean Agamemnon, curator of the Luce museum at Mantes-la-Jolie, has confirmed the sketch's place in Luce's Dutch works.[1] In handling and approach, it relates directly to *Rotterdam, The Ferry*, dated 1907 (Arthur G. Altschul Collection, New York).

In his travels, Luce often made preliminary studies that were not realized into finished compositions until long after he had returned to his Paris studio. This small marine painting has all the immediacy and spontaneous brushwork of one of these sketches rendered on the spot. The freer handling is not due exclusively to the improvisatory nature of a sketch; since the late 1890s, Luce's pointillist facture had loosened to a broader Impressionist stroke. In this small painting, he laces the choppy waters of Rotterdam's port with bright, impulsive bursts of color to create a picture in which atmosphere and reflection are the real subjects.

It is not known when Luce actually presented *The Estuary* to his colleague Lucien Pissarro, but this sketch as well as two others by Luce remained in the Pissarro family collection through 1961.

Note
[1] Letter from J. Agamemnon to E. Lee, March 10, 1981.

Provenance: Gift of the artist to Lucien Pissarro, London; London, Orovida Pissarro (Lucien's daughter); London, Sotheby's, sale, December 6, 1961, no. 144; Cologne, Abels Gemäldegalerie, 1961; W. J. Holliday, 1962.

Exhibitions: Cologne, Abels Gemäldegalerie, *Französische Maler des Nachimpressionismus*, March 10-April 20, 1962, no. 31; HC 1968-69.

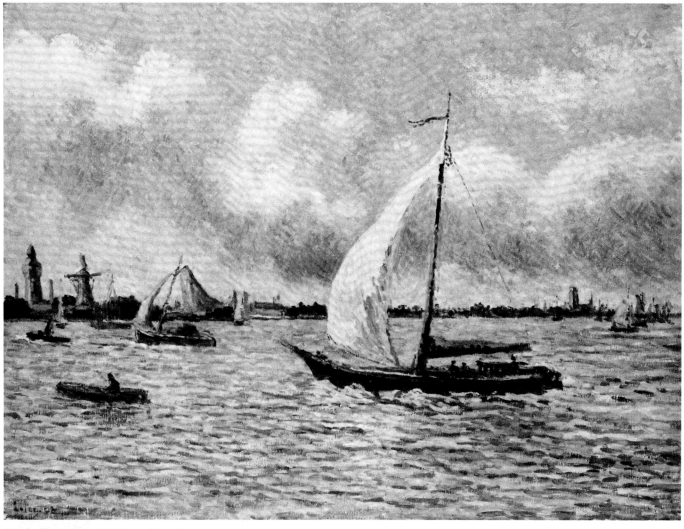

Maximilien Luce, *The Meuse Near Dordrecht*

The Meuse Near Dordrecht, 1908
La Meuse près de Dordrecht
oil on canvas, 23½ x 32 (59.7 x 81.3)
signed and dated lower left: Luce 08
inscribed on upper stretcher bar: La Meuse près Dordrecht
colorman stamp on central vertical stretcher bar: Maison
 Tasset, Paris
Gift of Mr. and Mrs. B. Gerald Cantor 71.204.3

Another scene from Luce's visit to Holland, *The Meuse Near
Dordrecht* lacks the freshness and verve of the small Rotterdam
sketch. This less than dynamic composition is dated 1908, the
year after the artist's tour with Van Dongen. Robert Rousseau,
in his essay for the catalogue of Luce's 1966 exhibition at
Charleroi, has explained that the years inscribed on Luce's
canvases do not always correspond to the dates of his voyages,
since the artist often reworked motifs from sketches made
during earlier travels.[1] Some of Luce's impressions of Holland

were painted as late as 1909. This canvas, as well as several
other pieces from the Dutch series, was featured in a 1909
exhibition at Galerie Bernheim-Jeune, organized by Luce's long-
time friend and sympathetic critic from the Neo-Impressionist
era, Félix Fénéon.[2]

Notes
[1] R. Rousseau, "Maximilien Luce et la Belgique, un Néo-Impressionniste au Pays
Noir," *Maximilien Luce*, Charleroi, Palais des Beaux-Arts, 1966, unpaginated.

[2] M. F. Krause, *From Baroque to Fauve: Recent Acquisitions in French Painting*, In-
dianapolis Museum of Art, 1978, no. 13.

Provenance: Purchased from the artist by Bernheim-Jeune et Cie., Paris, 1909;
Mr. Boxberger, 1909; Paris, sale, November 26, 1927; . . . Paris, Palais Galliera,
sale, May 21, 1971; Beverly Hills, Mr. and Mrs. B. Gerald Cantor, 1971.

Exhibitions: Paris, Bernheim-Jeune et Cie., *Exposition Maximilien Luce*, 1909, no.
12; Indianapolis, Indianapolis Museum of Art, *Your New Treasures: A Six-Year
Retrospective*, October 19-December 10, 1972, p. 62; Indianapolis, Indianapolis
Museum of Art, *From Baroque to Fauve: Recent Acquisitions in French Painting*,
February 24-March 19, 1978, no. 13.

George Morren
Belgian 1868-1941

George Morren first studied painting in Antwerp. At the suggestion of his friend Emile Claus, he then moved to Paris, where he studied with Alfred Roll and Eugène Carrière from around 1888 to 1891. Morren undoubtedly learned of Neo-Impressionism while in France, before his return to Antwerp in 1892. Morren produced divisionist paintings through the mid-1890s and dabbled in sculpture and the decorative arts. After 1900, however, his oeuvre was dominated by luminous Intimist interiors and by portraits of young women rendered in an Impressionist manner indebted to Renoir.

Morren's exhibition career began with his return to Belgium and reflected the multifaceted nature of his works. He exhibited with the Antwerp groups Als Ik Kan and the Association pour l'Art, periodically at La Libre Esthétique in Brussels, and in several one-man shows. In 1904, along with Anna Boch, James Ensor, A.-J. Heymans, Georges Lemmen, and the premier Belgian Luminist Emile Claus, he founded the group Vie et Lumière and served as its secretary. Morren's decorative arts projects were included in Italian exhibitions of the applied arts during the early 1900s.

After residing in St. Germain-en-Laye, France from around 1910 to the late 1920s, Morren moved to Brussels, where he spent the rest of his life.

Sunday Afternoon, 1892
Dimanche après-midi
oil on canvas, 20 x 29⁵⁄₁₆ (50.8 x 74.5)
signed and dated lower right: George Morren/1892.
The Holliday Collection 79.278

The silent, private realm of *Sunday Afternoon* (see p. 56) is one of the few examples in the Holliday Collection in which the focus shifts from the landscape to an interior setting. Popular throughout nineteenth-century European art, the theme of a woman seated beside a window was especially common in Belgian and Dutch paintings. In this canvas, George Morren takes on the tradition and recasts it in the language of Neo-Impressionism. His countryman Henry van de Velde had treated a similar subject during his divisionist period: *Woman at the Window,* 1889 (Koninklijk Museum voor Schone Kunsten, Antwerp). The young Morren, who was studying in Paris at the time, could have seen Van de Velde's picture in the spring of 1890, when it was exhibited at the Salon des Indépendants. Van de Velde's treatment of the austere setting is almost spartan compared to the attention that Morren has lavished upon the objects and the textures of *Sunday Afternoon.* Paul Signac also provided Morren with precedents for comfortable middle-class interiors, illuminated by the light from a draped window, with his paintings entitled *Breakfast,* 1886-87 (Rijksmuseum Kröller-Müller, Otterlo) and *Sunday in Paris,* 1890 (Private Collection, Paris). The most telling indication of Morren's approach, however, comes from a small watercolor (fig. 1) that he also painted in 1892. This picture, now called *Dutch Interior* (Samuel Josefowitz Collection, Lausanne), parodies the seventeenth-century Dutch genre scenes of a woman sewing by the light of a window. Morren again emphasizes the furnishings of the setting, but as in *Sunday Afternoon,* he renders his tradi-

tional subject with the modern handling of pointillism.

The complex composition of *Sunday Afternoon* made it a taxing subject for divisionist treatment. As one Belgian critic warned after viewing Signac's *Breakfast* at Les Vingt: "It is perilous beyond all other effort to undertake such a canvas, in full light filtered and altered and infinitely affected by the many local colors of the furniture, the clothing, and the walls."[1] Morren accepted the challenge and even set himself the ambitious task of rendering the complex pattern of a paisley shawl in both shadow and bright light. The old woman's wrap becomes Morren's vehicle for distinguishing the effects of sunlight: the gold, orange, rose, blue, and green pigments on the front of the shawl change to deeper green, blue, and violet on the back. Red is the only warm hue that Morren allows to recur in the shaded passages. Indeed, a profusion of red dots dances across the darker side of the garment, deriving extra vibrance from the presence of their complement, green.

Elsewhere in the composition, Morren records the play of light within the scope of his individual sense of color. He has chosen a novel coloration to render outdoor light as it penetrates the window. Restricting his palette to one hue, Morren stipples the canvas with shades of yellow, as if he could capture light and warmth on a pane of glass. He also uses yellow to reinforce the precise silhouette of the woman's profile, but he does not apply the typical Neo-Impressionist halo of complementary color. Morren's method of adding brilliance to shaded

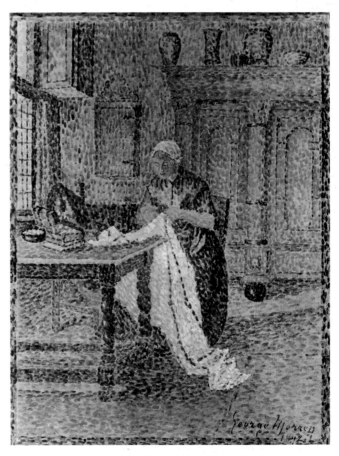

Fig. 1 George Morren, *Dutch Interior,* Collection of Samuel Josefowitz, Lausanne

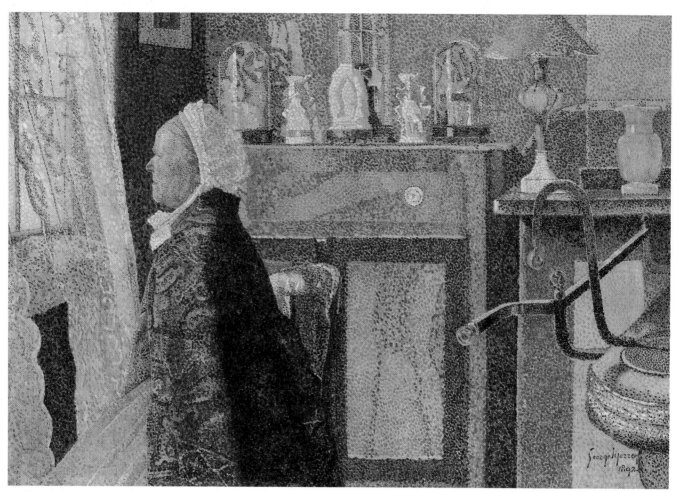

George Morren, *Sunday Afternoon*

zones by concentrating dots of a warm complementary hue is demonstrated in the dark corner of the room at upper left. Creating an effect comparable to that of the shaded side of the shawl, Morren pairs points of orange with points of blue to tint the dark wall. Throughout the complex format of the picture, pairs or trios of juxtaposed colors move in gradually shifting combinations from passage to passage, as Morren renders the many chromatic variations of his subject. Robert Herbert has observed that Morren's dotted application of paint is similar to that of contemporary Dutch Neo-Impressionists like H. P. Bremmer,[2] though the majority of the Dutch divisionist works were painted from 1893 to 1895, during the years just after the execution of *Sunday Afternoon.*

Attentive to the Neo-Impressionist movement's dictate for stable compositions, Morren manages to bring a sense of order and solidity to the varied assemblage of still-life elements. His surface pattern is intricate, as the straight lines and right angles of the setting interact with the gentler curves of the woman and her collection of domes and porcelains. A strangely energetic note is added to the motionless effect of the scene by the twisted forms of the rods at the right. Robert Herbert has identified the object as a stove with drying racks.[3] Cropping the picture with only a truncated view of the stove, Morren anticipates the slice-of-life compositions of today's super realist artists.

Since Morren was back in Antwerp by January 1892[4], *Sunday Afternoon* was apparently among his first efforts following his return from France. The critical response to Morren's other works of the early 1890s indicates that his embrace of Neo-Impressionism was far from wholehearted. Some reviewers faulted Morren's less than rigorous application of divisionist theories, while others regarded his flirtation with other styles as a sign that the young artist was still searching for his own idiom. Morren's floral subjects and Impressionist figural groups like *Child and Nurse,* 1892 (Hirschl and Adler Galleries, Inc., New York) illustrate the breadth of his work during this period. Evidently the critics were not basing their judgment on

Sunday Afternoon, since the picture is a serious Neo-Impressionist effort and it is noticeably absent from the records of Morren's early exhibition activity in Brussels and Antwerp.

At Morren's 1926 retrospective at the Galerie Giroux in Brussels, however, *Sunday Afternoon* was both the earliest painting and the only example of pointillism. The critics then cited its historical value, dismissing *Sunday Afternoon* as a point of departure for the Impressionist paintings that eventually dominated Morren's oeuvre.[5] Today *Sunday Afternoon* stands out as much more distinctive than the Intimist subjects that succeeded it. Many of Morren's works of the 1890s have been destroyed,[6] and *Sunday Afternoon* survives as his finest example of Neo-Impressionism and one of the Holliday Collection's most important paintings.

Notes

[1] _____ "Le Salon des XX, L'Ancien et le nouvel Impressionnisme," *L'Art Moderne,* VIII, 6, February 5, 1888, p. 42 (trans).

[2] Herbert, *Neo-Impressionism,* pp. 177, 193.

[3] Herbert, *Neo-Impressionism,* p. 177.

[4] Morren was in Antwerp in January 1892 to sign the charter for the new Association pour l'Art. See C. Bernard, *George Morren,* Brussels, 1950, p. 10.

[5] See *Le Thyrse,* March 7, 1926; *L'Etoile belge,* February 23, 1926.

[6] Bernard, p. 10, notes that several of his works were destroyed, but Herbert, *Neo-Impressionism,* p. 176, specifies that they were paintings from the 1890s.

Provenance: Paris, Madame Dagieu-Sully; Paris, Stephen Higgons; New York, Hammer Galleries, 1963; W. J. Holliday, 1964.

Exhibitions: Brussels, Galerie Georges Giroux, *Exposition George Morren,* February 20-March 3, 1926, no. 1; Paris, *66ᵉ Exposition de la Société des Artistes Indépendants, Hommage à Paul Signac et ses amis,* April 15-May 8, 1955, no. 48; New York, Hammer Galleries, *French Impressionist and Post-Impressionist Paintings,* ca. 1963-64, (reprod.); New York, The Solomon R. Guggenheim Museum, *Neo-Impressionism,* February 9-April 7, 1968, no. 132 (reprod.); HC 1968-69; HC 1969-70 (reprod.).

Literature: *L'Etoile belge,* February 23, 1926; "La vie artistique à Bruxelles, George Morren," *La flandre libérale,* February 28, 1926; *Le Thyrse,* March 7, 1926; "L'art à Bruxelles," *Neptune,* March 12, 1926; L. Jottrand, "Le peintre George Morren," *Savoir et beauté,* VI, 7, July 1926, p. 195.

Théo van Rysselberghe

Belgian 1862-1926

A key figure in Belgian Neo-Impressionism, Théo van Rysselberghe began his career with a traditional, conservative education. During the late 1870s, he studied with the history painter Théodore-Joseph Canneel at the Ghent Academy and under the orientalist Jean-François Portaels at the Brussels Academy. In 1881 he exhibited for the first time at the Brussels salon and was awarded a travel scholarship that took him to Spain and Morocco, where he developed his taste for luminous atmospheric effects. After his return to Brussels, Van Rysselberghe befriended Emile Verhaeren and Octave Maus and in 1883 joined them in founding Les Vingt.

With Maus, the secretary and guiding force of Les Vingt, Van Rysselberghe played an active role in organizing the group's annual salons. He traveled extensively throughout Europe recruiting progressive artists for the exhibitions. As Maus' talent scout, Van Rysselberghe was largely responsible for establishing the international tone of Les Vingt and that of its successor, La Libre Esthétique.

While in Paris in 1886, Van Rysselberghe saw Seurat's *Sunday Afternoon on the Island of La Grande Jatte* at the last Impressionist exhibition. Although his initial reaction was reportedly anger, over the next two years Van Rysselberghe became more familiar with Neo-Impressionism, and his attitude gradually changed. By 1889 he had relinquished his previous style, which recalled that of Manet and Whistler, and adopted a divisionist technique. He painted in this manner, with modifications particularly noticeable after 1900, for nearly twenty years. Van Rysselberghe used Neo-Impressionism for landscape themes, but he is most renowned for his portraits. Though few of the Neo-Impressionists were portraitists, Van Rysselberghe did successfully combine the rigors of Seurat's theories with sensitive portraits of his family and friends. Although primarily a painter, during the 1890s he also executed numerous decorative arts projects, including designs for catalogues, posters, and installations for Les Vingt and La Libre Esthétique.

Because of his widespread travels and his use of divisionism, Van Rysselberghe was a prominent figure in Paris as well as in Brussels. In addition to annual exhibitions with Les Vingt and La Libre Esthétique, he was regularly included in salons of the Société des Artistes Indépendants from 1890 to 1906 and had his first one-man show in Paris in 1895. In 1898 Van Rysselberghe settled in Paris but stayed in close contact with the Brussels art world. In 1906 he was responsible for introducing the Fauves to the forum of La Libre Esthétique.

By 1910, when he retired to Saint-Clair in southern France, Van Rysselberghe had virtually abandoned Neo-Impressionism. Like many other divisionists, he began using intensely heightened colors in loosely applied strokes. These late works focus primarily on the nude female figure and often depict idyllic bathing scenes.

Big Clouds, 1893
Gros nuages
oil on canvas, 19½ x 23½ (49.5 x 59.7)
signed and dated with monogram lower left: 18·⟨VR⟩·93
inscribed on central horizontal stretcher bar: gros nuages
colorman stamp on reverse: Mommen, Bruxelles
The Holliday Collection 79.287

This unusual seascape by Belgium's foremost Neo-Impressionist is one of the masterpieces of the Holliday Collection. Théo van Rysselberghe painted *Big Clouds* in 1893, during the period of his finest divisionist landscapes.[1] In this picture, he has abandoned the more traditional pictorial devices of marine painting in favor of a composition devoted to the interplay of patterns and the contrast of colors. Occasionally, Van Rysselberghe took exception to the stock divisionist harmonies by building color schemes around blue, green, and violet; but in *Big Clouds* the artist confines himself to orthodox pairings of two sets of complementaries. His orchestration of color is based on the opposition of yellow and violet, orange and blue. Applied with a uniform pointillist technique, these hues knit into tight, interlocking harmonies that unify the composition. Around the image, the artist has painted a dark border of the type pioneered by Seurat. Applied directly to the canvas, this three-quarter inch perimeter contrasts with the picture's luminous, glowing effect. While the border's dominant hue is a deep blue, it is also composed of flecks of color selected to continue the canvas' complementary harmonies. Thus, violet pigments tint the border adjacent to the yellow passages of the sky, and small dots of orange occur opposite the blue hues of the water. An occasional use of green pigments near violet areas shows the artist's attachment to the green-violet harmonies.

The chromatic balance of *Big Clouds* is enhanced by the stasis of its construction. Its sense of harmony and calm is reinforced by the repetition of horizontal bands, a straightforward illustration of Charles Henry's theory of the expressive effect of lines. Robert Herbert has observed that the simplicity of this format is common in Van Rysselberghe's landscapes of 1892 to 1894.[2] *The Escaut, Upriver from Antwerp, Following a Fog* (Arthur G. Altschul Collection, New York), dated 1892, also presents an uncluttered shore parallel to the picture plane and a sailing vessel perched near the horizon. Yet this scene, with its four wood pilings articulating the near ground and the house and shrubbery delimiting the distance, has a finite, immediate perspective distinct from the remote sense of *Big Clouds*. Van Rysselberghe also executed watercolor sketches (Sotheby's, New York, June 23, 1982, no. 92) devoted to empty seas and cloudy skies. Another Belgian Neo-Impressionist, Willy Finch, seized upon the vacant, expansive seascape motif in his canvas *Breakwater at Heyst, Grey Weather*, 1889-90 (Collection of Mr. and Mrs. Hugo Perls, New York). It is also tempting to see a correlation between *Big Clouds* and the combination of tranquil expression and formal construction that pervades Seurat's Gravelines landscapes from the summer of 1890.

The actual site of *Big Clouds* has been confused by the addition of an incorrect subtitle, "Christiania Fjord." The reference to Christiania, the former name for the city of Oslo, implied Van Rysselberghe's presence in Norway which, despite his varied travels, was impossible to confirm. A note in the records of

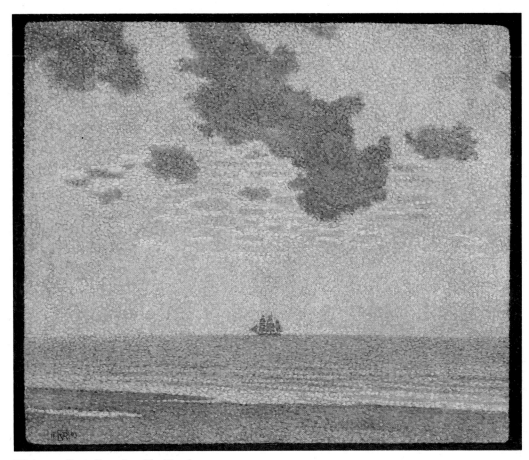

Théo van Rysselberghe, *Big Clouds*

Wildenstein & Co., Inc. indicates that the picture was assigned the second title about twenty years ago because of a confusion with a painting by Claude Monet.[3] Although the locale of *Big Clouds* is patently unspecific, several factors, beyond the dramatic coloration often associated with the south of France, link the painting to Mediterranean motifs. The only canvas that has come to light which could be a preliminary study for *Big Clouds* is entitled *Big Clouds Above the Mediterranean Sea* (Collection of Karl van Rijn, Merelbeke). Very similar in conception to the Holliday painting, its schema is devoted to the flat horizon of the water and the cloud formations above, without even the presence of a vessel in the distance. In addition, Van Rysselberghe's correspondence reveals that as early as 1892 the artist did not restrict his travel in France to just Paris; he also ventured to the Mediterranean shore in the company of Paul Signac. On March 18, 1892, Van Rysselberghe wrote to Octave Maus, "I leave tomorrow for the coast—with Pierre Olin—At Bordeaux he departs and Signac joins me. And then: canal of the Midi: Montauban, Carcassonne, Toulouse, etc. and then Cette, Marseille, Toulon, and the open sea! Ah, it's going to be quite splendid."[4] This voyage was clearly the inspiration for a few canvases, since Van Rysselberghe's entries to the salon of Les Vingt early the next year include *Fishing Boats, The Mediterranean* (current location unknown). Another nautical motif, *Man at the Rudder* (Palais de Tokyo, Musée du Louvre, Paris), dated 1892, must also derive from the artist's Mediterranean cruise with Signac. On its distant horizon is a schooner similar to that of *Big Clouds*.

In the final analysis, the formal elements of *Big Clouds* outweigh its descriptive qualities, and the painting's actual location becomes irrelevant. Its glowing harmonies, and the contrast of the flat planes with the sculptural essence of the cloud formation, endow it with a decorative and poetic *raison d'être*. A powerful example of Van Rysselberghe's tendency during the 1890s to use color and structure for expressive purposes,[5] the painting summons a contemplative mood. *Big Clouds* becomes a metaphor of thought, a landscape of the mind.

Notes

[1] Herbert, *Neo-Impressionism*, p. 183.

[2] Herbert, *Neo-Impressionism*, p. 183.

[3] Since Monet actually traveled to Norway, visiting Christiania in 1895, the reference must have pertained to one of his pictures executed during that trip.

[4] Letter from packet 1892, Inv. 6292, transcribed in M.-J. Chartrain-Hebbelinck, "Les lettres de Van Rysselberghe à Octave Maus," *Bulletin*, Musées Royaux des Beaux-Arts de Belgique, 1966, no. 1-2 (trans).

[5] See *Post-Impressionism*, Royal Academy, pp. 270-271, for an analysis of Van Rysselberghe's *Canal in Flanders* and its evocative effect.

Provenance: New York, Wildenstein & Co., Inc., 1959; New York, Charles Lock Galleries, 1962; New York, Hammer Galleries, 1962; W. J. Holliday, 1962.

Exhibitions: San Francisco, California Palace of the Legion of Honor, July 1-30, 1961, and Santa Barbara, Museum of Art, August 8-September 3, 1961, *Painters by the Sea;* New York, Hammer Galleries, *Seurat and His Friends*, October 30-November 17, 1962, no. 92; New York, The Solomon R. Guggenheim Museum, *Neo-Impressionism*, February 9-April 7, 1968, no. 137 (reprod.); HC 1968-69; HC 1969-70 (reprod.); Buffalo, The Albright-Knox Art Gallery, September 15-November 1, 1970, and Dayton, Dayton Art Institute, November 20, 1970-January 10, 1971, and Cleveland, Cleveland Museum of Art, February 4-March 28, 1971, *Color and Field 1890-1970*, no. 34 (reprod.).

Literature: J. Sutter, ed., *The Neo-Impressionists*, Neuchâtel, London, and Greenwich, Conn., 1970, p. 185 (reprod.); *Belgian Art: 1880-1914*, Brooklyn: The Brooklyn Museum, 1980, p. 118.

Georges Seurat
French 1859-1891

Although undistinguished by his background or training, Georges Seurat revolutionized Post-Impressionist art in the ten short years of his mature career. Born into a well-to-do family supportive of his artistic inclinations, Seurat began drawing lessons at the age of fifteen with sculptor Justin Lequien. Seurat spent three years executing precise renditions of the human figure from life and Antique sculpture before enrolling in 1878 in the atelier of Henri Lehmann, a pupil of Ingres. During his brief term with Lehmann at the Ecole des Beaux-Arts, Seurat proved an able but unremarkable draughtsman in the Ingres tradition.

By 1881, after a tour of military duty, Seurat had begun an intensive study of color theory. Over the next two years, he created velvety conté crayon drawings recalling Millet and Daumier and small oils reminiscent of the Barbizon masters. At the same time, he read scientific treatises on the dissection of color and light by Michel Chevreul, Charles Blanc, and Ogden Rood. Seurat also studied the journals and paintings of Eugène Delacroix, carefully noting the master's use of fragmented and contrasting hues. These color analyses and an acquaintance with Impressionism are apparent in works from 1883, including his first monumental canvas, *Bathing Place, Asnières* (National Gallery, London).

In 1884 Seurat helped establish the Société des Artistes Indépendants, with whom he exhibited throughout his brief career. Many of the group's members were sympathetic to his research, but he found an especially perceptive ally in Paul Signac. At Signac's suggestion, Seurat abolished all earth tones from his palette and over the next two years evolved the systematic brushwork that cemented his theories of optical mixture. Neo-Impressionism was announced amidst controversy in 1886, when Seurat, Signac, and Camille and Lucien Pissarro exhibited divisionist works, including Seurat's masterpiece *A Sunday Afternoon on the Island of La Grande Jatte* at the last Impressionist exhibition. While the subject of much abuse, Seurat's radical innovations were championed by leading Symbolist writers, headed by Félix Fénéon, and steadily drew recruits from the ranks of young artists in both France and Belgium. He was invited to exhibit with Les Vingt in 1887, 1889, and 1891.

By 1887 Neo-Impressionism was a major force in European avant-garde art. Seurat, however, sought an even more thoroughly rational basis for his art. During the last years of his life, he augmented his codification of color with a scientific approach to composition. Works such as *La Parade* (Metropolitan Museum of Art, New York) and *Le Chahut* (Rijksmuseum Kröller-Müller, Otterlo) reveal Seurat's preoccupation with the theories of Charles Henry, who explored the expressive capabilities of line and movement as well as color.

Georges Seurat died at the age of thirty-one from acute diphtheria.

Nude, from the Back, with Legs Stretched, after Raphael, ca. 1878
Nu, de dos, les jambes écartées
pencil on off-white laid paper, mounted to heavy white wove paper, 11¹¹⁄₁₆ x 8⁹⁄₁₆ (29.8 x 21.8)
inscribed by Félix Fénéon on reverse of mount: Dessin de G. Seurat/ff
inscribed by Paul Signac on reverse of mount: P.S.
The Holliday Collection 79.291

This pencil drawing represents the early stage of the astonishingly rapid evolution of the art of Georges Seurat. In little more than fifteen years, he passed from his first formal art education, through a period of research and experimentation, to the refinement of his own mature aesthetic. *Nude, from the Back, with Legs Stretched* reflects the traditional nature and academic values of Seurat's training. Classical norms, as expressed through Antique sculpture and the widespread respect for J.-A.-D. Ingres, were the steady diet of the conventional student at the Ecole des Beaux-Arts.

Robert Herbert divides Seurat's student work into three basic groups: studies from life, drawings after Antique sculpture, and copies after the paintings and drawings of Renaissance masters, Poussin, and Ingres.[1] As a copy after Raphael, the Holliday drawing falls into the last category, which Herbert numbers at about thirty works.[2] Seurat made his drawing from a sketch by Raphael, *Study of Three Warriors*, in the collection of the Albertina in Vienna.[3] Raphael was a revered artist in the academic circles of Seurat's era; and through photo albums, books, and lithographs, the works of the Renaissance master were accessible to the young student.

In his copy of the striding figure on the right of Raphael's drawing, Seurat has carefully followed the original design. He defines the contours with short, overlapping strokes rather than with one continuous line. Seurat has sustained, and sometimes even accentuated, the angular treatment of the leg muscles and the pointed effect of the kneecap. This inclination toward an angular definition of anatomy occurs in other student copies by Seurat, such as *Nude, from the Back, Striding Forward* (Musée du Louvre; De Hauke no. 309),[4] and is even more evident in some of the rapid sketches he made during his period of military service in Brest during 1879-1880. Seurat has also repeated Raphael's parallel hatching to indicate shading. His foreshortening of the figure's left foot is less distinct than Raphael's treatment, making the sense of space surrounding Seurat's figure less convincing. If the drawing lacks the dynamism and robust plasticity of the original, it is, after all, a copy; and part of the distinction can be explained by Seurat's use of a dry pencil medium to transcribe the more fluid strokes that Raphael applied with pen and ink.

The Holliday drawing relates to another copy after Raphael from the Albertina: *Nude Leaning Against a Table* (Collection of John Rewald, New York). The two copies show a similar handling of hair and contour and a comparable use of crosshatching. Herbert's date of ca. 1878 for the leaning figure provides the basis for assigning the Holliday drawing to 1878, the same year Seurat entered Lehmann's class at the Ecole des Beaux-Arts. De Hauke also proposed a date of ca. 1878 for the striding nude in the collection of the Louvre.

Georges Seurat, *Nude, from the Back, with Legs Stretched*

Although *Nude, from the Back, with Legs Stretched* is not included in César de Hauke's *catalogue raisonné* of Seurat's oeuvre, Herbert has accepted the drawing,[5] which does carry the inscriptions that mark it as the work of Seurat. Shortly after Seurat's death, his colleagues Maximilien Luce, Paul Signac, and Félix Fénéon conducted an inventory of the artist's atelier, initialing and numbering the canvases, panels, and drawings in his studio. The verso of the Holliday drawing bears the blue crayon monogram of Félix Fénéon, "ff", as well as the initials of Paul Signac in red. Several other drawings from the student era also carry the two sets of initials and are numbered in the 500s. Curiously, the Holliday drawing has no inventory number, but the upper right corner, where such numbers were often applied, shows some abrasion and some pencil lines that may have obscured the numerals.

In date, genre, and inventory marks, the Holliday picture is similar to many of the drawings that passed from Félix Fénéon to John Rewald. Rewald has explained that before the war, Fénéon entrusted him with several early Seurat drawings believed to be copies after various artists so that he could identify their sources.[6] *Nude, from the Back, with Legs Stretched*, with its obvious debt to Raphael, was apparently among this group. While the Holliday drawing predates the conté crayon pieces that are the best known of Seurat's graphics, it does illustrate the origin of the classical discipline and spirit at the heart of even his most progressive work.

Notes

[1] R. Herbert, *Seurat's Drawings*, New York, 1962, p. 15.

[2] Herbert, p. 26.

[3] O. Fischel, *Raphaels Zeichnungen*, II, Berlin, 1919, no. 95.

[4] C. de Hauke, *Seurat et son oeuvre*, II, Paris, 1961, p. 30.

[5] Letter from R. Herbert to E. Lee, December 18, 1980.

[6] Letter from J. Rewald to E. Lee, March 11, 1981.

Provenance: Paris, family of the artist; Paris, Félix Fénéon; New York, John Rewald; ... London, Sotheby's, sale, March 22, 1961, no. 40; W. J. Holliday, 1961.

Exhibition: HC 1968-69.

The Channel of Gravelines, Petit Fort Philippe, 1890
Le chenal de Gravelines, Petit Fort Philippe
oil on canvas, 28⅞ x 36½ (73.4 x 92.7)
signed lower right on border: SEURAT
colorman stamp on reverse: M. Chabod, Paris
Gift of Mrs. James W. Fesler in memory of Daniel W. and
 Elizabeth C. Marmon 45.195

The Channel of Gravelines, Petit Fort Philippe is one of the last canvases painted by Georges Seurat, and in the stillness of this harbor scene, he achieves a fusion of the luminous effects and the precise construction at the heart of his artistic program. During the summer months, Seurat customarily left his Paris studio and his large figural compositions to paint the fresh air and remote beaches along the English Channel coast. He spent the summer of 1890 in the tiny seaport of Gravelines, not far from the Belgian border. There he executed a series of four views along the town's narrow channel, including *The Channel of Gravelines, Petit Fort Philippe*. Early the next year, Seurat sent all four canvases to the 1891 exhibition of Les Vingt in Brussels.[1] The paintings were also featured at the annual salon of the Indépendants in Paris, where they were hanging when Seurat died on March 29, 1891.

 Underlying the tranquility of these pictures is a subtle tension between the artist's fidelity to images of the natural world and his proclivity for formal design. Seurat's art was always grounded in a firm sense of order and structure, but during the later 1880s, he intensified his study of line and surface pattern and experimented with the theories of Charles Henry and David Sutter. Painted during the same summer that Seurat actually summarized his ideas into a specific statement on aesthetics, the Gravelines series demonstrates the growing role

of abstraction in his work. These canvases offer vistas purged of almost all vegetation or forms that do not lend themselves to regular geometric shapes. Each of the four pictures shows Seurat taking up a different compositional device, from the parallel bands of *The Channel of Gravelines, Evening* (Museum of Modern Art, New York), to the truncated corners and oblique lines of *Grand Fort Philippe* (Collection of Lord Butler of Saffron Walden, London) and *Heading to Sea* (Rijksmuseum Kröller-Müller, Otterlo), to the plunging diagonal of the Indianapolis canvas.

 A photograph of the Petit Fort Philippe at Gravelines (fig. 1) indicates that Seurat has faithfully transcribed the site, but he has relied upon elements like the bollard and boats, which can be rearranged at will, to complete his design. The small boats of the Indianapolis canvas, staggered across the narrow waterway, allow Seurat to repeat the flat line of the horizon. He finds vertical elements everywhere: in the tall forms of the lighthouse and its reflection, in the spikey masts of the small craft, and even in the sturdy form of the bollard that stands isolated on the promenade. Poised within a few centimeters of the middle of the composition, the bollard presides over the empty foreground area, drawing the viewer into the picture plane and linking him with the picturesque but somewhat detached scene in the upper half of the canvas. The delicate equilibrium of these compositional elements is animated by the sweeping curve of the wharf that bends upward and to the right.

 An oil study (Sotheby's, London, December 4, 1978; De Hauke no. 207) for *The Channel at Gravelines* shows Seurat searching for the proper approach to the foreground. This small panel indicates that the bollard was not the artist's first choice for the dominant foreground element. In the study, the

Fig. 1 View of the channel of Gravelines, at low tide (after installation of utility poles)

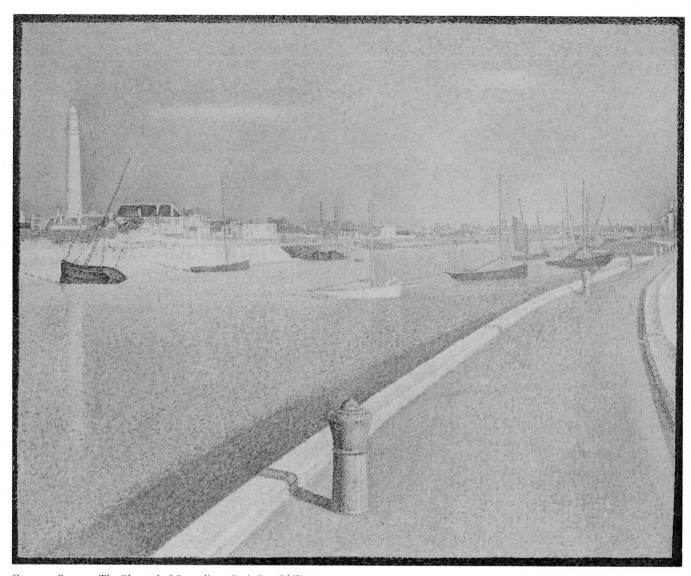

Georges Seurat, *The Channel of Gravelines, Petit Fort Philippe*

mooring post is absent, and the lower section of the picture plane is occupied by a two-masted vessel parallel to the quay. By substituting the bollard for the boat in the final version, Seurat opted for symmetry and stasis, intensifying the prevailing lack of motion in the composition. One conté crayon drawing (The Solomon R. Guggenheim Museum, New York; De Hauke no. 204a) for the white sailboat in the middleground was transferred with few changes to the finished composition. However, three other Gravelines drawings of boats at full sail traveling along a receding curve do not appear in the finished oil, their sense of movement suppressed in favor of the stationary vessels. With all its careful adjustments and meticulous organization, *The Channel of Gravelines* embodies what Henri Dorra called the "remarkable lyrical possibilities of a form of art that was essentially abstract."[2]

All the geometry of Seurat's architectonic canvas is suffused with the blond tones and delicately varied hues of the Channel atmosphere. For the Gravelines series, Seurat turned to a gentler range of harmonies, often building his luminous color schemes around related hues rather than with the more standard complementaries. Observing this distinction in the Gravelines pictures, critic Emile Verhaeren was moved to defend "this harmony born just as successfully from a combination of light and blond tones as from strong and vibrant ones." He continued, "For this precision of harmonies, this special and clear sonority, is miraculously achieved in the *Forts* . . . of M. Seurat. It is air and light, even and tranquil, fixed in frames."[3]

The recent cleaning of the Indianapolis canvas exposes the startling clarity of Seurat's colors and the delicate orchestration of his harmonies. Happily, the artist's rejection of all surface coating was respected, and the canvas has never been varnished. After removal of simple surface dirt, the Gravelines scene which once existed in a thick atmospheric haze now basks in shimmering light and limpid air. (See David Miller's technical statement, p. 30, for a photograph of the canvas during cleaning.) The sea was covered by a greenish-yellow film that concealed the purity of its blue tints, and the intensity of the warm rose tones of the paved promenade was numbed by layers of dirt. Nowhere is the dazzling brilliance of Seurat's color more obvious than in the white pigments of the wharf. Under the beating sun, the curb of the quay has been bleached almost pure white, with only a few flecks of yellow, rose, and blue betraying the existence of an occasional reflection.

The cleaning further reveals the distinctions between each juxtaposed point of color, showing that Seurat has taken full advantage of the unlimited nuance of hue afforded by the small, dotted facture. Within the broad planes of the composition, he deftly moderates the color by gradually adding and eliminating the various tints that compose a particular passage. Subtle variations in the concentration and value of the blue pigments, for example, model the curve of the promenade and indicate the changing shades of the translucent water.

As a prominent example of the chromatic effects of light and shadow, the sturdy form of the bollard becomes the object of Seurat's scrupulous attention. He presents the post in the full range of exposure, from direct sunlight to total shade, modulating the colors from the white border on the right to the deep blue of its shaded left edge. The narrow shadow that the bollard projects across the wharf is composed of the standard blue pigments, a sprinkling of yellow flecks of reflected sunlight, and dots of rose, red, and green generated by the promenade's local color and its complement.

Seurat uses irradiation, or the juxtaposition of light and dark tones, to emphasize many of the composition's contours and to enhance the spatial relief of its forms. Next to the darker, shaded edge of the lighthouse, he applies pale violet and white pigments, while clustered in the sky, adjacent to the bright white side of the structure, he concentrates deep hues of blue and violet. A similar treatment defines the bollard as well as many of the spindly masts that pierce the diaphanous atmosphere.

While the Gravelines seascape is based upon relatively uniform strokes, there is some diversity in their shape and considerable variety in their placement. The brushwork ranges from a fine point to a short, broad patch, but the more obvious distinctions occur in the surface patterns. In the center of the promenade, a thatched effect prevails, the result of many short touches applied at right angles to each other. An even more tightly woven pattern exists among the intersecting strokes to the immediate right of the bollard. The powerful curve of the wharf is accentuated on both sides by parallel bands of dots, which emphasize the diagonal thrust of the composition through their configuration as well as through their contrasting colors. A clear indication of Seurat's growing preoccupation with decorative elements, this practice is also found in *Le Chahut* (Rijksmuseum Kröller-Müller, Otterlo), where bands of strokes mimic the design's main lines.

Surrounding the gentle oscillation of color and the taut network of forms is one of Seurat's narrow dotted borders, painted directly on the canvas. While its predominant color is deep blue, the tints of the border are varied to contrast with the different colors of the canvas. Below the rose pigments of the walkway, for example, is a concentration of dark green and blue touches; but as the border meets the area adjacent to the water, complementary hues of red and orange appear on the perimeter. The upper margin opposite the blue sky is flecked with orange. The painted border functions, along with the frame, as a transitional element between the harmonies of the canvas and the surrounding environment. Like most of Seurat's original frames, that for *The Channel of Gravelines* no longer exists. It is believed, however, that the frames for the Gravelines series were deep blue with contrasting dots and were designed to enhance the canvas' luminous effects as well as to sustain its harmonies.

Like the analysis of a complex poem, examination of Seurat's seascape can reward the viewer with a new understanding of the artist's methods and insight into the creative process. Yet just as the poetry is not fully explained by the dissection of each word or stanza, the essence of Seurat's painting cannot be discovered by analyzing each line and value. In contemplating *The Channel of Gravelines*, the viewer might agree with one of Seurat's colleagues, who concluded that the ineffable quality of his landscapes is "due much more to the soul of Seurat than to his methods and his theories."[4]

Notes

[1] An 1891 letter from Seurat to Octave Maus about the exhibition is preserved in Archives de l'Art contemporain, Musées Royaux des Beaux-Arts de Belgique, Brussels, no. 5.722.

[2] H. Dorra and J. Rewald, *Seurat: L'oeuvre peint, biographie et catalogue critique*, Paris, 1959, p. CII.

[3] E. Verhaeren, "Chronique Artistique, Les XX," *La Société Nouvelle*, VII, 1891, p. 249 (trans.).

[4] T. de Wyzewa, "Georges Seurat," *L'Art dans les Deux Mondes*, April 18, 1891, quoted in Rewald, *Post-Impressionism*, p. 397.

Provenance: Paris, Madame Seurat, 1891; Paris, Léon Appert (the artist's nephew); Paris, Léopold Appert (Léon's son); Lanark, Scotland, D. W. T. Cargill, 1935; London, Alexander Reid and Lefevre, Ltd.; New York, Bignou Gallery, 1937; New York, Knoedler Galleries, 1945; Indianapolis, Mrs. James W. Fesler, 1945.

Exhibitions: Brussels, Musée Moderne, *7ᵉ Exposition des XX*, February 1891, no. 6; Paris, Pavillon de la ville de Paris, *7ᵉ Exposition de la Société des Artistes Indépendants*, March 20-April 27, 1891, no. 1105; Paris, Pavillon de la ville de Paris, *8ᵉ Exposition de la Société des Artistes Indépendants*, March 19-April 27, 1892, no. 1105; Paris, Salon de l'Hôtel Brébant, *Exposition des peintres néo-impressionnistes*, December 2, 1892-January 8, 1893, no. 50; Paris, *Expositions de la Revue Blanche: Georges Seurat, oeuvres peintes et dessinées*, March 19-April 5, 1900, no. 37; Paris, Grand Palais, *Trente ans d'art indépendant: rétrospective de la Société des Artistes Indépendants*, February 20-March 21, 1926, no. 3217; London, Alexander Reid and Lefevre, Ltd., *Pictures and Drawings by Georges Seurat*, April-May 1926, no. 2; Glasgow, McClellan Galleries, *A Century of French Painting*, May 1927, no. 38; London, Burlington House, Royal Academy of Arts, *Exhibition of French Art*, January-March 1932, no. 559 of official catalogue, no. 513 of commemorative catalogue; Liverpool, Walker Art Gallery, *French Art*, 1933, no. 586; Toronto, Art Gallery of Ontario, *Loan Exhibition of Paintings*, November 1935, no. 194; London, Wildenstein Galleries, *Seurat and His Contemporaries*, January 20-February 27, 1937, no. 32; New York, Bignou Gallery, *The Post-Impressionists*, March-April 1937, no. 10; London, Alexander Reid and Lefevre, Ltd., *The XIXth Century French Masters*, July-August 1937, no. 45; Providence, Rhode Island School of Design, Museum of Art, *French Art of the 19th and 20th Centuries*, November 1942, no. 64; New York, Bignou Gallery, *Twelve Masterpieces by 19th Century French Painters*, November 1-December 4, 1943, no. 12; Rochester, Rochester Memorial Art Gallery, *Old Masters of Modern Art*, April 10-May 7, 1944; Indianapolis, Indianapolis Museum of Art, *Caroline Marmon Fesler Collection*, August 4-October 10, 1976.

Literature: J. Meier-Graefe, *Entwicklung der modernen Kunst*, 1, Stuttgart, 1904, p. 232; G. Coquiot, *Des peintres maudits*, Paris, 1924, p. 222; R. Fry, *Transformations*, London, 1926, p. 195 (reprod.); *Cahiers d'art*, October 1926, p. 209 (reprod.); Ozenfant and Jeanneret, *La Peinture moderne*, Paris, 1927, p. 33 (reprod.); *La Revue de l'art*, LXI, February 1932, p. 103 (reprod.); M. Davidson, "The Post-Impressionists in Review," *Art News*, XXXV, 24, March 13, 1937, pp. 9, 10 (reprod.); *Journal, Royal Society of Arts*, January 19, 1940, p. 233; J. Rewald, *Seurat*, New York, 1943, pp. 72-73, 115 (reprod.); "Masters of France's Golden Century," *Art Digest*, XVIII, 4, November 15, 1943, p. 11 (reprod.); J. de Laprade, *Georges Seurat*, Monaco, 1945, p. 60; "Two Recently Acquired Paintings in the John Herron Art Institute," *Art Quarterly*, VIII, 2, Spring 1945, pp. 166-167 (reprod.); "Two XIXth Century Canvases for Indianapolis," *Art News*, XLIV, 10, August 1945, p. 29 (reprod.); B. Stillson, "Port of Gravelines (Petit Fort Philippe) by Georges Seurat," *The Bulletin of the Art Association of Indianapolis, Indiana: John Herron Art Institute*, XXII, 2, October 1945, pp. 25-27 (reprod.); "Seurat's *Le port de Gravelines* for the John Herron Institute," *Connoisseur*, CXVII, 499, pp. 47, 52 (reprod.); *The Marmon Memorial Collection of Paintings*, Indianapolis: John Herron Art Institute, 1948, pp. 36-40 (reprod.); J. Rewald, *Georges Seurat*, Paris, 1948, p. 141 (reprod.); "The Indianapolis Way to Collect," *Art News*, XLVIII, 1, March 1949, pp. 1, 41 (reprod.); J. de Laprade, *Georges Seurat*, Paris, 1951, p. 82; *105 Paintings in the John Herron Art Museum*, Indianapolis, 1951, no. 38 (reprod.); J. Cassou, *Les impressionnistes et leur époque*, Paris and Lucerne, 1953, p. 84 (reprod.); B. Taylor, *The Impressionists and their World*, London, 1953, p. 84; J. Rewald, *Post-Impressionism from van Gogh to Gauguin*, New York, 1956, p. 123, New York, 1962, p. 123, New York, 1978, p. 115 (reprod.); R. Herbert, "Seurat in Chicago and New York," *Burlington Magazine*, C, 662, May 1958, p. 155; H. Dorra and J. Rewald, *Seurat: L'oeuvre peint, biographie et catalogue critique*, Paris, 1959, pp. cii, 267, no. 205 (reprod.); J. Muller, *Seurat*, Paris, 1960, no. 16 (reprod.); C. de Hauke, *Seurat et son oeuvre*, I, Paris, 1961, pp. 186-187, no. 208 (reprod.); R. Fry and A. Blunt, *Seurat*, London, 1965, pp. 21, 84-85 (reprod.); P. Courthion, *Seurat*, New York, 1968, p. 154; D. Miller, *A Catalogue of European Paintings*, Indianapolis: Indianapolis Museum of Art, 1970, pp. 198-199; N. Prak, "Seurat's Surface Pattern and Subject Matter," *Art Bulletin*, LIII, 3, September 1971, pp. 372, 376 (reprod.); A. Chastel and F. Minervino, *L'opera completa di Seurat*, Milan, 1972, p. 110 (reprod.); R. Shone, *The Post-Impressionists*, London, 1979, p. 25 (reprod.); A. Janson, *100 Masterpieces of Painting*, Indianapolis: Indianapolis Museum of Art, 1980, pp. 189-190 (reprod.); R. Hughes, *The Shock of the New*, New York, 1981, pp. 114-116 (reprod.)

Paul Signac

French 1863-1935

As the son of a wealthy saddler and harness maker, Paul Signac enjoyed lifelong financial security, but he was nevertheless a staunch Anarchist. By the age of nineteen, he had devoted himself to painting full time. Although he spent a few months at the studio of Emile Bin in 1883, Signac was essentially self-taught. For guidance, he looked to the works of the Impressionists, primarily Monet and Guillaumin.

After their meeting at the foundation of the Indépendants in 1884, Signac initiated Seurat into the Impressionist use of prismatic hues. Seurat in turn introduced Signac to scientific laws governing light and color, which led him to study the writings of Chevreul, Blanc, and Rood. Signac, however, still venerated Impressionism: not until 1886, after seeing divisionist canvases by Camille Pissarro, Seurat's first convert, was Signac convinced of the new style's merit. He then helped to announce Neo-Impressionism at the eighth Impressionist exhibition that year.

Signac's energetic personality and privileged relations with the taciturn Seurat naturally established him as Neo-Impressionism's public leader. He sponsored weekly gatherings at his Paris studio, attended by Symbolist intellectuals as well as by Seurat's followers. A close friend of Théo van Rysselberghe and Henry van de Velde, Signac was closely associated with the growth of Neo-Impressionism in Belgium; he exhibited with Les Vingt in 1888 and again in 1890, the year he became a member. From 1888 to 1890, Signac collaborated with Charles Henry, developing chromatic charts and diagrams for the aesthetician's publications.

Signac was greatly affected by Seurat's death in 1891 but shortly resumed his divisionist campaigns with enhanced vigor. In 1892 Signac discovered the village of Saint-Tropez, where he made his Mediterranean home. There Signac played host to his Neo-Impressionist colleagues and introduced a new generation of painters to Seurat's theories. These included Jeanne Selmersheim-Desgrange, Lucie Cousturier, Henri Person, and most significantly, Henri Matisse, who visited throughout the summer of 1904. By this time, Signac had personalized his divisionist technique with large strokes and hot colors, which Matisse subsequently transformed into the Fauve style. As its vice-president and as its president, beginning in 1908, Signac not only insured the Indépendants' Neo-Impressionist tone, but also provided early exposure for the Fauves and Cubists.

Throughout his life, Signac propounded his artistic and political views in literary as well as visual media. He contributed articles to journals such as *Art et Critique, La Révolte,* and *La Revue Blanche* and provided texts for numerous exhibition catalogues. Signac was the author of studies on Stendhal (1913) and the painter Jongkind (1927). Of greatest significance for the Neo-Impressionist movement was the publication in 1899 of Signac's text on color theory and method, *D'Eugène Delacroix au néo-impressionnisme.*

Entrance to the Port of Honfleur, 1899
Entrée du port de Honfleur
oil on canvas, 16⅜ x 19⅞ (41.6 x 50.5)
signed and dated lower left: P. Signac 99
The Holliday Collection 79.292

Entrance to the Port of Honfleur was painted in 1899 and marks a transitional point in Paul Signac's stylistic evolution. He completed the canvas after the finely dotted works of his Neo-Impressionist heyday of the late 1880s and early 1890s, but it predates his early twentieth-century paintings with their larger mosaic strokes. It is the work of a self-confident, forceful personality at mid-career, who has mastered the divisionist aesthetic and codified its principles in one of the most important theoretical documents on the visual arts, *D'Eugène Delacroix au néo-impressionnisme.* Yet it is also the product of an artist who was continuously refining his technique and tirelessly reviewing his approach to his craft, one who would travel to London to study J.M.W. Turner's works for "the most useful lesson in painting ever to be gotten."[1]

Seascapes, and particularly harbor scenes, are a common theme in Signac's oeuvre. An able seaman, Signac painted hundreds of pictures of the ports that face the Atlantic, Mediterranean, and Channel waters where he often sailed. In 1965 this seascape was purchased and subsequently catalogued as *Rainbow, Port in Brittany,* and its date was misread as 1893. Françoise Cachin, the artist's granddaughter and author of his forthcoming *catalogue raisonné,* has confirmed that the picture is cited in the artist's journal during July 1899 and listed in his notebook as no. 288, *Entrance to the Port of Honfleur.*[2] Cachin has also indicated that the July 1899 date in the roster refers to the beginning of Signac's work on the canvas. Signac was at that time in residence at Saint-Tropez, and thus his picture, which presents a scene from Normandy, was painted from memory. This information corresponds not only to the artist's itinerary during 1899, but also to the details of his working methods, which are very clearly documented in his diaries of the 1890s. On April 10, 1899, Signac departed from Paris for a brief excursion to the Normandy shore with Théo van Rysselberghe. Signac visited the coastal town of Port-en-Bessin,[3] and he could easily have traveled to nearby Honfleur before returning to Paris, and thence to Saint-Tropez.

Signac's journals from this period are filled with references to his disenchantment with painting directly from nature and his endorsement of compositions conceived and executed in the studio. In June 1895, he wrote, "No, one does not make a painting by sitting down before nature and copying what is in front of one."[4] And just a few months before beginning the Honfleur canvas, he commented, "It is always the same lesson; to take from nature some elements of the composition, but to handle them to one's liking."[5] Signac turned to watercolors and rapid oil sketches to record his observations as inspiration for future works. While no studies have been positively linked to the Honfleur composition, one small watercolor (Collection of the artist's family) identified as Honfleur does depict a rainbow spanning the coastal waters before curving into the tip of the shore.

The brushwork of *Entrance to the Port of Honfleur* follows distinct directional patterns, creating the varied surface rhythms

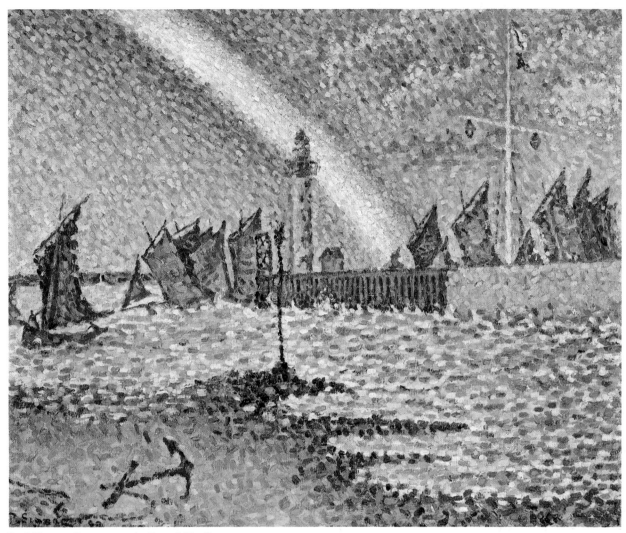

Paul Signac, *Entrance to the Port of Honfleur*

that reflect the artist's growing preoccupation with decoration. The sea and the two sections of the blue sky are actually distinguished from each other by changes in the flow of brush strokes rather than by variations in hue. In the color selection, a freer, arbitrary orchestration of harmonies has replaced the naturalism and luminosity of earlier paintings. As Signac commented in August 1898, "I harmonize my tints as I please—placing everything in the right spot, just the tint I need, without bothering with imitation or verisimilitude."[6] In the purple, green, red, and orange of the sailboats are the heightened colors typical of Signac's mature works, but he has placed them in a setting where the predominant colors are cool blue and violet. The artist is now less attentive to systematic division of color. There is a concentration of blue pigment on each side of the rainbow, but little reliance on the juxtaposition of complementaries. The sequence of colors in the glowing band of the rainbow, however, is similar to their positions on the chromatic circle, as blue and purple at the upper edge move into red, yellow, green, and eventually back to blue and purple.

Signac's careful construction of the Honfleur port scene illustrates his belief in the artist's primary role as designer of an image. The composition is clearly based on the verticals of the lighthouse, lamppost, and sails intersected by the horizontal band of the pier and the orderly extension of sailboats across the water. The rainbow thus becomes the picture's dynamic,

decorative element, relieving the composition's stasis by its diagonal movement and animating the color scheme with its warm hues. From this composed canvas it is only a short step to the large port scenes of 1904-05, whose careful construction shows Signac's attraction to the classical landscapes of Claude Lorrain and Poussin.

Notes

[1] Letter from Signac to Charles Angrand, April 18, 1898; quoted in Rewald, Signac Diary, III, p. 73.

[2] Letter from F. Cachin to E. Lee, May 7, 1981.

[3] Rewald, Signac Diary, III, p. 79.

[4] Rewald, Signac Diary, I, p. 174.

[5] Rewald, Signac Diary, III, p. 80.

[6] Rewald, Signac Diary, II, p. 303.

Provenance: Hamburg, Germany, Richard Samson, before 1935; New York, Alfred Aufhauser (Samson's nephew), 1930s; London, Christie's, sale, November 30, 1962, no. 34, (unsold); Paris, Martin Fabiani; London, Edward Speelman, Ltd.; England, Private Collection; London, Sotheby's, sale, March 31, 1965, no. 42 as *L'arc en ciel—Port Breton;* W. J. Holliday, 1965.

Exhibitions: HC 1968-69; HC 1969-70.

Literature: J. Sutter, ed., *The Neo-Impressionists,* Neuchâtel, London, and Greenwich, Conn., 1970, p. 126, as *L'arc en ciel—Port Breton* (reprod.); A. Janson, *100 Masterpieces of Painting,* Indianapolis: Indianapolis Museum of Art, 1980, p. 194, as *The Rainbow* (reprod.).

Paul Signac, *Antibes, Umbrella Pine in the Foreground*

Antibes, Umbrella Pine in the Foreground, ca. 1916
Antibes, pin pignon au premier plan
black ink with black pencil on tan wove paper, 16¹⁄₁₆ x 11³⁄₁₆
 (40.8 x 30.0)
watermark: winged goddess driving a chariot, numbered 642
signed lower right: P. Signac
The Holliday Collection 79.293

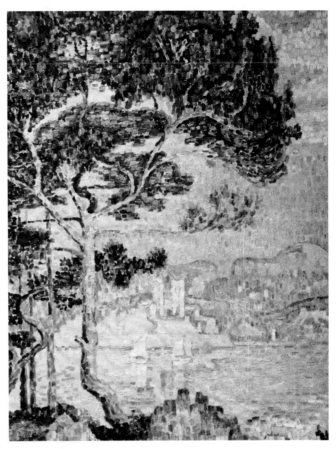

Fig. 1 Paul Signac, *Antibes. La Salis,* Rosenthal & Rosenthal, Inc., New York

The picturesque little town of Antibes, sandwiched between the Mediterranean Sea and the French Alps, has attracted some of France's most distinguished landscape painters, including Monet, Cross, and Signac. Situated just a few miles east of his home in Saint-Tropez, Antibes is a recurring motif in the work of Paul Signac. Its distinctive silhouette, readily identifiable by the towers of the cathedral and the Château Grimaldi Museum, appears in numerous oils, watercolors, and drawings by Signac. He painted Antibes as early as 1904,[1] but the subject is prevalent in his works of 1914 through 1919.

The Holliday drawing relates to an oil of 1916 (fig. 1) entitled *Antibes. La Salis* (Rosenthal and Rosenthal, Inc., New York).[2] La Salis is the beach that skirts the small peninsula south of Antibes and affords a picturesque vantage point, complete with pine trees in the foreground, for views of the Antibes coast. The Holliday drawing differs from the finished oil in several details and is not its final preparatory sketch. An intermediate drawing (David David, Inc., Philadelphia), virtually identical to *Antibes. La Salis,* illustrates Signac's method of preparing a composition. After his quick sketches and color studies, he finalizes his design by drawing the image on a paper exactly the size of the canvas that will bear the finished product.

In spite of the key role that color plays in the art of Paul Signac, he often experimented with pen and ink drawings, many of which he sketched with a bamboo reed. The short curves and broken lines of the Holliday drawing are typical of his decorative approach, and this calligraphic style also appears in the sinuous patterns of his lithographs. The small letters that occur throughout the Antibes drawing correspond to Signac's practice of making color notations in his studies.[3]

Notes
[1] M.-T. Lemoyne de Forges, *Signac,* Paris, Musée du Louvre, 1963-64, p. 81.

[2] Letter from F. Cachin to E. Lee, May 7, 1981.

[3] Letter from F. Cachin to E. Lee, May 7, 1981.

Provenance: London, Sotheby's, sale, March 22, 1961, no. 44; W. J. Holliday, 1961.

Exhibition: HC 1968-69.

Literature: J. Sutter, ed., *The Neo-Impressionists,* Neuchâtel, London, and Greenwich, Conn., 1970, p. 55 (reprod.).

Pont St. Michel, early 1920s
watercolor with black crayon on white laid paper, 11½ x 17½
 (29.2 x 44.4)
signed and inscribed lower right: P. Signac/Pt. St. Michel
Julius F. Pratt Fund 27.22

In the early 1890s, as Signac turned away from painting canvases directly from nature, the watercolor assumed increased importance in his art. He turned to watercolors rendered on the site as studies and notations for oils he would compose in the studio. The watercolor gave the artist, still moved by the power of nature, the opportunity to indulge in painting his spontaneous impressions of the landscape. By 1895 Signac was exhibiting his watercolors, and within a few years the medium was established as an abiding interest and fundamental part of his career.

In her monograph on Signac, Lucie Cousturier made one of the most perceptive observations about this segment of her mentor's oeuvre: "In none of his watercolors does Signac wash or wipe, any more than he models: he writes. He writes lightly, delicately, by the angles of contrast and the contours of similarities."[1] Signac's watercolors do indeed have a sense of the artist's handwriting. Instead of displaying the more anonymous pointillist technique, these works on paper are composed of the short strokes of pencil and brush that capture Signac's free, fluid expression.

Pont St. Michel is typical of the artist's ability to integrate crayon or pencil drawing with translucent watercolors to form the finished image. For Signac, the pencil outline is not an underdrawing to be concealed by an overlay of pigment; its dark line complements the staccato daubs of color, giving structure to the composition. Signac was a great admirer of the painter Jongkind, and in his 1927 study of his works, Signac expounds upon aspects of the watercolor technique, emphasizing the importance of the white paper that appears amid the washes of color.[2] In *Pont St. Michel*, these unpainted areas are integral to the picture's chromatic and spatial sense. Signac uses them to enhance the reflective properties of the river and the luminous effects of the sky. The amorphous colored shapes are virtuoso displays of bravura handling, but they coalesce to build a balanced, legible composition.

The city of Paris consistently provided Paul Signac with ready material for his art. In the spring of 1899, he wrote in his diary of painting watercolors on the banks of the Seine.[3] This watercolor of the bridge that connects the Ile de la Cité with the Place-St. Michel was probably painted a quarter of a century later, in the early 1920s, when Signac's delight in the city had not diminished. Though not one of Signac's most common motifs, the bridge was painted at least one other time, in a watercolor reproduced in Cousturier's monograph.[4] Guillaume Apollinaire's reaction to an exhibition of Signac's watercolors is appropriately applied to *Pont St. Michel:* "The watercolors all relate to aspects of the Seine in Paris and they are assembled under the title Bridges of Paris, and isn't that what Paris has that is its most beautiful: the Seine and its bridges?"[5]

Notes

[1] L. Cousturier, *Paul Signac*, Paris, 1922, p. 19 (trans).

[2] Paraphrased and quoted in M.-T. Lemoyne de Forges, *Signac*, Paris, Musée du Louvre, 1963-64, p. 104.

[3] Rewald, Signac Diary, III, p. 78.

[4] Cousturier, no. 29.

[5] G. Apollinaire, *L'Intransigéant*, January 28, 1911; quoted in Lemoyne de Forges, p. 87 (trans).

Provenance: New York, Weyhe Gallery, 1927.

Literature: "Other Accessions," *The Bulletin of the Art Association of Indianapolis, Indiana: The John Herron Art Institute*, XIV, 4, October-November 1927, p. 40.

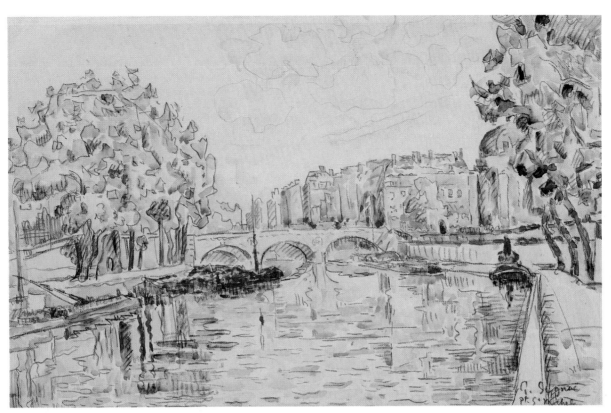

Paul Signac, *Pont St. Michel*

Henry van de Velde
Belgian 1863-1957

Although best known for innovative architecture and decorative arts designs, Henry van de Velde devoted his early career—and his only formal training—to painting and drawing. He studied in Antwerp at the Academy and with Charles Verlat from 1880 to 1884, before a brief stint in Paris under Charles Carolus-Duran. Van de Velde returned to Belgium full of admiration for Millet, the Barbizon painters, and the Impressionists. He affiliated himself with the Belgian *plein-air* painters Emile Claus and A. J. Heymans and painted scenes of rural Wechelderzande, his home from 1886 to 1890.

Heymans, an early exhibitor at Les Vingt, recommended his young colleague to Octave Maus, and in 1889 Van de Velde first exhibited as a member of the Brussels group. As an exhibition forum for the avant-garde art of Europe, Les Vingt and its successor, La Libre Esthétique, provided Van de Velde with a cosmopolitan array of influences. Soon after seeing *A Sunday Afternoon on the Island of La Grande Jatte* at Les Vingt in 1887, Van de Velde abandoned Luminism in favor of Neo-Impressionism. No doubt part of the movement's appeal was its alliance with Anarchism, a philosophy that closely paralleled his own socialist ideals. Van de Velde's Neo-Impressionist period was brief. By the early 1890s he used long, sinuous strokes of pure color influenced by Van Gogh, whose works received their first important exposure at Les Vingt.

With his colleagues Willy Finch and Georges Lemmen, Van de Velde also explored the ideals of William Morris and the English Arts and Crafts movement. These British influences helped solidify his own belief that art could be a powerful reforming agent in society. In 1894 Van de Velde gave up painting entirely and dedicated the rest of his life to architecture and the applied arts. In addition to creating designs for furniture, tapestries, ceramics, jewelry, and a vast array of functional objects, Van de Velde propounded his new aesthetic by writing articles for scholarly journals in France, Germany, and the Lowlands.

From 1900 to 1917, Van de Velde resided in Germany and was largely responsible for the spread of Art Nouveau there. He was involved in a number of building projects, including the redesigning of the Folkwang Museum in Hagen. From 1901 to 1914, he served as the director of the School of Art in Weimar, where his workshop approach to teaching set a precedent for the Bauhaus. Forced to leave Germany with the advent of World War I, Van de Velde lived in exile in Switzerland and Holland, where he designed the Rijksmuseum Kröller-Müller. He was able to return to Belgium in the early 1920s, and in 1926 was appointed director of the Institut Supérieur des Arts Décoratifs. Van de Velde retired to Oberägeri, Switzerland in 1947 to write his memoirs.

The Old Peasant Woman, ca. 1887-88
pastel on ivory wove paper, 12⅝ x 9⁹⁄₁₆ (32.1 x 24.3)
unsigned
The Holliday Collection 79.295

Like Jean-François Millet, Camille Pissarro, and Georges Seurat, Henry van de Velde gave peasant themes a prominent place in his art. During the 1880s, he produced numerous paintings and pastels devoted to rural life and the dignity of labor. Far from picturesque or sentimental portrayals of an unfamiliar way of life, Van de Velde's works were drawn from his experiences in the Belgian countryside and they reflected his social consciousness. The young painter was an avid reader of socialist treatises and the novels of Emile Zola. In 1891 he expressed his special interest in a lecture entitled "The Peasant in Painting," delivered at the Brussels salon of Les Vingt.

For long periods from October 1886 through May 1890, Van de Velde lived in the Campine countryside at Wechelderzande, a remote village frequented by many of the Belgian *plein-air* painters. *The Old Peasant Woman* belongs to the body of work he produced there. Its subject corresponds to the series of divisionist oils, *Faits du Village*, or *Facts of Village Life*, that Van de Velde painted in 1889. In the Van de Velde Archives of the Bibliothèque Royale, Brussels, are a number of photographs from the artist's Welchelderzande interlude, including one of an old peasant woman who resembles the figure in the Holliday picture.[1]

This portrait dates from 1887 or 1888.[2] Van de Velde's pastels of this type are not numerous, and the picture has its closest stylistic rapport with an oil painting of 1887 entitled *Washerwoman* (Koninklijk Museum voor Schone Kunsten, Antwerp). Both works reflect Van de Velde's sensitivity to light and shadow, and their construction is based on the application of short, linear bands of downward strokes. While the sun-struck pastel, with its contrast of throbbing color and cool shadows, is primarily Impressionist in conception, it does display some of the division of color that Van de Velde later fully developed. As the artist explained, "The preference I have for the pastel comes from the use of this dry material, which permits the practice of division of tone and optical mixture."[3] In the Holliday portrait, traces of pink, yellow, and yellow-green are superimposed on the blue pastel of the woman's dress, and the vibrant light of the background is transcribed in separate hatchings of warm hue. Fine strokes of red, blue, coral, and yellow compose the precise treatment of the woman's face. By the time this portrait was completed, Van de Velde had already seen Seurat's Neo-Impressionist paintings and was probably within months of painting his own pointillist oils.

With its straightforward composition and rectilinear articulation of the background, *The Old Peasant Woman* clearly predates the undulating forms and fluid lines that first appear in Van de Velde's pastels and drawings of late 1889 and 1890. In these later works, the artist approached his images from untraditional vantage points and indulged in bold foreshortening. Focusing on the theme of peasants at work, Van de Velde presented his subjects from the back, resting, or bent over in the labor of the field. Entitled *Attitudes*, these studies of poses and postures lack the individuality and character of this sympathetic portrait. *The Old Peasant Woman*, therefore, presents

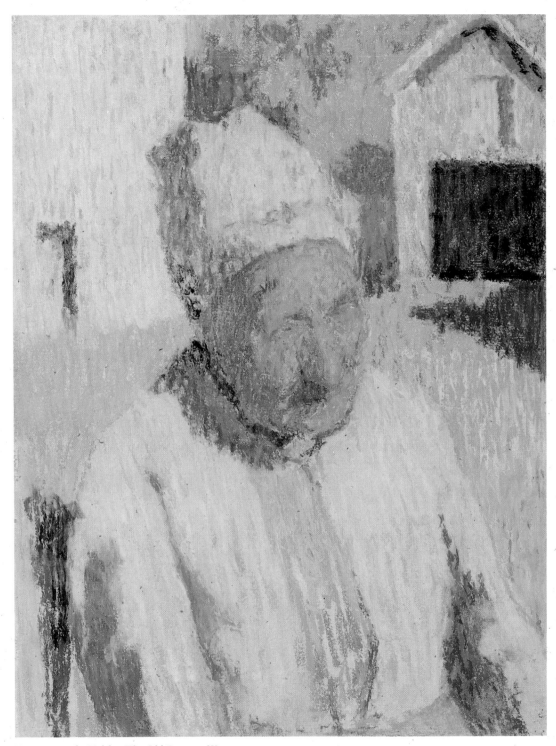

Henry van de Velde, *The Old Peasant Woman*

an uncommon treatment of one of Van de Velde's standard themes.

Notes

[1] Fonds Henry van de Velde, Bibliothèque Royale de Belgique, Brussels, no. 1300.

[2] The pastel is assigned to the period 1888-89 in E. Billeter's "Catalogue de l'oeuvre peint, dessiné et gravé," in A. M. Hammacher, *Le monde de Henry van de Velde*, Antwerp and Paris, 1967, no. 49, p. 331.

[3] Hammacher, p. 322 (trans).

Provenance: Purchased from the artist's son by Nicolas Poussin, Paris; Paris or Versailles, art market, 1965; W. J. Holliday, 1965.

Exhibition: HC 1968-69.

Literature: A. M. Hammacher and E. Billeter, *Le monde de Henry van de Velde*, Antwerp and Paris, 1967, no. 49, p. 331; G. Pogu, *Néo-impressionnistes étrangers et influences néo-impressionnistes*, Paris, 1963 (reprod.).

Père Biart Reading in the Garden, 1890 or 1891
Le Père Biart lisant au jardin
oil on brown paper mounted to canvas, 24⁷⁄₁₆ x 20⁷⁄₁₆
 (62.1 x 51.9)
signed with floral emblem and dated lower right:
The Holliday Collection 79.320

Père Biart Reading in the Garden is the Holliday Collection's earliest example of a serious Belgian response to Neo-Impressionism. It is one of a limited number of works executed by the young Henry van de Velde before he turned from Seurat's aesthetic to a new style and, ultimately, to a new artistic philosophy.

Van de Velde was introduced to Neo-Impressionism in 1887, with the first appearance of Seurat's work at the annual salon of Les Vingt in Brussels. In his memoirs, Van de Velde describes the painting's effect upon him: "Put in the presence of Seurat's *Sunday on the Island of La Grande Jatte*, I felt myself thrown into an indescribable excitement, it was impossible for me to resist the need to assimilate the theories, the rules, and the fundamental principles of the new technique."[1] During the summer of 1888, as he emerged from a siege of severe nervous depression, Van de Velde began to apply Seurat's theories to his first Neo-Impressionist pictures. Painting steadily in the divisionist manner, the young artist produced this portrait about two years later.[2] The second numeral of the two-digit date accompanying the artist's floral emblem is difficult to decipher, but there is no doubt that the picture fits the evolution of the artist's work during 1890-91.

This painting is built upon the repetition of the uniform round dot that Van de Velde had mastered in even his earliest efforts with the technique. It is his only oil painting from this period that is executed on brown paper, and the tiny areas of dark paper exposed throughout the scene figure in its harmonies. The color scheme is based upon green, violet, blue, and light rose, combinations that the artist favored in other divisionist works. In this painting, however, Van de Velde's use of color begins to shift from a strict application of laws and theories to an exploration of more decorative concerns. He displays less sensitivity to the effects of light than he demonstrated in *Woman at the Window* (Koninklijk Museum voor Schone Kunsten, Antwerp) of 1889, a picture that the artist considered his closest embodiment of Seurat's ideas.[3] Van de Velde represents the grass in the background with green and blue pigments, eliminating the warm tints commonly used to denote the presence of sunlight. While the shadows on Père Biart's papers and chair are an appropriate blue, Van de Velde omits the most logical place for a shadow—on the ground just below his subject's chair. The absence of this shadow, which complicates the chair's integration into the picture plane, does preserve the unity of the surface design. This painting's composition reveals the same tendency to create a flat expanse of foreground as that found in *Bathing Huts on the Beach at Blankenberge* (Kunsthaus, Zurich) of 1888. Here, however, the plunging diagonals and sharp angles of the Blankenberge beach have been replaced by a winding path and a curving swath of lawn. Van de Velde's modifications are subtle precursors of the curvilinear rhythms and decorative patterns that dominate the next phase of his work.

The likeness of Père Biart, father of the artist's brother-in-law, was painted in the Belgian countryside at Calmpthout while Van de Velde was a guest at Vogelenzang, his sister's summer home. In his memoirs, Van de Velde recounts that after he left Wechelderzande in 1890, he set up his studio on his sister's property to keep her company during her husband's extended stay in Antwerp:

> During the first months of my installation at "Vogelenzang," I abandoned myself to the well-being of the family life. The satisfaction which my hosts expressed, and the presence of the two charming and intelligent children, helped me to surmount the alienation I had felt and which had afflicted me since my arrival at Vogelenzang . . . As soon as I tried to set up a work program, I had more trouble defending myself against the repulsion I felt with the use of the technique: that of "the point."[4]

Père Biart belongs to this period in the artist's personal and professional development—it is a document of his family life, painted at the end of his confidence in the Neo-Impressionist aesthetic.

Like other followers of Georges Seurat, Van de Velde soon became impatient with the painstaking procedures of Neo-Impressionism and its limitations on his personal expression. Six paintings by Vincent van Gogh were included in the 1890 salon of Les Vingt, and the pictures were instrumental in re-orienting Van de Velde's style. As he described their impact:

> After the shock undergone in 1887 by *Sunday on La Grande Jatte*, I was shaken a second time in 1889. Seurat exhibited *The Models* in [18]89. It restored my faith in the theory of Seurat and Signac. The revelation of the salon of 1890, of the works of Vincent van Gogh, among which was *The Sunflowers*, shook me violently in the opposite direction. On one hand, a technique hopelessly peaceful and slow; on the other, an impetuous technique, fixing forever a moment of excessive emotion.[5]

The powerful linear rhythms of Van Gogh's pictures, together with his predilection for peasant and rural subjects, struck a responsive chord in Van de Velde. Paul Gauguin, who exhibited at Les Vingt in 1889, also provided Van de Velde with an example of the trend toward flat, ornamental design.

By 1891 Van de Velde was producing pictures animated by long, sinuous bands of pure color. *Garden in Summer* (Osthaus-Museum, Hagen) probably painted at Vogelenzang in 1891 or 1892, is a revealing transitional work, combining the short strokes and luminous effects of Neo-Impressionism with the more serpentine patterns that succeeded it. Van de Velde turned with greater frequency to pastels and drawings, exploiting the decorative potential of his curvilinear patterns. A second portrait of a Biart family member sitting in the garden is the natural comparison for measuring Van de Velde's change in style. *M. Biart in the Garden* (Galerie L'Ecuyer, Brussels), a pastel of 1892-93, shows the artist's brother-in-law in a similar setting, where the regular dots of the landscape have loosened into a fluid configuration of wavy lines.

Père Biart Reading in the Garden is not only one of Van de Velde's last divisionist works, it is also one of his final paintings. His tastes soon turned to Art Nouveau and his convictions to the value of producing utilitarian objects to enhance everyday life. The artist's social concerns culminated in his rejection of easel painting in favor of the applied arts. Van de Velde's change was a conscious decision, and the artist wondered why his colleagues "were not haunted as much as I am by the idea of providing society with nothing more than unique works."

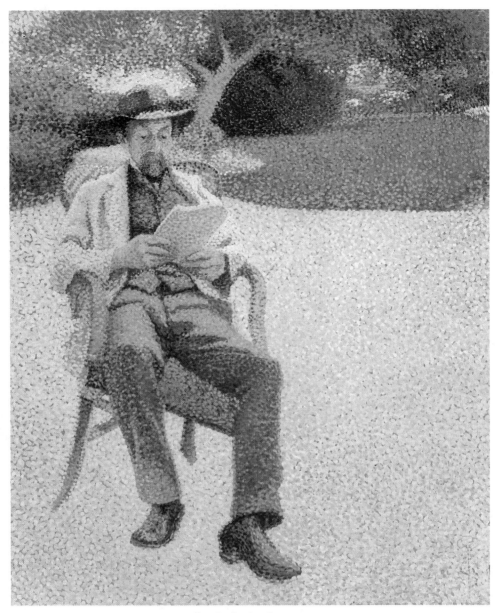

Henry van de Velde, *Père Biart Reading in the Garden*

He explained his commitment to art in daily life by adding that even those "unique works" that "end up in some museum are accessible only to those people who frequent museums . . . and no worker thinks to go there unless it's to warm himself during harsh winter days."[6] Actually, other artists, notably Van de Velde's colleagues at Les Vingt, were also drawn to the Arts and Crafts movement and eventually participated in the larger trend toward decorative arts during this period. Thus the delicate portrait of Père Biart marks not only a high point of Belgian Neo-Impressionism, but also a pivotal point in the career of one of the era's most influential figures.

Notes

[1] Fonds Henry van de Velde, Bibliothèque Royale de Belgique, Brussels, Autobiographical manuscripts, Chapter I, Part II, no. 79 (trans.).

[2] E. Billeter's *catalogue raisonné* in A. M. Hammacher, *Le monde de Henry van de Velde*, Antwerp and Paris, 1967, p. 329, states that the picture was probably executed in 1889, but the author was not aware of the floral emblem with date, where the first of the two digits is clearly a 9.

[3] From Van de Velde's autobiography, quoted in R.-L. Delevoy, "Van de Velde avant van de Velde," *Henri van de Velde*, Brussels, Palais des Beaux-Arts, 1963, p. 27.

[4] Fonds Henry van de Velde, Bibliothèque Royale de Belgique, Brussels, copy of file INV 1960 -N° 525, "Le récit de ma vie," p. 41 (trans.).

[5] Fonds Henry van de Velde; see note 1 above (trans.).

[6] Fonds Henry van de Velde; see note 1 above (trans.).

Provenance: Antwerp and Calmpthout, Biart family; Lausanne, Edgard Biart; ... Paris, Madame Ionesco; New York, Hammer Galleries, 1967; W. J. Holliday, 1969.

Exhibition: Antwerp, *Exposition Als Ik Kan*, 1891, no. 262.

Literature: A. M. Hammacher and E. Billeter, *Le monde de Henry van de Velde*, Antwerp and Paris, 1967, no. 22, pp. 43 (reprod.), 322, 329; *Connoisseur*, CLXVI, November 1967, p. lix (reprod.); R. Herbert, *Neo-Impressionism*, New York: The Solomon R. Guggenheim Museum, 1968, p. 187; J. Sutter, ed., *The Neo-Impressionists*, Neuchâtel, London, and Greenwich, Conn., 1970, p. 211 (reprod.).

Jan Vijlbrief
Dutch 1868-1895

At the age of seventeen, while a student at the Leiden school of Mathesis Sientiarum Genetrix, Jan Vijlbrief won medals for his drawings. He then pursued a painting career at the Fine Arts Academy in The Hague during the late 1880s. Vijlbrief's early paintings, although often composed with a loose, Impressionist brushwork, are essentially academic in orientation. By 1894, however, he had turned to brilliant hues and a precisely dotted facture also used by his friends H. P. Bremmer and Johan Aarts. At the age of twenty-seven, Vijlbrief committed suicide.

Boat Along a Bank, 1894 or 1895
wax-resin (?) medium on canvas, 21¾ x 15⅞ (55.3 x 40.3)
unsigned
The Holliday Collection 79.298

Jan Vijlbrief's farmyard scene is exquisite evidence that the Neo-Impressionist influence also extended to Holland. During the middle years of the 1890s, Vijlbrief, Johan Joseph Aarts, and H. P. Bremmer, led by Jan Toorop, all produced intricate divisionist pictures that demonstrate both a refined decorative sense and an adept use of the small, rounded brush stroke. The concentration of pointillist works between 1893 and 1895[1] can be directly related to an exhibition of Les Vingt organized by Toorop at The Hague in the summer of 1892. At this show, many Dutch painters had their first opportunity to view important works by Seurat, Signac, and the Belgian divisionists. *Boat Along a Bank* is part of the enthusiastic wave of response to the new aesthetic.

With this landscape, Vijlbrief expands the standard Neo-Impressionist palette. Adding unusual shades of mauve, gray, magenta, and ochre, the young artist proves himself an original colorist. Not only are his colors uncommon, they are juxtaposed in novel combinations, such as the points of gray-violet and pastel blue that coalesce to define the tree trunks. The yellow-orange cast of the sky suggests a twilight scene, but the setting has an unreal quality, as if naturalism has been replaced by the exploration of color effects. No single color scheme predominates: the picture's elusive harmonies defy easy classification, disappearing and recurring in myriad variations throughout the composition.

Vijlbrief's decorative priority is confirmed in the complex pattern of his lines as well as his colors. The lacy leaves and curvilinear branches, even the jagged bank of the narrow stream, form elegant arabesques that are more delicate and less rhythmic than the Art Nouveau shapes animating the contemporary work of Henry van de Velde. The scene has an intricate construction that produces a static, almost frozen effect. Some passages of this complex schema, abetted by the unpredictable color shifts, are difficult to interpret, as planes merge mysteriously and the silhouettes of boat and shore remain ambiguous.

Capping this landscape's striking presence is its jewel-like texture. Across its unvarnished surface some pigments reflect a shiny finish while others are dull. Instead of using an oil medium, which produces a consistent surface effect, Vijlbrief has chosen a curious wax-resin binder that yields varying degrees of gloss when used in different ratios.[2] Thus the greens

and blues mixed with a greater proportion of resin are shinier than the other pigments, creating the faceted, sparkling surface effect.

Like the other works assigned to the brief career of Jan Vijlbrief, *Boat Along a Bank* is both unsigned and undated. However, the picture clearly dates from 1894 or 1895,[3] when Vijlbrief and his friend Johan Aarts were painting similar subjects with intricate patterning and subtle color shifts. In fact, two canvases in the Rijksmuseum Kröller-Müller, Otterlo, *Landscape with Haystack* (fig. 1, p. 78) by Vijlbrief and *Farm in the Dunes* (fig. 2, p. 78) by Aarts, which has been dated 1895, show that the artists painted the identical scene of a landscape with hayrick. At the left of the composition in both paintings is a curious shed or small structure that may be the same building that appears at the right edge of the Holliday landscape, suggesting that *Boat Along a Bank* could be one of a number of works they painted in the vicinity. With its unusual blend of precision and lyricism, *Boat Along a Bank* is a rare work from a regrettably obscure interpreter of the Neo-Impressionist vision.

Notes
1 See Herbert, *Neo-Impressionism*, pp. 192-202, for a discussion of the Dutch Neo-Impressionists and their concentration of works during the period of 1893-95.

2 John Hartmann, IMA Assistant Conservator, provided the analysis of the medium and the explanation of its reflective properties.

3 M. L. Wurfbain, Director of the Stedelijk Museum "De Lakanhal," Leiden, concurs with this date. Letter from Wurfbain to T. Smith, February 19, 1982.

Provenance: Probably London, Kaplan Gallery; Paris, Galerie André Maurice; New York, Hirschl and Adler Galleries, Inc., 1960; W. J. Holliday, 1966.

Exhibitions: New York, Hirschl and Adler Galleries, Inc., *Neo-Impressionism, An Exhibition of Pointillist Paintings*, November 19-December 14, 1963; HC 1968-69; HC 1969-70.

Literature: M. Kozloff, "New York Letter," *Art International*, VIII, 1, January 1964, p. 44 (reprod.).

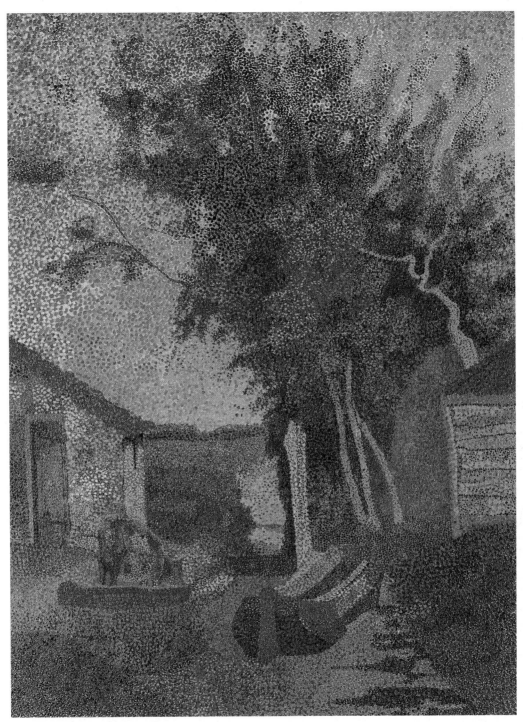

Jan Vijlbrief, *Boat Along a Bank*

Fig. 1 Jan Vijlbrief, *Landscape with Haystack*, Rijksmuseum Kröller-Müller, Otterlo

Fig. 2 Johan Joseph Aarts, *Farm in the Dunes*, Rijksmuseum Kröller-Müller, Otterlo

II

Paul Baum
German 1859-1932

Paul Baum was a leading proponent of Neo-Impressionism in Germany. In 1876 he worked as a figure and flower painter in the Meissen porcelain factory. The following year he studied under Friedrich Preller in Dresden, then from 1878 to 1887 with Karl Buchholz and Theodor Hagen at the Weimar Academy. In the 1880s he first cultivated his passion for landscape painting. Although Baum was apparently unaware of French precedents and used a dark palette typical of the Academy, his early works were characterized by an Impressionist spontaneity.

A month spent in Paris during 1890 finally introduced Baum to Impressionism and not only confirmed his *plein-air* approach to landscapes, but also brightened his palette and loosened his brushwork. In 1894, while in Knocke, Belgium, Baum learned of Seurat's color theories through contact with Van Rysselberghe and Signac. By 1896 he was painting in a divisionist manner with muted colors.

Baum's favored residence from 1895 to 1910 was the small village of St. Anna ter Nuiden, just across the border from Knocke in Holland. He traveled extensively during this period and regularly exhibited in Dresden, Munich, Düsseldorf, and Berlin. He continued painting in a divisionist technique, modified shortly after the turn of the century by rectangular strokes and intensified colors. In 1902 Baum's works were included in German shows dedicated to Neo-Impressionism.

Baum lived in Italy from 1910 until the outbreak of World War I, when he returned to Germany. There he was received as one of his country's prominent artists. He held posts in landscape painting at academies in Kassel and Marburg and was honored by one-man shows in Düsseldorf and Dresden. Baum returned to Italy in 1924 and spent the rest of his life in the Tuscan village of San Gimignano.

Constantinople, The Boats, 1900-01
Constantinople, les barques
watercolor with pencil on cream laid paper,[1]
 9 x 15⅞ (22.9 x 40.3)
signed lower right: P. Baum
The Holliday Collection 79.233

This port scene is one of Paul Baum's most intense pointillist efforts. Baum had been experimenting with Neo-Impressionist methods since the mid-1890s. Though he was based in Holland at the time, Baum traveled widely and often wintered in Berlin. There he must have witnessed the growing German interest in Neo-Impressionism, exemplified by Count Kessler's exhibition in 1898 and articles in *Pan* magazine during the same year. In Berlin in 1900, Baum met archaeologist Theodor Wiegand, who invited the artist to visit him in Constantinople. Baum remained in Turkey until 1901 and produced about twenty-five landscapes of the Bosporus. The Holliday painting is part of that body of work. Depicting Constantinople rather than a view of the Rhine,[2] as previously catalogued, the watercolor relates directly to two other scenes of the Constantinople harbor also executed in a divisionist technique. An oil, *At Constantinople* (location unknown; see Hitzerodt no. 30), is painted from the vantage point of the sea, looking back at the shore. *Constantinople with the Sultan's Palace*

(Flender Collection, Düsseldorf), a watercolor dated 1900, presents a more distant vista on the active port. Both this scene and the Holliday painting were probably among the three watercolors of Constantinople that Baum exhibited at La Libre Esthétique in 1903.

The composition of Baum's elevated view of the port is based on horizontal lines appropriate to the broad format of the paper. The steamships, the sailboats, and both sides of the shore are aligned in long parallel planes. In the foreground is a network of neatly articulated structures. Thin blue lines reinforce the edges of the port buildings and enhance the strictly ordered geometric sense that is unusual for Baum's landscapes. The busy port scene is also a departure from the artist's standard rural subjects.

For this watercolor, Baum has tightened his facture to a very fine point, as dense dots of blue pigment in various degrees of saturation blanket the surface of the paper. The points of red and orange that tint the roofs and chimneys add vital contrasting accents but do not demonstrate a strict application of Seurat's methods of color division. With its precise, meticulous touches of the brush, the handling of *Constantinople, The Boats* is distinctly different from the broad, brick-like strokes of Baum's later divisionist works. The Holliday watercolor is significant as one of the early examples of the German response to Neo-Impressionism.

Notes
[1] The paper bears a large crowned watermark with a rampant lion encircled by the words: PRO PATRIA, EIUSQUE, LIBERTATE. It is very close to marks used by Dutch paper mills. See W. A. Churchill, *Watermarks in Paper*, Amsterdam, 1935, no. 87.

[2] Professor Dr. Erich Herzog of the Staatliche Kunstsammlungen Kassel identified the site. I am indebted to him, and his references to Carl Hitzerodt's biography of Baum, for the information on Baum's sojourn in Constantinople.

Provenance: Brussels, family of Willy Schlobach; Brussels, Madame Jacqueline Manguin (niece of Willy Schlobach); Brussels, Marcel Bas, 1964; Paris, Guy Pogu (Galerie de l'Institut), 1964; W. J. Holliday, 1965.

Exhibitions: Possibly Brussels, Musée Moderne, *10ᵉ Exposition de la Libre Esthétique*, February 26-March 29, 1903, no. 17 as *Constantinople, les barques*; HC 1968-69; HC 1969-70.

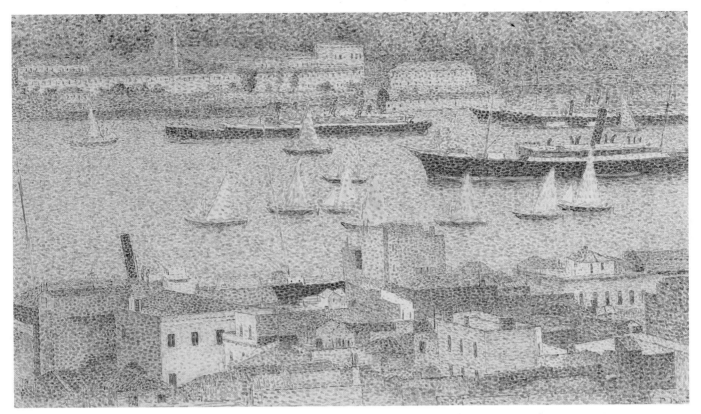

Paul Baum, *Constantinople, The Boats*

Anna Boch

Belgian 1848-1936

Anna Boch was in touch with the avant-garde art of her time, yet her work is not distinguished by bold innovation. Born to a family of master porcelain makers, Boch studied first with Louis Kühnen and then with Euphrosine Beernaert. Disillusioned by their approach, which confined her to copies and studio still lifes, she sought a less conventional apprenticeship with Isidore Verheyden in 1876. Under his tutelage, Boch explored light and color effects and turned to painting *plein-air* subjects with a lightened palette and loose strokes. This Impressionist style formed the basis for nearly all her succeeding works.

In 1882 she was introduced to Théo van Rysselberghe by her cousin Octave Maus. Through her friendship with Van Rysselberghe, Boch met many avant-garde artists throughout Europe and was introduced to the principles of Neo-Impressionism. In 1886 she became a member of Les Vingt, exhibiting in all its salons and most of those of its successor, La Libre Esthétique. Her first entries clearly revealed the influence of Verheyden, while those of 1890 and 1891 were conceived in vibrant colors reflecting an awareness of Neo-Impressionism. Before World War I, Boch traveled extensively but at its outbreak returned to Brussels. Cut off from the rural motifs she favored, Boch explored figure painting for the first time. After the war, she returned to landscapes but often incorporated figures into her compositions.

Boch is also remembered as a collector with discriminating clairvoyance. Her collecting activities began with her involvement in Les Vingt, where in 1890 she purchased Vincent van Gogh's *The Red Vineyard*, the only painting he sold during his lifetime. She also owned works by Gauguin, Seurat, Signac, Van Rysselberghe, and Ensor, as well as numerous Japanese prints.

Landscape

oil on canvas, 17⅝ x 23¹¹⁄₁₆ (44.8 x 60.2)
signed lower right: A Boch
colorman stamp on central vertical stretcher bar: Mommen, Bruxelles
The Holliday Collection 79.234

While Anna Boch was an enthusiastic observer of the rise of Neo-Impressionism and its prominence at Les Vingt, she produced few purely divisionist pictures. Boch's works of around 1890 came the closest to Neo-Impressionist precepts, but her love of spontaneity could not be expressed through Seurat's exacting methods. She did sustain an interest in atmospheric effects and used broad, loose strokes to transcribe the gray tones as well as the vibrant hues of nature.

The Holliday canvas shows the freedom Anna Boch achieved in her landscape painting. Clearly later than Boch's experiments with Neo-Impressionism, the painting should date from the decade prior to World War I. She depicts this scene in the Belgian countryside with varied brushwork, applying thick, choppy strokes to the slope of the hill; tinting the sky with long, thin swipes of the brush; and using a palette knife for the sharp angles of the little roadside shrine. The spontaneity of the landscape's rhythms is matched by the unrestrained handling of its colors. The ruddy tones of the right foreground show that Boch's use of warm hues was not reserved for her views of the Esterel on the Mediterranean, where she painted in 1910. As the composition opens up to the right, turquoise, violet, and blue expand the range of her color scheme. Boch was capable of painting brilliant Impressionist light, but with the color treatment of this landscape, she adds an expressionistic note to her naturalistic approach.

Provenance: Brussels, Marcel Bas, 1960; Paris, Guy Pogu (Galerie de l'Institut), 1964 or 1965; W. J. Holliday, 1965.

Exhibitions: HC 1968-69; HC 1969-70.

Literature: J. Sutter, ed., *The Neo-Impressionists*, Neuchâtel, London, and Greenwich, Conn., 1970, p. 201 (reprod.).

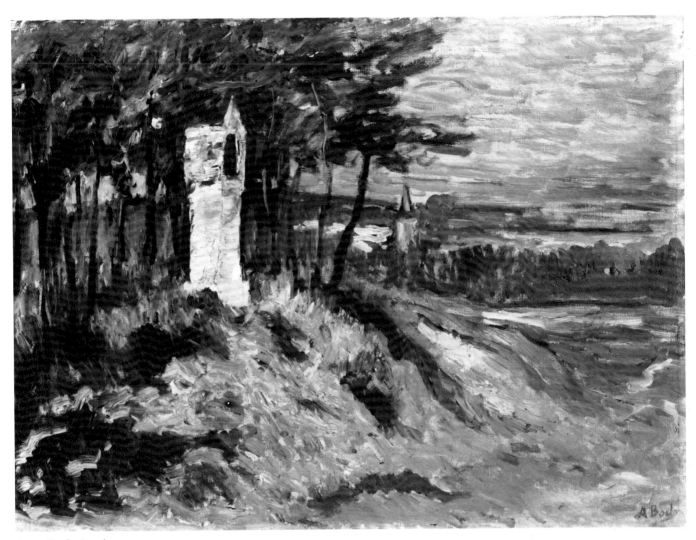

Anna Boch, *Landscape*

Ernest-Lucien Bonnotte
French 1873-1954

Landscapes of the Dijon countryside comprised Ernest-Lucien Bonnotte's first artistic efforts. At the Ecole des Beaux-Arts, he was a student of Emile Dameron and Charles Ronot. He also pursued music training in Dijon, but several painting and drawing awards propelled the young student toward a visual arts career. In 1893 Bonnotte went to Paris for further training under Léon Bonnat and Léon Glaize at the Ecole des Beaux-Arts. Bonnotte was modestly successful as a portraitist and received honors at the salons of the Société des Artistes Français, where he began exhibiting around the turn of the century. While Bonnotte painted most of his canvases in an Impressionist manner, he did have a divisionist period characterized by the juxtaposition of complementary hues in a variety of small strokes.

Landscape
oil on canvas, 12¾ x 16 (32.4 x 40.6)
unsigned
The Holliday Collection 79.315

Provenance: Dijon, G. Salvatori Collection; New York, Schweitzer Gallery, 1969; W. J. Holliday, 1969.

Portrait of a Boy
oil on canvas, oval: 15⁹⁄₁₆ x 13⁵⁄₁₆ (39.5 x 35.4)
signed lower left: Bonnotte
The Holliday Collection 79.321

This painting was formerly attributed to the Belgian painter Auguste P. R. Bourotte. Bourotte is not known to have produced any divisionist pictures, and close examination of the exceptionally small signature reveals that the letters do not in fact spell Bourotte. The signature on the Holliday canvas is, however, the same as that found in pictures by the French painter Ernest-Lucien Bonnotte, whose pointillist phase and preference for portraiture are well-documented facets of his varied career.[1]

For this small portrait, Bonnotte has chosen pure, bright hues that would have their rightful place on any Neo-Impressionist palette, but he has cooled their impact by applying them over a thin layer of blue paint. To Seurat's coterie, who began their search for luminous effects by preparing the canvas with only a white ground, the blue base that Bonnotte superimposed on his white ground would have been unacceptable. Using short strokes, Bonnotte juxtaposes orange, yellow, rose, and red hues across the boy's face, while the tiny exposed areas of underlying blue pigment accentuate the effect of fragmented strokes and divided color. The boy's head is conscientiously modeled, with the palest tones of yellow and rose marking the play of light down the right side of his face and neck. The orange dots defining the shaded side of the face set up a strong complementary relation to the adjacent blue background and maintain the firm silhouette of the left cheek. In the background, the palette expands to include touches of violet and green, applied with a looser handling.

Note
[1] For examples of Bonnotte's signature and pointillist painting, see Gaston-Gérard, *E.-L. Bonnotte 1873-1954: Peintre Dijonnais*, Dijon, Musée des Beaux-Arts, 1956.

Provenance: Nice, Delzenne Collection; New York, Schweitzer Gallery, 1968; W. J. Holliday, 1968.

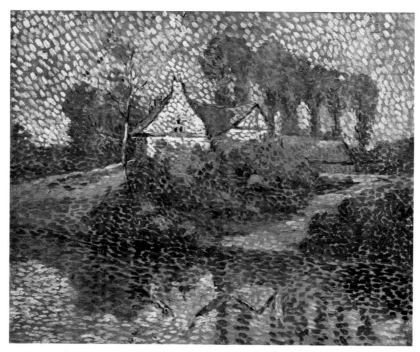

Ernest-Lucien Bonnotte, *Landscape*

Ernest-Lucien Bonnotte, *Portrait of a Boy*

Bernard Boutet de Monvel

French 1881-1949

Bernard Boutet de Monvel is often characterized as a meticulously attired, elegant dandy, and his art possesses similar traits. In pursuing a painting career, he continued a family tradition begun by his father Maurice, a popular painter-illustrator who was Bernard's first instructor. He also studied with Luc-Olivier Merson and in the sculpture studio of Jean Dampt.

From 1903 to 1914, Boutet de Monvel participated in numerous Paris exhibition societies. His precisely rendered portraits and scenes of aristocratic life were seen annually at salons of the Société Nationale des Beaux-Arts and frequently at the Salon des Artistes Français. In 1905 he began contributing to the Salon d'Automne and, two years later, to the annual international exhibitions of the Carnegie Institute in Pittsburgh.

During World War I, Boutet de Monvel saw active military service in North Africa. Enchanted by the exotic life of Morocco, he remained in Africa until around 1925. At the Paris gallery of Barbazanges that year, Boutet de Monvel drew favorable attention with a series of canvases executed during his Moroccan residence. In 1926 he made his first trip to the United States, where he debuted in a major exhibition at the Anderson Galleries in New York. Until 1939 Boutet de Monvel wintered in Palm Springs. He enjoyed renown as a portraitist of elite society on both sides of the Atlantic. His love of precision and geometric order was further revealed in depictions of skyscrapers and in industrial scenes that recall the works of Charles Sheeler.

After World War II, Boutet de Monvel resumed his trips to the United States and in 1947 exhibited at Knoedler Galleries, New York. Two years later he disappeared in a plane crash.

Rita del Erido, 1907
oil on canvas, 27¼ x 74¾ (69.2 x 189.9)
signed and dated lower left: BERNARD/B. DE MONVEL
 1907
The Holliday Collection 79.301

"Mr. Bernard Boutet de Monvel is a young modernist who makes us present at the morning promenade of the beautiful Rita del Erido, impeccably driving her tandem carriage down the side streets of the avenue Champs-Elysées."[1] With these words critic Louis Vauxcelles described an almost identical version of the Holliday painting when it was exhibited at the salon of the Société Nationale in 1907. The young artist had already embarked upon a successful career painting genre scenes and elegant portraits for a fashionable and distinguished clientele. With precise draftsmanship and a refined decorative sense, Boutet de Monvel placed his subjects in their proper milieu, amid all the trappings of their station. The artist was intrigued with the world of riding and racing, and smart coaches pulled by handsome horses are common in his work.[2] Mademoiselle del Erido was an accomplished equestrienne and a well-known figure, who conducted her elegant carriages through the streets of Paris. In Boutet de Monvel's setting, she is probably parading down the Avenue Foch, off the Champs-Elysées.

Bernard Boutet de Monvel would never have classified himself as a divisionist. It is only his use of small, individual touches of paint in the Holliday picture, and select other works from the era, that places him in a pointillist context. The surface of the wide canvas is covered with small strokes of pigment applied without regard to systematic color division. A meticulous pencil underdrawing, often visible through the paint layer, establishes virtually every angle of the intricate design. It was Boutet de Monvel's standard practice to compose his pictures by a meticulous grid system,[3] and the precision of that method is reflected in the finished Holliday painting, with its stylized forms and crisp geometric shapes. Frozen into severe profile, the two figures and the two horses never budge from their strict, formal poses.

The Holliday painting differs only slightly from the other portrayal of Rita del Erido also painted in 1907. In the canvas submitted to the 1907 salon, she turns to confront the viewer, and the horses assume even more static positions, but the general arrangement of trees and background buildings is unchanged. One contemporary review concluded that the picture was intended to be a frieze,[4] not an implausible idea considering the canvas' proportions and its flat, hieratic figures. If so, the Holliday painting might have belonged to a decorative schema. The artist's daughter has also explained, however, that when Boutet de Monvel arrived at a composition he liked, he often executed several copies of it.[5] With this picture, Boutet de Monvel combines his penchant for portraiture and genre with his instinct for decoration and graphic precision.

Notes
[1] L. Vauxcelles, *Salons de 1907*, Paris, 1907, p. 25.

[2] J. Louvet, "Vie, oeuvre, et art du peintre Bernard Boutet de Monvel, 1884 [sic]-1949," Master's thesis, Paris, 1979, p. 39.

[3] Louvet, p. 75.

[4] Unidentified review, IMA library archives.

[5] Conversation with Sylvie Boutet de Monvel, Paris, October 6, 1981.

Provenance: Estate of the artist; Paris, Hôtel George V, sale, June 25, 1969, no. 43 as *La promenade en calèche*; Paris, Galerie Jean Claude Bellier, 1969; W. J. Holliday, 1969.

Literature: G. Schurr, *Les petits maîtres de la peinture, valeur de demain: 1820-1920*, Paris, 1969, p. 89 as *Promenade en calèche*; J. Louvet, "Vie, oeuvre, et art du peintre Bernard Boutet de Monvel, 1884 [sic]-1949," Master's thesis, Paris, 1979, pp. 39-40.

Bernard Boutet de Monvel, *Rita del Erido*

Louis-Gustave Cambier

Belgian 1874-1949

In the first years of his career, Louis-Gustave Cambier followed conventional artistic paths. He studied at the Brussels Academy and was a successful contributor to salons of both the Brussels Cercle Artistique and the Paris Société des Artistes Français. Through the early years of the twentieth century, Cambier painted in a traditional, academic fashion and portrayed scenes from his extensive travels in the Holy Land, Turkey, Egypt, and Italy. Around 1914, however, Cambier settled on the French Mediterranean coast, a move that decisively altered his artistic outlook. There he initiated friendships with Renoir and Signac and, under their influence, painted landscapes and village scenes with brilliant hues and Impressionist brushwork. In 1924 Cambier turned almost exclusively to portraiture and late in his career extended his interest to sculpture.

Landscape with Bathers, ca. 1915
oil on canvas, 8⅝ x 10⅝ (21.9 x 27.0)
signed lower right: Louis G. Cambier[1]
atelier stamp on reverse: Louis G. Cambier, Bruxelles
The Holliday Collection 79.235

If *Landscape with Bathers* does not exemplify a pure divisionist aesthetic, it does mark the period of the artist's closest contact with Paul Signac and his most direct exposure to color theories. At the onset of World War I, Louis Cambier moved to Cagnes, where he became friendly with Renoir and Signac and achieved a dramatic reversal in style from that of his large compositions of the Holy Land. Described by Signac as a "victim of academic thinking,"[2] Cambier rejected his formal training and turned to nature, Cézanne, and the works of the great colorists of the nineteenth century for his models. In the preface to the catalogue for Cambier's 1918 exhibition in Nice, Signac observed that the example of Seurat and Henri Edmond Cross armed Cambier with a knowledge of harmony and of the advantages of contrast.[3]

This small canvas from Cambier's sojourn in southern France is brushed with long, thick strokes of Fauve color, tempered by earth tones in the figures and tree. There is an angular articulation of the forms of the bathers and the rocky shore behind them. The setting bears a general resemblance to the coast of Antibes and is typical of the compositions selected by the many artists who frequented the Mediterranean shore. Cambier's biographer describes his works of this era with words appropriate to the Holliday canvas:

> landscapes, for the most part, inspired by the Mediterranean, where, on a screen of blue to violet, the silhouettes of pine or olive trees are outlined, where bursting forth on the horizon are orange, ochre, and veritable gold tones of the rocky hills which support that other azure sea, the sky. Sometimes, in the typical landscape, one sees the body of a beautiful nude appear, . . . blended into the ensemble, assuming the same values as the other parts of the painting.[4]

Cambier also painted more precise, tightly constructed views of the Côte d'Azur before portraiture took precedence in his career during the mid-1920s.

Notes
[1] The signature, which has suffered considerable losses, was applied above a surface varnish.

[2] P. Signac, "Préface," *Exposition de M′ et M^me Louis G. Cambier*, Nice, 1918, p. 5 (trans).

[3] Signac, p. 6.

[4] F. Hellens, *L.-G. Cambier*, Brussels, 1929, pp. 17-18 (trans).

Provenance: Purchased from the artist's widow, Madame Juliette Cambier, by Marcel Bas, Brussels, after 1949; Paris, Guy Pogu (Galerie de l'Institut); W. J. Holliday, 1965.

Exhibition: HC 1968-69.

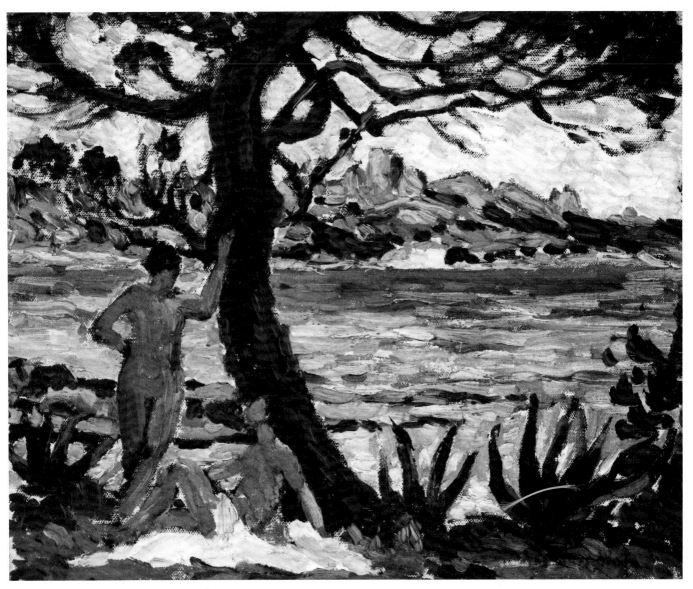

Louis-Gustave Cambier, *Landscape with Bathers*

Yvonne Canu

French, b. 1921

Yvonne Canu began art studies at the Paris Ecole des Arts Décoratifs, but was forced to postpone her career at the outbreak of World War II. She served as a military nurse in Morocco and returned to Paris at the close of the war. There she entered the artistic milieu of Montmartre and was able to fulfill her professional aspirations. Through friendships with Foujita and Elisée Maclet, Canu was introduced to *plein-air* landscape painting and the principles of Impressionism. Later, she adopted a form of Cubism under the tutelage of Ossip Zadkine. In 1955 Canu began to use the Neo-Impressionist technique that characterizes her mature works.

Evening at the Port
Soirée au port
oil on canvas, 18⅛ x 21⅝ (45.9 x 54.1)
signed lower right: Canu
numbered, inscribed, and signed on reverse: 512 Soiree au
 Port/Y. Canu
James E. Roberts Fund 80.16

The practice of divisionist painting continues today in the work of Yvonne Canu. Not unlike Marevna a generation earlier, Canu moved from an interest in Cubism to experimentation with Neo-Impressionist techniques. The origins of her divisionist work can be traced to 1955, when Canu first saw Seurat's study for *A Sunday Afternoon on the Island of La Grande Jatte* on exhibit in Paris. Since that time, she has developed a style based on pointillism and divided color.

Canu often draws upon the port of Saint-Tropez for pictures inspired by the subjects and coloration of Paul Signac. *Evening at the Port* is typical of Canu's works devoted to the activity of the wharf at Saint-Tropez. She uses rounded strokes of uniform size that conform to a consistent surface texture instead of creating their own decorative patterns. The artist's reliance on a regular dotted facture allows her to apply divisionist color principles, but in this picture, it also leads to a stiffness in the figures and a slight disproportion in scale.

The picture incorporates a wide range of colors, with frequent juxtapositions of complements in the foreground. Canu's color selection shows her flexibility in modifying local color by the effects of light and shadow: large areas of the sea are practically devoid of blue under the impact of direct sunlight. From the horizon to the highest point in the sky, Canu has orchestrated a gradual modulation from warm to cool hues, which must be one of the special pleasures of painting divisionist sunsets.

Provenance: Purchased from the artist by a private collector; New York, Sotheby's, sale, January 18, 1980, no. 34.

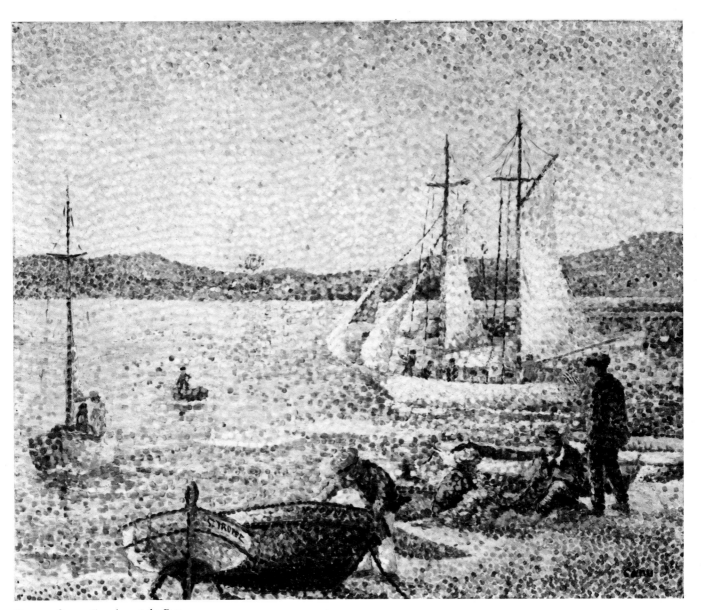

Yvonne Canu, *Evening at the Port*

Lucie Cousturier

French 1876-1925

A child during the movement's heyday in the 1880s, Lucie Cousturier first learned of Neo-Impressionism around the turn of the century, when she was a student of Paul Signac. She soon adopted divisionism and befriended several of its original advocates, including Henri Edmond Cross, Maximilien Luce, and Emile Verhaeren. Cousturier also acquired Seurat's *A Sunday Afternoon on the Island of La Grande Jatte*, which she retained in her studio until her death.

Cousturier usually painted still lifes, nudes, and landscapes of the Côte d'Azur. She applied bright pigments in rectangular strokes characteristic of Neo-Impressionism's second flowering. She exhibited her works with the Indépendants in Paris and at La Libre Esthétique in Brussels.

During the war, Cousturier lived on the French Riviera at Fréjus and befriended Senegalese soldiers billeted nearby. She later made an extended trip to West Africa and produced numerous watercolors of her excursion. During these late years, Cousturier also pursued a literary career. She published important monographs on Seurat, Signac, and Ker-Xavier Roussel; articles on Cross, Pierre Bonnard, and Maurice Denis; and accounts of contemporary African life.

Self-Portrait, ca. 1905-10
oil on panel, 13¾ x 10⁷⁄₁₆ (34.9 x 26.5)
signed lower left: Lucie Cousturier
Gift of Dr. and Mrs. M. D. Ratner 71.40.1

This modest picture holds a rather unique place in Neo-Impressionism. In an arena where the landscape predominates, the body of Neo-Impressionist painting does include some notable portraits by Signac, Cross, and Van Rysselberghe. Lucie Cousturier's likeness, however, appears to be one of a very small number of self-portraits executed by Neo-Impressionist artists.

In depicting her own likeness, Cousturier first laid in a heavy underdrawing, thoroughly establishing the geometry of the face. To the gold, rose, and orange of the flesh tones she has meticulously added the blue and violet points of divisionist shadows, bathing her neck and right cheek in cool hues.

While Cousturier has used the larger brush strokes common to the second wave of Neo-Impressionism, the daubs of impasto are smaller and more random than the square tesserae often found in her work and that of her mentor, Signac, during the first decade of the twentieth century. The backdrop, probably intended to be a tapestry or painting, exhibits a looser handling and thinner impasto, leaving much of the white ground exposed. From this paler background, the winsome image of the artist emerges to form a most agreeable composition. The angular neckline, wavy hair, and tilt of the head combine with a pleasing contrast of warm and cool tones to create a very engaging portrait.

Provenance: Paris, Galerie René Drouet; Chicago, Galleries Maurice Sternberg; Chicago, Dr. and Mrs. M. D. Ratner.

Literature: *Connoisseur,* CLXXI, 688, June 1969, p. CLXV (reprod.).

Lucie Cousturier, *Self-Portrait*

Vase of Flowers
oil on canvas, 31⅛ x 25¼ (79.1 x 64.2)
signed lower center: Lucie Cousturier
The Holliday Collection 79.238

As Neo-Impressionism entered the twentieth century, its standard-bearer, Paul Signac, frequently proclaimed the primary role of the artist's imagination in creating a work of art.[1] He acknowledged that the natural world was a fertile source of inspiration, but he maintained that truth to nature should not take precedence over formal concerns or the artist's judgment. This attitude prevails in the still life by his pupil, Lucie Cousturier. She may indeed have begun this painting by transcribing a sumptuous bouquet of tulips, roses, irises, and lilacs. In the finished work, however, it appears that harmony, composition, and texture have become her real subjects.

Flowers are the ostensible *raison d'être* for a glowing canvas of blues, yellow, and violet. Silhouetted by a white halo, they loom in the picture plane, creating an image that seems more intellectually constructed than directly observed. Occasionally the artist tints the aureole with its color complement, as in the violet touches that surround the yellow flowers. The accepted Neo-Impressionist practice of adding white to modify color values is evident in many of the thick strokes of impasto.

Cousturier has used the larger mosaic stroke typical of the movement in the early twentieth century. As the tesserae follow the different contours of the flowers, however, the surface texture sometimes competes with the subject's legibility and interrupts a clear reading of its passages. While the oval format is unusual for Neo-Impressionism, Cousturier has attempted to balance the composition by adding several horizontal planes at its base to offset the volume of the bouquet.

Note
[1] Rewald, Signac Diary, III, p. 80.

Provenance: New York, Hammer Galleries; W. J. Holliday, 1961.

Exhibitions: Paris, *66ᵉ Exposition de la Société des Artistes Indépendants, Hommage à Paul Signac et ses amis*, April 15-May 8, 1955, no. 14 as *Fleurs*; New York, Hammer Galleries, *Seurat and His Friends*, October 30-November 17, 1962, no. 12; HC 1968-69; HC 1969-70.

Lucie Cousturier, *Vase of Flowers*

Henri Delavallée

French 1862-1943

A brilliant young scholar, Henri Delavallée enrolled in both the Sorbonne and the Paris Ecole des Beaux-Arts in 1879. He studied with academicians Henri Lehmann, Luc-Olivier Merson, and Ernest Hébert but was drawn to the works of Millet, Corot, and Courbet. He adopted both Millet's favored pastel medium and his peasant themes.

Delavallée visited Pont-Aven annually beginning in 1881. Inspired by Brittany's rugged landscape and colorful folklife, he was among the first to depict these subjects. While Delavallée sometimes painted in the style of the Pont-Aven School, he also experimented with Neo-Impressionism. In the Indépendants salon of 1888, he exhibited canvases executed in a divisionist technique, which he utilized through 1890. Delavallée also sojourned in Millet's native Londemer countryside during 1889 and executed a series of engravings unrelated to either Neo-Impressionism or the Pont-Aven School.

Sometime in the early 1890s, Delavallée moved to Constantinople, where he lived for ten years. While in Turkey, he relied upon the local landscape and laborers for his subjects. His works were well received and he earned commissions from Turkish officials. Delavallée is also credited with introducing the cinematography process of his friends, the Lumière brothers, to Turkey. Delavallée returned to France shortly after the turn of the century. He divided his time between his Oise and Brittany properties and once again painted according to divisionist principles.

During his lifetime, Delavallée exhibited regularly with the Société Nationale des Beaux-Arts and was actively supported by Durand-Ruel and Vollard in Paris. He enjoyed the first success of his career in an 1890 exhibition of engravings at Durand-Ruel and in 1941 was the subject of a retrospective at Galerie Saluden in Quimper.

The Road in Sunlight, ca. 1887
La rue en soleil
oil on canvas, 18 x 21¾ (45.7 x 55.2)
signed lower left: Delavallée
inscribed on left strainer bar: Delavallée Laudes Paysage
colorman stamp on reverse: Paul Foinet, Paris
The Holliday Collection 79.241

While Henri Delavallée is chiefly associated with Brittany, his work is distinguished by a number of paintings that show his sympathy with the tenets of Neo-Impressionism. Most of Delavallée's paintings and prints are devoted to Breton subjects, and they often display the flat planes and shallow perspective common to the Pont-Aven School. Delavallée had met Gauguin at Pont-Aven in 1886 and was familiar with the coterie of artists active there during the pivotal years of the late 1880s. During 1886 and 1887, many of these progressive young painters, from Gauguin to Bernard to Anquetin, were experimenting with pointillism and divided color. It was at this time that Delavallée also elected to paint divisionist pictures, though his exposure to the movement reportedly came from a meeting with Camille Pissarro near Fontainebleau in 1887. From 1887 to 1890, he painted landscapes and figural pieces conceived according to Neo-Impressionist principles.

The Road in Sunlight is a fine example of his foray into Neo-Impressionism. With adept pointillist execution, Delavallée knits small dots of pigment into the subtle variations of violet, green, and orange that compose the landscape's harmonies. His treatment of the grassy areas demonstrates the standard method of applying several gradations of green for the local color of the grass, with flecks of yellow-orange to indicate the effect of bright sunlight. The shadow that falls across the road has cool violet tones punctuated by points of orange and green reflected from the local colors of adjacent surfaces. Delavallée apparently chose another Breton subject for this divisionist effort, since the glimpse of the sea at the left edge of the horizon indicates a coastal locale, and the architecture of the stone house suggests that the painting's setting is Brittany.

Previous references to the Holliday canvas have dated it ca. 1907, assigning the picture to a second Neo-Impressionist phase in Delavallée's career after his return from a ten-year residency in Turkey. Due to their scarcity, it is difficult to establish a standard of comparison for his later divisionist works. On the basis of its similarity to two dated canvases from the earlier period, however, *The Road in Sunlight* should actually be dated around 1887. The two other landscapes are distinctly different from one another, but each offers elements linking *The Road in Sunlight* to the late 1880s. *Little Yard with Rabbits*, 1887 (Private Collection, France) exhibits a less rigorous pointillism but projects a naturalism and a three-dimensional sense also present in the Holliday canvas. *Farmyard* (Samuel Josefowitz Collection, Lausanne), one of Delavallée's major pieces of 1887, is close to the Holliday landscape in many aspects of technique and sensibility. In both paintings, the buildings are precisely constructed to conform to a strict geometric sense. Though their dominant tonalities differ, both pictures rely on harmonies responding to the same rose and orange hues. *The Road in Sunlight* has a thorough underdrawing, apparent through an infra-red lens and, in some areas, visible to the naked eye. Even in a reproduction, it is possible to detect that fine line which also traces the composition of *Farmyard*. The artist's attention to shadow, and the role its shape and color play in the landscape, is evident in both scenes. Each canvas also reflects Delavallée's sensitivity to the varied silhouettes of the landscape, as the gentle curves of natural forms interact with rigid architectural shapes. *The Road in Sunlight* is both an early and an adept divisionist work by an artist whose brief but strong Neo-Impressionist affiliation resulted in the most distinctive canvases of his career.

Provenance: Paris, art market; London, Arthur Tooth and Sons, Ltd., early 1960s; London, Lord Runcimen, 1963; W. J. Holliday (through Arthur Tooth and Sons, Ltd.), 1965.

Exhibitions: London, Arthur Tooth and Sons, Ltd., *Paris-Londres*, April 30-May 25, 1963, no. 19; New York, The Solomon R. Guggenheim Museum, *Neo-Impressionism*, February 9-April 7, 1968, no. 111 (reprod.); HC 1968-69; HC 1969-70.

Literature: J. Sutter, ed., *The Neo-Impressionists*, Neuchâtel, London, and Greenwich, Conn., 1970, p. 171 (reprod.); *Reader's Digest*, June 1980, back cover (detail reprod.).

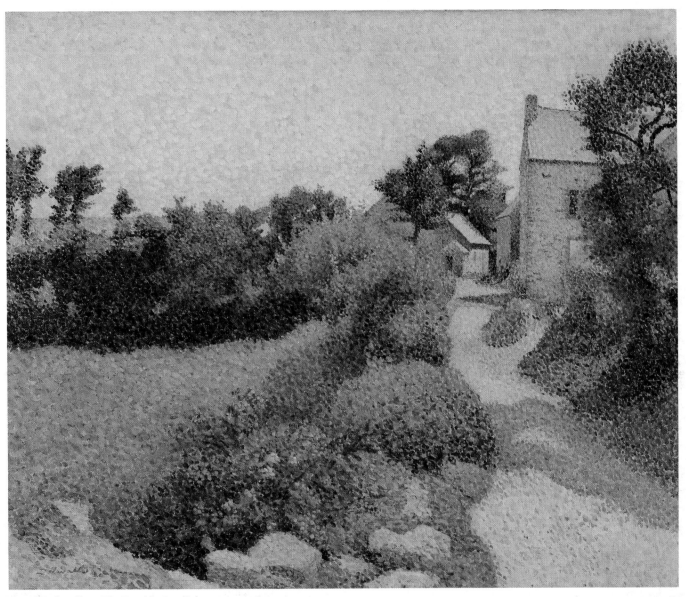

Henri Delavallée, *The Road in Sunlight*

Maurice Denis
French 1870-1943

Maurice Denis was a distinguished aesthetician and art critic as well as a painter and decorative artist. He began art studies in the mid-1880s while a student of classical literature at the Lycée Condorcet in Paris. In 1888 he attended the Académie Julian and the following year joined classmates Paul Sérusier, Paul Ranson, Pierre Bonnard, and Edouard Vuillard in the formation of the Nabis. Brought together by an interest in abstraction and in the spiritual rather than the physical realities of life and nature, the Nabis distorted, but never relinquished, representational subjects. Denis' works are characterized by bold, flat forms arranged with an acute sense of decorative patterning, and they often portray religious themes, a manifestation of his devout Catholicism. Like his colleagues, he also designed settings and costumes for Symbolist theater productions, illustrated works by progressive writers, and executed large-scale mural projects.

Denis emerged as the Nabis' chief spokesman. He contributed numerous theoretical articles to Symbolist journals but is especially renowned for his first piece, "The Definition of Neo-Traditionalism," published in *Art et Critique* in 1890. In its famous opening remark, Denis not only articulated the Nabi disdain for academic imitation of nature, but also unwittingly provided a motto for future abstractionists: "It is well to remember that a picture—before being a battle horse, a nude woman, or some anecdote—is essentially a flat surface covered with colors assembled in a certain order."

In 1891 Denis began showing with the Indépendants and organized the first Nabi exhibition in his hometown of Saint-Germain-en-Laye. Over the next five years, the dealer Le Barc de Boutteville actively promoted their works in his Paris gallery. In contemporary writings, Denis was consistently singled out for praise. After 1892 his works were also exhibited outside France, and he was included in the salons of Les Vingt and La Libre Esthétique.

After the turn of the century, the Nabis no longer functioned as a cohesive group, but Denis continued his multifaceted activities. He published articles in Catholic journals as well as reviews in art periodicals and provided catalogue texts for exhibitions by his colleagues. His decorative projects of this later period include murals, stained glass windows, mosaics, and tapestries. Denis' post-Nabi paintings reveal a veneration for the classicizing style of the Italian Renaissance. They were seen annually in group shows throughout Europe, and, beginning in 1904, in several one-man shows in Paris. From 1908 to 1921, Denis taught at the Académie Ranson and in 1919 founded the Ateliers d'Art Sacré with Georges Desvallières. The Musée du Prieuré, located in Denis' home in Saint-Germain-en-Laye, houses a major collection of his works.

Fountain at the Villa Medici, 1904
oil on layered cardboard, 10⅛ x 14⁹⁄₁₆ (25.7 x 37.0), irregular
signed with monogram and dated lower right:
The Holliday Collection 79.327

Maurice Denis painted this small landscape in 1904, during his third trip to Italy. He spent February of that year in Rome with two friends from Parisian literary circles, André Gide and Adrien Mithouard. Denis' previous Italian tours had profoundly influenced him, but his admiration for classical art and the Renaissance masters is not apparent in the Holliday picture. It is, rather, an informal sketch of one of the city's most picturesque views, painted atop the Pincian Hill at the Villa Medici, home of the French Academy in Rome. A contemporary critic quoted Denis' feeling for the site: "If only you knew, he exclaims, how beautiful those evenings on the Pincio are, how conducive to reflection!"[1]

The panel displays an interest in decorative pattern that is not unexpected in the work of Maurice Denis. His treatment of the upper portion of the scene, with its large arch surrounded by short, patchy strokes, is not, however, just artistic invention. Comparison with a contemporary photograph (fig. 1) proves Denis' picture to be based on an accurate topographical view. The broad touches of orange, green, and brown pigment are actually the dense foliage of adjacent trees, trimmed to form a thick bower arching over the fountain. The arc of the leaves echoes the silhouette of St. Peter's Basilica, visible at the upper right of the composition.

Denis' view of the fountain emphasizes geometry and surface pattern. The circular form of the basin is reflected in the deep arch of the trees, and Denis also draws upon the octagonal base of the fountain and the low wall behind it to fortify the composition's structure. His red crayon underdrawing is often detectable. Denis' palette is based on blue, yellow-orange, and earth tones, which he does not apply according to divisionist principles. While the artist did borrow the pointillist technique of the Neo-Impressionists for a brief period around 1891, it would be misleading to associate that handling with the treatment of the trees in the Holliday panel. Denis' facture,

Fig. 1 Fountain at the Villa Medici, Rome

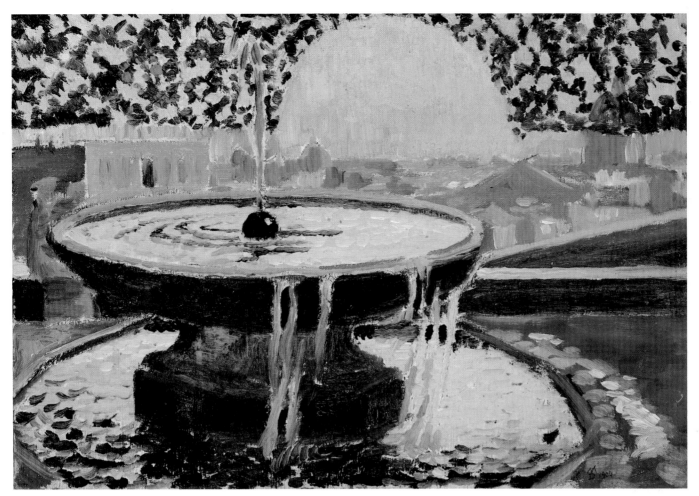

Maurice Denis, *Fountain at the Villa Medici*

employed for its decorative and descriptive potential, is closer to the colorful patterns of Edouard Vuillard, his fellow Nabi, than to the divided brush strokes of Neo-Impressionism.

Denis painted several other Roman scenes during his 1904 trip; and upon his return to Paris, many of them were featured in his first one-man show at the Galerie Druet in late 1904. *Studies of Italy* met with warm critical reaction. André Gide wrote the catalogue preface, referring to the pictures as fleeting impressions of the traveler, recorded without effort as notations for future paintings.[2] Three views of the basin at the Villa Medici at different times of day were included in the exhibition, but it is not clear that the Holliday panel was one of them. A larger version of the same subject is in the collection of the Musée Toulouse-Lautrec, Albi.

Maurice Denis was not the first artist to paint the Villa Medici motif, and there is no doubt that Denis was aware of his predecessors. During his 1898 tour of Italy, he wrote to a friend about Gide's efforts to introduce him to Rome, "It was evening. He directed me very near to the Villa Medici, in front of that basin surrounded by trees which Corot has painted."[3] Corot's painting, *Rome, the Fountain of the French Academy* (Hugh Lane Municipal Gallery of Modern Art, Dublin), is presented from a more distant vantage point, with the arch of the trees again framing the dome of St. Peter's. Another Post-Impressionist visitor to Rome also drew the vista from the Pincian Hill. Two drawings in the Bibliothèque Royale, Brussels (misidentified as London park scenes), and one sketch (art market, London) show that Théo van Rysselberghe was also attracted to the picturesque Roman site.

Notes
[1] L. Vauxcelles, "Notes D'Art, Exposition Maurice Denis," *Le Gil Blas*, November 23, 1904 (trans).

[2] A. Gide, "Préface," *Exposition Maurice Denis, Etudes d'Italie 1898-1904*, November 22-December, 1904 (trans).

[3] Letter from Denis to Edouard Vuillard, quoted in *Maurice Denis*, Paris, Orangerie des Tuileries, 1970, p. 63, no. 175 (trans).

Provenance: Paris, Galerie XVIII; W. J. Holliday, 1970.

René Durey
French 1890-1959

René Durey had no formal training and stole free moments from his business career to paint. In 1912 he began contributing to the Indépendants' salons and the following year to the Salon d'Automne. As his choice of exhibition forums indicates, Durey founded his art on progressive trends. His landscapes and still lifes reveal the dual influence of Cézanne and of the Fauves. In 1916, while convalescing in Saint-Tropez from the illness that released him from military service, Durey met Paul Signac. With the older painter's encouragement, Durey abandoned his commercial profession for a painting career. Although always in contact with leading artists in Paris and in the Midi, Durey worked independently.

The Esterel Mountains, Le Trayas, 1913
L'Esterel, Le Trayas
oil on canvas, 14⅞ x 18 (37.8 x 45.7)
signed and dated lower left: R. Durey 13
inscribed on upper strainer bar: L'Esterel (le Trayas)/ vernis/
 Gibert 53/ancienne collect [sic] de Dr. Depaignes 12[1]
The Holliday Collection 79.244

Durey's landscape is set on the Mediterranean Sea at the little town of Le Trayas, southwest of Cannes. Taking his cue from the vivid natural colors of the Esterel mountain range, as well as from the example of the Fauves, Durey has produced a vibrant canvas based upon a surprisingly uncomplicated palette. The famous fiery-colored rocks are composed of shades of orange, which Durey cools with the deep blue tones of the sea. The distant mountain peaks are divided into two angular planes, with acid green hues predominating on the left and violet on the right. Durey transcribes the distinct sculptural quality of the mountains, adding his powerful color scheme to a firm sense of volume and decorative pattern.

The Esterel Mountains, Le Trayas was a promising debut for a young artist who had begun to paint seriously only two years earlier. Durey chose to send this picture, under the title *Mediterranean Landscape,* to the big Indépendants' retrospective in 1926. The seascape was also included in Durey's Paris retrospective in 1960, where it represented the earliest years of his career.

Note

[1] The inscription on the strainer bar appears to be in the artist's hand, on the basis of its similarity to the writing on the Indépendants' sticker also on the back of the painting. Its reference to a former owner of the picture, a Dr. Depaignes, suggests that the painting was returned to the artist, since it belonged to Durey's estate at the time of his retrospective in 1960.

Provenance: Dr. Depaignes (?); estate of the artist; . . . Paris, Galerie Jean Claude Bellier; W. J. Holliday, 1965.

Exhibitions: Paris, Grand Palais, *Trente ans d'art indépendant: rétrospective de la Société des Artistes Indépendants,* February 20-March 21, 1926, no. 2757 as *Paysage méditerranéen;* Paris, Musée Galliera, *René Durey,* January 22-February 22, 1960, no. 2; HC 1968-69.

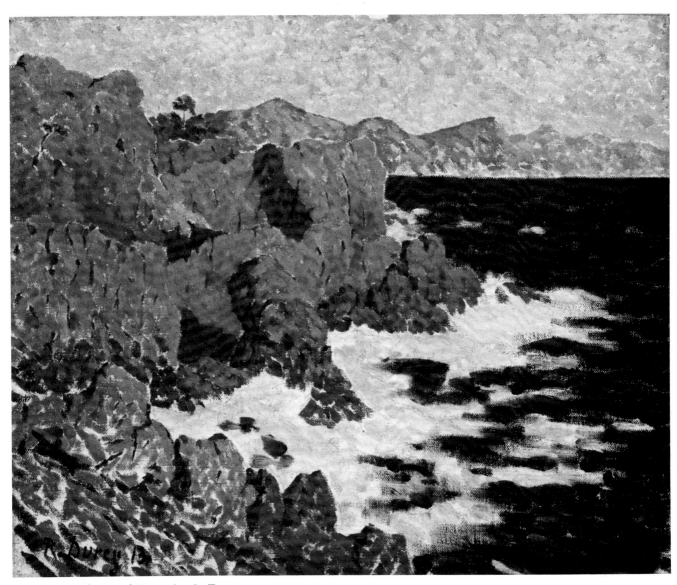

René Durey, *The Esterel Mountains, Le Trayas*

Jean vanden Eeckhoudt

Belgian 1875-1946

The grandson of genre painter François Verheyden and the nephew of widely recognized artist Isidore Verheyden, Jean vanden Eeckhoudt first received art instruction in his uncle's atelier. Although Verheyden stressed conservative values, he also provided his nephew with an important link to avant-garde developments in Belgium. From 1885 to 1888, Verheyden was a member of Les Vingt and through him Vanden Eeckhoudt came to know Octave Maus, Georges Lemmen, and Théo van Rysselberghe.

In 1892 Vanden Eeckhoudt debuted at the Ghent salon, where he exhibited regularly thereafter. Critical and public response to his early works was immediately favorable. Until shortly after the turn of the century, Vanden Eeckhoudt produced portraits and still lifes that blended the legacy of Verheyden with innovative, bright colors and painterly strokes.

From 1904 through 1914, Vanden Eeckhoudt wintered on the Mediterranean coast at Menton. Stimulated by the shimmering effects of the intense Midi sunlight, he began using luminous tones applied in a divisionist manner. Vanden Eeckhoudt experimented with this style until 1910, when he turned to landscapes of the Midi depicted in the flat, decoratively simplified forms and sparkling colors of the Fauves. During this period, he exhibited frequently with La Libre Esthétique.

In 1915 Vanden Eeckhoudt and his family settled in Roquebrune, on the French Riviera. There he waited out World War I in the company of an intellectual circle that included Lytton Strachey and Roger Fry. Their discussions had a profound effect on Vanden Eeckhoudt: he gained insight into the Cubism of Picasso and developed a great respect for Cézanne. In the early 1920s, this admiration became apparent in works heralding his mature style. Sometimes characterized by a severity of form and color, these paintings are tightly structured with a sense of volume indebted to Cézanne. In 1925 Vanden Eeckhoudt burned the vast majority of his earlier works, firmly convinced that they were of little value in light of his new style.[1]

Vanden Eeckhoudt returned to Belgium in 1936, residing in Bourgeois-Rixensart. There he kept abreast of contemporary trends through steady correspondence with his French and Belgian colleagues; and he continued exhibiting his works in Paris and Brussels galleries, as he had done since the 1920s.

Under the Orange Tree or ***The Terrace at Les Pâquerettes,*** 1908
Sous l'oranger or *La terrasse des Pâquerettes*
oil on canvas, 39¼ x 31¾ (99.7 x 80.7)
signature removed when canvas was cut down
The Holliday Collection 79.245

When Jean vanden Eeckhoudt left Belgium to winter in southern France, he produced luminous garden scenes such as *Under the Orange Tree*. From 1904 until the outbreak of World War I, the artist and his family spent the colder months at Menton, where the brilliant Mediterranean sunshine spurred Vanden Eeckhoudt to paint vibrant canvases animated by the play of light. As the artist wrote to Octave Maus in 1909, "We live in a villa surrounded by the ideal garden, the sea and an entire mountain, and the glory of the sun in our pine trees and cypresses is incomparable."[2]

Vanden Eeckhoudt's landscape is set in the garden outside Les Pâquerettes, his Menton home. The canvas was painted in 1908, as indicated by a dated study in the collection of the artist's family.[3] The standing figure is the artist's wife, and the model for the little girl is their daughter, who became the painter Madame Zoum Walter. Before selling this picture in 1966, Madame Walter removed damaged portions of the canvas by cutting it down on all four sides. The biggest alteration occurred along the right margin, where the signature and another orange tree were eliminated. An illustration in an early text on Belgian painting reproduced the picture in its entirety, revealing how the additional tree enhanced the balance and depth of the composition.[4]

Vanden Eeckhoudt's tendency to duplicate and transfer titles complicates the documentation of his oeuvre, and references to the Holliday picture have not been consistent.[5] It is not clear if *Under the Orange Tree,* the listing in the 1909 catalogue for La Libre Esthétique, refers to the Holliday painting or to a similar composition of the same name, dated 1907, in the Musée d'Ixelles, Brussels. Given the later date and larger size of the Holliday canvas, it is more likely that the Indianapolis painting was featured in the exhibition. The other title, *The Terrace at Les Pâquerettes,* derives from the name assigned to its preliminary sketch. It also differentiates this canvas from the picture in the Musée d'Ixelles.

The Holliday painting shows Vanden Eeckhoudt's assumption of an Impressionist palette, as blue and purple tint the shadows and high-key hues compose the three figures. The woman on the left provides a clear demonstration of the impact of dazzling light, as the local color of her skirt is virtually bleached by the intense sunshine. Vanden Eeckhoudt also adopts the separate strokes of divisionism, constructing his composition with short, loose stripes of color. The light tonality of the terrace floor is heightened by broader areas of white ground left exposed in the foreground.

The broken bands of vibrant color in *Under the Orange Tree* represent Vanden Eeckhoudt's closest approximation to Neo-Impressionism. His works from this era have been classified as divisionist, but here the term becomes a relative one, inspired in part by the obvious contrast with the solid tones and flatter brushwork typical of the later works for which Vanden Eeckhoudt is best known. By 1910 he had abandoned the fragmented application of paint. The figures of the Holliday canvas

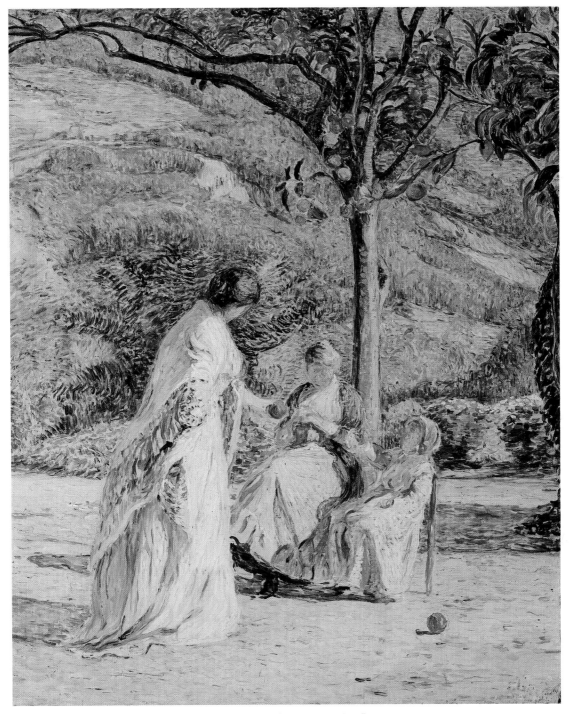

Jean vanden Eeckhoudt, *Under the Orange Tree* or *The Terrace at Les Pâquerettes*

already hint at the simplification of form that would assume increasing importance in his work. Since the artist destroyed the majority of his early paintings in 1925, this canvas is a particularly rare example of his divisionist phase.

Notes

[1] Letter from the artist's son, Jean-Pierre vanden Eeckhoudt, to E. Lee, August 11, 1981.

[2] Letter from J. vanden Eeckhoudt to O. Maus, Fonds M. O. Maus, Archives de l'Art contemporain, Musées Royaux des Beaux-Arts de Belgique, Brussels; quoted in *Hommage à Jean Vanden Eeckhoudt*, Brussels, Musée Royaux des Beaux-Arts de Belgique, 1973, p. 6 (trans).

[3] References to this study, as well as details about the models and alteration to the canvas, were provided by J.-P. vanden Eeckhoudt in a letter to T. Smith, June 3, 1981.

[4] See P. Colin, *La peinture belge depuis 1830*, Brussels, 1930, p. 342.

[5] Letter from J.-P. vanden Eeckhoudt to E. Lee, August 11, 1981; see literature section for this painting's documentation.

Provenance: Purchased from the artist's daughter, Madame Zoum Walter, Paris, by Guy Pogu (Galerie de l'Institut), Paris; W. J. Holliday, 1966.

Exhibitions: Probably Brussels, *16ᵉ Exposition de la Libre Esthétique*, March 7-April 12, 1909, no. 257 as *Sous l'oranger;* HC 1968-69; HC 1969-70.

Literature: P. Colin, *La peinture belge depuis 1830*, Brussels, 1930, p. 342 (reprod.) as *Au jardin;* P. Lambotte, *Jean vanden Eeckhoudt*, Brussels, 1934, no. 29 as *Sous l'oranger;* probably M. O. Maus, *Trentes années de lutte pour l'art, 1884-1914*, Brussels, 1926, rept., 1980, p. 400.

Edouard Fer
French 1887-1959

Edouard Fer received his earliest art training at schools of the decorative arts in Nice and Paris before enrolling at the Ecole des Beaux-Arts in Paris around 1905. He knew Paul Signac and was executing divisionist works by 1912. In that year, he earned his first award at the Salon des Artistes Français. Active in the artistic life of his native city of Nice, Fer designed in the early 1920s the monumental painting that adorns the municipal library. Mural decorations continued as an important part of his career, and in 1928 he accepted a commission to paint the canvas representing Nice for the luxury liner *Ile-de-France*. Fer was also an accomplished watercolorist and engraver. Landscapes and figural pieces were his principal subjects.

In 1925 his exhibition activity extended to the Indépendants in Paris. Since his death, Fer has been featured in solo shows at the Galerie Georges Barry, Saint-Tropez, in 1973 and the Galerie des Ponchettes, Nice, in 1975.

Today Fer is more widely known for his writing than for his painting. He produced two articles on the scientific principles of Neo-Impressionism and published a treatise relating the science of optics and physics to the handling of light and color.

Bellerive, Switzerland, 1913
Bellerive, Suisse
oil on embossed cardboard, 8½ x 6¼ (21.6 x 15.9)
inscribed, dated, and signed on reverse: Bellerive Suisse/
 29 mai 1913/E.F.
colorman label on reverse: George Rowney & Co.
The Holliday Collection 79.246

The Red Tree, 1913
L'arbre rouge
oil on canvasboard, 6¼ x 8⅝ (15.9 x 21.9)
signed lower left: E Fer
signed and inscribed on reverse: E. Fer/L'arbre Rouge/ Geneve
inscribed, dated, and signed on reverse: ... rouge/Jardin Mon
 Repos./Geneve Mai 1913./E. Fer.
colorman label on reverse: Sennelier, Paris
The Holliday Collection 79.326

These landscapes by Edouard Fer offer the collection's only opportunity to compare one artist's handling of two divisionist works separated by only a brief period of time. Painted in the vicinity of Geneva within days of each other during May 1913, Fer's small paintings illustrate his variations on the pointillist technique. The blue, green, and purple hues of *Bellerive, Switzerland* show the artist working within a restricted, cool range of colors, while *The Red Tree* presents a vibrant palette that draws upon the full scope of the chromatic circle. Its pungent colors are applied in a dense network of whipped strokes, with an occasional flourish of thick impasto. The Bellerive boating scene displays a thinner paint layer, with broad areas of the white cardboard left exposed. Its short, less varied strokes create a surface pattern more cohesive than that of *The Red Tree*. The small format of the two paintings is standard for Fer's works in oil.

When Fer painted these pictures in 1913, he had already demonstrated his adherence to divisionist principles. One year earlier, Guillaume Apollinaire had noted in *Mercure de France* that this young artist had dared to submit a Neo-Impressionist work to the Salon des Artistes Français instead of sending it to the Indépendants, the more progressive forum where the Neo-Impressionists usually exhibited. Describing Fer's canvas, Apollinaire remarked, "It was not at all one of those pointillist pictures where the artist streaks the canvas in order to give it a hazy, poetic appearance; it was a veritable divisionist painting where the colors kept all their force and all their purity."[1]

Fer's interest in divisionist painting procedures was expressed in his writing. Four years after he painted these landscapes, Fer wrote two articles entitled "The Scientific Principles of Neo-Impressionism."[2] The chromatic circles that Fer devised for his treatise on color, *Solfège de la couleur,* published late in his career, were used by William Homer to describe Seurat's colors in his book *Seurat and the Science of Painting.*[3]

Notes
[1] G. Apollinaire, *Mercure de France*, June 1, 1912; quoted in *Edouard Fer 1887-1959*, Nice, Galerie des Ponchettes, 1975, unpaginated (trans).

[2] E. Fer, "Les Principes scientifiques du néo-impressionnisme," *Pages d'Art*, December 1917 and May 1918.

[3] E. Fer, *Solfège de la couleur*, Paris, 1954; see W. Homer, *Seurat and the Science of Painting*, Cambridge, Mass., 1970, p. 261, note 24.

Bellerive, Switzerland
Provenance: Paris, Galerie Urban; W. J. Holliday, 1965.
Exhibition: HC 1968-69.

The Red Tree
Provenance: Family of the artist; . . . Paris, Galerie Urban; W. J. Holliday, 1970.
Exhibition: Nice, Galerie Henri-Gaffié, 1945.

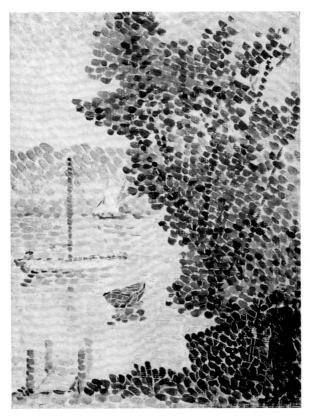

Edouard Fer, *Bellerive, Switzerland*

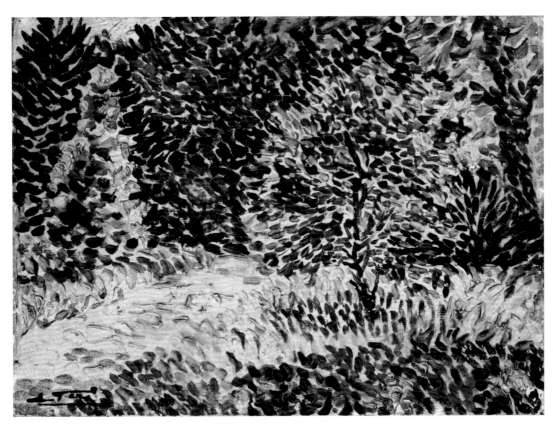

Edouard Fer, *The Red Tree*

Louis Gaidan
French 1847-1925

Louis Gaidan began to devote himself to painting around 1863. He painted for pleasure only and did not try to support himself by his art. Gaidan served briefly in the 1870 Franco-Prussian war and was in public service again when, in 1884, he traveled to North Africa for the Marseilles Department of Historic Monuments. He studied with C. F. Jalabert and P. Bertrand and debuted at the Salon des Artistes Français in 1887. Gaidan was attracted to the luminous landscapes of southern France and the works of the Impressionist masters. He worked primarily in Nîmes, Hyères, and the Carqueiranne. While he reportedly met Signac at Saint-Tropez in 1911, Gaidan had apparently already begun to paint with separate touches of color.

Villa in the Midi
oil on canvas, 21¼ x 28⅝ (54.0 x 72.7)
signed lower right: L. Gaidan
colorman stamp on reverse: Louis Etienne, Toulon
sticker on right stretcher bar: crossed anchor/caduceus
The Holliday Collection 79.319

Louis Gaidan was a contemporary of the first generation of Neo-Impressionists. Though he developed a pointillist style inspired by their technique, he remains an obscure figure, not generally associated with this phase of Post-Impressionist painting. Gaidan was a native of Nîmes and usually painted subjects of southern France. For the colorful setting of this villa, he draws upon a wide spectrum of hues but stipples them over a ground layer of dull gray. There is little systematic division of color, and many passages are confined to small touches of the same hue. Gaidan's solid composition rests upon a firm linear construction and the repetition of uniform, rounded strokes.

Provenance: London, Kaplan Gallery; W. J. Holliday, 1968.

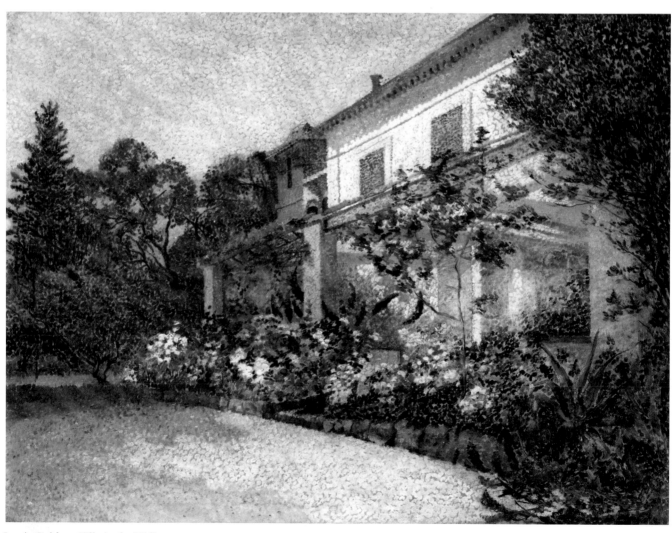

Louis Gaidan, *Villa in the Midi*

Arielle Gaury
French, 20th century

View of Monte Carlo
oil on canvas, 18¹⁄₁₆ x 21⅝ (45.9 x 54.9)
signed lower right: A. Gaury
The Holliday Collection 79.247

Arielle Gaury's *View of Monte Carlo* is another indication that in the twentieth century, Neo-Impressionism's hardiest legacy was rooted in the Mediterranean. With this glimpse of the famous Garnier casino presiding over the coastline, the artist has painted a landscape that shows the enduring influence of Paul Signac. Though there is no evidence that Gaury actually studied with Signac, her picture shows a familiarity with the rectangular-shaped strokes he adopted after 1900. Some precision and subtlety in drawing are sacrificed in her use of this larger, more cumbersome module of brushwork, but Gaury compensates by arranging the strokes into a firm compositional structure. Principles of contrast are not emphasized: the coloring revolves around shifts in green, yellow, and blue pigments, with occasional accents of rose.

Provenance: Purchased from the artist by La Boutique d'Art, Nice; New York, Hammer Galleries, 1965; W. J. Holliday, 1965.

Exhibition: HC 1968-69.

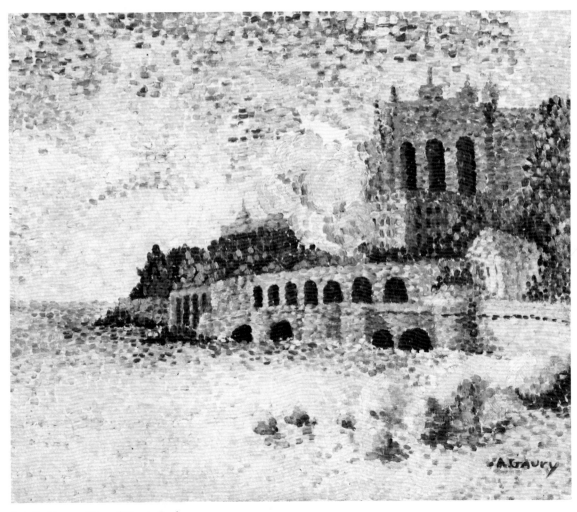

Arielle Gaury, *View of Monte Carlo*

Paul-Elie Gernez
French 1888-1948

Paul-Elie Gernez pursued formal art training only sporadically and was essentially self-taught. At the age of twelve, he began studying in Valenciennes, but left three years later for an apprenticeship in a china factory. Despite his youth, Gernez made a small reputation for himself through local portrait commissions. By 1905 he was spending most of his days in the Valenciennes museum copying Rubens, Watteau, and the Dutch masters. In 1906 Gernez studied briefly at the Ecole des Beaux-Arts in Paris but found more appealing teachers in the Louvre's collection of Flemish and Dutch Old Masters. He remained in Paris until called into military service in 1908.

When illness left him unfit for duty, Gernez returned to Valenciennes and was given a teaching post at the local lycée. In 1911 his growing reputation earned him a professorship in drawing at Honfleur, where he remained until his death. The move to Normandy marked a turning point in Gernez's career, for he abandoned the Old Masters in favor of more innovative trends. Shortly after his arrival in Honfleur, he began painting *plein-air* seascapes and beach scenes following the examples of Boudin and Jongkind. In addition, he met Félix Vallotton, who familiarized him with the works of Cézanne. Until the early 1920s, Gernez experimented with Cézanne's technique as well as with the violent contrasts of Fauvism and the taut angularity and structure of Cubism. His mature work includes landscapes, nudes, and floral arrangements.

After 1919 Gernez exhibited nearly every year in Paris, with the Indépendants and the Salon d'Automne as well as in one-man shows.

Landscape, 1912
oil on panel, 16⅛ x 12⁷⁄₁₆ (41.0 x 31.6)
signed and dated upper right: P. E. Gernez/1912
colorman stamp on reverse: crossed anchor/caduceus
The Holliday Collection 79.249

At his home on the Channel coast, Paul-Elie Gernez painted in a rich variety of styles. He occasionally produced lyrical landscapes characterized by soft color and fluid line. Sometimes he treated the human figure as a ponderous monumental form and rendered it in faceted planes borrowed from Cubism; in other works, he approached the nude as a sensuous odalisque surrounded by flowers and seashells. Despite such diversity in Gernez's career, the Holliday panel is distinctly different from those later paintings and pastels for which he is best known.

The Holliday landscape is an early work dating from 1912, shortly after Gernez moved to Honfleur. Instead of using the limpid tones usually associated with the North coast, Gernez turned to brilliant hues for this composition. Gernez's friend Félix Vallotton introduced him to the work of Seurat, but this landscape derives more from the pungent colors and rectangular strokes of Neo-Impressionism's second phase. Gernez does not attempt to simulate the shimmer of natural light; he revels in the vibrant effects unleashed by his bold juxtapositions of short patches of brightly colored impasto on a white ground. In spite of the cooler hues that differentiate the play of light and shadow on the grass, color is used less for naturalistic purposes than for its abstract potential. Gernez applies his dense strokes in a consistent downward direction, creating a thatched surface texture that the eye easily transforms from the image of trees in a sunny field into a flat, decorative arrangement of tone and color.

Provenance: Paris, Galerie du Palais Bourbon; W. J. Holliday, 1965.
Exhibitions: HC 1968-69; HC 1969-70.

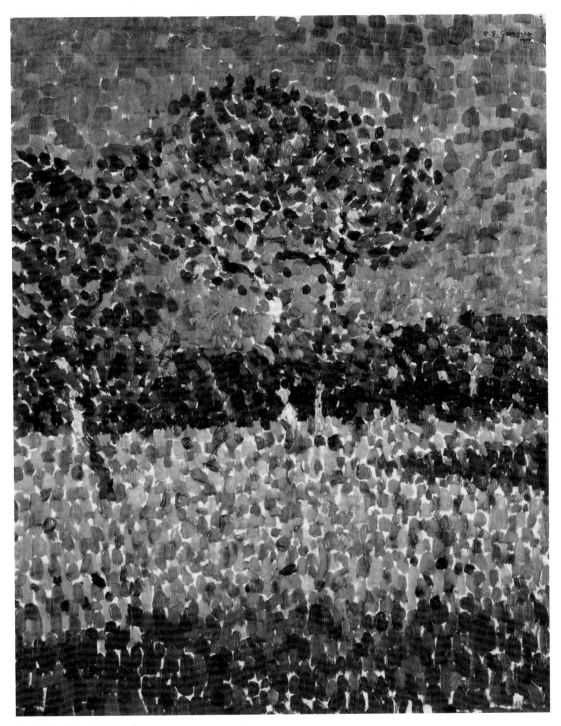

Paul-Elie Gernez, *Landscape*

Germain Guibal

French, late 19th-early 20th century

Sunshine Under the Trees, 1913
Soleil sous les arbres
oil on canvas, 28⁹/₁₆ x 36 (72.6 x 91.5)
signed and dated lower left: Germain Guibal 1913
inscribed on label on reverse: Germain Guibal/29 rue de
 Sèvres Paris/no. 1/Soleil sous les arbres
The Holliday Collection 79.250

Virtually no documentation exists on landscapist Germain Guibal
beyond the record of his participation at the Société des Artistes
Indépendants. At their salon of 1914, he exhibited this pic-
ture, which bears a title that manifests his Impressionist ap-
proach. *Sunshine Under the Trees* is enlivened by the play of
sunlight as it filters through the trees and falls in random
patches on the ground. With a large, relaxed pointillist tech-
nique, Guibal transcribes the infinite changes from yellow and
rose to blue, green, and violet that take place across the broad
expanse of grass. He lavishes thick impasto on the foliage di-
rectly touched by the sun's rays, but lapses into a thin, flat
handling for the trees and buildings.

Provenance: Paris, Galerie du Palais Bourbon; W. J. Holliday, 1967.

Exhibitions: Paris, Champs de Mars, *30ᵉ Exposition de la Société des Artistes Indé-
pendants,* March 1-April 30, 1914, no. 1470; HC 1968-69; HC 1969-70.

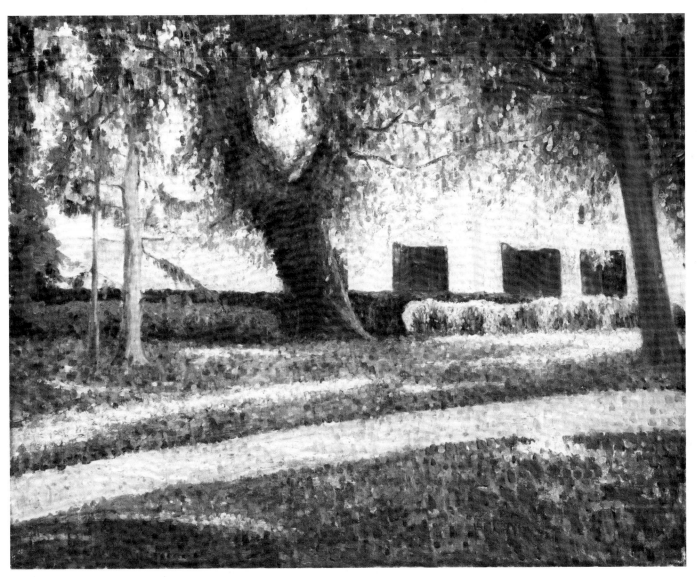

Germain Guibal, *Sunshine Under the Trees*

Ferdinand Hart Nibbrig

Dutch 1866-1915

Ferdinand Hart Nibbrig produced a formidable body of works, but is little known outside the Netherlands. His career began with a traditional education, as he studied first in Amsterdam with Johan Adolph Rust and August Allebé and then in Paris during the late 1880s with Fernand Cormon and at the Académie Julian. When Hart Nibbrig settled in Laren in the early 1890s, he painted portraits and figures in a naturalistic manner consistent with his academic background. By the turn of the century, however, he was painting landscape motifs using a divisionist technique. Inspiration for this change can be traced to both his exposure to Neo-Impressionism while in Paris and to the strong influence of his colleague, Jan Toorop. Hart Nibbrig's divisionist canvases portray scenes of North Africa and Germany as well as the Netherlands, and they document his extensive travels after 1900.

Hart Nibbrig exhibited sporadically with La Libre Esthétique in Belgium from 1896 to 1908, and beginning in 1901, he was the subject of several one-man shows in the Netherlands. In 1981 the Singer Museum in Laren inaugurated a Hart Nibbrig room for the permanent display of his numerous paintings, drawings, and lithographs.

Landscape, 1902
oil on canvas, 15⅞ x 19¹³⁄₁₆ (40.3 x 50.4)
signed and dated lower right: FHART. NIBBRIG. 1902
The Holliday Collection 79.309

The development of Neo-Impressionism in Holland centers around the figure of Jan Toorop. An influential member of Les Vingt and the first Dutch artist to embrace divisionism, Toorop was instrumental in organizing the 1892 exhibition at The Hague that introduced Dutch artists to French and Belgian Neo-Impressionist painting. Shortly thereafter, the three other artists usually identified with the movement, Johan Joseph Aarts, H. P. Bremmer, and Jan Vijlbrief, were executing divisionist paintings.[1] One more painter whose name can be linked to Toorop and to the growth of divisionism in Holland is Ferdinand Hart Nibbrig.

Hart Nibbrig seems to have adopted the pointillist facture a few years later than his countrymen, since the Holliday landscape of 1902 is among his earliest documented works in the technique. At a time when many Neo-Impressionists in Holland as well as France were shifting to enlarged mosaic brushwork, Hart Nibbrig took up the fine dotted technique of early Neo-Impressionism. At the 1905 exhibition of La Libre Esthétique in Brussels, he was linked with Toorop as an artist "seduced" by Neo-Impressionism. A decade later, Hart Nibbrig was still depicting the landscape of Holland in a style indebted to divisionism.

In the Holliday landscape, Hart Nibbrig uses the small, round dot similar to that found in Dutch works of the 1890s, but he does not apply it with the same sense of rhythmic pattern found in many of his colleagues' paintings. For Hart Nibbrig, the repetition of the tiny flecks of color was a means for transcribing his image rather than for creating a strong surface design. He lapses into a looser handling for the road and tall trees and abandons the technique completely for the figural elements and the verticals of the fence posts. The color scheme is structured by the juxtaposition of intense pastel hues, as the green, rose, and yellow of the meadow contrast with the blue tints of the sky. Deviating from the prescribed color combinations, Hart Nibbrig chooses dark green for all the shadows and uses no complementary violet hues, despite the picture's heavy concentration of yellow.

The artist's son has suggested that the site of the landscape may be the vicinity of Laren, where Hart Nibbrig had settled a decade earlier.[2] The strong horizontal format of the landscape is broken by the gentle curves of the dirt road and the undulating line of the fence. This band that meanders across the foreground also puts the broad vista into a stage-set format in which the tall trees balance the figures of the man and the burro on the left. Despite the picturesque nature of these elements, Hart Nibbrig's landscape has a simplicity and a stillness common to some of the purest examples of Neo-Impressionist painting.

Notes

[1] For information on Neo-Impressionism in Holland, see Herbert, *Neo-Impressionism,* pp. 191-202; J. Joostens, "Painting in Holland," in *Post-Impressionism,* Royal Academy, pp. 255-259.

[2] Letter from P. J. Hart Nibbrig to T. Smith, August 8, 1982. Emke Raassen-Kruimel, Curator of the Singer Museum, Laren, The Netherlands, also proposed Laren as a possible site for this landscape. Letter from E. Raassen-Kruimel to T. Smith, July 20, 1982.

Provenance: Amsterdam, Prof. J. H. der Kinderen; . . . Amsterdam, Kunsthandel G. Douwes; Amsterdam, Kunsthandel M. L. de Boer; New York, Hammer Galleries, 1969; W. J. Holliday, 1971.

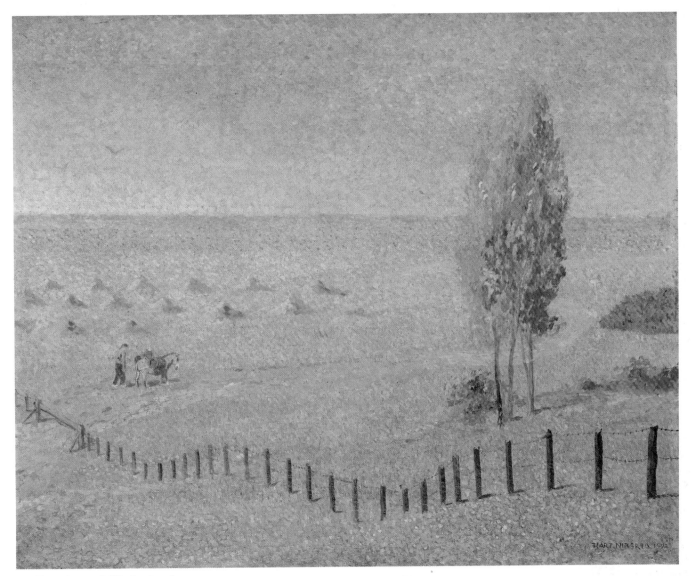

Ferdinand Hart Nibbrig, *Landscape*

Auguste Herbin
French 1882-1960

After two years at the Ecole des Beaux-Arts in Lille, Auguste Herbin arrived in Paris in 1901. Over the next eight years, he painted in a Neo-Impressionist and then a Fauve manner. Herbin's works were soon promoted by Paris dealers, and from 1906 to 1909, he exhibited with the Indépendants.

1909 marked the beginning of Herbin's flirtation with Cubism. He worked near Juan Gris at the Bateau Lavoir and painted landscapes and still lifes with stylized shapes and intersecting planes. During this pre-war period, Herbin's paintings received widespread exposure at Clovis Sagot's Paris gallery, with the progressive exhibition societies of Germany, and in the 1913 Armory Show in New York. In 1915 he signed a contract with dealer Léonce Rosenberg.

During World War I, Herbin did camouflage work for the military. When he returned to painting in 1917, he had evolved a new style. His canvases of the next five years are configurations of flat, geometric shapes in strong, unmodulated hues. They appear to be totally abstract, but Herbin in fact based many of these on the human figure.[1] Between 1922 and 1926, Herbin returned to figurative painting, but in 1927 he began arranging solidly colored triangles, circles, hemispheres, and rectilinear bands without representational associations. In 1931 he joined former members of De Stijl in founding the Abstraction-Création group in Paris. Herbin arrived at a fully non-objective art in 1940 with the creation of his "Plastic Alphabet." In this codification of formal elements, Herbin systematically matched each letter of the alphabet with a specific color, geometric configuration, and musical chord. In 1949 he explained its theoretical basis in his book *L'Art non figuratif-non objectif*. Recognized as a groundbreaker in the development of abstract art, Herbin exhibited steadily in both group and one-man shows throughout Europe and the United States from 1920 until his death in 1960.

by 1906 the fragmented brushwork of *Park in Paris* was stretched to longer strokes and flat areas of more solid color.

Herbin takes a simple, uncomplicated approach to the composition of his small landscape. Framing the lone woman with her baby carriage, he places her near the center of an empty stage that opens up directly before the viewer. Although *Park in Paris* is hardly an obvious harbinger of Herbin's later abstractions, the small landscape does offer subtle clues to the formal concerns embodied in his mature work. There is already a geometric purity in the division of the composition, as the broad horizontal of the picture plane is partitioned by the ramrod straight tree trunks that define the depth of the space. The austerity of the schema is camouflaged by the less regular patterns of shadows and leaves.

Much later in his career, Herbin created the "Plastic Alphabet," a language of abstract symbols that established a correspondence between the letters of the alphabet and particular colors, shapes, and musical notes. Herbin's attraction to such a system offers an intriguing parallel to Charles Henry's ideas on the expressive power of line and color, but it is not known how much this aspect of the Neo-Impressionist aesthetic contributed to Herbin's art.[3] *Park in Paris* has the pink hue that he assigned to the letter A and the deep violet of Z, but it still represents only the tentative first steps toward Herbin's non-objective art.

Notes

[1] J. Kennedy, "Auguste Herbin's Early Geometrical Compositions (1917-1921)," *Arts Magazine*, 56, 7, March 1982, pp. 66-71.

[2] Letter from G. Claisse to T. Smith, January 22, 1982.

[3] For the relationship between Herbin's later work and Charles Henry's theories, see J. Kennedy's article cited above.

Provenance: Private Collection; Amsterdam, Kunstveilingen S. J. Mak van Waay, sale, December 16, 1965, no. 72; Amsterdam, Kunsthandel M. L. de Boer, 1965; New York, Hammer Galleries, 1966; W. J. Holliday, 1966.

Exhibitions: HC 1968-69; HC 1969-70.

***Park in Paris*,** 1904
oil on canvas, 12¹³⁄₁₆ x 16 (32.6 x 40.7)
signed lower right: Herbin
The Holliday Collection 79.252

Many of France's future Fauves, Cubists, and abstract painters experimented with Neo-Impressionism early in their careers. For Auguste Herbin, this phase manifested itself in the bright colors and staccato brushwork of pictures such as *Park in Paris*. Geneviève Claisse, the artist's niece and author of his forthcoming *catalogue raisonné*, assigns the Holliday canvas to 1904,[2] three years after Herbin arrived in Paris and five years before he embarked on a course inspired by Cubism.

The Holliday picture demonstrates Herbin's affinity for the heightened palette and broken brushwork of the Impressionists and Neo-Impressionists. The young painter has eliminated earth tones, rendered his shadows in lavender and blue, and applied liberal doses of high-key pink in the background trees. Herbin's landscape rests upon a network of short dashes of impasto that follow the configuration of his image, with orderly horizontal strokes for the park ground, consistently vertical ones for the tall, thin trees, and varied directions for their leaves. This stage of Herbin's development was short-lived, for

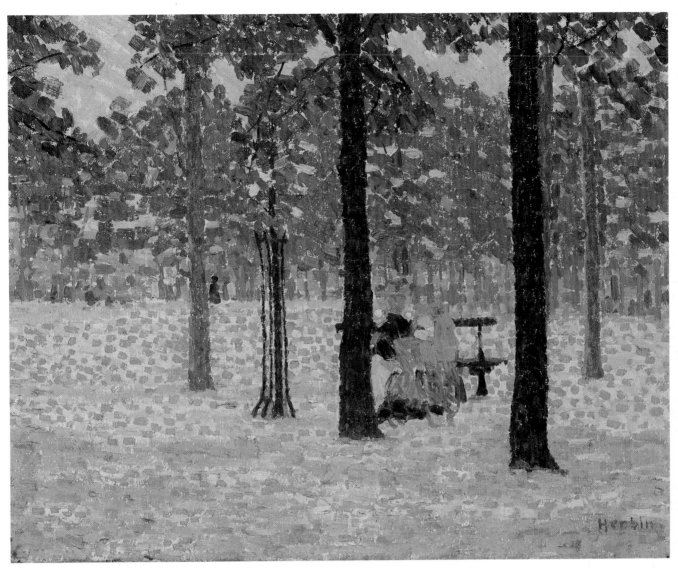

Auguste Herbin, *Park in Paris*

Adrien-Joseph Heymans
Belgian 1839-1921

Adrien-Joseph Heymans, the oldest artist represented in the Holliday Collection, is more closely associated with the development of Belgian Impressionism than with the spread of divisionism. Between 1854 and 1856, he studied at the Antwerp Academy, but it was a stay in Paris from 1856 to 1858 that decisively influenced his development. Fascinated by the fluidity of natural light, Heymans saw a kindred interest in the works of Barbizon painters Corot, Daubigny, and Millet. In the 1860s, he began painting *plein-air* scenes of the Belgian countryside near his home in Wechelderzande, using broad strokes and pale tones suffused with a gentle, blond light.

Heymans' exhibition career also began in the 1860s, when he was regularly included in one-man and group shows in Brussels. He earned a reputation as an independant painter of light and color effects and was asked to exhibit in the first salon of Les Vingt in 1884. Although never actively involved in avant-garde promotions, Heymans enjoyed the lasting respect and friendship of young Vingtistes.

Heymans' approach changed little until about 1890. He then adopted a systematically fragmented stroke but retained the subtle tones of his early palette. Since a monochromatic scheme remained the most effective means for rendering the delicate nuances of color characteristic of the Campine, Heymans produced a large body of works devoted to explorations of gray. Around 1900 he relaxed his facture and again produced lyrical landscapes devoted to atmospheric effects. By this time, he was a recognized leader of the Belgian Impressionist movement, and in 1904 he and Emile Claus founded the Vie et Lumière group. Heymans' career ended in 1913 when failing health forced him to give up painting.

The Dunes, 1890s
oil on canvas, 28 11/16 x 39 5/16 (72.9 x 99.9)
signed lower right: A. J. Heymans.
The Holliday Collection 79.253

The long and distinguished career of A.-J. Heymans spans the period that extends from the Barbizon School through the Post-Impressionist era. Heymans spent most of his life in the remote Belgian countryside of Campine, painting atmospheric effects that he called "my research on the equilibrium of the air."[1] His luminous outdoor scenes earned him a reputation as the doyen of the Belgian landscapists, and his participation in the inaugural exhibition of Les Vingt in 1884 lent credibility and a sense of continuity to the efforts of the new avant-garde group.

Heymans' relationship to the Neo-Impressionist movement in Belgium is somewhat ambiguous, and reports of his involvement with the new aesthetic are sometimes exaggerated. In her reliable account of the Belgian art scene between 1884 and 1914, Madeleine Maus characterized Heymans in 1896 as a venerable but flexible senior painter whose research touched on the interests of the younger generation of artists.[2] In the early 1890s, Heymans did adopt a slashing stroke to record his responses to the vibration of light.[3] Although this striated facture linked him to the Neo-Impressionist camp, Heymans' treatment never involved Seurat's methodical handling or his

rigorous decomposition of color, and his works do not approach the divisionism practiced by his countrymen Théo van Rysselberghe, Henry van de Velde, or Georges Lemmen. Most of Heymans' pictures are undated and because his oeuvre is marked by subtle progression rather than by abrupt change, assigning precise dates to individual paintings is difficult. The Holliday painting, however, appears to belong to that period of the 1890s when Heymans turned to a bold, hatched brushwork.

The hilly terrain of *The Dunes* is built upon small stripes of impasto set in patches of parallel strokes that give the composition a sense of energy as well as structure. Heymans occasionally increased the density of the brushwork by sprinkling round dots of pigment amid the longer strokes. For the sky and sea, the artist abdicated the striated brushwork in favor of a smoother texture. This thinner paint layer is applied with a loose, gestural technique that reveals the freedom of handling also found in Heymans' other works. The blond light that was a hallmark of Heymans' landscapes suffuses *The Dunes,* where his colors range from earth tones to coral, rose, blue, and violet. They are applied by a painter sensitive to the nuances of reflected light but uncommitted to recording them through prescribed rules.

Heymans painted many scenes of the sandy hills of the Wechelderzande region. The Holliday painting is similar in handling and color to the best known, a very large composition also called *The Dunes* (art market, Paris). The second canvas focuses on only the topography of the dunes instead of providing a vista to the sea. The unusual composition of the Holliday canvas has a curious vacant quality, as if the glimpse of the setting sun and sailboats does not have sufficient pictorial emphasis to balance the weight of the rolling dunes.

Notes
[1] Unidentified letter from Heymans, quoted in M. O. Maus, *Trente années de lutte pour l'art, 1884-1914*, Brussels, 1926, rept. 1980, p. 209.

[2] Maus, p. 209.

[3] P. Colin, *La peinture belge depuis 1830*, Brussels, 1930, p. 157.

Provenance: Brussels, Marcel Bas; Paris, Guy Pogu (Galerie de l'Institut); W. J. Holliday, 1965.

Exhibition: HC 1968-69.

Adrien-Joseph Heymans, *The Dunes*

Modest Huys
Belgian 1875-1932

Modest Huys executed his first paintings on the walls of inns as a young assistant to his father, a *peintre-décorateur*. Although steadily employed in this family business through the 1890s, Huys committed his leisure hours to the pursuit of a career as an *artiste-peintre*. He produced *plein-air* studies of the Lys countryside—often utilized in his decorating projects—and studied drawing briefly at the Ecole Industrielle in Ghent. Realizing the shortcomings of self-instruction, the young Huys sought the counsel of Luminist painter Emile Claus, who resided nearby. Huys was not formally a student of Claus, but his visits were pivotal in his artistic development. Armed with a recommendation from Claus, Huys enrolled in the Academy at Antwerp around 1895.

His training was prematurely ended when a serious illness forced his return to the Lys valley. There he resumed his painting efforts, drawing upon the surrounding rural life for motifs executed with sunstruck hues and feathery strokes. Huys' oeuvre shows little deviation from this approach. Even the privations and shattered illusions of World War I, which so profoundly affected the tenor of European art, hardly altered the sanguine outlook expressed in Huys' paintings.

Huys' modestly successful exhibition career commenced shortly after the turn of the century. Often included in official salons in Paris as well as in Belgium, Huys also exhibited in the more progressive milieu of La Libre Esthétique and Vie et Lumière.

Woman in a Meadow, ca. 1900
oil on canvas, 12¾ x 15¼ (32.4 x 38.7)
signed lower right: MHuys
inscribed, dated, and signed on reverse: AAN MEESTER/
 C.V.D. Wegen/UIT DANKBAARHEID. 1900/MHuys
The Holliday Collection 79.256

In this painting from the debut of Modest Huys' career are the basic traits that distinguish his oeuvre: a love of the Belgian countryside, a willingness to integrate figures into his landscape subjects,[1] and a reliance on luminous colors applied with thatched brushwork. *Woman in a Meadow* flaunts the pungent colors Huys used to paint his native land. In the background, searing hues of orange, rose, and green compose the familiar Belgian sight of tall, thin trees lining a canal. In the shaded foreground is a surprisingly adept application of Neo-Impressionist color theory, where the varied green shades of the grass are flecked with the blue pigment appropriate for the shadows, as well as with the yellow-orange of the reflected sunlight and the rose hues from the woman's skirt. Though Huys is not generally associated with Neo-Impressionism, two early works exhibited in Antwerp were pronounced Neo-Impressionist by the Belgian critics.[2]

When this picture entered the Holliday Collection, Huys' inscription on the reverse of the canvas had been partially painted over. However, Marcel Bas, who owned the painting in the mid-1960s, had transcribed the inscription before its alteration. The artist dedicated the picture to a C. V. D. Wegen, with gratitude, in 1900.[3] Since many of Huys' works were destroyed with his studio during World War I, this canvas is a particularly useful record of his style at the turn of the century.

Notes
[1] G. Chabot, "Modest Huys," *Gand Artistique*, 7, July 1928, p. 126.

[2] G. D'Aconit, "Modest Huys," *Gand Artistique*, 7, July 1928, pp. 133-134.

[3] Conversation with M. Bas, Brussels, July 1980.

Provenance: Gift of the artist to C. V. D. Wegen, 1900; . . . Brussels, public sale; Brussels, Marcel Bas; Paris, Guy Pogu (Galerie de l'Institut); W. J. Holliday, 1965.

Exhibition: HC 1968-69.

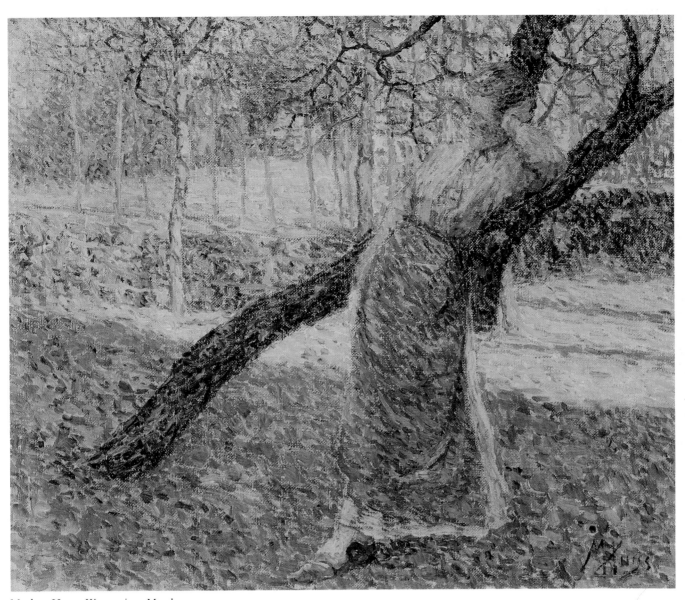

Modest Huys, *Woman in a Meadow*

Georges Lacombe
French 1868-1916

Georges Lacombe began art studies with his mother, the painter and printmaker Laure Lacombe. He received additional training from close family friends Georges Bertrand, Alfred Roll, J.-F. Humbert, and Henri Gervex. It was, however, Paul Sérusier and Paul Gauguin who exerted the decisive influence on his career.

From 1888 to 1897 Lacombe spent his summers in the small Breton port of Camaret. In 1892 he met Sérusier in Brittany and was immediately won over by the Nabi philosophy. Lacombe's paintings of the 1890s include Breton scenes and stylized landscapes recalling Japanese prints. Also known as "The Nabi sculptor," Lacombe is most remembered for his wood figures of the 1890s. The influence of Paul Gauguin is apparent in his use of polychromy as well as in his deliberately crude carving technique.

In 1897 Lacombe settled in the forest of Ecouves in Normandy and soon turned to its lush undergrowth for his themes. By 1905 he was working in a Neo-Impressionist mode, the result of a new friendship with Théo van Rysselberghe. Lacombe's love of nature led him gradually away from scientific divisionism, however, and within a few years, he was painting fields and gardens in an Impressionist manner.

In Normandy Lacombe led an isolated life, detached from artistic developments in Paris and Brittany. He exhibited regularly with the Indépendants and at the Salon d'Automne but was virtually unknown in the French art world. This obscurity was a result not only of his isolation, but also of his opposition to selling his works. He never sold a painting but instead gave them to his friends. Only in the last thirty years has he won recognition.

The Scuffle, 1894 or 1895
black crayon accented with orange on cream wove paper,
 image: 9⅝ x 7¼ (24.5 x 18.4)
 sheet: 13⅛ x 10⅝ (33.3 x 27.0)
stamped with monogram lower right: [1]
The Holliday Collection 79.259

When Georges Lacombe drew this small sketch in 1894 or 1895, Neo-Impressionist concerns had not yet entered his work. During the mid-1890s, Lacombe was immersed in the Nabi aesthetic, and Brittany and its natives provided the settings or subjects for his paintings, wood carvings, and drawings. This sketch was formerly catalogued as *La lutte bretonne,* a reference to a traditional wrestling sport played in Brittany. Lacombe's mentor, Paul Sérusier, treated this theme in his painting *The Wrestlers,* 1890 (Collection of Henriette Boutaric, Paris). Lacombe's barefoot wrestlers do appear locked in a position common to the "lutte bretonne," but the use of a knife or dagger, which figures so prominently in the Lacombe drawing, was strictly forbidden in these contests.[2]

It is very tempting to identify the subject of *The Scuffle* with Paul Gauguin's notorious encounter in the port of Concarneau in May 1894. Gauguin had returned to Brittany with Annah, his Javanese mistress, whose manners and penchant for wearing Breton costume irritated the local people. In the course of a walking expedition, some young boys mocked Annah, and

Gauguin was drawn into a brawl, where he sustained a broken ankle that troubled him for the rest of his life. The placement of a pair of wooden shoes at the lower right of the drawing may refer to one version of the story, in which Gauguin's injury was caused by a blow from a sabot. The man wielding the knife does indeed resemble Gauguin, and the peasant woman projects a rather affected bearing; but other details of the sketch, such as the absence of a seaside setting and Annah's ever-present pets, are not totally consistent with the tale.

On the basis of his knowledge of Lacombe's artistic taste, Georges Martin du Nord contends that the relationship between this drawing and Gauguin's incident is tenuous. While Lacombe's themes were often symbolic, they were seldom based on anecdote or oriented to narrative. Far from feeling a sentimental appreciation for quaint Breton customs, the refined Lacombe expressed a certain disdain for the primitive Breton ways. Martin du Nord suggests that the drawing was more likely motivated by Lacombe's disapproval of some aspects of Breton life than by his fascination with the misfortune of his acquaintance, Paul Gauguin.[3]

In spite of the visual and historical premises for dissociating the drawing from the specific incident, the contention that *The Scuffle* was indeed inspired by Gauguin's mishap is the more persuasive argument. First, the knife discredits the theory of the typical Breton wrestling match. Second, Lacombe's contemporary rendition of the incident could easily vary in small details from the published account now known. Finally, even if there were little actual familiarity between the two artists, Lacombe's sculpture and bas-reliefs reveal the powerful influence Gauguin exerted upon him at precisely this period. It is not implausible that Lacombe would devote one casual sketch to an event in the life of this charismatic personality. No related studies or finished paintings of the same topic have come to light.[4]

The Holliday picture is typical of the drawings from Lacombe's sketchbooks, many of which have survived in the artist's family. When Lacombe's works were catalogued in the 1960s, *The Scuffle* had already been detached from its album and was found as an unbound sheet interleafed between pages of sketchbook VI.[5] Sketchbook VI, however, measures 45 x 30 centimeters, substantially different from the 33.3 x 27.0 dimensions of the Holliday drawing. Yet on the reverse of *The Scuffle* is a most legible image, transferred by contact with another Lacombe sketch, which offers an explanation for the discrepancy in size. This transferred image shows a peasant woman rotating a wheel. Since many other works have now been removed from Lacombe's sketchbooks,[6] the location of the original drawing for this image was unknown until a sketch entitled *Peasant Turning a Crank* appeared on the art market in 1982 (Sotheby's, London, March 31, 1982, no. 270). The right two-thirds of this drawing corresponds exactly to the scene that spans the verso of *The Scuffle,* identifying it as the source of the counterproof. The dimensions of *Peasant Turning a Crank* match those of sketchbook VI, and since the left portion of this drawing is missing from the counterproof, it provides a rationale for concluding that *The Scuffle* was indeed trimmed down from its original size.

Stylistic and thematic factors also link the Holliday piece to sketchbook VI. Other drawings from this album display the

Georges Lacombe, *The Scuffle*

same simplified profile treatment of the faces; similar energetic, curly lines to define the images; and a common tendency to build compositions with a shallow, layered picture plane and a high horizon line. Dated 1894 and 1895,[7] these sketches present a variety of the Breton subjects that inspired Georges Lacombe in the closing years of the nineteenth century.

Notes
[1] The stamp at the lower right of the sheet, not visible in the illustration above, imitates the form of Lacombe's monogram and was issued by the artist's daughter to identify his unsigned works. Letter from Joëlle Ansieau to W. J. Holliday, March 29, 1969.

[2] Letter from G. Martin du Nord to E. Lee, October 1, 1980.

[3] Letters from G. Martin du Nord to E. Lee, October 1, 1980, and April 15, 1981.

[4] In his letter of October 1, 1980, Martin du Nord observed that the artist's daughter, Madame Mora-Lacombe, was unaware of any other works relating to this subject.

[5] J. Ansieau, "Georges Lacombe, peintre et sculpteur," Master's thesis, Ecole du Louvre, 1969. Ansieau, who catalogued and numbered the sketchbooks, observed that the Holliday drawing was found placed between the pages numbered 25 and 26 in sketchbook VI.

[6] See *Georges Lacombe 1868-1916: Drawings*, New York, Shepherd Gallery, 1974.

[7] Ansieau, "Georges Lacombe"; quoted in letter from Martin du Nord to E. Lee, April 15, 1981.

Provenance: Purchased from the artist's daughter, Madame Sylvie Mora-Lacombe, Paris, by Galerie Urban, Paris; W. J. Holliday, 1965.

Exhibition: HC 1968-69.

Literature: J. Ansieau, "Georges Lacombe, peintre et sculpteur," Master's thesis, Ecole du Louvre, 1969.

Oaks and Blueberry Bushes, 1905
Chênes et myrtils
oil on canvas, 21¼ x 28½ (54.0 x 72.4)
signed with monogram lower left: 𝒞
inscribed and signed on central vertical stretcher bar: N⁰ 5
 Chênes et myrtils[1] Georges Lacombe
The Holliday Collection 79.258

In this lush forest landscape, the Holliday Collection has a rare example of the brief Neo-Impressionist period of Georges Lacombe. Separated since 1897 from his colleagues in Brittany, Lacombe had gradually abandoned Breton themes in favor of the wooded landscape scenes around his Alençon home. Sometime after 1900 Lacombe befriended Belgian expatriate Théo van Rysselberghe, who introduced him to the divisionist aesthetic. In Lacombe's paintings of 1904-05, a more intimate observation of nature and a willingness to experiment with light and color have supplanted the flat hues, shallow picture plane, and stylized drawing of his Nabi period.

Although Lacombe's Neo-Impressionist efforts coincide with the development of Fauvism and with divisionism's second phase, he does not adopt their larger, rectangular brush stroke or strident color schemes. The pointillist handling of *Oaks and Blueberry Bushes* is well suited to the dappled light of the woods, where the sunshine filters through the trees, juxtaposing contrasts of light and shadow on the forest floor. Lacombe's cool palette, with its emphasis on green, blue, and violet tonalities, has much in common with Van Rysselberghe's preferred color combinations.

Oaks and Blueberry Bushes figured in the Indépendants' exhibition during the spring of 1906, making the summer of 1905 the logical date for its execution. Lacombe's inscription of "N⁰ 5" on the stretcher probably refers to its sequence as the fifth of eight pictures he displayed at the 1906 Indépendants' show. An inscription on a label affixed to the stretcher is not in the artist's hand and incorrectly assigns the picture to ca. 1895, a date Robert Herbert wisely questioned when the pic-

ture was included in his Neo-Impressionist exhibition at the Guggenheim in 1968. Lacombe did not paint divisionist works in the 1890s; and, unlike the Holliday canvas, many of his works of that period were executed in an egg-based medium. Further, Joëlle Ansieau, cataloguer of Lacombe's oeuvre, has noted that Lacombe adopted the monogram signature found in *Oaks and Blueberry Bushes* around 1905-06.[2]

Though *plein-air* paintings often convey the artist's immediate sense of the site, in this scene Lacombe has also placed the viewer deep within the woods. Cropping the composition below the treetops, he draws the observer into the cool shade and tranquility of his secluded forest. The four central trees stake out a sense of space, while the less naturalistic tree trunks at the right of the picture are a subtle reminder of the flatter, stylized rendering of Lacombe's paintings inspired by Sérusier. The forest of Ecouves is the site for what one critic termed Lacombe's "tête-à-tête with the trees."[3]

Notes
[1] "Myrtils," a rare spelling for "myrtilles," the French word for blueberry bushes, is a rather precious but correct usage befitting the artist's arcane interests. I am indebted to Georges Martin du Nord, and his contact with Madame Sylvie Mora-Lacombe, daughter of the artist, for information confirming that the inscription is in the artist's hand, and for his translation of the word "myrtils." Letter from G. Martin du Nord to E. Lee, October 1, 1980.

[2] Letter from J. Ansieau to W. J. Holliday, March 29, 1969.

[3] P. Hepp, "Georges Lacombe," *L'Art et les artistes*, October 1924, p. 15.

Provenance: Purchased from the artist's daughter, Madame Sylvie Mora-Lacombe, Paris, by Galerie Urban, Paris (through Maurice Malingue); W. J. Holliday, 1960.

Exhibitions: Paris, Serres de la ville de Paris, *22ᵉ Exposition de la Société des Artistes Indépendants,* March 20-April 30, 1906, no. 2704; New York, The Solomon R. Guggenheim Museum, *Neo-Impressionism,* February 9-April 7, 1968, no. 114 (reprod.); HC 1968-69; HC 1969-70 (reprod.).

Literature: J. Holl, "Les salons de 1906 illustrés," *Cahiers d'Art,* April-May 1906, p. 3; "Trio de salons, les Versaillais," *Echo de Versailles,* November 5, 1906; J. Ansieau, "Georges Lacombe, peintre et sculpteur," Master's thesis, Ecole du Louvre, 1969, no. 96.

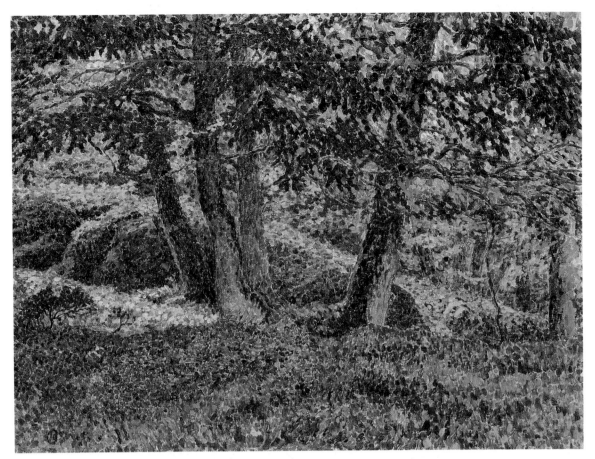

Georges Lacombe, *Oaks and Blueberry Bushes*

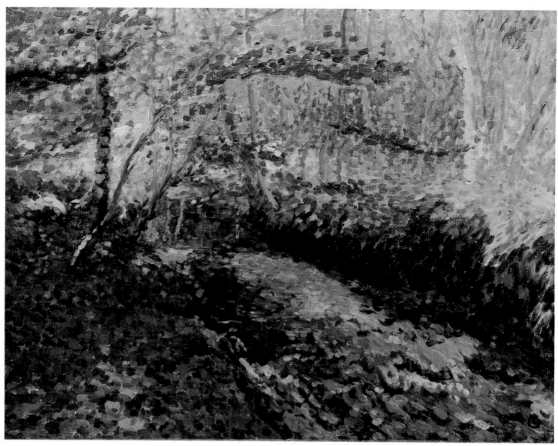

Georges Lacombe, *The Briante River (Forest Interior in Autumn)*

The Briante River (Forest Interior in Autumn), ca. 1907
Briante (Sous-bois d'automne)
oil on canvas, 17¹³⁄₁₆ x 23⅝ (45.3 x 60.0)
signed with monogram lower right: ℂ
The Holliday Collection 79.257

For this look into the forest interior, Lacombe has changed from the cool palette of *Oaks and Blueberry Bushes* to a brighter color scheme, juxtaposing acidic tones amidst the autumn foliage. Though the image is still composed of separate patches of color, Lacombe's pointillist handling has visibly relaxed, as his shift to a more Impressionist sensibility emerges. Areas of white ground are allowed to appear between the brush strokes, and most tree trunks are now treated with a long, thin wash of violet. The date of 1907, proposed by Lacombe's cataloguer as well as by his daughter, is based upon the artist's evolution from a Neo-Impressionist approach of 1904-05 to a looser style.[1]

The setting is again the forest of Ecouves, where the narrow Briante River crossed the artist's property not far from Alençon. The banks of the Briante appear frequently in Lacombe's studies and finished canvases of the early 1900s. By this time, his unabashed love of the landscape could no longer be conveyed by the patterns of the Pont-Aven School. In this painting, all the vitality and immediacy of Lacombe's rapport with nature are expressed through his modification of divisionist methods.

Note
[1] J. Ansieau, "Georges Lacombe, peintre et sculpteur," Master's thesis, Ecole du Louvre, 1969; letter from G. Martin du Nord to E. Lee, October 1, 1980.

Provenance: Purchased from the artist's daughter, Madame Sylvie Mora-Lacombe, Paris, by Galerie Urban, Paris (through Maurice Malingue); W. J. Holliday, 1960.

Exhibitions: New York, Hammer Galleries, *Seurat and His Friends,* October 30-November 17, 1962, no. 35; HC 1968-69; HC 1969-70.

Literature: J. Ansieau, "Georges Lacombe, peintre et sculpteur," Master's thesis, Ecole du Louvre, 1969, no. 113.

Fernand Lantoine

French, active 1907-1913

Fernand Lantoine spent most of his life in Paris and Brussels. His oeuvre consists primarily of landscapes and marine scenes. Lantoine began exhibiting with the Indépendants in 1907 and was included in the 1913 salon of La Libre Esthétique dedicated to "Interprétations du Midi."

The Model
La poseuse
oil on canvas, 26 x 11¹¹⁄₁₆ (66.0 x 29.7)
signed lower right: F. LANTOINE
The Holliday Collection 79.260

Although Fernand Lantoine is best known as a marine painter, he devotes *The Model* to recording the effects of sunlight and shadow on the human figure. The flesh tones of Lantoine's model have been painstakingly divided into their constituent hues. No broad expanses of local color exist, as her skin is entirely composed of small flecks of rose, violet, orange, and blue pigments. The light falls from overhead, bathing the model's shoulders in blond light and casting the rest of her body in colorful shadows. Lantoine has used white and rose paint, as well as the exposed areas of the white ground, to indicate the direct sunlight on the woman's shoulders and right hip. The nude is dressed in the reflections of her setting, as nearly all the colors that compose the three zones of the background are echoed in the vivid tints of her flesh. The artist renders the background with large, loose strokes that create a flat, rectilinear plane behind the voluptuous curves of the statuesque nude.

Provenance: Brussels, Médard Verburgh; Brussels, Marcel Bas; Paris, Guy Pogu (Galerie de l'Institut); W. J. Holliday, 1965.

Exhibition: HC 1968-69.

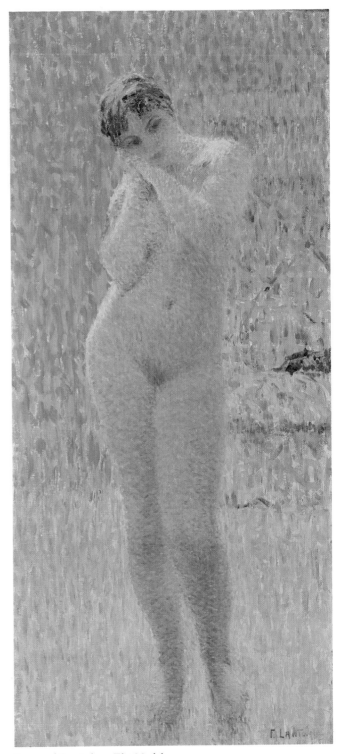

Fernand Lantoine, *The Model*

Achille Laugé
French 1861-1944

In 1878 Achille Laugé began part-time art studies in Toulouse while apprenticed to a pharmacist. Three years later, he enrolled in the Paris Ecole des Beaux-Arts under Alexandre Cabanel and Jean-Paul Laurens. In 1888 Laugé returned to his family, then residing in Cailhau, and remained in the south of France for the rest of his life. He rejected the conservative ideals of his teachers and began producing landscapes that were assiduous experiments in the division of color. Laugé never conformed to Seurat's strict scientific method, but it is not likely that he evolved his technique independently, as many of his biographers claim. He had been living in the capital when *La Grande Jatte* was first exhibited amidst much controversy in 1886, and he maintained close contact with the Parisian art world through friendships with fellow artists, frequent visits, and exhibition activities.

From 1888 until around 1896, Laugé composed his pictures with small points of color. He then abandoned dots and painted landscapes, portraits, and still lifes with thin, systematically placed strokes resembling crosshatching. After 1905 he applied his pigments more freely with enlarged strokes and a thick impasto.

It was not until the 1968 Guggenheim show that Laugé was included in an exhibition devoted to Neo-Impressionism. He did, however, exhibit with the Indépendants in 1894 and with the Nabis at an exhibition sponsored by the newspaper *La Dépêche de Toulouse* the same year. In addition, Laugé held several one-man shows in Paris from 1907 to 1930.

An Orchard in Springtime (Apple Trees in Bloom), 1920s
Un verger au printemps (Pommiers en fleur)
oil on cotton fabric, 20⅞ x 28½ (53.0 x 72.4)
signed lower right: A. Laugé
The Holliday Collection 79.261

Achille Laugé's favorite subjects were found in the countryside near his home in south central France. For more than fifty years, he painted the trees, farms, and lonely roads around Cailhau, Carcassonne, and Alet. In *An Orchard in Springtime*, Laugé's delight in the Languedoc landscape is unrestrained, as he indulges exclusively in bright, high-key colors. His palette is based on rose, yellow-green, and blue and creates a confection so rich that the orange and white farm buildings stand out as tonic relief. Faithful to Impressionist and Neo-Impressionist principle, Laugé uses blue pigment to define the shaded side of the central apple tree. The flecks of rose repeated in the sky and foreground reinforce the cohesive color scheme and emphasize the surface rather than the depth of the picture plane. In this landscape, short, loose brush strokes are woven into a shimmering texture that melts volumes into flat surface patterns.

The single tree planted in the middle of the composition establishes a symmetry unusual in landscape painting. This balance, restated less forcefully by the trees in the middleground, escapes being static by the off-center placement of the buildings. The artist's careful construction is confirmed by an infra-red photograph that exposes a meticulous underdrawing (see fig. 1). The format is not a squared grid but a framework of rectangles, where each of four quadrants is bisected by a pair of crossed diagonals. The presence of rectangles and the placement of the focal point slightly below center first suggested that Laugé might have been exploring the use of the golden mean, a formula of proportion used to construct harmonious compositions. However, the relationship of parts in *An Orchard in Springtime* does not coincide with the golden mean ratio of 5 to 8, and a survey of other landscapes reveals

Fig. 1 Infra-red photograph of Laugé, *An Orchard in Springtime*

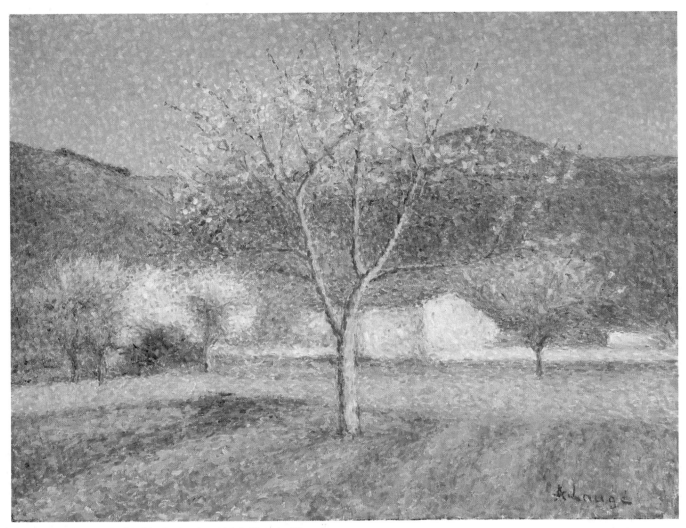

Achille Laugé, *An Orchard in Springtime (Apple Trees in Bloom)*

that Laugé often relied on a central element to divide the compositions bilaterally. In several scenes, the artist has placed a tree directly in the middle of the composition.[1] In *The Garden at Alet* (Drouot-Rive Gauche, Paris, March 11, 1977, no. 71), the same rectangular and diagonal grid found in the Holliday painting is clearly visible beneath the pastel layer. This evidence of Laugé's careful preparatory work should alter the impression given by many of his biographers that after his most intense Neo-Impressionist period, Laugé was essentially a *plein-air* painter. They all describe his *atelier roulante*, a glass-enclosed studio on wheels that allowed him to work outdoors under any weather conditions. The precise construction of *An Orchard in Springtime* proves that however vivid his views of Languedoc light, Laugé's landscapes were not limited to direct, rapid transcriptions of nature.

In the Holliday landscape, Laugé has relaxed the tight dots and trellises of strokes that characterized his style during the 1890s. By about 1905, he had evolved a looser brushwork and a less rigorous division of tone; and after this time, it is difficult to detect significant stylistic change in his work. This fact, when combined with Laugé's failure to date many works after the 1890s, leaves the chronology of his late works rather vague. With its lavish color and brushwork, the handling of *An Orchard in Springtime* clearly places it in the last period of Laugé's career.[2]

Notes

[1] Tracy Smith proposed the survey of other examples of Laugé's work where a tree marked the center of the composition.

[2] Messieurs Flavian, of Galerie Marcel Flavian, Paris, agents for the artist's estate, and Philippe Cézanne, who presided over the auction of the artist's studio, concur. In a conversation during October 1981, Messieurs Flavian placed the painting in the period from 1920 to 1930. In a conversation on July 17, 1980, Cézanne proposed a date of 1925 to 1930.

Provenance: Purchased from the artist's family by Galerie Marcel Flavian, Paris, early 1960s; London, Kaplan Gallery; W. J. Holliday, 1965.

Exhibitions: HC 1968-69; HC 1969-70.

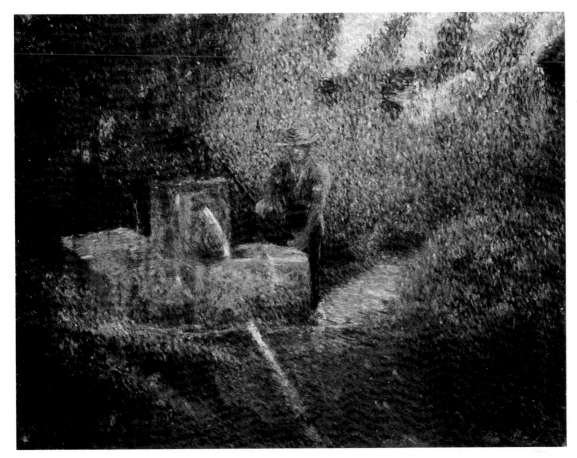

Achille Laugé, *Man at the Well*

Man at the Well
pastel on paper, 19⁷⁄₁₆ x 24⁷⁄₈ (49.4 x 63.2)
unsigned[1]
The Holliday Collection 79.262

While most of Laugé's landscapes are unpeopled celebrations
of nature, he did devote a number of works to the theme of
the farm laborer. *Man at the Well* is one of those rare examples
where Laugé integrated figures into the landscape. In this
pastel, the artist has relied on the use of comma-shaped strokes,
often described as *virgulisme*, to create a dense landscape set-
ting where the hatchings flow in distinct patterns. These short
threads of color, which often juxtapose dark and light tones,
are also found in another pastel of rural labor, *The Grape Har-
vest* (Drouot-Rive Gauche, Paris, March 5, 1976, no. 22). The

simplified treatment of the man's head as a basic geometric
convention is similar to the drawing of the faces in *The Harvest
at Cailhau* (Drouot-Rive Gauche, Paris, March 5, 1976, no. 58),
the artist's most ambitious treatment of the subject. *Man at the
Well*, however, relates most directly to another single-figure
pastel, *The Reading* (Sotheby's, London, December 3, 1970, no.
34), where the figure of a woman is set in the midst of a very
similar current of brisk, choppy strokes in contrasting hues.

Note
[1] An illegible inscription is barely perceptible in the lower left quadrant of the
paper.
Provenance: Paris or Versailles, public sale, 1967; W. J. Holliday, 1967.
Exhibition: HC 1968-69.

Ernest-Joseph Laurent
French 1859-1929

Ernest-Joseph Laurent began painting at the Paris Ecole des Beaux-Arts during the late 1870s. He studied in the atelier of Henri Lehmann and there befriended classmates Georges Seurat and Edmond Aman-Jean. In the early 1880s, Laurent exhibited award-winning canvases at the conservative Salon des Artistes Français, but by 1883 the impact of his young colleagues, and their interest in progressive painting, was apparent in his use of divided brushwork.

In 1885 Laurent earned a travel scholarship and went to Italy with Aman-Jean and Henri Martin. He returned to Italy in 1889 after winning the Prix de Rome. At the Villa Medici, Laurent worked with Ernest Hébert, director of the French Academy, and the two established a warm rapport. He continued painting the allegorical and historical scenes that had won him official acclaim in Paris, but under the influence of Hébert, he relinquished bright tones for a more somber palette.

In 1895 Laurent returned to Paris and the use of luminous colors. While he employed a technique of divided colors and strokes, in many other respects he remained faithful to traditional ideals. In 1896 he began painting the intimate portraits of women in an Impressionist manner that won him renown as a colorist. These figure studies eventually dominated Laurent's oeuvre, which also includes floral themes and murals for the Sorbonne. In 1919 Laurent's advocacy of academic values won him a professorship at the Ecole des Beaux-Arts and, in 1921, membership in the Conseil des Musées Nationaux.

Ernest Laurent's only one-man show during his lifetime took place at Durand-Ruel in 1911. A major retrospective was held in 1930 at the Musée de l'Orangerie.

After the Bath, ca. 1903
oil on canvas, 29¹⁵⁄₁₆ x 26⁷⁄₁₆ (76.0 x 67.2)
signed lower left: Ernest Laurent
signed on lower stretcher bar: Ernest Laurent
The Holliday Collection 79.302

After the Bath places Ernest Laurent in the mainstream of the modern French painting tradition. Like Renoir and Degas, he painted the nude in the intimacy of her bath and boudoir; and, like them, he was attracted to the play of light and shadow against the skin. In this composition, Laurent contrasts the model's luminous flesh and lavender drape with the stark white linens and somber tones of her setting.

Laurent's use of fragmented brushwork has often linked him too closely with the Neo-Impressionist movement. Yet for all the separated strokes and blue-toned shadows of *After the Bath,* the wall that forms the picture's backdrop actually marks the closest rapport with Neo-Impressionist practice. Its warm tan surface is laced with flecks of orange, green, blue, and rose, which demonstrate the attempt to represent a local color and its reflections by breaking them into their composite hues. The critic Paul Jamot, a close friend of the artist and a vocal commentator on his work, was in a position to offer an informed view of Laurent's paintings. Specifically separating him from Signac's camp, Jamot described Laurent as one who absorbed the lessons of Impressionist technique and applied them to pictures that dwell on mood or personality rather than on the division of color.[1]

In *After the Bath,* Laurent shows his ability to create a realm of intimacy and warmth. Posing his nude between the fireplace and her attentive maid, he blankets the canvas with a dense network of feathery brush strokes. Attentive to the details of his model's milieu, Laurent does not overlook the many opportunities for still-life painting in *After the Bath.* The setting must be the artist's studio, since the hearth, tan wall, and framed picture appear in several of his paintings executed after the turn of the century. In a canvas dated 1903 and entitled *Woman Seated on a Bed* (Collection of M. Albert Pra), Laurent repeated the model, flowers, and cropped picture on the wall, providing a plausible date for the Holliday painting. The treatment of *After the Bath* is also consistent with the handling of other figure studies and portraits of the early 1900s.

Note
[1] P. Jamot, "Ernest Laurent," *Gazette des Beaux-Arts,* 4th ser., V, 1911, pp. 179-180.

Provenance: Paris, public sale, mid-1930s; Paris, Louis Le Sidaner, mid-1930s; Detroit, Walter P. Chrysler, Jr., mid-1950s; ... New York, Schweitzer Gallery; W. J. Holliday, 1968.

Exhibitions: Dayton, Dayton Art Institute, *French Paintings 1789-1929, from the Collection of Walter P. Chrysler, Jr.,* March 25-May 22, 1960, no. 82 (reprod.); New York, Schweitzer Gallery, *40th Anniversary Exhibition,* November 1970, no. 36 (reprod.).

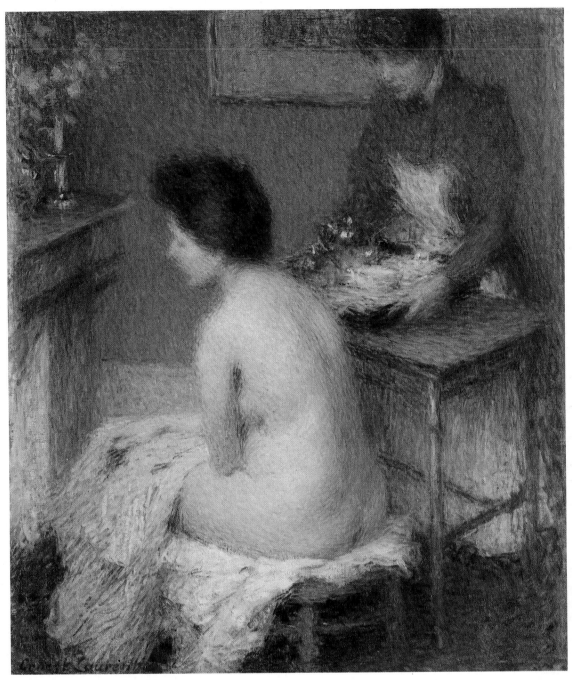

Ernest-Joseph Laurent, *After the Bath*

Henri Le Sidaner

French 1862-1939

After spending the first years of his life in the West Indies, Henri Le Sidaner returned to France with his family in 1872. He began art studies in 1877 with history painter Alexandre Desmit in Dunkerque and in 1882 entered Alexandre Cabanel's atelier at the Ecole des Beaux-Arts in Paris. From 1882 to 1893, Le Sidaner often retreated to Etaples. The stern coastal landscape of the northern town appealed to the young artist, who suffered under the Ecole's dictum of copying pictures in the Louvre. Le Sidaner explained that "Etaples—that is to say, Nature—revived me,"[1] and that city provided many themes for his *plein-air* works.

Le Sidaner began exhibiting at the Salon des Artistes Français in 1887. His naturalistic figural groups set in Etaples were well received and won him trips to Italy and Holland in 1891. Three years later, he exhibited Impressionist works influenced by Monet at the less conservative Société Nationale des Beaux-Arts. From around 1896 to the end of the century, Le Sidaner painted Symbolist themes where pensive, virginal women dressed in white inhabit dimly lighted gardens. In these paintings, which recall early canvases of his friend Henri Martin, Le Sidaner initiated the aura of mystery and the divisionist technique characteristic of his late work.

After the turn of the century, Le Sidaner rarely portrayed the human figure. Instead, he depicted provincial settings in Bruges, Beauvais, and Chartres and urban areas such as London and Venice. Images of the gardens and interior of his home in Gerberoy, where he resided from 1901 or 1902, also are prevalent in later works. He did, however, often imply human presence in a set table or an open book, adding to the intimate yet mysterious quality of his painting.

Like his close friends Henri Martin and Ernest Laurent, Le Sidaner was associated with Neo-Impressionism only tenuously and tempered its techniques with an otherwise traditional approach. He enjoyed continued favor and from 1897 was regularly honored by one-man shows not only in Paris, but also in London, Brussels, and the United States. In 1930 he was made a professor at the Académie des Beaux-Arts, replacing Ernest Laurent, and in 1937 was named its president.

Study for *Houses on the River at Fougères,* ca. 1920
Etude, *Maisons sur la rivière à Fougères*
oil on panel, 9⁹⁄₁₆ x 11⁷⁄₁₆ (24.3 x 29.4), irregular
signed lower left: LE SIDANER
signed lower right and partially overpainted: LE SIDA . . .
colorman stamp on reverse: Sennelier, Paris
The Holliday Collection 79.264

For decades Henri Le Sidaner transformed unremarkable views of peaceful villages and cities into memorable landscapes imbued with a powerful sense of mood and place. He was drawn to the tranquil towns of northern Europe, where he painted simple houses perched on the banks of canals or rivers and bathed them in the reflections of twilight and moonlight. This small panel is typical of Le Sidaner's brand of cityscape, where no human figures disturb the silence of his setting.

The Holliday panel was formerly catalogued as *Falaise au soleil couchant,* a title which was alternately interpreted as a bluff at sunset or as a reference to the Norman city of Falaise. The picture is now known to be a preparatory sketch for a larger work entitled *Houses on the River at Fougères* (Galeries G. Petit, Paris, sale, April 26, 1922; present location unknown). An old photograph of the larger painting, provided by the artist's son, reveals that the Holliday composition has been faithfully transferred to the central section of this painting (see fig. 1). In the finished work, Le Sidaner has deepened the picture plane and extended the view both left and right to include additional buildings and the arch of a small stone bridge.

The subject was identified by an inscription on the photograph labeling the painting *Houses on the River at Fougères.* Correspondence with the local government of Fougères, a small town on the eastern edge of Brittany, corroborates the new title.[2] The painting presents a view from the old neighborhood of Saint-Sulpice, with the river Le Nançon in the foreground and the Fougères belfry in the distance. Louis Le Sidaner assigns the paintings to around 1920,[3] a date consistent with the

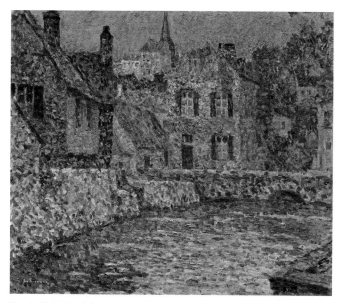

Fig. 1 Henri Le Sidaner, *Houses on the River at Fougères,* location unknown

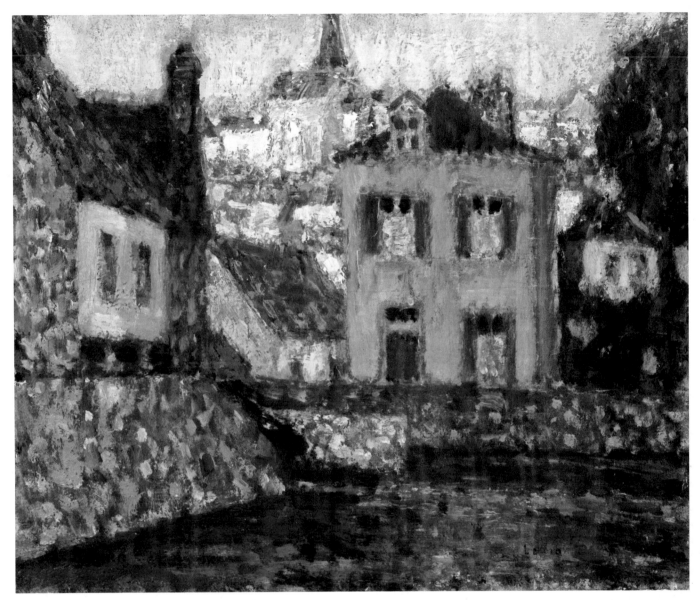

Henri Le Sidaner, Study for *Houses on the River at Fougères*

1921 stock number and the 1922 sale date of the larger version of the painting at the Galeries Georges Petit, Paris.

Typical of Le Sidaner's twilight scenes, the buildings in the Holliday picture reflect the glow of the setting sun. The distant structures still catching the sun's rays are burnished with warm yellow-orange hues, contrasting with the somber coloring of the houses near the river already steeped in shadow. The magenta tones in the darker areas create vivid color combinations, but Le Sidaner has not systematically divided his harmonies. The irregular, patchy brushwork, which owes nothing to Neo-Impressionist facture, assumes a more uniform surface pattern in the completed composition. The interplay of windows and walls builds an intricate framework of planes that reveals the artist's emphasis on construction, an

aspect of Le Sidaner's style too often overshadowed by the emotive power of his paintings.

Notes

[1] G. Mourey, "The Work of M. Le Sidaner," *Studio International,* XV, November 1901, p. 33.

[2] Letter from the Syndicat d'Initiative, Fougères to E. Lee, June 1, 1982; letter from the Mayor's office, Fougères to E. Lee, July 1, 1982.

[3] Conversation with Louis Le Sidaner, Paris, July 18, 1980; letter from L. Le Sidaner to E. Lee, November 6, 1980.

Provenance: Purchased from the artist's son, Louis Le Sidaner, Paris, by Galerie Jean Claude Bellier, Paris; W. J. Holliday, 1961.

Exhibitions: New York, Hammer Galleries, *Seurat and His Friends*, October 30-November 17, 1962, no. 46; HC 1968-69; HC 1969-70.

André Léveillé
French 1880-1962

André Léveillé was a self-taught artist. From the turn of the century until World War I, he worked as a designer for textile factories in Roubaix and Lille and devoted his leisure hours to painting and excursions to local museums. Although attracted to Rembrandt, Rubens, Goya, and Zurbaran, Léveillé was more discernibly influenced by Impressionist works seen during visits to Paris.

His landscapes of Auvergne, in which he used broad, comma-like strokes of pure color, were featured in his exhibition debut with the Indépendants in 1911. In 1914 Léveillé decided to leave his factory position altogether. Before he could implement his plan, he was injured in the outbreak of war and evacuated to a hospital in Angoulême.

While recuperating, Léveillé explored various scientific fields: he read tracts on mathematics, physics, and astronomy and studied hypotheses on the fourth dimension. At the same time, he submitted his Impressionist philosophy and style to intense critical scrutiny. Aware of innovations by Derain, Vlaminck, and Picasso, Léveillé sought a more contemporary approach for his paintings. Although introduced to Cubism at the Indépendants' shows and the Salon d'Automne of 1912 and 1913, he did not rally under its banner until led there by scientific inquiry. In the dissociated elements and complex, shifting planes of Cubism, Léveillé found a dynamic pictorial equation for denoting concepts of time and change.

His enthusiasm for Cubism was soon dampened by his concern for legibility, especially regarding the human figure. Léveillé's late portraits, landscapes, and figural groups are rendered naturalistically, but they retain Cubist elements in their rhythmically structured masses. In the mid-1920s, he also designed jewelry with a Cubist-derived geometry.

In addition to exhibitions with the Indépendants, where he served with Luce as vice-president, and at the Salon d'Automne, Léveillé was the subject of one-man shows at the Barbazanges and Bernheim-Jeune galleries during the 1920s. In 1937 he relinquished his painting career to become director of the Paris museum Palais de la Découverte, a post he held until 1960.

The Side of the Farm, 1903
oil on canvas, 14¾ x 21⁷⁄₁₆ (37.5 x 54.5)
signed and dated lower right: A. Léveillé 1903
The Holliday Collection 79.265

André Léveillé painted *The Side of the Farm* at the age of twenty-three, while he was still earning a living by designing fabrics for a manufacturer outside Lille. Executed eight years before Léveillé ventured to exhibit his pictures, this early work already shows a well-developed sense of color and structure. Its regular, precise brush strokes demonstrate the young artist's control of Neo-Impressionist facture. While Léveillé's color scheme revolves around shades of purple and green, he has rendered the shadows on the wall in blue pigment and uses flecks of orange in the foreground to complement the dense blue strokes found in the zone immediately above it. Despite his reliance on vibrant harmonies, Léveillé's approach seems to depend on an intuitive sense of pleasing color balance rather than on a systematic application of laws and theories. His sky is virtually monochromatic, and the grass shows none of the separate points of yellow-orange used by the Neo-Impressionists to represent sunlight.

In its emphasis on planar construction, *The Side of the Farm* prefigures Léveillé's Cubist orientation of the next decade. The series of sloping roofs, the facades, even the hillside in the background establish the picture's framework of tilting planes. Léveillé reinforces many of the angles of the schema by highlighting the roof lines with thin bands of white. The plunging diagonal of the wall, which slices through the composition beside the neatly demarcated yard, completes the painting's strict geometric division. Although Léveillé's postwar works never approach total abstraction, he often chose to represent volume through the faceted planes of the Cubists, the painters who were first to recognize the abstract qualities inherent in Seurat's art.[1]

Note
[1] N. Broude, "Introduction," *Seurat in Perspective*, Englewood Cliffs, 1978, p. 8.

Provenance: Paris, art market, early 1960s; London, Arthur Tooth and Sons, Ltd.; W. J. Holliday, 1965.

Exhibitions: HC 1968-69; HC 1969-70.

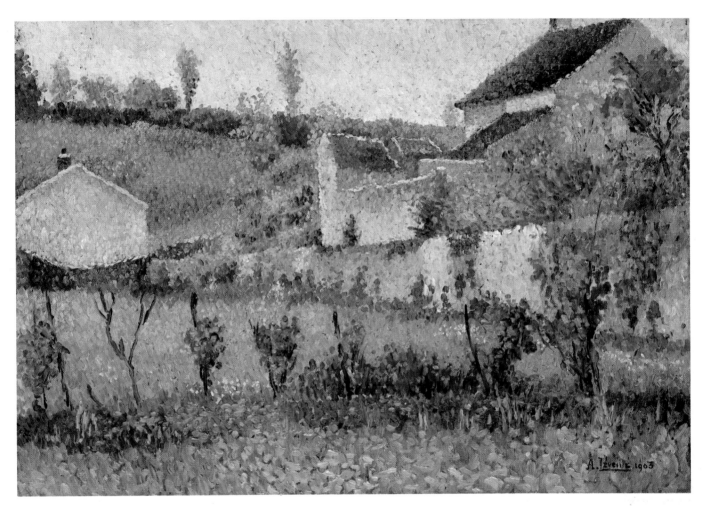

André Léveillé, *The Side of the Farm*

Marevna (Maria Stebelska Rosanovick)
Russian, b. 1892

Of Polish-Russian origins, Maria Stebelska Rosanovick spent her youth in the Caucasus. In 1910 she sought formal training in Moscow academies, where she first saw the work of the French avant-garde. While traveling in Italy the following year, she met Maxim Gorki, who suggested she take the name Marevna, meaning Daughter of the Sea, from a Russian fairy tale.

In 1912 Marevna arrived in Paris. She pursued art studies informally at the Académie Colarossi and the Académie Russe, where she was readily admitted into a cadre of Russian emigré poets and painters. Through them she was introduced to the tumultuous artistic and intellectual milieu of Montmartre and Montparnasse and to Chaim Soutine, Modigliani, Fernand Léger, Picasso, Apollinaire, Max Jacob, and Diego Rivera.

Marevna soon adopted a Cubist technique, using highly simplified geometric forms and prismatic grids. Around 1920 she turned to pointillism and often incorporated a dotted paint application into cubistic grid patterns. Marevna links this stylistic change to recollections of her youth: "When I gave up Cubism for Pointillism, I was beset with memories of the Caucasus, by visions of its mosaics, tapestries and frescoes."[1] Her subjects are usually restricted to still lifes, portraits, and figural groups. Marevna has subsequently made intermittent use of both Cubism and pointillism in her art.

During her early years in Paris, Marevna began exhibiting with the Indépendants and at the Salon d'Automne. From the late 1920s through the mid-1950s, she was the subject of occasional shows in France and England; but only since 1968, when her works were rediscovered by Robert Herbert for the Guggenheim's Neo-Impressionism exhibition, has she enjoyed international recognition.

Marevna drifted from Paris to Holland to southern France between world wars and finally settled in England in the late 1940s. Today she resides in London with her daughter by Diego Rivera, Marika.

Young Woman Sleeping, 1939
watercolor and pencil on cream heavy wove paper,
18½ x 24⅜ (47.0 x 62.0)
signed and dated lower left: Marevna/1939
inscribed lower left: P
The Holliday Collection 79.270

Although examples of Marevna's works inspired by Neo-Impressionism span the half century from 1919 to 1969, she produced some of her most ambitious pointillist pictures in the south of France during the war years. The three watercolors by Marevna in the Holliday Collection were painted in 1939 and 1940, after the artist had moved to Cannes.

The model for *Young Woman Sleeping* was the daughter of a neighbor living on the Boulevard de la Source in Cannes.[2] From myriad fine points of watercolor, Marevna has formed the image of the sleeping figure. Surmounting many of the pitfalls of a rigorous pointillist execution, she has given her subject a fresh, life-like quality as well as a sense of volume and texture. Marevna has an intuitive ability to suggest the effects of light and color on skin tones. Leaving some areas of the paper totally exposed, she gradually models the pale flesh with subtle variations of a wide range of hues. Green and blue generally indicate shadows, and denser clusters of small dots reinforce the image's main contours and enhance its sense of three-dimensionality. The picture's scale and composition are set from a vantage point so immediate that the viewer feels party to an invasion of the sleeper's privacy.

Notes
[1] Marevna, *Life with the Painters of La Ruche*, New York, 1974, p. 109.

[2] Letter from the artist's daughter, Marika Rivera Philips, to T. Smith, May 20, 1981. The barely legible date of 1939, inscribed lower left, was corroborated by the artist's daughter in the same letter.

Provenance: Purchased from the artist by Dr. Stolar, Cannes; . . . Private Collection; Paris, Galerie Jean Claude Bellier; W. J. Holliday, 1965.

Exhibitions: HC 1968-69; HC 1969-70.

Marevna, *Young Woman Sleeping*

Marevna, *Two Sleeping Women*

Two Sleeping Women, 1940
Deux endormies assises
watercolor and pencil on cream laid paper, 19⅛ x 13¼
 (48.6 x 33.7)
signed lower left: MAREVNA
inscribed on reverse: N2/Deux endormies assise [sic]
inscribed on reverse: N° 11
The Holliday Collection 79.268

The sharp angles and tilting facets of Marevna's Cubist-derived works often recur in her pointillist efforts. *Two Sleeping Women,* however, has none of the emphasis on planar structure and geometry that characterizes many of Marevna's portraits and figure studies. In this watercolor, the composition is built upon the repetition of gentle curves. Sweeping lines define the women's languid bodies, their wavy hair, and even the undulating band of the striped cloth. Some division of hues is perceptible in the treatment of their skin and hair, but most of the color modulation actually derives from gradating the saturation of the local colors, a basic watercolor technique.

In Marevna's era, the theme of lesbian love became more common and appeared in paintings by such contemporaries as Jules Pascin and Tsugouharu Foujita.

Provenance: Purchased from the artist by Mr. Aslangul, 1942; . . . Paris, Galerie Urban; W. J. Holliday, 1960.

Exhibitions: New York, Hammer Galleries, *Seurat and His Friends,* October 30-November 17, 1962, no. 68; HC 1968-69.

Marevna, *Portrait of a Boy*

Portrait of a Boy, 1940
watercolor and pencil on cream laid paper, Arches
 watermark, 18½ x 12⅛ (47.0 x 30.8)
inscribed on reverse: N° 5/bords (?) N° 73-B
inscribed on reverse: 73B/S. Vor (illegible)
The Holliday Collection 79.269

In this watercolor, Marevna has caught the surprisingly intense expression of a very young face. The artist has identified the boy as one of the gardeners working outside Cannes at the estate of Prince Serghei Luboviski, who commissioned this portrait.[1] The military look of the boy's cap and jacket was undoubtedly the source for the painting's former title, *Enfant de troupe.*

This likeness is the product of a very precise stipple technique. The boy's face is composed of slight gradations of related, rather than complementary, hues. Marevna indicates the play of light quite simply, by concentrating blue hues in the shaded zones and leaving paper exposed to mark the areas of brightest illumination.

Note
[1] Letter from M. R. Philips to T. Smith, May 20, 1981.

Provenance: Commissioned from the artist by Prince Serghei Luboviski, Cannes, 1940; . . . Paris, Galerie Urban; W. J. Holliday, 1964.

Exhibition: HC 1968-69.

Reginald Saint Clair Marston
English 1886-1943

Reginald Saint Clair Marston was never directly associated with the Neo-Impressionist movement. Though he lived in England, he made frequent excursions to Italy and southern France, where he painted the scenery of Provence, the Mediterranean, and northern Italy. He was a member of the Royal Society of British Painters and the Royal Institute of Oil Painters, where he exhibited regularly. In 1929 he and his wife Freda, also a painter, showed a number of watercolors at the Fine Arts Society in London.

Landscape
oil on canvas, 15¾ x 19¾ (40.0 x 50.2)
signed lower right: ST CLAIR MARSTON
The Holliday Collection 79.271

This alpine landscape suggests that the example of Paul Cézanne played a greater role than that of any Neo-Impressionist in the creation of Marston's art. Since Cézanne's paintings had been shown in England even before Roger Fry's landmark Post-Impressionist exhibitions of 1910 and 1912, Marston had the opportunity to become familiar with his work. The massive volumes of the mountains, anchored behind a screen of trees that bend into neatly balanced diagonals, recall Cézanne's motifs as well as his desire for architectonic compositions. Marston's remarkably uniform, short strokes function less as a method for dividing color than as a means for reinforcing his strong design. Consistently applied in orderly rows, the separate blocks of impasto are not exploited for the vibrant color effects sought by second-generation Neo-Impressionists. Indeed, most passages are based on related rather than contrasting pigments, playing into the painting's harmony of blue, green, and tan.

Provenance: London, art market; Paris, Galerie du Palais Bourbon; W. J. Holliday, 1965.

Exhibitions: HC 1968-69; HC 1969-70.

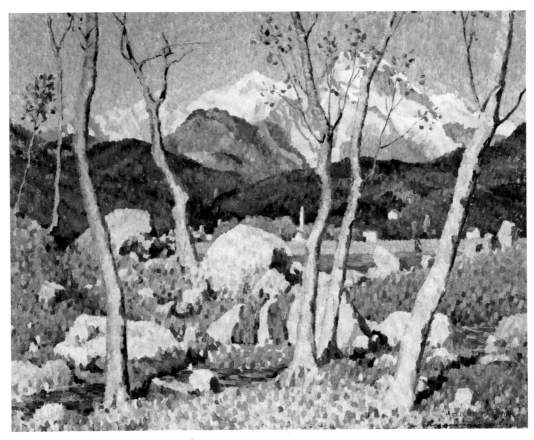

Reginald Saint Clair Marston, *Landscape*

Henri-Jean-Guillaume Martin

French 1860-1943

While an art student in Toulouse, Henri Martin was awarded a scholarship and entered the Paris atelier of Jean-Paul Laurens in 1879. The following year he began exhibiting at the Salon des Artistes Français. His works were critically acclaimed and he won numerous honors, including a travel scholarship to Italy in 1885. At this time, Martin painted allegorical and literary motifs in a classicizing manner.

Martin's trip to Italy somewhat undermined his strict adherence to traditional standards. Impressed by works of fourteenth- and fifteenth-century Italian primitives, he began to seek a mystical symbolism for his own paintings. In addition, the brilliant southern sun aroused his interest in luminous landscape painting. After his return to Paris, Martin synthesized these new concerns into a personal style influenced by Ernest Laurent and Impressionism. By 1889 he painted with short, feathery strokes of fragmented color often associated with Neo-Impressionism. Martin utilized this technique in his lyrical Symbolist works of the 1890s and in large historical and literary scenes. After 1895 these included numerous decorative mural commissions, both public and private.

Critical opinion of Martin's fusion of the progressive and the academic was mixed. The originators of Neo-Impressionism were far from enthusiastic. In 1897, Signac wrote, "I was saddened by the first rooms of the Indépendants—but, frankly, those of the Salon are still more heart-breaking ... Henri Martin and Cladel have looted us ... they now pass as inventors of 'Pointillism.' Is it really worth applying divisionism, to do it uselessly, with impure colors and no advantage whatever?"[1]

Martin's divisionist-inspired technique changed little over the rest of his life. After the turn of the century, however, he concentrated on landscape motifs, relying especially on the familiar surroundings of his homes in La Bastide-du-Vert and St. Cirq-la-Popie. He executed more mural compositions and still exhibited regularly at the salon. In addition, Martin held one-man shows in Paris and exhibited with his friends Le Sidaner and Laurent of the Société Nouvelle at the Galeries Georges Petit.

The Pergola, ca. 1915
oil on canvas, 26 x 31½ (66.0 x 80.0)
unsigned
inscribed on lower stretcher bar: La Pergola
The Holliday Collection 79.272

The sun-baked pergola, with its sturdy columns and twisting vines, is a familiar motif in the mature works of Henri Martin. In the course of his long career, Martin approached this setting from an endless variety of vantage points and consistently produced landscapes that were fresh expressions of his direct contact with nature. The site is Marquayrol, the artist's property in the village of La Bastide-du-Vert, where he maintained a home and studio atop a hill in the Lot valley, about seventy-five miles north of Toulouse. *The Pergola* was formerly catalogued as a view along the Mediterranean coast; no doubt the blue area at the right edge of the canvas was mistaken for the sea. From other paintings of the pergola, it is clear that the distant horizon is not water but the countryside beyond La Bastide-du-Vert. A local critic visiting Martin in September 1938, described his lofty retreat, "Behind the house, overlooking ... the village, extends a large terrace, paved with pretty pink bricks. On a strong and simple pergola, an untrimmed vine is turning red."[2]

In *The Pergola*, Martin transmits the intense sunlight and pulsating colors of southern France. His palette is based on bright greens, orange, and touches of red, superimposed in tiny comma-shaped strokes that give the surface a rich texture. Violet hues are reserved for the long shadows that crisscross the terrace. The brushwork, fragmented colors, and cool shadows help explain Martin's frequent classification as a follower of Seurat, but his handling of the shimmer of outdoor light lacks the systematic execution of orthodox Neo-Impressionism.

The majority of Martin's terrace scenes are undated; and as a series stretching through several decades, they maintain a remarkable stylistic consistency. Except for works of the 1890s, in which women clad in long white dresses seem to predominate, isolating distinguishing factors in the chronology of these pictures is problematic. The surface texture of *The Pergola*, however, does resemble the handling of other landscapes from the period of 1915.

Notes
[1] Rewald, Signac Diary, II, p. 299.

[2] J.-L. Gilet, "A Marquayrol," *Art Méridional*, 41, January-1939, p. 12.

Provenance: Paris, Galerie André Maurice; New York, Hugo Moser; New York, Hammer Galleries, 1960; W. J. Holliday, 1960.

Exhibitions: HC 1968-69; HC 1969-70.

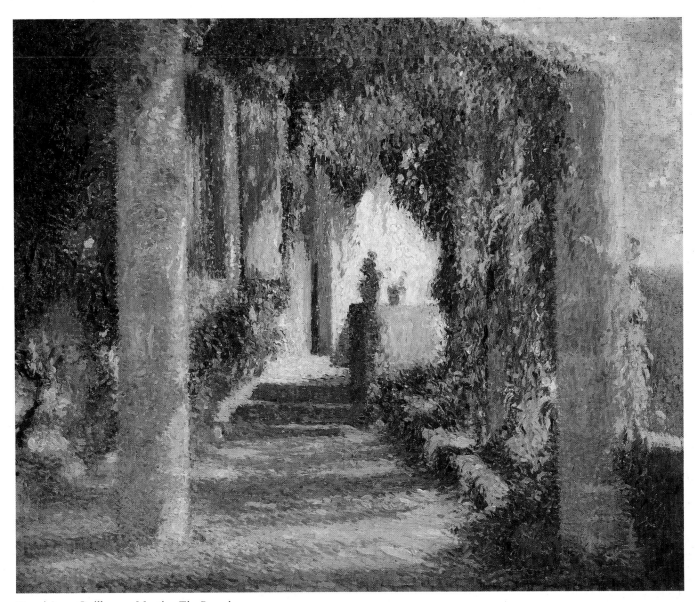

Henri-Jean-Guillaume Martin, *The Pergola*

Study for *Ditch Diggers, Place de la Concorde,* 1925 or 1926
Etude, *Terrassiers place de la Concorde*
oil on panel, 16⅛ x 12¹³⁄₁₆ (41.0 x 32.6)
signed lower right: Henri Martin
oil sketch painted on reverse
The Holliday Collection 79.273

If *The Pergola* exemplifies the landscape motifs typical of Martin's easel paintings, this sketch can be linked to the mural subjects that constitute the other side of his career. From 1895, with his first commission to decorate the Hôtel de Ville of Paris, Martin executed numerous mural paintings for government buildings and institutions throughout France. His oeuvre is replete with rapid sketches, untitled and undated, that are preparatory studies for these projects.

The Holliday sketch can be conclusively identified with one of Martin's most important assignments: the General Assembly deliberation room of the Conseil d'Etat at the Palais-Royal in Paris. The subject for this monumental triptych on the rear wall of the chamber is the resurfacing of the Place de la Concorde. While this particular laborer, with his dark cap and bib front, is absent from the composition that hangs in the Conseil d'Etat, the figure does appear in another painting of the same scene, also entitled *Ditch Diggers, Place de la Concorde.*[1]

This second version, which is a single panel, differs markedly from the mural triptych and appears to be a finished variation on the subject rather than a preparatory work for the Palais-Royal commission. This painting reveals that the worker in the Holliday sketch is actually leaning on a jackhammer, dislodging the paving stones of the famous Parisian square. Two other studies for this picture, including a full-length view of the Holliday figure, are reproduced in the Martin monograph written by the artist's son, who assigns the sketches to 1925 and 1926.[2] The location of the finished painting, which was exhibited at the salon in 1931, is undetermined and its composition is known only through reproductions.[3]

While many of Martin's mural projects illustrate mythological themes, his decorations are also drawn from contemporary subjects. Labor, and the working man and woman, are recurring themes in Martin's paintings.[4] Espousing the subject of both the rural and the urban worker, Martin has placed vignettes of the harvest on Parisian walls, installed sowing scenes in Toulouse, and painted the labor of the vineyards in Cahors. In the Savings Bank of Marseille is *Travail,* a monumental three-part cycle depicting labor through the three ages of life. In *Ditch Diggers, Place de la Concorde,* it is obvious that the focal point of the painting is not the historical event or the scenic beauty of the square, but the backbreaking work of the laborers.

In the Holliday study for the ditch digger, Martin's energetic, unrestrained execution yields a simple sketch of vitality and luminosity. On an unprimed board the artist has loosely brushed the fundamentals of the worker's posture and the balance of tonalities. The sunlight is almost palpable, as Martin lathers rich daubs of thick white impasto to indicate the sunshine beating down upon the man's shoulder. Broad strokes of rose, violet, and blue, accented with green, make up the vibrant palette. The artist's fragmented brushwork is not just the shorthand of a hasty preparatory study; Martin used divided color for his finished compositions as well. He was well known for his efforts to combine traditional mural subjects with an Impressionist treatment that simulated outdoor light. Martin began using the vibrant palette and separated strokes in his academic, mystically oriented pictures of the 1890s. He sustained the naturalistic technique, endowing a long series of decorative projects with fresh color and natural light.

Notes
[1] Tracy Smith discovered the figure of the ditch digger in the second version of *Ditch Diggers, Place de la Concorde.*

[2] J. Martin-Ferrières, *Henri Martin, sa vie, son oeuvre,* Paris, 1967, pp. 89, 91.

[3] *Terrassiers place de la Concorde* in Edouard-Joseph, *Dictionnaire-Biographique des Artistes Contemporains 1910-1930,* II, Paris, 1931, p. 457.

[4] A. Fajol, "Henry Martin et son oeuvre," *Art Méridional,* 41, January 1939, p. 10.

Provenance: Purchased from the estate of the artist by Galerie Muller et Clair, Paris, early 1950s; W. J. Holliday, 1962.

Exhibition: HC 1968-69.

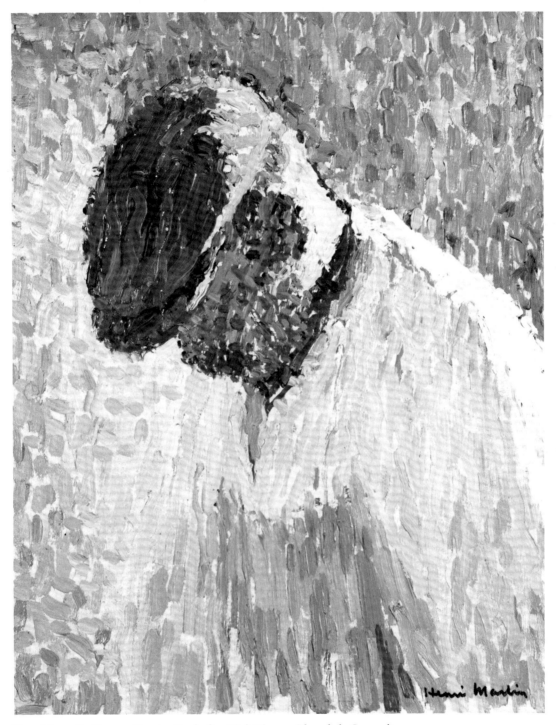

Henri-Jean-Guillaume Martin, Study for *Ditch Diggers, Place de la Concorde*

Jac Martin-Ferrières
French 1893-1974

Although Jac Martin-Ferrières sought an independent artistic identity, he never ventured far from the precedents set by his father, Henri Martin, or from the shelter of official endorsement. A student of Martin and of family friend Ernest Laurent, he adopted a modified pointillist facture in his earliest paintings. In the mid-1920s, however, Martin-Ferrières replaced this technique with one using broad color areas and heavy outlines. While he became a prominent figure in the Salon des Artistes Français, where he began exhibiting in 1920, he nonetheless remained indebted to his father in his choice of provincial landscape subjects.

Like his father, Martin-Ferrières also found inspiration in both the topography and artistic heritage of Italy. He first traveled to Italy in 1924 on a salon award and returned frequently between 1925 and 1928. From 1928 to 1933, Martin-Ferrières executed a series of frescoes for the church of St. Christophe de Javel in Paris, the first of numerous decorative commissions acknowledging the influence of his Italian studies. By turning to a large mural format, he also followed in Henri Martin's footsteps.

Martin-Ferrières interrupted his painting career to serve in the French resistance movement during World War II. Although he lost an eye while a prisoner of war, he resumed his art efforts around 1950.

The Seine in Winter, 1921
oil on canvas, 21³⁄₁₆ x 25½ (53.8 x 64.8)
signed and dated lower left: Martin-Ferrières 21
The Holliday Collection 79.274

In the early years of his career, Jac Martin-Ferrières often painted the quays of Paris. From 1916 through the early 1920s, he used a broad pointillist technique unrestricted by the formulas of color theory. Indeed, the dotted facture of *The Seine in Winter* does more to establish the picture's firm structure than to articulate its color scheme, and many of the color effects could have been achieved without fragmented brushwork. The scene is composed of large, uniform bricks of color applied over a thick, white ground. In the river, bridge, and distant horizon, the colors are based on related rather than complementary hues. The artist has used dark gray and black strokes to reinforce contours in the fore- and middle grounds. The flat, almost childlike rendering of the trucks accentuates the naive simplicity that is the painting's overall effect.

Reversing the usual course of artistic development, Martin-Ferrières executed his experimental, pointillist pictures prior to the works that brought him salon medals and Italian travel. By the mid-1920s, he had broken completely with his earlier technique and was producing realistic portraits and landscapes based on a firm linear framework and a more solid handling of color. Gustave Kahn's 1927 review of his early career does not even acknowledge the pointillist phase.[1] Like his father, Martin-Ferrières eventually divided his interests between landscape subjects and decorative projects embracing historical or religious themes.

Note
[1] G. Kahn, "Jac Martin-Ferrières," *L'Art et les artistes,* March 1927, pp. 200-204.

Provenance: Purchased from the artist by Galerie Paul Pétridès, Paris, ca. 1967; W. J. Holliday, 1967.

Exhibition: HC 1968-69.

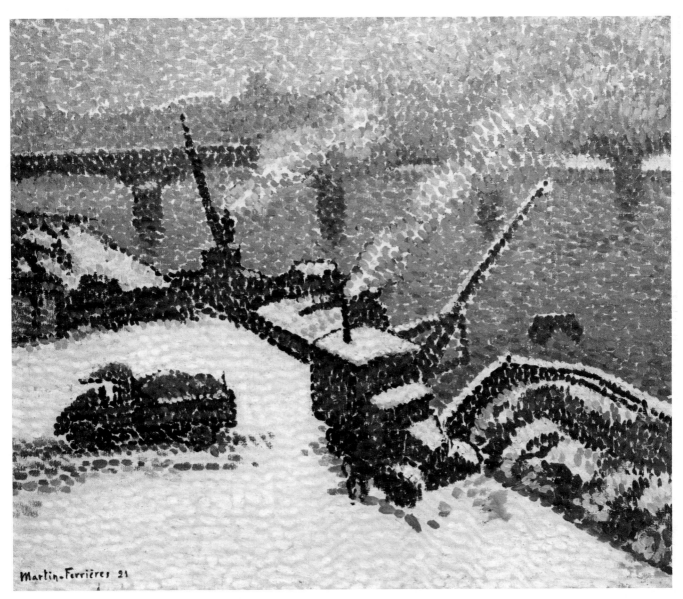

Jac Martin-Ferrières, *The Seine in Winter*

Thomas Buford Meteyard
American 1865-1928

Like most American painters of the late nineteenth century, Thomas Meteyard mapped the course of his career according to transatlantic artistic currents. Educated in Chicago and at Harvard University, Meteyard also received art training in Paris during his first trip there sometime in the late 1880s. Influenced by the canvases of Monet, possibly even working with the master at Giverny, he quickly adopted the subject matter and technique of French Impressionism. By 1891 Meteyard had exhibited his French scenes in Chicago, where they were praised for their sparkling light and color effects.

For the next twenty years, Meteyard was in perpetual motion, dividing his time between Paris, London, and his home in Scituate, Massachusetts. His paintings were seen in exhibitions throughout the United States, in London, and in Paris during this period. Although Meteyard is nearly always characterized as an Impressionist, his oeuvre also includes book illustrations executed in a decorative, linear manner.

In 1910 Meteyard settled near Rye with his English wife. While he had enjoyed a moderately successful career during his years of travel, he lapsed into obscurity for the remaining eighteen years of his life. In the 1950s, however, Meteyard's paintings were once again exhibited, primarily in London.

The Beach, Scituate
oil on canvas, 14¾ x 21¹³⁄₁₆ (37.5 x 55.4)
unsigned
The Holliday Collection 79.275

The Beach, Scituate is the Holliday Collection's sole American example of an Impressionist approach to landscape painting. Thomas Meteyard painted this canvas on the Atlantic coast south of Boston, in the Massachusetts town he made his home between frequent voyages abroad. Though the exact dates of Meteyard's residence in Scituate are not known, exhibition catalogues from 1903 and 1905 record Scituate as his address. *The Beach, Scituate* must have been painted sometime between the mid-1890s and 1910, the year that Meteyard settled in England. It is one of at least a dozen views of Scituate where Meteyard, demonstrably influenced by Claude Monet, used the New England shore as his backdrop for the elusive effects of light and atmosphere.

Limiting his palette to a few high-key hues, Meteyard has achieved a truly radiant landscape. He applies short, thin strokes of yellow, rose, blue, and bright green to an unprimed canvas. Meteyard eschews a rich, glossy surface in favor of a thin paint layer, which allows the texture of the canvas to emerge, creating an effective means of conveying the haze of intense sunlight. He showers the dunes in yellow and defines their shadows and recessions with blue pigment and the darker tone of the raw canvas.[1]

Some of the silence and simple grandeur of Seurat's Channel seascapes pervade *The Beach, Scituate*. Meteyard's panoramic sweep of coastline has an underlying firmness undissolved by shimmering colors or rapid brushwork. In Meteyard's hands, the land becomes an enduring form that persists amidst the fleeting effects of natural light.

Note
[1] The relief, or shaded effect, created by these exposed areas of canvas may now be of greater contrast than the artist intended. A combination of aging and discoloration caused by a varnish coat has contributed to the darkening of the canvas fabric. Cleaning by IMA conservator John Hartmann has recovered some of the canvas' original lighter shade.

Provenance: Purchased from the artist's widow by Redfern Gallery, London, 1950s; New York, Hirschl and Adler Galleries, Inc., 1960; W. J. Holliday, 1966.

Exhibitions: London, Redfern Gallery, *Selected French Paintings*, February 18-March 18, 1960, no. 26; HC 1968-69; HC 1969-70.

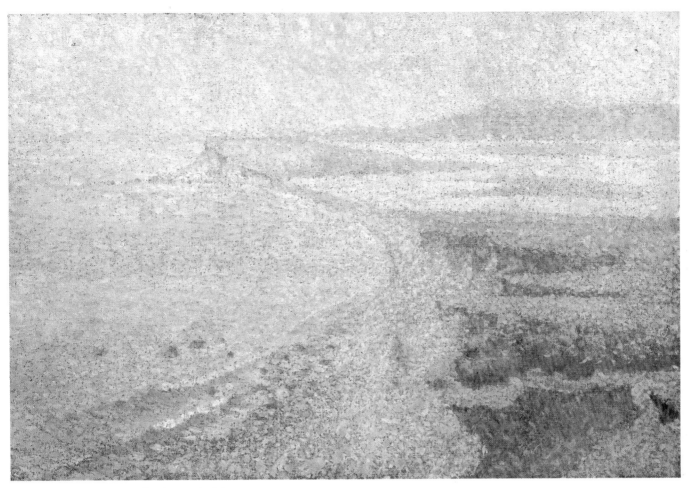

Thomas Buford Meteyard, *The Beach, Scituate*

Jean Metzinger
French 1883-1956

Jean Metzinger is known as a Cubist, but he began his painting career as a Neo-Impressionist. At the age of twenty he moved to Paris and by 1905 was painting according to divisionist principles. With his close friend Robert Delaunay, Metzinger joined Neo-Impressionism's second wave by dissecting landscape, figure, and still-life subjects into vibrant, uniformly rectangular brush strokes.

By 1909 Metzinger had abandoned Neo-Impressionism for Cubism. A frequent visitor to Picasso's studio in the Bateau Lavoir, he was one of the first to realize the importance of Picasso's and of Braque's pictorial explorations and was instrumental in organizing their followers into a coherent movement. Cubism was officially announced at the 1911 Indépendants' through works by Fernand Léger, Albert Gleizes, Henri Le Fauconnier, Delaunay, and Metzinger, who had insisted they be hung together in the now famous "Salle 41." In 1912 Metzinger and Gleizes published the first theoretical discussion of the new style, *Du Cubisme*. During this pre-war period, Metzinger exhibited with other Cubist painters throughout Europe as well as with the Indépendants, the Salon d'Automne, and the Section d'Or in Paris. In 1915 he signed a contract with dealer Léonce Rosenberg.

After serving in the military during the war, Metzinger returned to Paris and painted in a synthetic Cubist manner. Through the years he evolved a figural style of simplified forms and flat colors, which subjugated Cubist elements to decorative purposes.

The Seashore, ca. 1905
oil on canvas, 25⁷⁄₁₆ x 35¹⁵⁄₁₆ (64.6 x 91.3)
signed lower left: Metzinger[1]
The Holliday Collection 79.276

Jean Metzinger's *Seashore* is a prime example of the Neo-Impressionism adopted by many artists who later became Fauves or Cubists. In these works from the first decade of the twentieth century, the small points of pigment have become the conspicuous building blocks of the composition, and the search for naturalistic light and color has been superseded by efforts to achieve the most vibrant chromatic effects. Metzinger's divisionist phase stretches from 1905 to 1908.[2] The Holliday painting was executed around 1905, before Metzinger's brand of Neo-Impressionism took the form of sharp, precise rectangles of color carefully arranged in mosaic patterns. The brushwork of his 1906 *Portrait of Robert Delaunay* (Christie's, London, December 2, 1966, no. 20) is far from being the artist's most tightly structured, but it is still much more consistent than the overlapping dashes of *The Seashore*. The looser strokes of the Holliday landscape lack the mechanical rigor of the later works and give *The Seashore* a lyricism absent from the more strictly ordered compositions.

Metzinger's coastal scene may have been inspired by Henri Matisse's famous bow to Neo-Impressionism, *Luxe, calme et volupté* (Musée National d'Art Moderne, Paris; fig. 1). This canvas was painted in late 1904 or early 1905, after Matisse spent the summer of 1904 with Signac at Saint-Tropez.[3] Metzinger could have seen Matisse's painting at the Indépendants' salon during the spring of 1905. In his treatment of the subject, Metzinger reverses the emphasis that Matisse gave the elements of his scene: the prominent figures posed along Matisse's serpentine shoreline have been relegated to a minor compositional detail in *The Seashore*, where landscape elements predominate. Metzinger has, however, imitated the stylized treatment of Matisse's bathers, outlining the silhouettes of his figures with a thin blue band.

Fig. 1 Henri Matisse, *Luxe, calme et volupté,* Musée National d'Art Moderne, Paris

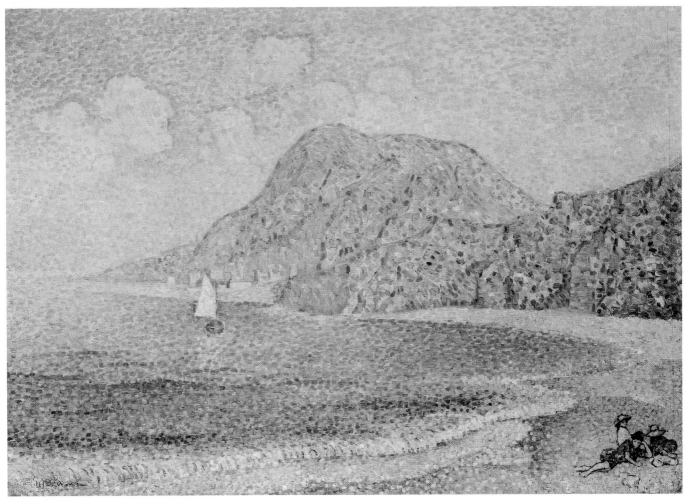

Jean Metzinger, *The Seashore*

A recent cleaning of *The Seashore* has unveiled the iridescent hues of Metzinger's picture. Its exalted harmonies now meet the objectives of the younger Neo-Impressionists and match the intense colors appropriate for the Côte d'Azur. Turquoise and violet dominate the sky, and Metzinger has articulated the great volume of the hills by alternating warm and cool hues over its sunny and shaded planes. The most overtly decorative treatment occurs on the shore just above the reclining bathers, where a violet area of the beach (presumably a shadow cast by an unseen hill) assumes the form of two arcs that contrast with the light tonality of the sandy shore and act as foils to the ellipses of the coastline. Often visible beneath the broken strokes is a dark blue paint that Metzinger used to delineate the main angles of the composition.

Just a few years after his embrace of Neo-Impressionism, Metzinger directed his formalist tendencies to Cubism. Within a decade of painting *The Seashore*, he joined Albert Gleizes in writing a treatise on Cubism. From his new perspective, Metzinger expressed some distinctly different views on the color choices fundamental to Neo-Impressionism. As a Cubist, Metzinger regretted the Neo-Impressionists' tendency to avoid neutral colors in favor of a reliance on complementary harmonies.[4]

Notes

[1] Remnants of an earlier signature, in blue paint, lie below the somewhat abraded signature in the lower left corner. The latter has been partially obscured by the artist's reworking of that area of the canvas.

[2] In *Neo-Impressionism*, p. 220, Herbert brackets Metzinger's Neo-Impressionist phase from sometime before the Indépendants' exhibition in the spring of 1905 to 1908.

[3] When Matisse first made his study for *Luxe, calme et volupté*, he was a guest of Signac at Saint-Tropez, where Cross' *Evening Air*, 1894 (Musée du Louvre, Paris), with its similar figures and approach, hung in his host's villa.

[4] A. Gleizes and J. Metzinger, *Cubism*, London, 1913, pp. 37–39.

Provenance: Brussels, Galerie Europe; New York, Hirschl and Adler Galleries, Inc., 1960; Paris, Galerie René Drouet, 1964; W. J. Holliday, 1964.

Exhibitions: New York, Hirschl and Adler Galleries, Inc., *Selections from the Collection of Hirschl and Adler Galleries*, January 1961, no. 73 (reprod.); HC 1968-69; HC 1969-70.

Literature: "Divide and Conquer," *Apollo*, XCIV, October 1971, p. 316 (reprod.).

Georges Daniel de Monfreid
French 1856-1929

Georges Daniel de Monfreid was born to affluence and lived in relative ease. He was educated in Geneva and Montpellier and then devoted himself to sailing the Mediterranean, managing the family estate in the Pyrenees, and painting. In 1874 he first sought formal training at the Académie Julian in Paris. By 1880 de Monfreid was depicting landscapes of Roussillon and the Paris environs in the style of the Barbizon School.

In 1882 de Monfreid met Emile Schuffenecker, who introduced him to Paul Gauguin in the mid-1880s. By 1887 he was using a conspicuous, lengthened stroke and an intensified palette in landscape and figure subjects that recall works of the Pont-Aven School. When de Monfreid debuted two years later in the *Groupe Impressionniste et Synthètiste* exhibition at the Café Volpini, he was painting with divided colors. His so-called Neo-Impressionist period lasted only through 1890, but for the next ten years he exhibited at the Indépendants and other avant-garde shows.

During the 1890s de Monfreid was one of Gauguin's staunchest supporters. While Gauguin painted in Oceania, de Monfreid actively promoted Gauguin's works to dealers and provided him with financial assistance. Their friendship produced the body of correspondence that intimately documents Gauguin's South Pacific experiences. De Monfreid's beneficence was not exclusive: he also supported sculptor Aristide Maillol during this period.

After the turn of the century, de Monfreid spent the greater part of each year at his estate, Saint-Clément. His late oeuvre is dominated by landscapes, but it also includes portraits and still lifes painted in rich colors with an Impressionist brushwork.

Roussillon Landscape, 1889
oil on canvas, 28¹¹⁄₁₆ x 39⁵⁄₁₆ (72.9 x 99.9)
inscribed, signed, and dated lower left: *Souvenir d'amitié à/
mon vieux camarade/Ernest Cros./Daniel 1889*
The Holliday Collection 79.277

Heat, and the dazzling brilliance of Mediterranean light, are the overriding sensations of Daniel de Monfreid's landscape. In a simple juxtaposition of sun-baked rock and vibrant blue sky, de Monfreid presents the coast of the province of Roussillon, near the Pyrenees mountains. The artist's mother acquired property in that region when de Monfreid was a young boy, and throughout his life he would return to the area to paint and indulge his love of the sea.

Roussillon Landscape was one of several coastal scenes painted in the vicinity during 1889, the same year de Monfreid entered the Paris art arena with his participation in the Café Volpini exhibition. The years 1889-1890 are considered the period of his flirtation with Neo-Impressionism, and this canvas shows de Monfreid venturing to divide color for luminous effect. Across the blue sky is a pointillist overlay of colors, which changes gradually from warm shades on the right side of the picture to cooler ones on the left. Since the light source is off to the right of the composition, the modulation is presumably a novel attempt to indicate distance from the sun. Below the horizon line and the sea, de Monfreid's surface texture is not consistent: the vegetation has a dotted, or comma-shaped facture, while rocks are generally composed of smoothly blended strokes rather than of discrete particles of color. The artist tints the predominant warm tan of the shore with reflections of rose, green, blue, and violet, but his use of complementaries is limited and unsystematic. De Monfreid's adept coloring of the Roussillon coastline owes more to his sensitivity to the nature of outdoor light than to his reliance on Neo-Impressionist principles.

While the emphasis in de Monfreid's painting may be atmospheric effects, three-dimensionality remains a distinctive element of *Roussillon Landscape.* The artist has anchored his light and shadow to the very convincing solidity of the rocky shore and its tiny hut. Beneath an Impressionist's intuition for the transience of light lies an enduring sense of volume and pictorial construction.

Provenance: Paris, Galerie Jean Claude Bellier; W. J. Holliday, 1964.

Exhibitions: HC 1968-69; HC 1969-70.

Literature: W. Jaworska, *Gauguin et l'école de Pont-Aven,* Neuchâtel, 1971, p. 84 (reprod.).

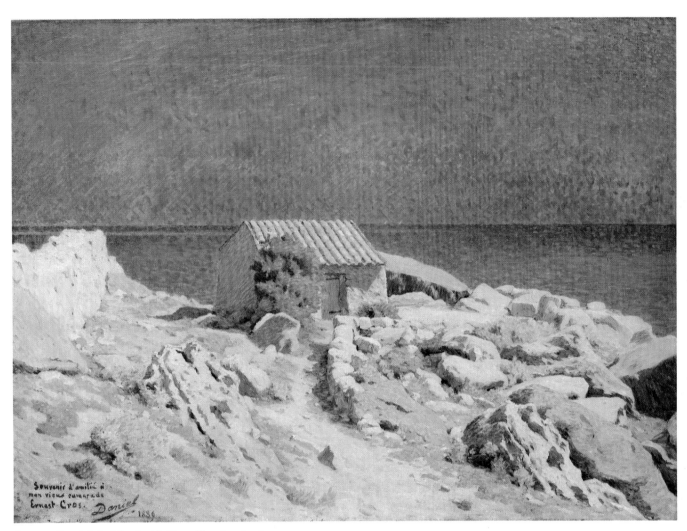

Georges Daniel de Monfreid, *Roussillon Landscape*

Georges Paul-Manceau
French 1872-?

Georges Paul-Manceau was a man of great versatility. Trained as a medical doctor and a lawyer, he expressed his artistic temperament as a critic as well as a painter and sculptor. His oeuvre consists primarily of landscapes, which he began exhibiting with the Indépendants in 1897 and with the Société Nationale des Beaux-Arts in 1900.

On the Rhine, Midday Sunshine, 1909
oil on panel, 10⁷⁄₁₆ x 13¾ (26.5 x 34.9)
signed and dated lower left: PAUL-MANCEAU-1909
inscribed on reverse: (illegible) /Le Rhin à St. Goar/Tournant
 de la Souris/Soleil du Midi
colorman stamp on reverse: Sennelier, Paris
The Holliday Collection 79.267

With great freedom of execution and a palette restricted to pure prismatic colors, Paul-Manceau has brushed this fresh landscape sketch. Over a bright white ground and a simple pencil underdrawing, he applies broad strokes in varied directions, not confining himself to a single surface pattern. The picture's vibrant colors and 1909 date place it in the immediate wake of the Fauves' brash use of color. An inscription on the reverse indicates that the locale is a bend along the Rhine River. The artist has also noted that his picture was painted under the light of midday sun.

Provenance: Nice, Private Collection; New York, Schweitzer Gallery, 1966; W. J. Holliday, 1966.

Exhibition: HC 1968-69.

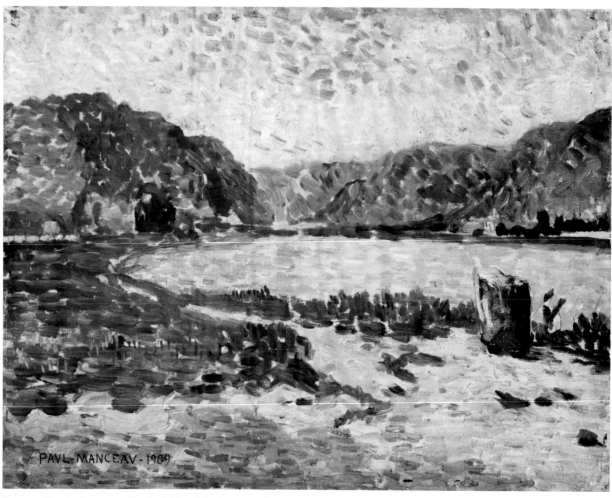

Georges Paul-Manceau, *On the Rhine, Midday Sunshine*

Henri Person
French 1876-1926

The art and life of Henri Person revolved around Paul Signac and the attractions of the southern French coast. Like Signac an avid seaman, he often accompanied the older painter on sailing ventures throughout the Mediterranean. Sometime around the turn of the century, he settled in Saint-Tropez. Person had studied formally at the Paris Ecole des Beaux-Arts with Fernand Cormon and Fernand Humbert, but as a frequent guest at La Hune, he acquired a more progressive artistic outlook. His oeuvre, which consists almost exclusively of watercolor and oil depictions of the Midi, reveals the impact of both divisionism and Fauvism.

Person exhibited with the Indépendants and in 1913 was the subject of a one-man show at Bernheim-Jeune. He was a founder of the Musée de l'Annonciade; and although he led a quiet life and never received widespread recognition, he is honored in Saint-Tropez with a street bearing his name.

Tree in Bloom, ca. 1904
L'arbre en fleur
oil on paper mounted to canvas, 13⅜ x 16⅞ (34.0 x 42.9)
signed lower left: Person
The Holliday Collection 79.280

Henri Person found his motifs in the bright sunshine of southern France and his mentor in Paul Signac. His flowering tree blooms amidst the sun-baked walls of a deserted street that may well be a corner of the picturesque old quarter of Saint-Tropez known as La Ponche. The warm hues of the facades and the contrast of their blue and violet shadows convey the sense of intense heat and sunlight associated with Mediterranean townscapes.

Person's composition is constructed with separate patches and strokes borrowed from divisionism. He draws upon the pure colors common to the movement, but is not strictly bound by theories of constituent hues. This landscape shows a greater diversity of brushwork than do many of Person's pictures that are more closely related to Signac and Cross. In *Tree in Bloom*, rounded daubs of rich impasto are transformed into white blossoms, while larger, flatter strokes aligned in loose rows compose the remainder of the scene. Person works within a shallow picture plane, placing his tree in the narrow foreground left by the buildings. Threatening to extend beyond the border of its frame, the tree branches out into a delicate screen, acting as a foil to the rectilinear forms of the architecture.

The majority of Henri Person's works are undated. This landscape has been assigned to around 1904,[1] a plausible date for a picture intimately associated with the flowering of what could be called the Saint-Tropez school.

Note
[1] Lucile Manguin, who formerly owned this picture and organized a Person exhibition in 1961, provided the 1904 date. Letter from L. Manguin, Galerie de Paris, to T. Smith, November 30, 1981.

Provenance: Purchased from the artist's widow by Galerie de Paris, Paris, 1960; Cologne, Abels Gemäldegalerie; W. J. Holliday, 1962.

Exhibitions: Cologne, Abels Gemäldegalerie, *Französische Maler des Nachimpressionismus*, March 10-April 20, 1962, no. 35; HC 1968-69.

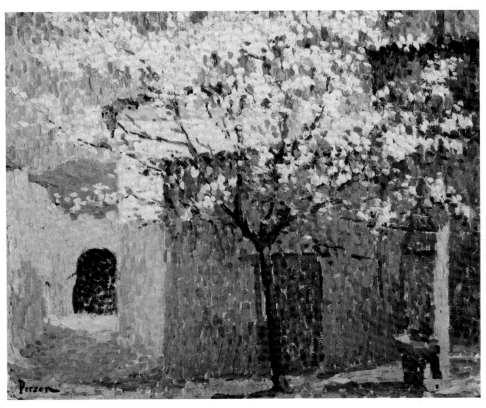

Henri Person, *Tree in Bloom*

Hippolyte Petitjean

French 1854-1929

Hippolyte Petitjean first studied art in Mâcon while employed as a *peintre-décorateur*, then in 1872 became a pupil of Alexandre Cabanel at the Paris Ecole des Beaux-Arts. Impressed by the work of Puvis de Chavannes, Petitjean created allegories and mythological scenes using academic standards. He was a regular contributor to the salon from 1880 to 1890.

Petitjean met Seurat in 1884 and joined the Neo-Impressionists in 1886. While he supposedly employed a Neo-Impressionist technique from 1887 on, his documented divisionist period occurred between 1890 and 1894. In 1891 Petitjean began to exhibit with the Indépendants and was included in a show at Le Barc de Boutteville in 1892 and with Les Vingt in 1893.

Feeling restricted by divisionism's formulas, Petitjean returned to more traditional standards in 1894. For the next fifteen years, Petitjean again looked to Puvis for inspiration, depicting mythological and bathing scenes with feathery strokes but little systematically divided color. He also admired Millet and Ingres. Their names, along with Puvis', graced the entrance to his Paris home. Although Petitjean exhibited occasionally with the Indépendants during this period, he returned to the official salon in 1897. The following year, he was employed as a drawing instructor in a city school.

Sometime after 1910, Petitjean once again adopted a Neo-Impressionist palette and technique and worked primarily in watercolor. Petitjean exhibited little during the last years of his life and died in poverty.

The Seine at Mantes

La Seine à Mantes
watercolor on white wove paper, $15\frac{15}{16}$ x $24\frac{13}{16}$ (40.6 x 63.0)
signed lower left: hipp. Petitjean
atelier stamp lower right: Atelier/Hipp. Petitjean
The Holliday Collection 79.282

Throughout his career, Hippolyte Petitjean vacillated between the conservative weight of sanctioned art traditions and the progressive pull of Neo-Impressionism. Even after he joined the group, he still tried to exhibit at the official salon. Within a few years, he was expressing doubts about the practice of divisionism and soon turned to imitating the mythological scenes of Puvis de Chavannes. Sometime after 1910 Petitjean was again attracted to Neo-Impressionism, but he never resumed a rigorous, wholehearted use of its theories.

The Seine at Mantes is one of several watercolors Petitjean painted in the later part of his career, during his second flirtation with Neo-Impressionist technique. The artist displays his ability to control pointillist handling in the watercolor medium, but his division of color is based on decoration rather than optics. Instead of careful combinations of local and reflected color, the tones of the foliage of the right riverbank are orchestrated to play into the picture's glowing harmony of blue, yellow, green, and rose.

Even if Petitjean used Seurat's laws of color arbitrarily, this watercolor shows his grasp of the master's stable compositions and massing of volume. He clearly defines the spatial progression of the scene, where the Seine winds into Mantes, thirty-five miles northwest of Paris. The gently bending river and majestic sweep of sky create two great axes that move into a firm yet dynamic format. The only verticals punctuating the soft curves of the landscape are the Tour St.-Maclou on the left and the twin towers of the Gothic church of Notre-Dame on the right. A brilliant blue is used for the shrubbery that rises to mark the foreground, and paler, less saturated hues and areas of unpainted white paper enhance the atmospheric perspective as the vista recedes. In *The Seine at Mantes*, Petitjean combines a strong pictorial framework with delicate nuances of color to create one of his finest watercolors.

Provenance: Paris, Galerie Charpentier, estate sale, December 5, 1957, no. 211; Paris, Galerie d'art du Faubourg, 1957; W. J. Holliday, 1959.

Exhibition: HC 1968-69.

Literature: J. Sutter, ed., *The Neo-Impressionists*, Neuchâtel, London, and Greenwich, Conn., 1970, p. 121 (reprod.).

Hippolyte Petitjean, *The Seine at Mantes*

Attributed to Hippolyte Petitjean
Three Figures in a Landscape
oil on cotton fabric, 18 x 14¹⁵⁄₁₆ (45.7 x 38.0)
unsigned
The Holliday Collection 79.239

This unsigned picture was formerly attributed to Neo-Impressionist painter Henri Edmond Cross, but neither the figures nor the technique establish it as his work. Isabelle Compin, author of the Cross *catalogue raisonné*, has observed that the brushwork and color range do not appear to relate to any period of Cross' career.[1] A more plausible attribution is to the occasional Neo-Impressionist Hippolyte Petitjean. The picture's setting corresponds to the other side of Petitjean's oeuvre, when his admiration for Puvis de Chavannes led him to paint pastoral groups posed in remote, wooded landscapes.

Petitjean's paintings in this genre span a period from 1895 to at least 1919. His subjects range from specific mythological characters in arcadian retreats to bathing figures with no explicit literary association. In handling they vary from a regular, pointillist application, usually found in the earlier works, to a looser treatment with longer and broader strokes flowing in diverse directions.

The Holliday picture most closely resembles *The Storyteller*, signed with monogram but undated (Palais Galliera, Paris, June 28, 1968, no. 28). Both compositions have the short, parallel brush strokes as well as the juxtaposition of bright and somber hues in the grassy areas. They have similar active surface patterns, as the directional flow of paint changes with the different elements of the scene. The figures in each are also comparably scaled within their settings. As in other landscapes by Petitjean, the planes in *Three Figures in a Landscape* are not well articulated, leaving the differentiation between pond, grass, and path somewhat unconvincing.

The painting is not identifiable as any of the works on Petitjean's roster of oil paintings, though the many studies he executed were not included in the roster.[2] Another troublesome aspect of the attribution lies in the everyday garb of the small girl, since Petitjean's figures are usually swathed in drapery. Yet the subject is hardly an uncommon one; and his biographer, Lily Bazalgette, has noted that the theme is typical of works Petitjean painted while summering at Verchizeuil (Burgundy) from 1897 to 1903, where he used his wife and young daughter as models.[3]

Three Figures in a Landscape is painted on lightweight blue cotton fabric. Infra-red reflectography shows a squared-off grid beneath the paint layer, which would suggest the existence of a preparatory drawing for the composition, though this picture certainly does not appear to be the result of a careful transfer of scale.[4] Petitjean did paint wall-size landscape scenes, but if the Holliday picture were intended to relate to a larger composition, it has not yet come to light.

Notes
[1] Conversation with I. Compin, Paris, July 11, 1980.

[2] L. Bazalgette, "Hippolyte Petitjean," in Sutter, ed., *The Neo-Impressionists*, p. 124.

[3] Letter from L. Bazalgette to E. Lee, August 20, 1981. Bazalgette is preparing a catalogue of Petitjean's works in oil.

[4] IMA textile conservator Harold Mailand and painting conservator David Miller analyzed the picture's support and underdrawing.

Provenance: Paris, Galerie Alfred Loeb; New York, Schweitzer Gallery, 1961; New York, Hammer Galleries, 1961; W. J. Holliday, 1962.

Exhibitions: New York, Hammer Galleries, *Seurat and His Friends*, October 30-November 17, 1962, no. 30; HC 1968-69; HC 1969-70.

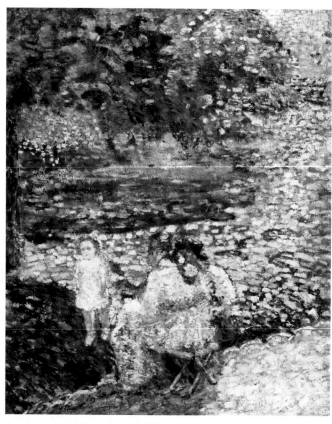

Attributed to Hippolyte Petitjean, *Three Figures in a Garden*

Georges Manzana Pissarro
French 1871-1961

Like his older brother Lucien, Georges Manzana Pissarro was initially trained at home by his father Camille. In 1889 he studied woodcarving with a disciple of William Morris in London, where he spent most of the next four years. Manzana Pissarro's painting career commenced in earnest with his return to France in 1893. For the next thirteen years, he looked to Impressionist principles for guidance, painting landscapes and portraits with a textured, flowing brushwork and subdued color contrasts. Manzana Pissarro enjoyed the camaraderie of many of Camille's colleagues and portrayed Cézanne, Monet, Toulouse-Lautrec, Signac, and Luce in a series of caricatures. He began exhibiting his Impressionist paintings in Paris galleries in 1898 and with the Indépendants in 1903. He also published drawings in the Anarchist journals *Le Père Peinard* and *Les Temps Nouveaux.*

In 1906 Manzana Pissarro shifted from a reliance on nature to a new emphasis on ornamentation. The fanciful paintings and decorative art objects he produced through the mid-1930s are the basis for his present reputation. Exotic plant life, animals, and harem themes inspired by literary sources such as *The Arabian Nights* are the subjects of most canvases from this period. Manzana Pissarro used stylized, richly patterned forms, swirling contours, and bright colors indebted to the Art Nouveau movement to portray his imagined scenes. His decorative art output included stained glass windows, furniture, screens, and tapestries, which also reflected his passion for orientalism. From 1906 to 1929, he exhibited nearly every year in Paris, with the Salon d'Automne as well as with the Indépendants, and in numerous one-man shows.

Manzana Pissarro seldom exhibited after 1929, but he never relinquished his art career. Around 1934 he renewed his interest in nature and painted landscapes and flower gardens with fragmented strokes and bright hues. These later Impressionist works, however, contain decorative elements which indicate that Manzana Pissarro now sought to embellish nature rather than to directly portray it.

Rue de l'Epicerie, Rouen, 1898
oil on cotton fabric, 25½ x 21¼ (64.8 x 54.0)
dated and signed lower right: 98 Georges Pissarro
colorman stamp on reverse: P. Contet, Paris
The Holliday Collection 79.283

Although Camille Pissarro's second son achieved his greatest fame as the designer of ornamental paintings and furnishings based on exotic motifs and materials, the Holliday cityscape shows his early training in the Impressionist mode. Through his father, Georges Manzana Pissarro was schooled in the close observation of nature. At the turn of the century, he was still pursuing the Impressionist aesthetic, exhibiting landscapes whose titles show his preoccupation with changing climate and light.

A comparison of *Rue de l'Epicerie, Rouen* with a contemporary photograph (fig. 1, p. 159) shows how faithfully Georges has transcribed his view of the street that leads to the south portal of Rouen Cathedral. More pertinent, however, is its similarity to three canvases executed by his father in the same year. Of the three paintings by Camille Pissarro, two (Venturi 1036 and 1037) present a more elevated vantage point and do not show the street's outlet at the steps of the cathedral. The third, also called *Rue de l'Epicerie, Rouen* (Venturi 1038; Private Collection, England), is virtually the same scene as Georges' and permits a direct view up the old street to the cathedral's Portail de la Calende (fig. 2, p. 159). The only notable variation is that Georges narrowed the left margin of his composition, eliminating the cathedral's south tower.

Given the close teaching relationship that existed between father and son, it is certainly possible that Georges painted this canvas in the company of Camille. While it is now known that Georges sometimes assigned earlier dates to pictures he had actually painted several years later, this possibility can be safely ruled out in the case of the Holliday picture. The records of Durand-Ruel document that the gallery purchased *Rue de l'Epicerie, Rouen* from the colorman Contet on November 12, 1898, and it remained at the gallery until 1965.[1] The signature "Georges Pissarro" is also appropriate because Georges did not begin signing his works "Manzana Pissarro" until the 1920s.

As a member of a close family for whom painting excursions were commonplace, Georges could easily have traveled from the family home at Eragny to join his father. While the published correspondence of the Pissarro family does not refer to Georges' presence in Rouen during the summer of 1898, three letters in the Pissarro Family Archive, Ashmolean Museum, Oxford, document that Georges did indeed visit his father in Rouen. On July 23, 1898, Camille wrote to his son Lucien, "Here I am finally in Rouen. I am waiting for Georges to arrive this morning from Eragny."[2] And on August 19, 1898, Camille wrote, "Yesterday I discovered an excellent place, where I hope to paint the rue de l'Epicerie and even the market, a really interesting one, which is held there every Friday."[3] Another comment in the same letter indicates Georges' intention to remain in Rouen several days beyond the date that Camille discovered his new motif.[4] Sometime during that period, father and son must have set up their easels at the rue de l'Epicerie. No more than a few hours separate the two canvases, since

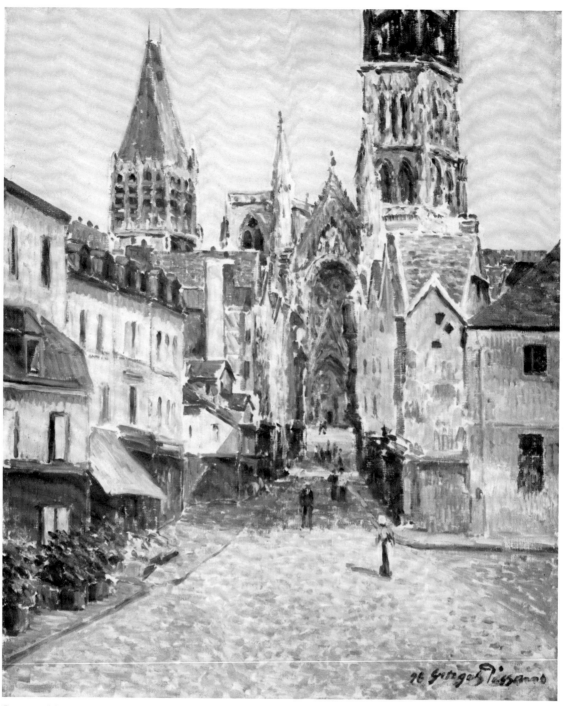

Georges Manzana Pissarro, *Rue de l'Epicerie, Rouen*

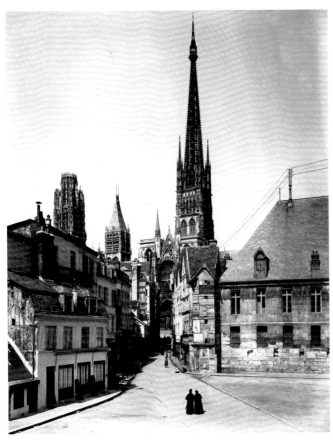

Fig. 1 View of the rue de l'Epicerie, approaching Rouen Cathedral

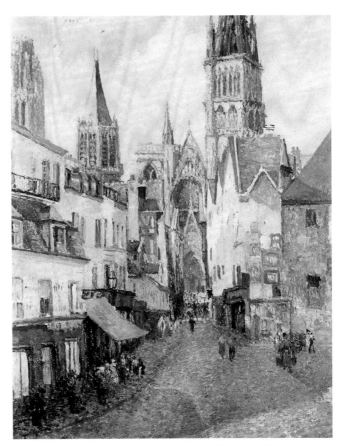

Fig. 2 Camille Pissarro, *Rue de l'Epicerie, Rouen*, Private Collection, England

Georges' scene reflects morning sunlight, while Camille has painted the long shadows of afternoon.

Comparing their versions of this same motif must have been a painful experience for the young artist, as the medieval buildings that line the street of Camille's picture show a sense of structure and articulation of planes absent from Georges' work. The facades of Georges' painting lose definition in his thinner, more timid application of pigment. He seems to have concentrated on composing the pleasing harmony of gray, tan, and rose, using short brush strokes that often leave areas of exposed canvas. This cityscape is Georges' nod to an artistic legacy he had to modify in order to realize his own mature expression.

Notes

[1] Letters from Charles Durand-Ruel to T. Smith, June 9 and July 9, 1981.

[2] Camille to Lucien Pissarro, July 23, 1898, Pissarro Family Archive, Ashmolean Museum, Oxford. The second letter confirming Georges' presence in Rouen is dated August 1. Anne Thorold generously provided me with these references confirming Georges' visit to Rouen.

[3] Camille to Lucien Pissarro, August 19, 1898, in J. Rewald, ed., *Camille Pissarro: Letters to His Son Lucien*, New York, 1943, p. 329.

[4] Camille to Lucien Pissarro, August 19, 1898, Pissarro Family Archive, Ashmolean Museum, Oxford. This portion of the letter is not published in Rewald.

Provenance: Paris, P. Contet, 1898; Paris, Galerie Durand-Ruel, 1898; London, Kaplan Gallery, 1965; W. J. Holliday, 1965.

Exhibition: HC 1968-69.

Lucien Pissarro
French 1863-1944

As Camille Pissarro's eldest son, Lucien Pissarro grew up with Impressionism. He was introduced to painting at home, where his counselors included frequent visitors Monet, Cézanne, and Guillaumin, as well as his father. The extensive correspondence between Lucien and Camille provides an intimate view of the Impressionist movement and also documents the lasting influence father exerted on son.

In 1878 Lucien left Pontoise for Paris and an office position in a textile firm. He was irresistibly drawn to art, however, and abandoned commerce in 1882. After a year of independent study spent largely in England, he returned to the family home in Eragny in 1884. Lucien then studied wood engraving with Auguste Lepère and accompanied his father on painting excursions and trips to Paris. In 1885 both artists were introduced to Seurat and Signac in the capital and soon became advocates of Neo-Impressionism. Lucien debuted the following year at the eighth Impressionist exhibition and at the Indépendants' salon with divisionist works.

Lucien also experimented with printmaking. In 1887 he worked at the lithography firm of Manzi-Joyant in Paris, where he produced woodcut illustrations for periodicals. Soon his contributions to the Indépendants, Les Vingt, and La Libre Esthétique consisted primarily of graphic works. Lucien's printmaking gained impetus when he moved to England in 1890. He published his first portfolio of woodcuts in 1891 and three years later founded the Eragny Press. With his British wife Esther, Lucien designed typefaces and issued thirty-five books before the establishment's demise with the outbreak of war. Although he maintained close ties with his family in France and even published a series of woodcuts after paintings by Camille, Lucien's graphic style owed more to the English Pre-Raphaelites and to the Arts and Crafts movement than to the influence of his father.

Shortly after the turn of the century, Lucien resumed his painting efforts. After Camille's death in 1903, he exhibited his canvases in London, where they aroused interest among artists seeking progressive directions for British painting. Acting as an intermediary, Lucien elaborated Impressionist theories to colleagues Walter Sickert, Spencer Gore, and Harold Gilman, which they translated into works associated with the Camden Town Group. Lucien's contribution to English painting is widely recognized, and he has been consistently honored with one-man shows in London since 1913.

Rye from Cadborough, Sunset, 1913
oil on canvas, 21 1/16 x 25 3/8 (53.5 x 64.5)
signed with monogram and dated lower right: ⟨LP⟩ '13
inscribed on upper stretcher bar: Rye from Cadboro' Sunset
 Aug 1913
The Holliday Collection 79.284

By 1913 Lucien Pissarro had already spent more than twenty years actively engaged in the production of woodcuts and illustrated books, but *Rye from Cadborough, Sunset* offers clear proof that he had lost none of his enthusiasm for oil painting. In 1890, he had left Paris and the immediate aura of his father's potent influence to settle permanently in England. At this

time he also abandoned the systematic methods of Neo-Impressionism, though he observed its lessons of color harmony throughout his career.

One of a series of nine landscapes painted during his summer holiday in 1913, this view of the English countryside reveals Pissarro's enduring attachment to nature's subjects. Pissarro's working holiday in Sussex was reserved for painting and sketching. He passed the months of July and August at Western House, near Rye, in the company of two less experienced but serious artists, James Brown and J. B. Manson.[1] There they were free to roam the fields, painting the old market town and its surroundings from various vantage points. In the Holliday canvas, the rooftops of Rye appear at the distant left, viewed from neighboring Cadborough. Though the region is officially cited as "Cadborough," its common spelling is "Cadboro," the more informal form Pissarro chose when he inscribed the painting's stretcher.

If his pictures themselves did not already suggest it, Pissarro's correspondence and titles confirm that he had resumed the Impressionists' practice of *plein-air* painting. Each of the nine canvases he completed that summer was executed outdoors, and many bear inscriptions specifically distinguishing gray morning from gray afternoon or sunny morning from sunset. As Malcolm Easton observed in his study of their sojourn in Rye, "Pretty well every letter which passed between Lucien and Manson from 1910 to 1944 contains some hope that the sun will shine or some regret that it has not."[2] The painters were not exempted from that occupational hazard during the summer of 1913, and the artist's letters to his wife reveal how directly his work was affected by the dismal weather.

The Holliday picture, carrying the notation "Sunset Aug 1913," was one of the works in progress described by Lucien in a letter to Esther:

> After tea we went to our sunset effect and it was a gorgeous effect—I thought the weather was going to be fine at last and expected to finish my pictures today—but this morning it was as grey and nasty as ever however I finished a *temps gris* this morning and this afternoon I am going to do a sketch in oil of small size.[3]

And toward the end of his stay, he lamented:

> I have only done 4 pictures in the month of August they did give me a lot of trouble and are v. much painted and looks [sic] quite "gras"—Probably I will like them better when I see them in a frame—All my former ones looks [sic] thin compared to them.[4]

Pissarro's word "gras" aptly describes the richly painted texture of the sky in *Rye from Cadborough*. In the thickly wrought impasto, clouds divide into active surface patterns, perhaps the result of the artist's reworking the sky as he awaited another vibrant sunset to finish his motif. Though its overall coloration is far from ruddy, the late afternoon sky is flecked with glowing shades of violet, pink, and coral.

Pissarro applied the same pungent colors to the foreground. There his brushwork follows the gentle slope of the hill, as the

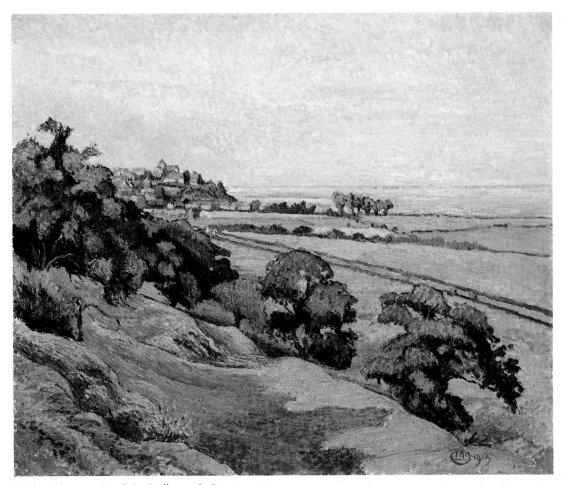

Lucien Pissarro, *Rye from Cadborough, Sunset*

deep green shadows are accented by the divided tones carried over from his Neo-Impressionist days. The throb of color in the picture's lush foliage illustrates Pissarro's succinct comment from another painting excursion of 1913, "It has always been my aim to obtain the maximum of vibrations."[5]

Descriptions of Lucien Pissarro's compositions typically draw upon words like conscientious, careful, and accurate, and *Rye from Cadborough* exemplifies the artist's sense of construction at its best. The planes of hill and field, meticulously delineated, interlock in a clearly ordered series of spaces. Even the picturesque townscape of Rye plays a role in fixing the spatial relationship between the foreground and distant meadows and sky. Pissarro's reliance on stable compositions is another logical vestige of the artist's Neo-Impressionist background.[6] His emphasis on contour is enhanced by the dark bands outlining the shaggy trees, a mannerism borrowed no doubt from the sinuous silhouettes of his wood engravings.

Contemporary critics often faulted Pissarro for his objectivity, accusing him of being too faithful to the image provided by nature. As a group, the nine Rye paintings do show the artist's relish for sober simplicity. He consistently avoids contrived scenes in favor of straightforward, commonplace views where not even the figure of a sketching companion is allowed to intrude. In the Rye series, however, the artist's restraint has become his strength. With each canvas, he develops another variation of a single theme. Despite the doubts expressed to his wife, Lucien built the sprawling countryside and cloudy skies of Rye into sturdy compositions of refined color that mark one of the finer episodes in Lucien's painting since his rejection of Neo-Impressionism.

Notes

[1] James Brown (1863-1943) was a professional musician who did not begin painting seriously until late in life. J. B. Manson (1879-1945) held a position at the Tate Gallery in order to support his painting interest. He wrote art criticism (including an article on Lucien Pissarro) and served as Director of the Tate from 1930 to 1938.

[2] M. Easton, "Lucien Pissarro and his Friends at Rye, 1913: A Group of Post-Impressionists on Holiday," *Gazette des Beaux-Arts*, 6th ser., LXXII, November 1968, p. 245.

[3] Lucien to Esther Pissarro, in English, undated, 1913, Cadborough series, Pissarro Family Archive, Ashmolean Museum, Oxford.

[4] Lucien to Esther Pissarro, in English, August 28, 1913, Cadborough series, Pissarro Family Archive, Ashmolean Museum, Oxford.

[5] L. Pissarro to J. B. Manson, March 27, 1913, The Mill, Blackpool, Pissarro Family Archive, Ashmolean Museum, Oxford; quoted in Easton, p. 248, note 6.

[6] W. Baron, *The Camden Town Group*, London, 1979, p. 18.

Provenance: London, S. L. Bensusan (the artist's brother-in-law); London, Mrs. S. L. (Marian) Bensusan; London, Mrs. Marjorie Hodson (Bensusan's adopted daughter); London, Christie's, sale, May 21, 1965, no. 179; London, Kaplan Gallery, 1965; W. J. Holliday, 1965.

Exhibitions: HC 1968-69; HC 1969-70.

Literature: J. B. Manson, "Some Notes on the Paintings of Lucien Pissarro," *Studio*, LX, 238, December 1916, p. 56 (reprod.); M. Easton, "Lucien Pissarro and Friends at Rye, 1913: A Group of Post-Impressionists on Holiday," *Gazette des Beaux-Arts*, 6th ser., LXXII, November 1968, pp. 237-248; A. Thorold, *Catalogue of Oil Paintings by Lucien Pissarro*, London, 1983, no. 167.

Enrico Reycend

Italian 1855-1928

Enrico Reycend received his art training at the Academia Albertina in Turin. Under the tutelage of Enrico Ghisolfi, Antonio Fontanesi, and Lorenzo Delleani, he dedicated himself exclusively to landscape painting. Reycend's canvases reveal the influence of Milanese painter Filippo Carcano as well as that of the French Impressionists, whose works he saw during a trip to Paris. In the mid-1870s, he began exhibiting regularly in Turin and received critical acclaim.

Landscape, ca. 1923-25
oil on canvas, 27^{15}/$_{16}$ x 37^{7}/$_{8}$ (71.0 x 96.2)
signed lower left: Reycend E.
The Holliday Collection 79.308

Enrico Reycend's shimmering landscape represents one of the most purely decorative uses of pointillism in the Holliday Collection. A screen of yellow-green light filters across the meadow, creating a bright, central core framed by darker tones applied in loose strokes. Within the illuminated area, the small dots of the foliage merge with the short strokes of the grass, forming a network of bright color that hovers on the surface, preventing any spatial recession.

Reycend was a contemporary of Seurat, but as this landscape indicates, his work relates to neither French Neo-Impressionism nor Italian Divisionism.[1] Restricted exclusively to shades of yellow and yellow-green, the dots of the Holliday landscape are not systematically divided to produce vivid complementary contrast or optical mixture. Reycend's oeuvre is fundamentally Impressionist, and he produced many landscapes in the vicinity of Turin that show his attention to luminous effects. The pointillist handling of the Holliday canvas, with its mesh of dotted color, recurs in many pictures from the last five years of the artist's life.

Note
[1] For a discussion of the relationship between French Neo-Impressionism and Italian Divisionism, see S. Berresford, "Divisionism: Its Origins, Its Aims and Its Relationship to French Post-Impressionist Painting," in *Post-Impressionism,* Royal Academy, pp. 218-226.

Provenance: Monte Carlo, Maccario Collection; New York, Christian Human, 1969; New York, Schweitzer Gallery, 1970; W. J. Holliday, 1970.

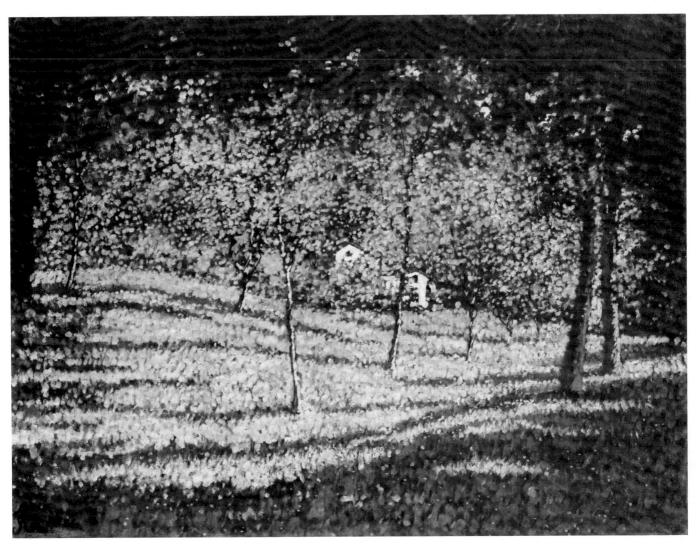

Enrico Reycend, *Landscape*

Christian Rohlfs
German 1849-1938

Christian Rohlfs discovered his artistic talents at the age of fifteen. While recovering from a serious injury, he started drawing to ease the tedium of confinement. After recuperating, Rohlfs sought formal training in Berlin with Ludwig Pietsch. In 1870 he entered the Weimar Academy, where he studied until around 1880. Despite that academic training, Rohlfs soon followed a progressive course, focusing on landscapes executed outdoors for the remainder of his time in Weimar. Rohlfs turned to *plein-airisme* independently; he was not familiar with French Impressionism until the 1890s, when paintings by Monet, Sisley, and Pissarro were first exhibited in Weimar. Rohlfs then began executing his landscapes with heightened colors, applied in a loose, painterly fashion.

In 1901, thanks to a recommendation from Henry van de Velde, Rohlfs was given a position at the new Folkwang Museum in Hagen. Its founder, Karl Ernst Osthaus, had amassed a collection rich in French and Belgian works, and he introduced the fifty-two-year-old Rohlfs to paintings of Seurat, Signac, Van Rysselberghe, Gauguin, and Van Gogh. Attracted by the luminous effects and innovative technique of the Neo-Impressionists, Rohlfs began his own experiments with divisionism shortly after arriving in Hagen. By 1904, however, he was painting in a manner clearly indebted to the energetic style of Van Gogh.

In the years before World War I, the varied artistic influences of Rohlfs' past began to coalesce into the highly individualized Expressionism for which he is most remembered. Abandoning landscape for figural, floral, and architectural motifs, Rohlfs washed broad areas of shifting, transparent color across strongly accentuated contours. Rohlfs continued working in an Expressionist vein after the war, using tempera, watercolor, and woodcuts as well as oils. Although he was never affiliated with any group or in direct contact with avant-garde developments—and despite his advanced age—Rohlfs' work placed him in the front ranks of progressive German art. He was included with the younger founders of German Expressionism in exhibitions of the Berlin Secession, the Munich Secession, and Sonderbund and in private gallery shows. Ironically, he lived just long enough to witness the discrediting of his life's work as "degenerate" by the German government of the late 1930s.

Attributed to Christian Rohlfs
Landscape, 1902 or 1903
gouache on light gray wove paper, 7¼ x 9⅝ (18.4 x 24.5)
signed with monogram lower right: CR
The Holliday Collection 79.299

Mr. Holliday acquired this small, whimsical landscape as the work of an unknown pointillist with the initials CR. The monogram, applied in red dots in the lower right corner of the paper, first inspired consideration of Christian Rohlfs as its artist. The German painter frequently signed his works with the simple block letters of CR, omitting the periods. The monogram's placement, with its slight downward slant from left to right, also occurs in examples of Rohlfs' signature.

The coincidence of the signature's form becomes pertinent when paired with the knowledge that Rohlfs did indeed have

a period of Neo-Impressionist activity. Before creating the pictures that established him as an independent figure in the German Expressionist movement, Rohlfs submitted to the influence of paintings by Seurat and his followers, which he studied first hand as artist-in-residence for the progressive new art museum in Hagen. During 1902 and 1903, Rohlfs painted a number of pointillist works. Many of those divisionist experiments were retained in the artist's possession and were given to the Museum Folkwang, Essen by Rohlfs' widow.[1]

The Holliday landscape is composed of fine points of saturated color that align themselves to form hieratic shapes of shrubbery and trees. Confirmation of the attribution to Rohlfs requires the resolution of this meticulous, delicate handling with the bolder, more personal style expected from a proto-Expressionist.[2] Yet if Rohlfs' style during the early 1900s was seldom the precise handling of the Holliday gouache, neither was it the enlarged strokes commonly associated with Neo-Impressionism's second phase. Many of Rohlfs' oils from 1902-03 are characterized by a deft pointillist execution. *Goethe's Garden House in Weimar Park,* 1902 (Galerie G. Paffrath, Düsseldorf) displays a consistent distribution of small dots across the surface of the canvas. Although in a different medium, the Weimar scene (also signed with the CR monogram) demonstrates Rohlfs' ability to control a very regular brushwork and to work within a rather schematic format. In the Holliday picture, the artist has included details such as the reflections of the far shore, subtly indicated by the yellow, orange, and green dots added to the blue water. The overall effect of this handling is an almost primitive simplicity that belies the painting's deft execution.

Notes
[1] M. L. Keiler, "Christian Rohlfs," *Art Journal,* 18, Spring 1959, p. 202; letter from Paul Vogt, Director, Museum Folkwang, Essen, to E. Lee, July 8, 1982.

[2] P. Vogt and Professor Robert Herbert, Yale University, do not accept this gouache as the work of a German artist. Letter from P. Vogt to T. Smith, October 28, 1981; letter from R. Herbert to E. Lee, November 18, 1981.

Provenance: London, art market; Paris, Eugène Rubin; W. J. Holliday, 1969.

Fig. 1 Christian Rohlfs, *Goethe's Garden House at Weimar,* Galerie G. Paffrath, Düsseldorf

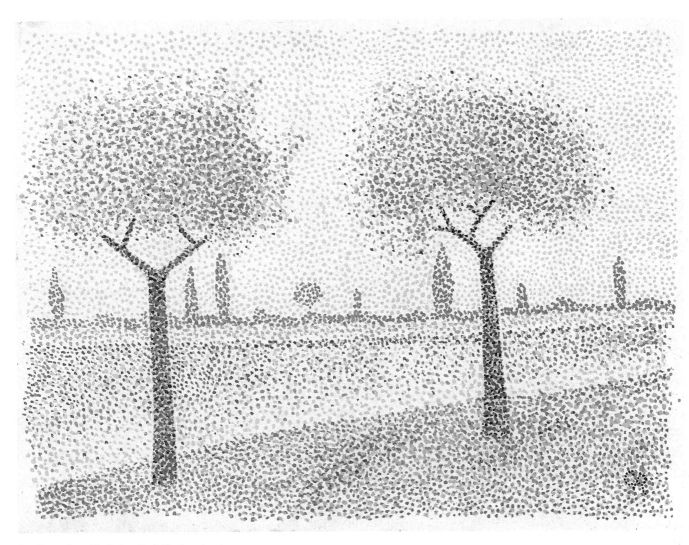

Attributed to Christian Rohlfs, *Landscape*

Jane Rouquet
French, late 19th-early 20th century

Jane Rouquet, the daughter of wood-engraver Achille Rouquet, debuted as a printmaker. She often collaborated with her father and her brother, Auguste, and in 1911 they published an ode to Provençal village life entitled *La ville du Passé*. Jane and Auguste designed a number of the woodcut illustrations that accompany the text written by Achille.

The Garden Path

oil on layered cardboard, 12¹⁵⁄₁₆ x 16³⁄₁₆ (32.9 x 41.1)
signed lower right: Jane Rouquet
colorman stamp on reverse: crossed anchor/caduceus
The Holliday Collection 79.286

During the early years of the twentieth century, Jane Rouquet experimented with the pointillist technique. One of her still-life compositions from 1900[1] bears a surprisingly strong resemblance to the floral subjects of her Languedoc neighbor,

Achille Laugé. It is not known whether the two artists working in the vicinity of Carcassonne ever met; but the approach, scale, and intricate silhouette of Rouquet's picture relate closely to the elder painter's treatment of the theme. The Holliday picture, however, represents a subsequent stage in Rouquet's career, when broad patches of thick impasto have replaced the tentative divisionist handling of her earlier works. Activating a more spontaneous, energetic brushwork, Rouquet allows the dense vegetation of *The Garden Path* to spill over the edges of the picture plane, precluding a horizon line or any recession into space. The clusters of vibrant, unmodulated colors reflect the Fauve orientation of Rouquet's landscape.

Note
[1] See G. Pogu, *Néo-Impressionnistes étrangers et influences néo-impressionnistes, exemples*, Paris, 1963, for illustration.

Provenance: Paris (?), public sale; Paris, Guy Pogu (Galerie de l'Institut); W. J. Holliday, 1966.

Exhibitions: HC 1968-69; HC 1969-70.

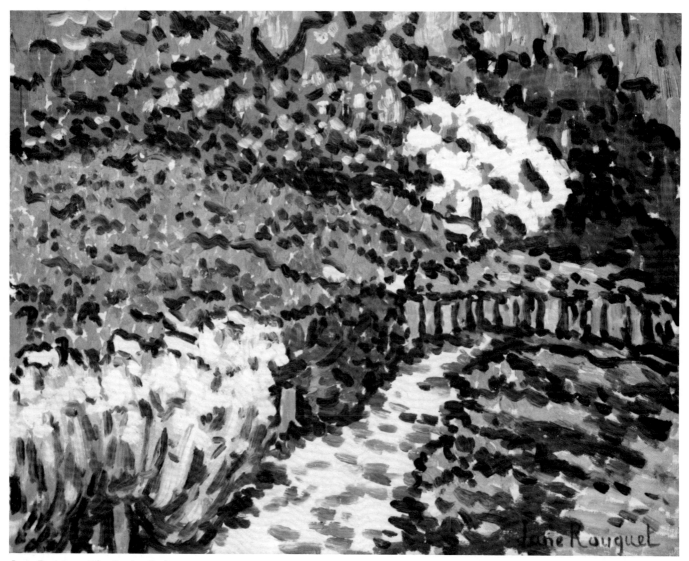

Jane Rouquet, *The Garden Path*

Paul Sain
French 1853-1908

Paul Sain, the son of a poor clockmaker, began art studies in Avignon while assisting in his father's business. In 1877 a municipal scholarship allowed him to enter the Paris Ecole des Beaux-Arts, where he worked under Jean-Léon Gérôme. Two years later, Sain began exhibiting regularly in the official salon, and he won numerous awards throughout his life. An independent painter, he adhered to no single aesthetic system and cannot be associated with any particular school. While landscapes, primarily of Avignon and the Normandy region, dominate his oeuvre, Sain also enjoyed renown for his portraits of leading Parisian intellectuals.

The Plough

oil on canvas, 7³⁄₁₆ x 9⁷⁄₁₆ (18.3 x 24.0)
signed lower left: P. SAIN
colorman label on strainer: S. Martin & Frère
The Holliday Collection 79.312

When critic Arsène Alexandre viewed the works of Paul Sain assembled for his atelier sale, he was moved by the beauty and freshness of Sain's small paintings and studies.[1] Despite the writer's familiarity with the large compositions Sain regularly exhibited at the salon, he was unprepared for the appeal of the artist's more intimate canvases. *The Plough* no doubt offers the delicacy and color that attracted Alexandre to Sain's informal pictures. Reflecting an Impressionist sensitivity, the canvas is lightly brushed with shades of green, turquoise, and blue. A pointillist overlay of dots floats across the composition, in which fine points articulate the reflections on the plough and larger, less consistent touches suggest the play of color across the field and distant horizon. Sain never espoused specific formulas or theories, and this turn to a random pointillist technique is little more than his way of rendering his vision of nature. The integration of the abandoned plough within the composition gives it a monumental reality, and the landscape itself is so harmoniously composed that it could be realized on any scale.

Note
[1] A. Alexandre, "Préface" to a Paul Sain estate sale catalogue, Paris, 1910, unpaginated.

Provenance: Paris, Eugène Rubin; W. J. Holliday, 1968.

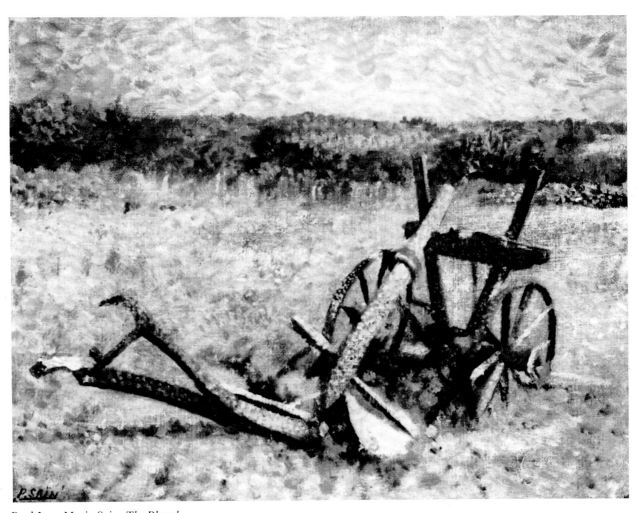

Paul Jean Marie Sain, *The Plough*

Willy Herman Schlobach

Belgian 1864-1951

Born in Belgium of German parents, Willy Schlobach studied at art schools in Brussels and Ghent. By the early 1880s, he counted Théo van Rysselberghe among his closest friends and painted Impressionist works praised for their exceptional *plein-air* qualities. He was a founding member of Les Vingt in 1883 and exhibited regularly in its salons. From 1884 to 1887, Schlobach often visited England, where he was attracted to the paintings of J. M. W. Turner. The landscapes, portraits, and still lifes Schlobach exhibited with Les Vingt during this period display an Impressionism modified by misty atmospheric effects that reveal Turner's influence.

In the late 1880s, as Seurat's theories were gaining adherents among the Vingtistes, Schlobach was one of the progressive Belgian artists who responded sympathetically to Neo-Impressionist ideals. Around 1890 he again changed courses. He turned to literary sources and interpreted verses of Baudelaire and Verhaeren with solemn figures derived from Pre-Raphaelite paintings seen during his English sojourns. With this shift, Schlobach joined Vingtistes such as Félicien Rops and Fernand Khnopff, who were inspired by Symbolist themes rather than by Neo-Impressionist methods.

From 1894 to 1897, Schlobach visited England frequently and again fell under the atmospheric spell cast by Turner. He returned to his earlier Impressionist style and subjects and exhibited intermittently at La Libre Esthétique from 1902 to 1914. Schlobach remained in Brussels throughout World War I, but anti-German sentiment forced him to flee in 1918. He moved to Nonnenhorn, on the shores of Lake Constance, where, greatly inspired by the landscape, he spent the rest of his life.

Marine, ca. 1887-88
oil on canvas, 23¾ x 27⅝ (60.3 x 70.2)
signed with monogram lower right: ℘
colorman stamp on central vertical stretcher bar: Mommen, Bruxelles
The Holliday Collection 79.288

Willy Schlobach's career was marked by a curious duality of interests. He was inspired by Symbolist poetry and Pre-Raphaelite painting as well as by the behavior of light and atmosphere in the physical world. This marine painting obviously reflects his attraction to natural phenomena, the more forceful of the two poles of the artist's imagination.

The Holliday Collection seascape displays a basic Impressionist approach as well as a somewhat hesitant pointillist handling. Across the surface of the canvas, the texture and rhythm of Schlobach's brushwork change. He uses a typical Impressionist broken stroke for the sea, a thinner treatment for the clouds and sky, and a dotted facture for the hills and rocks along the shore. The small points of color are sprinkled across the rugged coast, but Schlobach often superimposes one layer of colored dots on another, rather than juxtaposing the different hues side by side. Instead of oscillating, or merging in the eye to recreate the scintillation of light, the points of color remain static, discrete elements, not assimilated into the picture's surface pattern unless viewed from a considerable distance. The color scheme is dominated by variations of turquoise, blue, violet, and green that explore the iridescent side of the spectrum's cooler colors.

The stylistic analysis of this marine painting raises an interesting question about Willy Schlobach's reputation. In the early 1880s, Schlobach was in the forefront of the Belgian painters who were producing luminous landscapes. The young artist was an active member of Les Vingt; and in early 1887, when Signac proposed a Paris exhibition that would include many of the group's members, Schlobach was among the painters Signac described as "most closely approaching our tendencies."[1] This simple observation has often been exaggerated to suggest that Schlobach had joined the Neo-Impressionists' camp. The fact is that none of the Belgian painters had begun to produce full-fledged divisionist works when Signac made this comment. Further, the exhibition Signac was planning was not to be an exclusively Neo-Impressionist show, since Odilon Redon was also slated to participate. Thus, Willy Schlobach did indeed paint luminous landscapes with fragmented and even dotted brushwork, but there is no evidence that establishes him as a serious divisionist.

The combination of an Impressionist orientation with a tentative use of pointillism suggests that the Holliday seascape was painted around 1887 or 1888. Claude Monet had exhibited with Les Vingt in 1886, and Schlobach must have been familiar with the craggy cliffs and atmospheric effects of his paintings of the Etretat shore. One of these canvases was included in the 1886 exhibition at Brussels. Even closer in spirit to Schlobach's marine are Monet's views of the turbulent waters around Belle-Ile, in Brittany, from the autumn of 1886. As for the painting's emerging pointillism, Schlobach's flirtation with Neo-Impressionist technique could have occurred as early as 1887. Even though Seurat did not exhibit in Brussels before February of

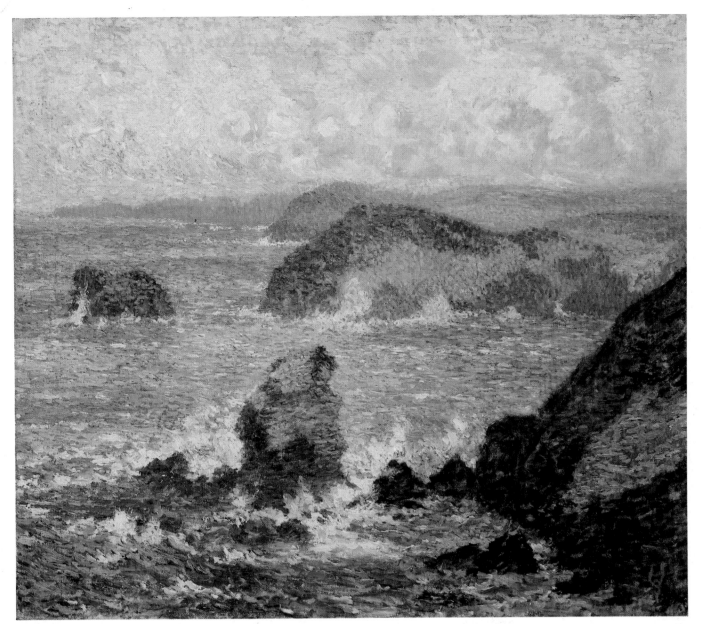

Willy Herman Schlobach, *Marine*

that year, avant-garde Belgian art reviews began publicizing his paintings in June 1886.[2] The 1887-88 date would also be consistent with the form of Schlobach's signature, since the last known work that bears the artist's full name is dated 1887, and succeeding pictures display variations of the ℘ monogram found in the Holliday canvas.

The artist's niece reports that Schlobach was attracted to the dramatic coast of southwest England and that some of his views of Cornwall show a pointillist handling.[3] The setting of the Holliday marine does resemble the Cornwall shore, where Schlobach summered during his English sojourns. Although his itinerary during the mid-1880s is unclear, Schlobach did travel to England in 1887,[4] when he could have painted this canvas. If the picture was produced the following year, it could be a reminiscence of his Cornwall stay. Since the artist's Symbolist works, which date from 1889, are often reflections of his British experiences, it is not improbable that this seascape, with its canvas and stretcher furnished by Brussels colorman Félix Mommen, was also painted after his return from England. The paintings that Schlobach submitted to Les Vingt in 1888, enti-

tled *Different Impressions of Color and Light,* testify to the atmospheric subjects that preoccupied him at this time. This same approach is well-served by the sensation of misty breezes and frothy waves suggested by the Holliday marine.

Notes

[1] Letter from P. Signac to Octave Maus, 1887, quoted in M. O. Maus, *Trente années de lutte pour l'art, 1884-1914,* Brussels, 1926, rept. 1980, p. 60 and in M. J. Chartrain-Hebbelinck, "Les lettres de Paul Signac à Octave Maus," *Bulletin,* Musées Royaux des Beaux-Arts de Belgique, 1969, 1-2, p. 60. Packet 1887, Inv. 4823.

[2] As Jane Block has indicated in her essay "Les XX: Forum of the Avant-Garde," *Belgian Art 1880-1914,* The Brooklyn Museum, 1980, p. 27, Octave Maus wrote about Seurat in *L'Art Moderne,* June 27, 1886, and Fénéon's explanation of Neo-Impressionism occurred in *L'Art Moderne* on September 19, 1886.

[3] Letters from Louise Eitel-Schlobach to E. Lee, July 3 and 21, 1981.

[4] *Le Groupe des XX et son temps,* Brussels, Musées Royaux des Beaux-Arts de Belgique, 1962, p. 105.

Provenance: Purchased from Jacqueline Manguin (the artist's niece) by Marcel Bas, Brussels; Paris, Guy Pogu (Galerie de l'Institut); W. J. Holliday, 1965.

Exhibition: HC 1968-69.

Claude-Emile Schuffenecker

French 1851-1934

Fatherless by the age of three, Claude-Emile Schuffenecker was raised by relatives in a small village near Paris. While attending a parochial school, he produced watercolors and drawings that so impressed his instructor, he was sent to study with Paul Baudry in Paris at the age of fifteen. Schuffenecker remained in Baudry's atelier until 1870, when he joined the Paris brokerage firm of Bertin. Over the next decade, he pursued his art career according to academic principles. He spent a brief term in the studio of Charles Carolus-Duran and from 1877 to 1881 exhibited architectural designs, genre scenes, and portraits with the Salon des Artistes Français.

In the early 1880s, Schuffenecker relinquished his commercial career and found a post as a drawing instructor, which he held until 1914. By 1884, when he helped found the Société des Artistes Indépendants, Schuffenecker was painting in an Impressionist manner. From 1884 to 1888, however, he produced several canvases revealing a peripheral attachment to Neo-Impressionist principles.

Schuffenecker was also associated with the Pont-Aven School. It was with Schuffenecker's encouragement and guidance that Paul Gauguin, a co-worker at Bertin's, turned to painting in the early 1870s. They remained on intimate terms until 1889; unfortunately, their relationship has caused many people to dismiss Schuffenecker as nothing more than Gauguin's friend. In 1886 Schuffenecker began regular summer visits to Brittany, where he befriended Emile Bernard, Paul Sérusier, Maurice Denis, and Charles Laval. Three years later, he was instrumental in organizing the famous exhibition of the Groupe Impressionniste et Synthétiste at the Café Volpini, which showcased the paintings of his Pont-Aven colleagues. Schuffenecker's own works, however, reflected little of their style. He continued to paint naturalistic landscapes that were Impressionist in orientation.

In the early 1890s, Schuffenecker's paintings began to emphasize mystical, spiritual elements. Influenced by Eastern religions and by the writings of popular occult figures such as the theosophist Helena Blavatsky, he created landscapes peopled with mysterious, hooded figures. Working in the forests of Meudon, Schuffenecker often turned to pastels for these later works, which are realized in evocative, blurred contours and sinuous lines.

Schuffenecker's only one-man show during his lifetime took place in Paris in 1896. Since his death, he has been featured in several solo exhibitions in Paris galleries as well as in group shows devoted to Gauguin and the Pont-Aven School. In 1980 Schuffenecker was the subject of an exhibition organized by the State University of New York at Binghamton.

A View of the Cliffs at Etretat, 1888
oil on canvas, 21⁵⁄₁₆ x 28¾ (54.1 x 73.0)
signed and dated lower right: E Schuffenecker/1888.
The Holliday Collection 79.289

Emile Schuffenecker is often classified with Gauguin's followers in Brittany, but the lure of the Normandy coast also exerted a long and powerful tug on the artist's imagination. From the mid-1880s to the turn of the century, Schuffenecker made many excursions to the Norman beaches of Etretat.[1] The coastal village had long been a popular site for painters and writers, engaging such artists as Eugène Boudin, Gustave Courbet, and Guy de Maupassant. When Schuffenecker painted *A View of the Cliffs at Etretat* in 1888, de Maupassant had already written his article, "La Vie d'un paysagiste," which was inspired by Claude Monet's encounters with the light and climate of the Etretat shore.[2]

Schuffenecker's panorama looks to the northeast, exposing a wide arc of glistening cliffs. Instead of the dramatic contrasts of scale found in many of Monet's close views of the rocks, Schuffenecker presents an elevated, distant vantage point, juxtaposing the mossy promontory of the foreground with the long sweep of the shore. The rocks at lower right resemble the formation known as La Chambre des Demoiselles on the Porte d'Aval. If the point at the opposite end of the beach is indeed the Porte d'Amont, northernmost of the famous pierced cliffs of Etretat, the artist has taken the liberty of shortening the cliff's projection into the sea.[3] He painted a similar view, *Fishermen at the Foot of the Cliffs* (Vente des Floralies, Versailles, May 13, 1964, no. 14), from a much lower elevation in 1887.

Given the fascination with light and color that he developed as he shed his academic orientation, it is not surprising that Schuffenecker was attracted to Seurat's methods. He had the opportunity to view Seurat's paintings as early as 1884, at the first Indépendants' show,[4] and at the last Impressionist exhibition in 1886. The dates assigned by various authors for Schuffenecker's involvement with Neo-Impressionism range from 1884 through 1888, but the strongest example of his adoption of divisionist principles is *Landscape—Two Cows in a Meadow* (Collection of Mr. and Mrs. R. Fitzmaurice), executed in 1886.

Though the broken brushwork and 1888 date of the Holliday picture might suggest that it also falls within Schuffenecker's Neo-Impressionist oeuvre, *A View of the Cliffs at Etretat* is primarily an Impressionist effort. Schuffenecker uses rapid, broad strokes to record the reflections on cliffs and waves, often exposing the canvas' white ground in his free handling of the painted surface. Unlike thoroughly Neo-Impressionist works, there is little reliance on the use of complementary hues. Despite the presence of a tighter pointillist technique in the rocky foreground, the picture's main emphasis is still the effects of sunlight on the sky, sea, and shore.

Visual clues are not the only evidence that by 1888 Schuffenecker had returned to an Impressionist idiom: contemporary documentation also points to the tenuous nature of his Neo-Impressionist affiliation. In May 1887, Camille Pissarro wrote sarcastically to his son Lucien of what he considered Schuffenecker's hollow praise for their scientific techniques.[5] In the spring of 1889, Schuffenecker and Gauguin organized the Café

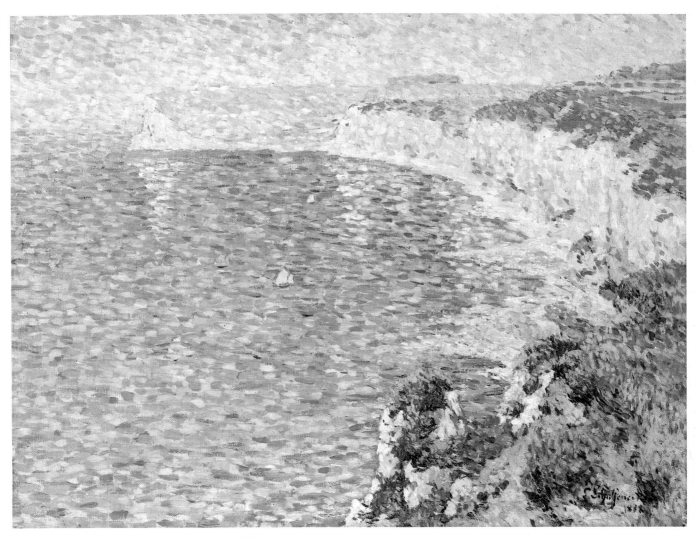

Claude-Emile Schuffenecker, *A View of the Cliffs at Etretat*

Volpini show, where Schuffenecker was represented by no fewer than twenty canvases. It is revealing that none of the reviews of this famous exhibition link "le bon Schuff" with the practice of Neo-Impressionism. Indeed, Gauguin pointedly excluded Seurat's followers from participation in their exhibition of "Impressionists and Synthetists." Since Schuffenecker exhibited such a large body of work at the Café Volpini, he must have been drifting away from Neo-Impressionist methodology well before the show opened, suggesting that the Holliday canvas was also painted after Schuffenecker had lost his initial enthusiasm for Seurat's methods.

With its flickering light and color, *A View of the Cliffs at Etretat* belongs to the long series of paintings that inspired this characterization of Schuffenecker and his work:

> Pure impressionist, he thought and he showed that the aiguille at Etretat, for example, taking advantage of the infinite play of light and the changing aspects with which that light adorned the rock formation, could summon up a world of sensations capable of providing the painter, throughout his entire life, work and delight.[6]

Notes

[1] In her exhibition catalogue essay, Jill Grossvogel refers to Etretat works ranging in date from 1884 to 1898. J. Grossvogel, "Margin & Image," *Claude-Emile Schuffenecker 1851-1934*, Binghamton, State University of New York Art Gallery, November 1980, p. 13.

[2] G. de Maupassant, "La Vie d'un paysagiste, (Etretat, septembre)," *Le Gil Blas*, September 28, 1886, p. 415; Gonon, ed., *Chroniques littéraires et parisiennes*, 14, pp. 413-17.

[3] For a schematic drawing of the Etretat shore, see R. Lindon, " 'Falaise à Etretat' par Claude Monet," *Gazette des Beaux-Arts*, 6th ser., LV, March 1960, pp. 179-182.

[4] Grossvogel, p. 23.

[5] J. Rewald, ed., *Camille Pissarro: Letters to His Son Lucien*, New York, 1943, p. 112.

[6] M. Gauthier, *Un Méconnu: Emile Schuffenecker*, Paris, Galerie Berri-Raspail, 1944; quoted in Grossvogel, p. 75.

Provenance: Paris, Madame Eugenia Errazuriz; Paris, J. A. Gandarillas (Madame Errazuriz's nephew); W. J. Holliday (through James Lord, Paris), 1963.

Exhibitions: HC 1968-69; Binghamton, State University of New York Art Gallery, November-December 1980, and New York, Hammer Galleries, January 9-25, 1981, *Claude Emile Schuffenecker, 1851-1934*, no. 10 (reprod.).

Literature: W. Jaworska, *Paul Gauguin et l'école de Pont-Aven*, Neuchâtel, 1971, p. 54 (reprod.); S. Monneret, *L'impressionnisme et son époque*, II, Paris, 1978, p. 232.

Arthur Segal

Rumanian 1875-1944

Arthur Segal contributed to progressive European movements throughout his career, but since he often worked independently, he is an overlooked figure in twentieth-century art. Segal began art training at the Berlin Academy in 1892 and then studied in Munich with Ludwig Schmidt-Reutte and Adolf Hölzel. In 1904, after two years of additional training in Paris and Italy, he settled in Berlin and exhibited annually in the Berliner Sezession. His early works manifested a wide range of avant-garde influences, but Segal specified debts to Segantini, Van Gogh, Matisse, and the Neo-Impressionists. In 1910 he entered the arena of German Expressionism as a founder of the Neue Sezession. There Segal regularly exhibited with members of the Brücke and the Blaue Reiter groups.

From 1914 to 1920, Segal resided in Switzerland, where he became involved with the Zurich Dada movement. He began exhibiting with leading Dada painters in 1916 and published woodcuts and essays in Dada journals. At the same time, Segal developed the idiosyncratic painting modes characteristic of his mature oeuvre. Motivated by a desire for balance and harmony, he devised "Equivalence" paintings in which "every part was of equal importance."[1] Segal divided his canvases into rectangles, each a discrete composition in its own right. These separate entities either coalesce into continuous landscape and still-life subjects or unfold as sequential narratives. Segal depicted many of his Equivalence works in stylized, Cubistic forms that extend onto flat, painted frames.

From 1920 to 1933, Segal once again resided in Berlin. He exhibited with the Novembergruppe and in several one-man shows in Berlin, and his canvases were seen throughout Europe. Around 1926 Segal formulated a new painting style based upon close observation of the physical world and therefore diametrically opposed to his Equivalence concept. His "View-Point" still lifes and interiors of 1926 to 1930 mirror the physiological process of vision with a single, crisply depicted object surrounded by softly blurred elements. Segal continued to employ a naturalistic approach for the last fifteen years of his life and imbued his realistically depicted landscapes and interiors with a surrealistic stillness. The few Equivalence paintings he produced during this period were also transformed by a naturalistic style. The resulting legibility was a boon to his narrative mode, which Segal now used to explore social themes such as hunger and abortion.

In 1933, after a brief residence in Spain, Segal moved to London. There he ran the Arthur Segal School of Painting and published numerous tracts on his visual ideas.

View from the Window, 1930
Blick aus dem Fenster
oil on canvas, 38⅝ x 30½ (98.1 x 77.5)
signed lower left: A Segal
The Holliday Collection 79.303

That Arthur Segal is represented in a collection devoted to the impact of Seurat's aesthetic is surprisingly appropriate. Segal acknowledged the influence of Neo-Impressionism in his earlier works, but _View from the Window_ was painted much later in his career, and the small colored flecks of paint on its surface are only the stylistic veneer of a deeper common outlook. The affinity between the two artists extends beyond the stippled treatment of a few canvases to a broader interest in the principles of harmony and vision. As an artist who believed that "meditation on the eternal laws of nature, seen from the optic point of view, is my salvation,"[2] Segal attacked many problems of perception and pictorial representation in his mature work. The Equivalence and View-Point pictures are indicative of his continuing pursuit of the challenge of transcribing the natural world.

View from the Window represents a successful integration of an image of the visible world with a highly developed abstract sense. The composition was painted in 1930[3] and does not fall neatly into one category of Segal's oeuvre. Neither an Equivalence nor a View-Point painting, it was executed late in the period of Segal's greatest emphasis on those modes, as he was turning to the more naturalistic conventions that dominated the final years of his career. The theme is not uncommon in Segal's work, and at least three other paintings of the subject date from the last decade of his life. The surface of _View from the Window_ is a rough, uneven crust of impasto, stippled with tiny dots spanning a wide range of colors. A similar pointillist handling occurs in _Marseilles_ (Estate of the artist, London), a less rigorous Equivalence landscape of 1929. In the Holliday picture, the distinct grid pattern of _Marseilles_ has disintegrated, only to be replaced by a composition conceived as a variety of rectangular forms. The window, its reflections, and the fa-

Fig. 1 Radiograph of Segal, _View from the Window_

172

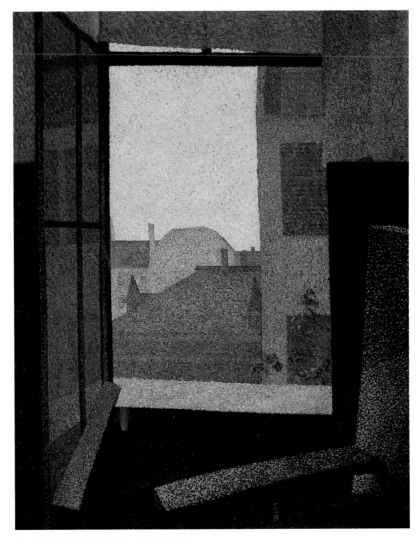

Arthur Segal, *View from the Window*

cades in the distance all repeat the geometric emphasis, leaving the treetop stretching into the lower right corner of the window as the only organic presence in the abstract composition. The window sill and chair are obvious instances of Segal's attention to the play of light. The sill is totally composed of pastel pigments of blue, rose, and yellow; and on the edges of the chair and window, warm hues dance across the deeper tones of the local color, suggesting the fall of sunlight across the surface.

The canvas represents the vista from the artist's studio in Berlin. When the picture was sold in 1970, the sales catalogue carried a reproduction of a 1907 painting of the same subject,[4] distinguished from the Holliday canvas by a leafy plant on the sill and the figure of a seated woman looking out the window. The catalogue stated that *View from the Window* is actually a repainted version of the 1907 canvas, reworked by the artist twenty-three years later. While the setting is indeed the same, radiographs (fig. 1) illustrate that the two images cannot have existed on the same canvas. The x-ray of the Holliday painting does reveal the hands and arms of a woman at lower right, and her cropped form is consistent with the physical evidence that the picture has been trimmed along the right margin. Her position relative to the rest of the composition, however, is vastly different from the 1907 painting. The figure in the

x-ray does not have her back to the viewer and was originally placed to the right of the open window rather than occupying its lower right corner as in the 1907 image. In the uneven surface texture of the Holliday picture, it is possible to detect the same form revealed by the x-ray. The areas inside the window, where according to the 1907 painting the plant and woman must be, show level paint layers and tiny areas of unprimed canvas that could not camouflage a distinctly different, reworked version of this composition. In Segal's alteration of the painting, he replaced the curvilinear shape of the chair, visible in the x-ray, with the starker, more austere furniture befitting his strict linear framework. Indeed, inclusion of the seated figure would have violated the pristine unity of *View from the Window*.

Notes

[1] Quoted in R. Nathanson, *Arthur Segal, 1875-1944: A Collection of Paintings*, London, The Alpine Club, 1973, unpaginated.

[2] Nathanson.

[3] Sotheby & Co., London, April 16, 1970, no. 21.

[4] Sotheby & Co., London, April 16, 1970, no. 21.

Provenance: London, Marianne Segal (the artist's daughter); London, Sotheby's, sale, April 19, 1970, no. 21; W. J. Holliday, 1970.

Jeanne Selmersheim-Desgrange
French 1877-1958

Jeanne Selmersheim-Desgrange came from a family of artists, architects, and craftsmen and began her career as a jewelry designer. She met Paul Signac in the early 1900s and later became his second wife. Her still-life and landscape paintings, executed in large rectangular strokes of bright pigment, bear a close affinity to Signac's canvases of the twentieth century. Beginning in 1909, Selmersheim-Desgrange exhibited regularly with the Société des Artistes Indépendants, and during the early 1930s, her paintings were included in several Paris shows dedicated to Neo-Impressionism.

Garden at La Hune, Saint-Tropez, 1909
Jardin de La Hune
oil on canvas, 25½ x 31⁵⁄₁₆ (64.8 x 79.5)
signed and dated lower right: J. SELMERSHEIM-
 DESGRANGE/1909
The Holliday Collection 79.270

This landscape presents a vista from the place that could well be considered the nerve center of Neo-Impressionism's second phase. La Hune was Paul Signac's villa at Saint-Tropez, and from this location on the Mediterranean, Signac produced pictures and treatises that sustained the movement and introduced a second generation of artists to the principles he championed. The author of this painting is one of Signac's most able but least-known protégés: his second wife, Jeanne Selmersheim-Desgrange.

Selmersheim-Desgrange has painted the garden at La Hune from a vantage point inside a porch or foyer. By deft manipulation of the rectangular brushwork, Selmersheim-Desgrange escapes the ornate patterns and somewhat artificial stylizations that detract from some landscapes executed in this manner. Arranging the mosaic strokes into a well-integrated composition, she maintains a delicate balance between the natural forms of the landscape and abstract surface patterns. The bouquet on the right, with its bending flowers echoing the shape of the arch, is typical of the decorative treatment found in her still lifes of the same period, such as *Flowers,* 1909 (Musée de l'Annonciade, Saint-Tropez). The artist's color scheme shows an equally judicious handling: pungent hues and frequent pairings of complementaries are tempered by a generous exposure of white ground that modulates the colors without dimming their intensity. She utilizes color to articulate the form of the arch, as yellow and orange compose the arch itself and blue and violet define its silhouette on the shaded inside wall.

Selmersheim-Desgrange painted another view of the same subject: *The Garden* (Hammer Galleries, New York). This scene is presented from the opposite direction, as the artist looks through the arch into the dim porch from her perspective in the garden. The canvas is also dated 1909 and has the same dimensions, suggesting that the two works were conceived as pendants. A third picture devoted to the garden at La Hune reveals how closely the work of Selmersheim-Desgrange parallels that of her mentor. Entitled *Garden at Saint-Tropez* (Christie's, London, December 2, 1966, no. 58), this landscape was painted by Signac in the same year and on the same size canvas. Showing the green bench and the clusters of flowers along the garden path, his composition is also built upon the orderly arrangement of mosaic-like strokes. Signac aligns the bricks of color in tighter rows, eliminating the white ground that appears in the Holliday picture. The comparison of these intimately related works reveals that Jeanne Selmersheim-Desgrange was able to turn the lessons of her teacher into a painting distinguished by its harmonious integration of color and line.

Provenance: Paris, Ginette Signac; Paris, Galerie Jean Claude Bellier; W. J. Holliday, 1961.

Exhibitions: Paris, Galerie Jean Claude Bellier, *Les néo-impressionnistes,* June 6-July 7, 1961, no. 29; New York, The Solomon R. Guggenheim Museum, *Neo-Impressionism,* February 9-April 7, 1968, no. 61 (reprod.); HC 1968-69.

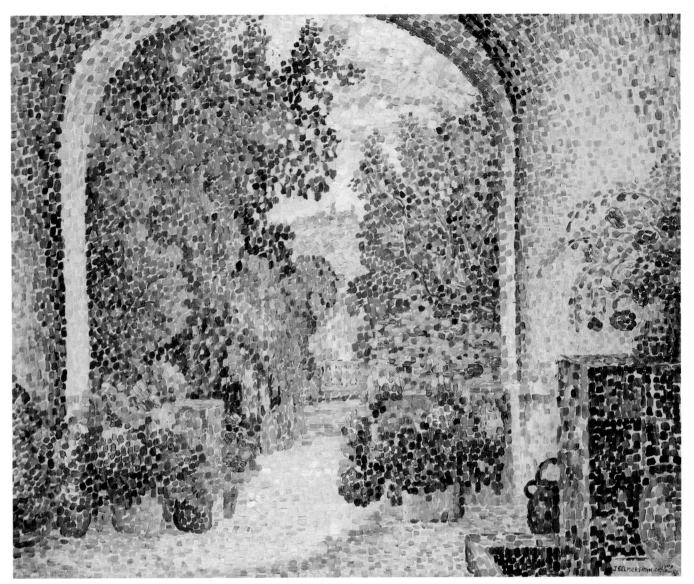

Jeanne Selmersheim-Desgrange, *Garden at La Hune, Saint-Tropez*

Léon de Smet

Belgian 1881-1966

Léon de Smet's early painting career was closely related to that of his older brother, Gustave. As children they often joined their father in the execution of mural, panel, and ceiling commissions. Both Léon and Gustave later pursued formal training at the Ghent Academy with Jean Delvin and Jules van Biesbroeck.

In 1906 Léon moved to Laethem-Saint-Martin on the Lys River near Ghent. There Gustave and other young Belgians fresh from the Academy formed what has been referred to as the Second Laethem-Saint-Martin School. The newcomers believed they had found a progressive aesthetic in tenets derived from Impressionism. They were champions of Luminism as practiced by Emile Claus, then at the peak of his celebrity, and of pointillism as defined by Théo van Rysselberghe. Accordingly, Léon painted the Lys landscape, interiors, portraits, nudes, and still lifes in bright, freely applied dabs of color. He exhibited these works with the Brussels group Vie et Lumière.

With the outbreak of World War I, Léon went to England. There he continued painting in his Laethem manner and was especially renowned as a portraitist of British intelligentsia. His subjects included John Galsworthy, George Bernard Shaw, and Joseph Conrad. De Smet's first major exhibitions occurred in London at this time.

De Smet's exile did not foster stylistic innovation, but when he returned to Brussels after the war, he briefly experimented with his brother's new Expressionist style. In the late 1920s, however, he once again sought the banks of the Lys, where he painted in the Impressionist mode of his Laethem days for the rest of his life.

Landscape
oil on canvas, 18⅞ x 13 (47.9 x 33.0)
signed lower left: Leon De Smet
The Holliday Collection 79.242

Except for a brief post-war Expressionist period, Léon de Smet's landscapes consistently reflect a commitment to painting nature's luminous effects. This wooded landscape displays the searing tones and broken brushwork common to his oeuvre. With short strokes, de Smet transcribes the glow of autumn foliage, and the reflections on the rows of tree trunks run the gamut from light yellow to bright green, blue, and violet. In subject and handling, this canvas resembles a picture from de Smet's wartime sojourn in London: *Hyde Park, Autumn* (Christie's, London, June 24, 1966, no. 52). In the Hyde Park *alleé* of trees, the branches are articulated in a similar manner, and the scene is composed of the same short, thick brush strokes. Like Modest Huys, also represented in the Holliday Collection, Léon de Smet is more appropriately classified with the Belgian Luminist painters, who found greater inspiration in the example of Emile Claus than in the works of Georges Seurat or Théo van Rysselberghe.

Provenance: Belgium, Anart Collection; Brussels, Marcel Bas; Paris, Guy Pogu (Galerie de l'Institut); W. J. Holliday, 1965.

Exhibitions: HC 1968-69; HC 1969-70.

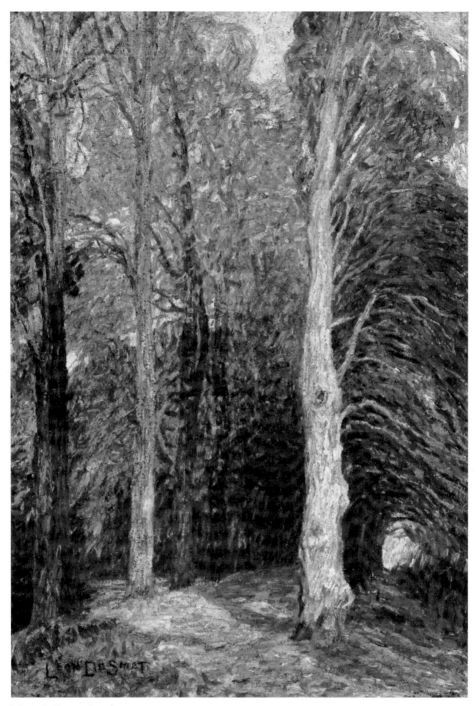

Léon de Smet, *Landscape*

Médard Verburgh
Belgian 1866-1957

Médard Verburgh began his art training in Roulers. He then studied at the Academy in Brussels, where his dedication and talent earned him highest student honors. To support himself, Verburgh worked as a *peintre-décorateur.*

Verburgh's career is marked by a progression through various contemporary styles, which brought him modest international success. His earliest canvases are Impressionist in motif and technique and show Monet's influence. By 1910 Verburgh composed landscapes with loose, rectangular strokes that reveal the impact of Fauve interpretations of Neo-Impressionism. After 1920, his still lifes, figures, and landscapes proclaimed a new allegiance to Cézanne. Like Jean vanden Eeckhoudt, he utilized the French master's analytic approach, which resulted in tightly knit, volumetric forms.

Verburgh exhibited often in one-man shows in Brussels and Paris following World War I. In 1930 he traveled in the United States, where he exhibited in New York. He then retired to the Balearic Islands.

The Village
oil on panel, 18⅞ x 21⅛ (48.0 x 53.7), irregular
signed lower right: Md Verburgh
The Holliday Collection 79.296

This landscape is an early work by Médard Verburgh, painted around 1910, before his preoccupation with color gave way to a style emphasizing solid volumes and firm construction. *The Village* is probably a picturesque site in Brabant,[1] where the young Verburgh often painted. Its cool tones and loose strokes floating over a white ground represent a somewhat diluted version of the vivid colors and crisp patches that characterize most of Verburgh's works of this period.

Note
[1] Marcel Bas proposed Brabant as a likely site for the landscape. Conversation with M. Bas, Brussels, July 1980.

Provenance: Purchased from the artist's widow by Marcel Bas, Brussels, after 1957; Paris, Guy Pogu (Galerie de l'Institut); W. J. Holliday, 1965.

Exhibition: HC 1968-69.

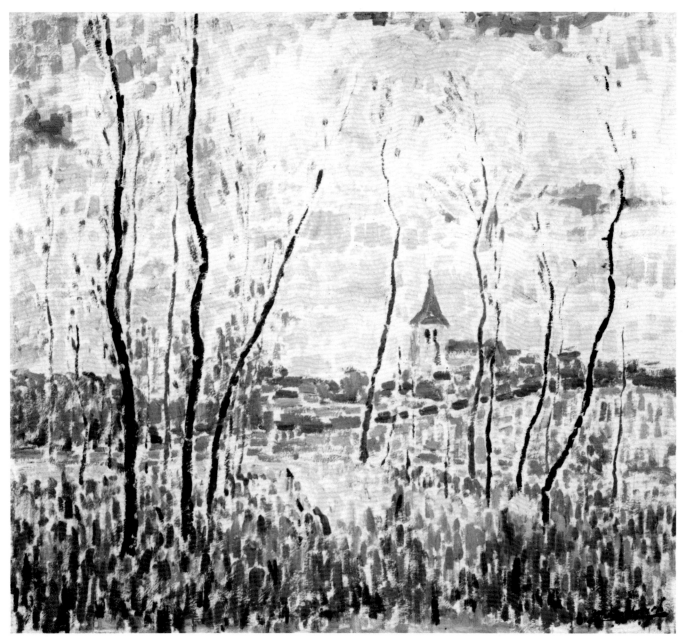

Médard Verburgh, *The Village*

Fernand Verhaegen

Belgian 1884-1975

Despite parental pressure to pursue an engineering career, Fernand Verhaegen enrolled in the fine arts academy in Brussels. There he studied with Constant Montald but rebelled against academic traditions. By 1904 the young artist was painting portraits, still lifes, and landscapes with divided colors and brush strokes influenced by Neo-Impressionism.

Around 1907 Verhaegen began depicting the carnival scenes from southern Belgium, called kermesses, which became the hallmark of his oeuvre. Early examples in this genre still show a Neo-Impressionist orientation. Since Verhaegen worked in the midst of the festivals, completing several canvases in a single sitting, his technique by necessity became more Impressionistic. Vivid color contrasts, spontaneously applied strokes, and garishly dressed crowds suggest the influence of James Ensor, who did in fact view Verhaegen's work with high regard.

Verhaegen exhibited regularly in Brussels, Antwerp, and Liége, and in 1914 was included in the final salon of La Libre Esthétique. He traveled frequently, working in England and France as well as Belgium. Around 1920 Verhaegen painted landscapes of southern France that signaled his first departure from an Impressionist approach and philosophy. This change was due in large part to the influence of Cézanne. Abandoning his spontaneous method of painting, Verhaegen began emphasizing pictorial structure.

Flowers and Fruit, ca. 1904
oil on canvas, 23⅛ x 19½ (58.7 x 49.5)
signed with monogram lower right:
The Holliday Collection 79.297

Fernand Verhaegen made his artistic debut in Antwerp with the exhibition of a pointillist picture.[1] *Flowers and Fruit* belongs to this brief pointillist period at the outset of Verhaegen's career. Around 1904 the young painter concentrated on still-life subjects, producing the works that James Ensor described as painted in "the juices of the great lemon-flavored yellows, of the deep reds, and the ruby purples."[2] The hot colors of the Holliday still life, arranged with limited allegiance to Neo-Impressionist color theory, are applied in loose dashes that expose large areas of the tan ground layer. The flow of strokes shifts directions with the different objects of the composition, creating a highly charged surface pattern.

While Verhaegen sustained an interest in still-life painting (the curious draped statuette reappears in later, more realistic works), he abandoned the pointillist technique after only a few years. *Flowers and Fruit,* which predates his famous scenes of Belgian folk festivals, is a rare picture from the second generation of Belgian artists touched by the influence of pointillism.

Notes

[1] R.-L. Delevoy, *Fernand Verhaegen*, Brussels, 1936, p. 16.

[2] J. Ensor, quoted in Delevoy, p. 16.

Provenance: Paris, Guy Pogu (Galerie de l'Institut); W. J. Holliday, 1965.

Exhibition: HC 1968-69.

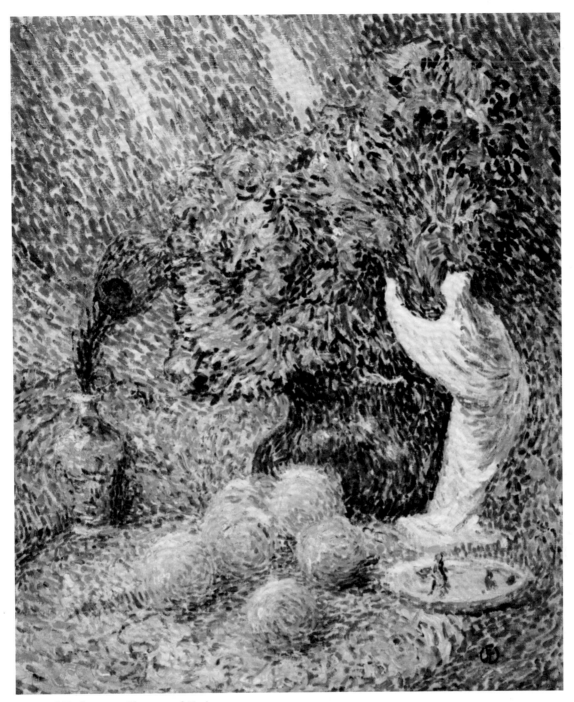

Fernand Verhaegen, *Flowers and Fruit*

Belgian (Flanders)
late 19th-early 20th century

Spring Landscape
Paysage printanier
colored pencil on cream wove paper,
 image: 19¹¹⁄₁₆ x 23¾ (50.0 x 60.3)
 sheet: 19¹¹⁄₁₆ x 25⁹⁄₁₆ (50.0 x 65.0)
unsigned
The Holliday Collection 79.305

The setting of the Holliday drawing identifies it as Belgian. The canal, with its fringe of tall, thin trees, is a familiar sight in the countryside of Flanders. Théo van Rysselberghe's oil painting *Canal in Flanders,* 1894 (Collection of Mr. and Mrs. Hugo Perls, New York) is probably the most famous of these views, but the motif was a common one for Flemish landscape artists.

The design of *Spring Landscape* is built upon short, broken lines of blue, green, and brown. Even the long, willowy tree trunks are cut into the small stripes that are applied consistently throughout the composition. This handling, a kind of elongated pointillism, might first suggest affinities with the Belgian Neo-Impressionist school, but in fact the fragmented stroke of the Holliday drawing is not out of place in the broader context of Belgian Impressionism. Often called Luminists, the

Belgian *plein-airists* were devoted to transcribing nature and recording the effects of light and atmosphere. From his home on the river Lys, Emile Claus was the acknowledged leader of the movement. His participation was key to the formation in 1904 of Vie et Lumière, the Belgian Impressionist group that reflected the vitality of the aesthetic in the early twentieth-century. Landscapes depicting the banks of the Lys and the canals of Flanders were common to these painters, and the Holliday drawing appears to be the work of one of the artists attached to the luminous tradition.

The fragmented facture of *Spring Landscape* is not imposed solely for the purpose of dividing color: the separated strokes allow much of the white paper to appear, adding luster and brilliance to the schema. Unlike the pastels and drawings of Henry van de Velde or Dutch artist Johan Thorn-Prikker, where the broken linear elements assume a more animated, autonomous role, the lines of the Holliday drawing are employed for their descriptive capabilities. In *Spring Landscape,* the emphasis is still on a lyrical transcription of the landscape rather than on a decorative arrangement of lines.

Provenance: Wiltshire, England, R. H. Hennay (by inheritance); London, Sotheby's, sale, March 17, 1970, no. 44; W. J. Holliday, 1970.

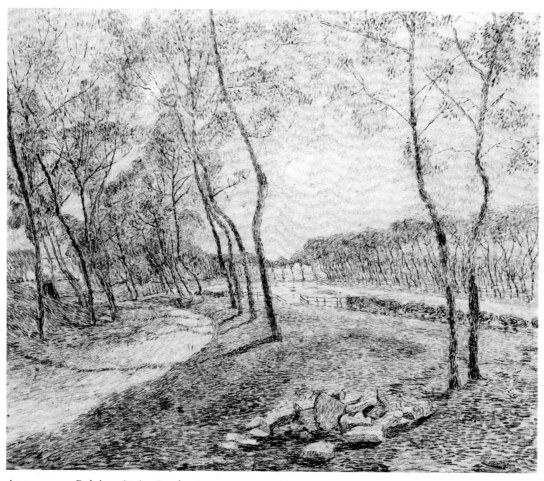

Anonymous, Belgian, *Spring Landscape*

French

19th-20th century

Formerly attributed to Albert Dubois-Pillet, French,
1846-1890
Landscape, La Baule, 1916
watercolor with pencil on white wove paper, 11⁵/₁₆ x 17⅛
(28.7 x 43.5)
inscribed and dated lower right: La Baule aout 86 (altered
from 16)
The Holliday Collection 79.243

Fig. 1 Detail of inscription, *Landscape, La Baule*

Albert Dubois-Pillet, one of the earliest members of the Neo-Impressionist movement, was formerly named as the painter of this watercolor. However, the doubts raised by its stylistic attributes are corroborated by historical factors, confirming that this landscape cannot be counted among the small body of works assigned to Dubois-Pillet.

Landscape, La Baule is not signed, but it bears a pencil inscription, "La Baule aout 86," suggesting that it was painted on the Atlantic coast of Brittany during the summer of 1886. This would have established it as one of the earliest examples of divisionist painting and one of the few watercolors executed by Dubois-Pillet. August 1886 was, however, an unlikely time for the artist to be in Brittany, since preparations for the second salon of the Société des Artistes Indépendants required his presence in Paris that month.

When the watercolor's inscription was examined closely, it was possible to detect an alteration in the numeral 8 of the date. The pencil (or black crayon) lines that form the 8 have two different consistencies, and a photograph (fig. 1) shows that the contour of the 8 was created when an s-shaped curve was superimposed on the numeral 1, changing the date from (19)16 to (18)86. The rest of the inscription is written in the same thicker pencil as the numeral 1. Thus the picture originally bore a date of (19)16, which explains why its date of execution was listed as "aout '16" in the 1961 sale catalogue of

Sotheby's. At some point after this sale, therefore, the date of this watercolor was changed, no doubt with the realization that Albert Dubois-Pillet could not have painted the watercolor in 1916 since he had died in 1890.

Thus *Landscape, La Baule* is a watercolor painted after the movement's heyday by an artist flirting with the divisionist technique. The landscape is dominated by flecks of yellow and green, with accents of blue, red, and violet in and under the trees. In the upper portion of the composition, the foliage merges into a screen of dense horizontal strokes. The proper attribution of the watercolor calls for a painter working in Brittany in a divisionist manner during the course of World War I. Of the second- as well as first-generation Neo-Impressionists still alive in 1916, most can be ruled out since they had renounced the style by that date.

Provenance: London, Sotheby's, sale, July 6, 1961, no. 243; London, Roland, Browse, and Delbanco, 1961; London, O'Hana Gallery, 1961; W. J. Holliday, 1961.

Exhibitions: New York, Hammer Galleries, *Seurat and His Friends*, October 30-November 17, 1962, no. 32; HC 1968-69; HC 1969-70.

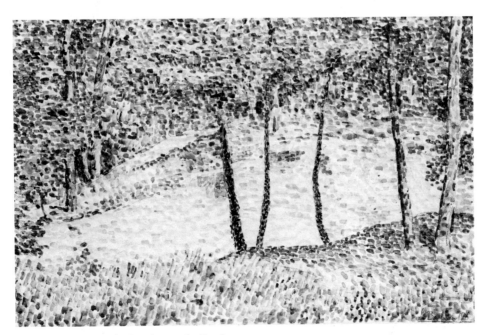

Anonymous, French, *Landscape, La Baule*

French

19th-20th century

Formerly attributed to Auguste Pégurier, French, 1856-1936
The Port of Saint-Tropez, 1911
oil on panel, 7⅝ x 10⁹⁄₁₆ (19.4 x 26.8), irregular
inscribed and dated lower left: St-Tropez 1911
The Holliday Collection 79.280

One of the most frequently painted views of Saint-Tropez is that of the Quai de Suffren, with its old houses lining the wharf and the familiar profile of the local church tower in the distance. This harbor scene was formerly attributed to Auguste Pégurier. The artist was a native of Saint-Tropez, and his oeuvre consists primarily of oils and pastels of the region. Although Pégurier was a friend of Paul Signac and an admirer of his work, he never espoused the divisionist aesthetic.[1] He resisted the rules of Neo-Impressionism in favor of a more spontaneous approach and looser, broadly brushed landscapes. None of Pégurier's views of the Saint-Tropez harbor display the pointillist technique of this small panel. Further, Mireille Pégurier has commented that her father's works were always signed and, unlike the Holliday painting, were never inscribed with the name of the site.[2] This observation is consistent with a survey of dozens of Pégurier's landscapes.

The unmistakable pointillist facture of *The Port of Saint-Tropez* is made unusual by the presence of a dull green ground layer, which appears amidst the vibrant pigments that build the composition. Any painter employing the pointillist technique in Saint-Tropez in 1911 had to be familiar with the approach propounded by the village's most renowned resident artist, yet the facture is noticeably finer than the mosaic stroke widely practiced by that time. The even distribution of small dots is not unlike Edouard Fer's handling in his Swiss boating scene of 1913, but the similarity is insufficient evidence for a sound reattribution. The panel can only be linked to one of the many painters who, in the years before World War I, were drawn to the Côte d'Azur and its legacy of Neo-Impressionism.

Notes
[1] C. Roger-Marx, *A. Pégurier, Le Premier Peintre de Saint-Tropez (1856-1936)*, Paris, 1970, p. 14.
[2] Letter from M. Pégurier to Tony Field, Galerie XVIII, Paris, November 1970.

Provenance: Paris, Galerie du Palais Bourbon; W. J. Holliday, 1965.

Exhibitions: HC 1968-69; HC 1969-70.

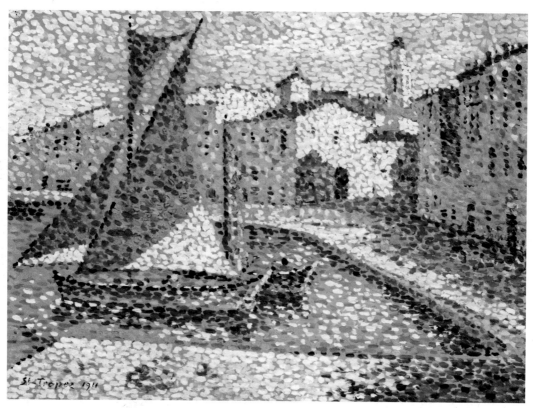

Anonymous, French, *Port of Saint-Tropez*

French

19th-20th century

Formerly attributed to Hippolyte Petitjean, French,
 1854-1929
The Brittany Coast, ca. 1910
oil on canvas, 14¾ x 21⅜ (37.5 x 54.3)
unsigned
The Holliday Collection 79.281

Formerly catalogued as the work of Hippolyte Petitjean, this
coastal landscape offers no convincing justification for such an
attribution. Even with its distinct, broken strokes, its handling
does not resemble the regular brushwork of Petitjean's Neo-
Impressionist oils of the 1890s or of his later pointillist land-
scapes. Instead, the surface pattern has an uncharacteristic
dual rhythm, as downward strokes define the sky and sea and
diagonal ones trace the slope of the hill.

In the lower right corner is a circular pink stamp, reinforced
after the canvas was lined. It cannot be the artist's atelier seal
since his stamp is a long rectangle. Sometimes Petitjean did
use a florid two-initial monogram in a round configuration,
but this circle bears no letters which can be construed as HP.
Though the locale has been labeled as Brittany, the landscape,
despite its curious crenellated tower, is so nondescript that it
cannot be conclusively identified. Therefore, the fact that ac-
counts of Petitjean's life include no references to travel in Brit-
tany does not alone disqualify the attribution. More significant
is the fact that the picture is not listed in Petitjean's roster of
237 oil paintings.[1]

The picture's high-key, iridescent palette indicates a date
contemporary with the Fauve era, ca. 1905 to 1915. Infra-red
reflectography uncovers a very thorough underdrawing, which
predicted a much defter landscape than the brush strokes
eventually produced.

Note
[1] Confirmed by Lily Bazalgette in a letter to E. Lee, March 5, 1982.
Provenance: London, Kaplan Gallery; W. J. Holliday, 1965.
Exhibition: HC 1968-69.

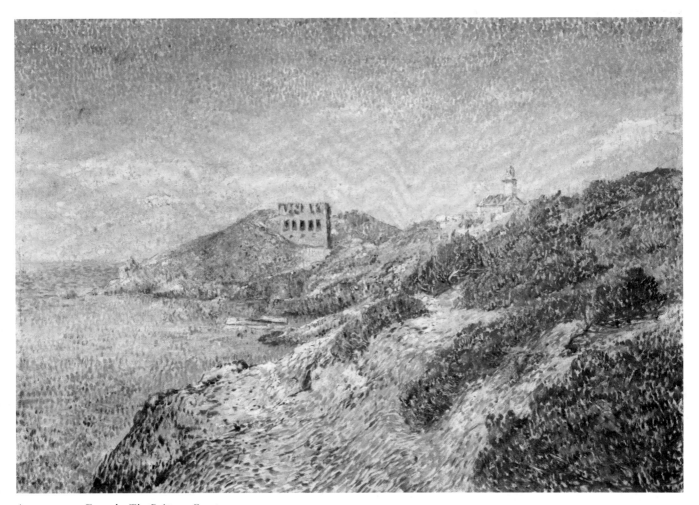

Anonymous, French, *The Brittany Coast*

III

Louis Abel-Truchet
French 1857-1918

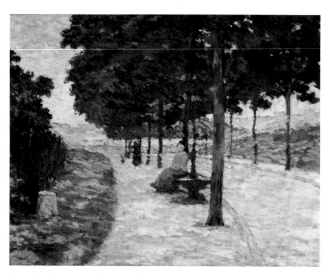

Louis Abel-Truchet, *Landscape*

Abel-Truchet did not seriously pursue his art career until 1890, when he abandoned a successful Parisian business position. He studied briefly with Jules Lefebvre, Tony Robert-Fleury, and Benjamin Constant, then in 1891 debuted at the Salon des Artistes Français. Shortly after the turn of the century, Abel-Truchet began participating in the Société Nationale des Beaux-Arts and the Salon d'Automne and held several one-man shows in Paris galleries. Using an Impressionist brushwork and palette, he painted scenes of Parisian city life, picturesque Italian villages, and numerous still lifes.

Although nearly sixty years old at the outbreak of World War I, Abel-Truchet volunteered for active military duty. He served as a Lieutenant and was killed in action in 1918. The following year, he was honored in a Salon d'Automne exhibition dedicated to "Artistes morts pour la Patrie."

Landscape
oil on canvas, 16½ x 21⅝ (41.9 x 54.9)
signed lower left: Abel Truchet
colorman stamp on reverse: A. Moreaux, Paris
The Holliday Collection 79.324

While Abel-Truchet is best known for his genre pictures of *fin-de-siècle* Parisian life, landscapes form an integral part of his oeuvre. His use of fragmented brushwork and high-key colors was never sufficiently systematic to link him with Seurat's aesthetic formulas, but this canvas does show his Impressionist sensitivity. In this luminous landscape scene, Abel-Truchet bases his harmonies on a deft orchestration of lavender, rose, pale blue, and green. With thick, freely handled strokes, he records the dappled effects of light as it filters through the trees onto the narrow road that sweeps out of the picture plane.

Provenance: Paris, Eugène Rubin; W. J. Holliday, 1968.

Merio Ameglio
Italian 1897-1970

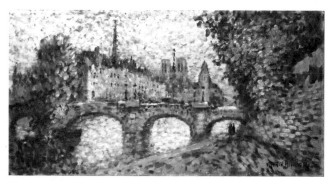

Merio Ameglio, *Le Pont Neuf*

Merio Ameglio was entirely self-taught and painted in a manner derived from Impressionism. He depicted the landscape of France, where he lived after 1908. Views of Paris dominate his oeuvre, which also includes scenes of the Mediterranean coast and Italy.

Le Pont Neuf, ca. 1940
oil on canvas, 11¹³⁄₁₆ x 23⅝ (30.0 x 60.0)
signed lower right: Merio Ameglio
inscribed and signed on reverse: Le Pont Neuf/Merio
 Ameglio
The Holliday Collection 79.314

Provenance: Purchased from the artist by Reyn Gallery, New York, 1965; W. J. Holliday, 1970.

E. Bailleul

French, late 19th century

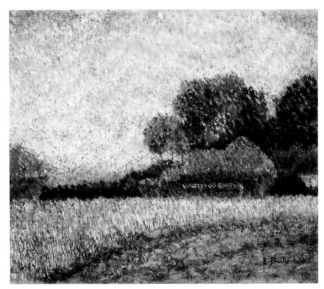

E. Bailleul, *Landscape*

Landscape
oil on canvas, 14¹⁵⁄₁₆ x 18 (38.0 x 45.7)
signed lower right: E. Bailleul
colorman stamp on left strainer bar: crossed anchor/caduceus
The Holliday Collection 79.306

Provenance: Paris, Eugène Rubin; W. J. Holliday, 1970.

Blanche-Augustine Camus

French 1884-1968

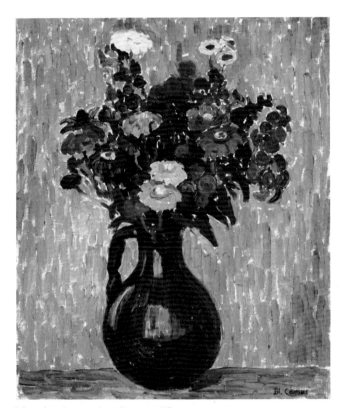

Blanche-Augustine Camus, *Flowers*

Blanche Camus studied at the Académie Julian and in the ateliers of Jules Lefebvre, Tony Robert-Fleury, and Adolphe Déchenaud at the Ecole des Beaux-Arts between 1902 and 1908. In 1910, she debuted at the Salon des Artistes Français, where she exhibited regularly through 1939. During the 1920s, she was the subject of several solo exhibitions in Paris.

Flowers
oil on canvas, 21¹¹⁄₁₆ x 18⅛ (55.1 x 46.0)
signed lower right: Bl. Camus
The Holliday Collection 79.236

Blanche Camus painted luminous *plein-air* landscapes of Provence, and probably came into contact with Paul Signac at Saint-Tropez, but very little is known about her relationship to the later phase of Neo-Impressionism. While this floral still life is an exuberant display of color, it is no exercise in divisionism. The red, yellow, and violet pigments are applied, not as constituent hues that interact with each other, but as the pure local colors of the flowers. Camus uses thick, unhesitating brushwork, arranging her flowers in a lively surface pattern that contrasts with the uniform downward strokes of the background. In the 1921 salon of the Société des Artistes Français, Camus' entry showed a similar application of thick bands of unmodulated color.

Provenance: Purchased from the artist by Guy Pogu (Galerie de l'Institut), Paris; W. J. Holliday, 1966.
Exhibition: HC 1968-69.

Alexandre-Paul Canu

French, active 1920-1926

Alexandre-Paul Canu, *Bridge Over the Seine*

The little that is known of Alexandre-Paul Canu reveals only that he exhibited with the Société des Artistes Indépendants from 1920 to 1926.

Bridge Over the Seine
oil on canvas, 23¼ x 31⅜ (59.1 x 79.7)
inscribed and signed lower right: a G. Grosbois/amicalement
 P. Canu
The Holliday Collection 79.237

Provenance: Paris, Swiss Flea Market; W. J. Holliday, 1964.
Exhibitions: HC 1968-69; HC 1969-70.

Eugène Chigot

French 1860-1923

Eugène Chigot, *Le Mazet at Juan-les-Pins*

Eugène Chigot's art training began in Valenciennes under the tutelage of his father Alphonse, a painter of military scenes. From 1880 to 1886, he studied in the Paris atelier of Alexandre Cabanel and also exhibited in the Salon des Artistes Français from 1883. His naturalistic portraits and historical and literary scenes reflected the conservative influences of both teachers and earned numerous honors.

In 1887, following a study trip to Spain and Italy, Chigot built a studio in Etaples, where he spent the greater part of the next ten years. His classmate Henri Le Sidaner first exposed Chigot to the site's natural beauty. However, Chigot continued to emphasize narrative painting while nature remained a backdrop for human action and emotion.

It was not until Chigot returned to Paris around 1900 that his landscape painting was influenced by avant-garde developments. In 1903 he exhibited as a founding member of the Salon d'Automne. Stimulated by the experiments of the Fauve painters, Chigot was painting with hotter colors, looser strokes, and a rich impasto by 1905. In the same year, he had the first of several successful exhibitions at the Galeries Petit in Paris.

During the remaining years of his life, Chigot traveled extensively throughout Europe and documented his journeys in landscape paintings. He stopped painting in 1920 with the onset of a terminal illness.

Le Mazet at Juan-les-Pins, ca. 1918
oil on canvas, 25⅜ x 31⅝ (64.5 x 80.3)
signed lower right: Eug Chigot
colorman stamp on reverse: Paul Foinet, fils, Paris
The Holliday Collection 79.316

Le Mazet is the name of the property where Chigot lived when he returned to the French Riviera at the close of World War I.[1] In subject and handling, this landscape resembles his canvases of the Côte d'Azur dated 1918. Chigot combines short daubs of impasto with thin strokes to create an active, dappled surface texture. While many of his colors are bright, the overall effect is hardly vibrant since earth tones, as well as rose, blue, and yellow, are applied over a dark gray ground. Some critics have termed Chigot a divisionist, but this reference seems to pertain to his broken brushwork rather than to a systematic division of color. From his early seascapes of Etaples to the final works of his career, Eugène Chigot was essentially an Impressionist painter.

Note
[1] Conversation with Madame Pierre Chigot, Paris, October 6, 1981.

Provenance: Purchased from the artist's son, Dr. Pierre Chigot, Paris, by Kaplan Gallery, London; W. J. Holliday, 1969.

Palma d'Annunzio Daillion

French 1863-?

Palma d'Annunzio Daillion, *River Landscape*

Palma d'Annunzio Daillion was primarily a sculptor and an engraver of medals. She apparently spent most of her life in Paris, where she studied with her husband, the French sculptor Horace Daillion; another sculptor, Louis-Alexandre Bottée; and painter Louis-Henry Deschamps. In the 1880s, Daillion began exhibiting regularly at the Salon des Artistes Français and was an award winner as late as 1930.

River Landscape
oil on canvas, 19⅝ x 24 (49.9 x 61.0)
signed lower right: P. DAILLION
The Holliday Collection 79.240

Provenance: Paris, public sale, 1962; New York, Schweitzer Gallery, 1962; W. J. Holliday, 1967.
Exhibition: HC 1968-69.

Julien-Gustave Gagliardini

French 1846-1927

Julien-Gustave Gagliardini, *Cannes*

Gagliardini, the son of a *peintre-décorateur*, spent his childhood in the Loire region and began his training under Claude Soulary, a disciple of Delacroix and Géricault, in Saint-Etienne. Around 1862 he went to Paris and studied in the atelier of Léon Cogniet. For the next twenty-five years, Gagliardini painted portraits, genre scenes, and melancholy depictions of the mining district of Forez.

Around 1890, however, Gagliardini concentrated almost exclusively on landscape motifs gleaned from extensive travels in the Midi and Italy. These sunlit southern locales seductively contrasted with the subtle tonalities of the north. For the rest of his life, Gagliardini painted scenes from Auvergne, Provence, the Pyrenees, and Venice in violently contrasting colors.

Gagliardini began exhibiting in Paris in 1869. He was favorably received within the art circle of the Société des Artistes Français, where he won numerous honors and served on the salon jury. He also exhibited frequently in Saint-Etienne. A major Gagliardini retrospective occurred in 1928 at the Galeries Georges Petit in Paris.

Cannes, 1910
oil on panel, 15¾ x 23⅞ (40.0 x 60.6), irregular
dated, inscribed, and signed lower right: 1910 Cannes/H
 (or JG in stylized monogram) Gagliardini
The Holliday Collection 79.310

Provenance: Nice, art market; New York, Schweitzer Gallery, ca. 1955-56; Mrs. Barney George; San Francisco, Maxwell Galleries, 1963; W. J. Holliday, 1968.

Exhibitions: New York, Schweitzer Gallery, *French 19th and 20th Century Drawings and Small Paintings*, December 1959; New York, Hammer Galleries, *Seurat and His Friends*, October 30-November 17, 1962, no. 33.

Literature: *Arts*, XXXIV, 3, p. 65 (reprod.).

Anatole-Eugène Hillairet

French, ca. 1880-1928

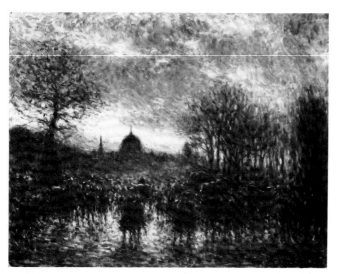

Anatole-Eugène Hillairet, *View from the Place de l'Hôtel de Ville, Across from the Commercial Law Courts*

Anatole-Eugène Hillairet favored landscape subjects of the Paris region, but he also painted nudes and figure groups. Beginning in 1907, he exhibited with the Société des Artistes Indépendants.

View from the Place de l'Hôtel de Ville, Across from the Commercial Law Courts, 1906
Coin de la Place de l'Hôtel de Ville d'avant le Tribunal de Commerce
oil on canvas, 19⁹⁄₁₆ x 25⅜ (49.7 x 64.5)
signed lower right: A. Hillairet
inscribed, dated, and signed on upper strainer bar: Coin de la Place de l'Hotel de Ville d'avant le Tribunal Commerce (Soir novembre) 1906/A Hillairet
colorman stamp on central strainer bar: Lefebvre, Paris
The Holliday Collection 79.254

This view of Paris was painted from the square just in front of the Hôtel de Ville, looking west and south across the upper branch of the Seine to the Ile de la Cité. There the silhouette of the massive dome of the Tribunal de Commerce, or commercial law courts, rises against a cloudy sky. To the left of the dome is the elegant spire of the church of Sainte-Chapelle. The artist has lengthened the actual distance from the Hôtel de Ville to the nearby Tribunal.

Hillairet often painted Paris at twilight, and for this view of the city, he uses broad dashes of blue, violet, yellow, and brown. With an Impressionist's attention to the changing effects of light and atmosphere, he has recorded the time of day and year—evening, November—on the reverse of the painting.

Provenance: Paris, Galerie Jean Claude Bellier; W. J. Holliday, 1965.
Exhibitions: HC 1968-69; HC 1969-70.

Eugène-Albert Horel

French 1876-1964

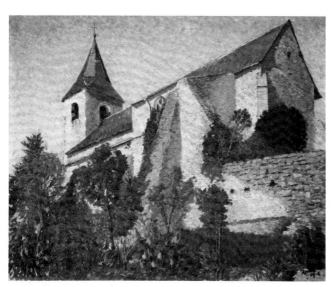

Eugène-Albert Horel, *Landscape*

Eugène-Albert Horel worked in Nancy, where he studied under Victor Prouvé at the Ecole des Beaux-Arts and with the painter-sculptor Emile Friant. He exhibited in Paris at the Salon des Artistes Français from 1909 to 1930 and in 1919 began showing with the Indépendants.

Landscape, 1912
oil on canvas, 25½ x 31¹³⁄₁₆ (64.8 x 80.8)
signed and dated lower right: A. Horel/1912
colorman stamp on right strainer bar: crossed anchor/ caduceus
The Holliday Collection 79.255

In this landscape, Eugène-Albert Horel makes the stone church his vehicle for registering nuances in color and facets of volume. Depicted from a close perspective, the edifice crowds the picture plane with its massive form. The church's carefully delineated planes show the artist's emphasis on firm pictorial construction. Perhaps inspired by Monet's Rouen Cathedral series of 1892-94, Horel uses the old weathered stone to record the variations in color induced by the effects of light and shadow. Shaded zones are not indicated solely by the addition of blue and violet pigments: muddier, blended tones and a brown priming layer are also found in those passages sheltered from direct sunlight.

The signature, which was initially inscribed in black oil paint, has been reinforced with dark brown. The date below it must have been added at this time since it is entirely in brown and shows no underlying black paint.

Provenance: Paris, Galerie Jean Claude Bellier; W. J. Holliday, 1966.
Exhibitions: HC 1968-69; HC 1969-70.

Jules Arthur Joëts
French 1884-1959

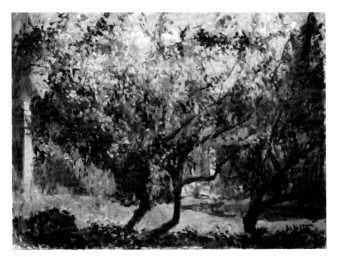

Jules Arthur Joëts, *At Montfermeil*

Although Jules Joëts suffered the loss of his right eye during infancy, his father encouraged him to study art at the Saint-Omer Academy. From 1905 to 1911, he held a teaching post there and assisted his father with *peintre-décorateur* projects. During these years, Joëts painted copies of the Old Masters and exhibited regularly at the Société des Artistes Français.

In 1912 Joëts enrolled in the Paris Ecole des Arts Décoratifs, but returned to his native village that same year. He painted portraits, genre scenes, and allegorical and literary subjects that reflected academic standards. Official recognition was forthcoming in medals, state purchases, and, in 1913, a travel scholarship that took him to Holland, Belgium, and England. During World War I, Joëts was named an official painter for the French army and executed portraits of high-ranking officers. After the war, he became the curator of the museum in Saint-Omer.

In 1923, as a result of contact with James Ensor and Georges Rouault, Joëts began to emphasize expressive qualities of color. He turned to nature, rather than literature, for inspiration and painted landscapes, still lifes, and portraits in an Impressionist mode. He abandoned the Société des Artistes Français and began exhibiting with the Indépendants. He also illustrated poems by his friend Rouault, produced stage designs, and experimented with ceramics. He exhibited often in both group and one-man shows in France and finally won public and critical acclaim at the 1933 Indépendants' salon. Joëts interrupted his painting career during World War II to devote himself to the safekeeping of the collections of the Saint-Omer museum. In 1955 he retired to Tilques.

At Montfermeil, 1955
oil on canvas, 23½ x 31⅝ (59.7 x 80.3)
signed lower right: J. Joëts
numbered, signed, and inscribed on reverse: N°716/par/Jules Joëts/A Montfermeil
The Holliday Collection 79.318

At Montfermeil represents the late years of Jules Joëts' long and productive career. The landscape was painted in 1955, while the artist was visiting a friend at the château of Montfermeil, east of Paris near the Marne. Joëts' widow recalls that after their host had asked repeatedly for a painting of his home, Joëts finally acquiesced.[1] With the thinly veiled excuse that the château was too long for the proportions of his canvases, the artist elected instead to paint the sunlight and trees surrounding it.

This canvas is one of four or five Joëts painted in Montfermeil. Here the artist dissolves forms with loose, Impressionist brushwork. The trees are transformed into active surface patterns of rose, green, coral, and violet. Lurking behind the screen of foliage is a structure that may be Joëts' capitulation to his friend's request. Executed about the time of Joëts' retirement to Flanders, *At Montfermeil* shows the energy and freedom he still applied to painting nature's subjects.

Note
[1] Conversation with Madame Jules Joëts, Paris, August 8, 1980.

Provenance: Estate of the artist; Paris, Palais Galliera, sale, June 28, 1968, no. 20; Paris, Galerie Jean Claude Bellier, 1968; W. J. Holliday, 1968.

Gaston La Touche
French 1854-1913

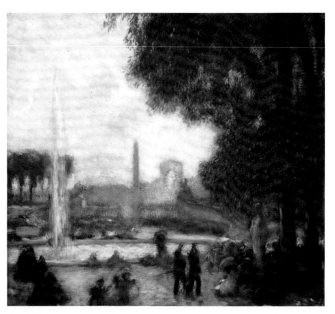

Gaston La Touche, *The Pool at the Tuileries*

Entirely self-taught, Gaston La Touche was influenced early in his career by the naturalism of Manet, Degas, and the literary master Zola. From 1875 to around 1890, he used somber colors and grim scenes from the lives of miners and laborers to proclaim his allegiance to social realism. During the 1890s, however, La Touche evolved a new coloristic manner with the guidance of his friend Félix Bracquemond. His canvases then portrayed light-hearted themes derived from the eighteenth-century *fêtes champêtres* of Watteau and Fragonard. These works brought him widespread acclaim within official French art circles, but they have little connection to progressive art of the early twentieth century.

The Pool at the Tuileries, ca. 1908
Le bassin des Tuileries
oil on canvas, 28½ x 31⅝ (72.4 x 80.3)
signed lower left: Gaston la Touche
The Holliday Collection 79.307

Provenance: Paris, Galeries Georges Petit, estate sale, June 2, 1919, no. 40; . . . Nice, Private Collection; New York, Schweitzer Gallery, 1969; W. J. Holliday, 1970.

Alfred Marie Le Petit
French 1876-1953

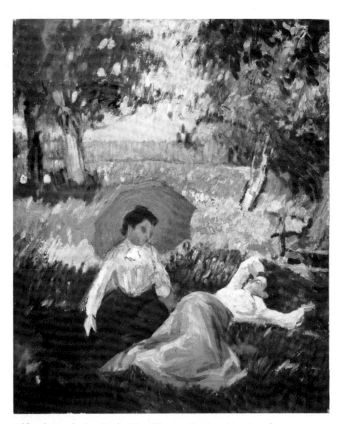

Alfred Marie Le Petit, *Two Women Resting in a Landscape*

Alfred Marie Le Petit was well-schooled in the academic tradition by his father, a painter-lithographer, and in the studios of established Parisian artists. He painted, however, according to Impressionist principles. Le Petit's first works from the late 1890s are *plein-air* scenes of the environs of Tréport and Rouen. Other canvases chart his life in Paris, travels in Corsica, and from 1930, the banks of the Seine at La Frette. Le Petit also painted still lifes and figure subjects and created illustrations for the works of Guy de Maupassant, Paul Verlaine, and Balzac, among others. By the early 1900s, he was participating in various Paris exhibition societies—the official salons as well as the Indépendants and the Salon d'Automne. Le Petit was the subject of a major retrospective at Galerie Creuze in 1954.

Two Women Resting in a Landscape
oil on canvas, 18³⁄₁₆ x 15¼ (46.2 x 38.7)
signed lower left: A. M. Le Petit
The Holliday Collection 79.263

Provenance: New York, art market; Private Collection; Houston, Jacob Greenberg; New York, Hammer Galleries, 1965; W. J. Holliday, 1965.
Exhibition: HC 1968-69.

Georges Edmond Maigret
French, 19th century

Georges Edmond Maigret was a painter of historical scenes who worked in the 1870s.

Portrait of a Girl
oil on panel, 18⅛ x 14¾ (46.0 x 37.5)
signed lower left: EDMOND MAIGRET
colorman stamp on reverse: Vibert, with crossed anchor/
 caduceus
The Holliday Collection 79.322

Provenance: Paris, Eugène Rubin; W. J. Holliday, 1969.

Georges Edmond Maigret, *Portrait of a Girl*

Annelies Nelck
French, b. 1925

Annelies Nelck was encouraged to paint by Henri Matisse. She derives her favored landscape motifs primarily from the French Midi. She often paints still lifes and is also active as a wood engraver. She exhibited in 1950 with the group "Les mains éblouies" and has also exhibited in Cagnes and Vence. Nelck was first seen in the United States in 1961, when she exhibited at the Thibaut Galleries in New York.

Landscape of Southern France
oil on canvas, 25⅜ x 21⅛ (64.5 x 53.7)
signed lower left: A. Nelck
landscape sketch on reverse
The Holliday Collection 79.325

Provenance: Paris, Eugène Rubin; W. J. Holliday, 1968.
Exhibition: HC 1969-70.

Annelies Nelck, *Landscape of Southern France*

Charles Sprague Pearce
American 1851-1914

Charles Sprague Pearce pursued his painting career in France, where he spent most of his life. He left Boston in 1873 and for the next three years studied under Léon Bonnat in Paris. In 1876 he began exhibiting regularly and won official honors on both sides of the Atlantic. Throughout his career, Pearce followed traditional academic principles. His oeuvre includes peasant themes as well as biblical tableaux and genre scenes inspired by journeys to North Africa, Italy, and southern France.

Peasant Girl
oil on canvas, 21½ x 17¹⁵⁄₁₆ (54.6 x 45.6)
signed lower left: CHARLES-SPRAGUE-PEARCE-
The Holliday Collection 79.323

Provenance: Needham, Mass., Castano Art Gallery; San Francisco, Maxwell Galleries, 1965; W. J. Holliday,1968.

Charles Sprague Pearce, *Peasant Girl*

Ferdinand Loyen du Puigaudeau
French 1864-1930

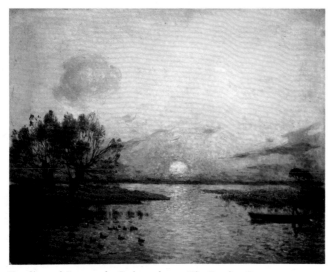

Ferdinand du Puigaudeau received no formal art training and developed a personal style close to Impressionism. In the early 1880s, he made his first trip to Italy and sometime between 1886 and 1888 was in Pont-Aven, where he became familiar with the work of Gauguin and his disciples. In his use of divided brushwork, however, du Puigaudeau leaned toward Impressionism rather than toward the Pont-Aven School. Du Puigaudeau also maintained a long-term correspondence with Degas.

After satisfying his wanderlust with trips through Switzerland, the Low Countries, southern France, North Africa, and Italy, du Puigaudeau retired to Brittany around 1908. He lived in isolation and died in almost complete obscurity, but he was honored by a retrospective exhibition at Galerie Dru in Paris in 1931.

Ferdinand Loyen du Puigaudeau, *The Pond at Sunset*

The Pond at Sunset
La mare au coucher du soleil
oil on canvas, 19⅝ x 25⅝ (49.9 x 65.1)
signed lower right: F. du Puigaudeau
The Holliday Collection 79.285

This painting reveals more about its collector than it does about pointillism. From a London dealer comes the anecdote that when Mr. Holliday, an avid duck hunter, spied this landscape, he believed it was the setting for a duck shoot, in spite of the title describing it simply as a sunset scene.

Although du Puigaudeau is sometimes linked with the pointillist painters, this landscape displays little more than a vague

Impressionist approach. Reflections on the pond are rendered in dappled strokes, while a change to tight, linear brushwork occurs in the reeded area. Twilight scenes are common in du Puigaudeau's works, which were often painted in the vicinity of his home at Croisic, in Brittany.[1]

Note
[1] C. G. Le Paul, "Ferdinand Du Puigaudeau," *Le Mouvement impressionniste dans l'école de Pont-Aven*, Musée de Pont-Aven, 1978, p. 24.

Provenance: Paris, public sale, ca. 1962; Paris, Daniel Malingue and Clément Altarriba, ca. 1962; London, Kaplan Gallery; W. J. Holliday, 1965.

Exhibitions: Probably London, Kaplan Gallery, *Recent Acquisitions, An Exhibition of Impressionist Paintings*, October 18-November 20, 1965, no. 4.

Josep Balasch Tataret
Spanish 1888-?

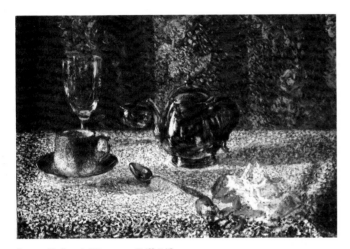

Josep Balasch Tataret, *Still Life*

Josep Balasch Tataret lived and worked most of his life in Paris and exhibited frequently in Barcelona. He painted landscapes and figural subjects as well as still lifes. The last known exhibition to which he contributed was the spring exhibition at the National Palace of Barcelona in 1932.

Still Life
oil on canvas, 15⅝ x 22¾ (39.7 x 57.8)
signed lower left: Tataret
The Holliday Collection 79.294

In this still-life composition, the little-known Spanish artist Josep Tataret has not confined himself to one consistent system of paint application. Across the surface of the tablecloth is a pointillist overlay of pastel tints, while the hot colors of the backdrop are applied in broader strokes as part of a very thick paint layer. Tataret has cast the reflections on the teapot with elongated streaks of bold, varied colors. The color and brushwork contrast sharply with the surrounding passages and render the teapot the focal point of the composition. Underlying the entire color scheme is a very dark layer of paint that clearly removes the picture from any association with divisionist color theory. A radiograph (x-ray) of the canvas reveals that Tataret changed his composition before arriving at a final design: in the earlier version, a floral arrangement occupied the area near the glass, and the teapot was placed in the opposite direction. In the finished painting, Tataret uses the diagonal of the spoon to integrate the cylindrical elements of the composition and the rose in the foreground.

Provenance: Barcelona, Sala Pares, Establecimientos Maragall; New York, Schweitzer Gallery, 1958 or 1959; W. J. Holliday, 1960s.

Exhibitions: New York, Schweitzer Gallery, *Still Life Movement*, October 10-31, 1966, no. 20 (reprod.); HC 1968-69; HC 1969-70.

Franz Waldraff
German 1878-?

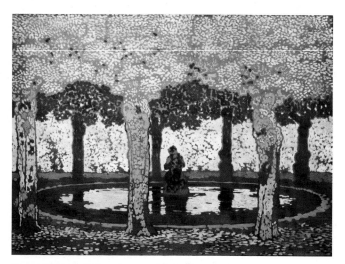

Franz Waldraff, *Landscape with Pool*

Franz Waldraff had a multifaceted career as a decorative artist. Although Waldraff was German by birth, he belonged to the French arts and crafts movement. In 1902 Waldraff moved to Paris and in 1909 settled permanently on the Mediterranean coast at Menton. He often collaborated with the Parisian artisan Clément Mere, with whom he fabricated book bindings and furniture inspired by Art Nouveau motifs. He also designed glassware, textile patterns, and stage settings for productions of Ibsen plays. While in Paris, he regularly exhibited in the decorative arts section of the Société Nationale des Beaux-Arts. Waldraff's paintings include decorative panels, watercolors, and numerous gouaches of Breton, Italian, and French landscape subjects.

Landscape with Pool
gouache on paper mounted to cardboard, 19¹⁵/₁₆ x 27¹¹/₁₆
 (50.7 x 70.3)
signed lower right: F Waldraff
The Holliday Collection 79.299

Landscape with Pool falls under the banner of Art Nouveau rather than Neo-Impressionism. Waldraff's dotted facture is used not as a means to divide or intensify color, but as a decorative way to incorporate the contrast of the exposed paper into his design. Although many of Cross' and Signac's paintings from the early twentieth century have stylized curvilinear patterns related to Art Nouveau, this gouache does not have the vibrant harmonies or mosaic construction of the later Neo-Impressionist phase. Instead of a brilliant palette based on contrasting hues, Waldraff uses a restricted color scheme limited to variations of gold, yellow, and green. Today his color scheme appears even less varied than he originally intended: edges of the paper wrapped around the reverse of the mounting, and therefore never exposed to light, reveal that the paper was once blue, though it has now faded to brown.[1] With its strong ornamental sense and stylized trees, *Landscape with Pool* could be a study for one of the many decorative panels executed by Waldraff.

Note
[1] Museum conservators David Miller and John Hartmann identified this change in paper color.

Provenance: Paris, Galerie du Palais Bourbon; W. J. Holliday, 1965.

Exhibitions: HC 1968-69; HC 1969-70.

Juliette Wytsman
Belgian 1860-1925

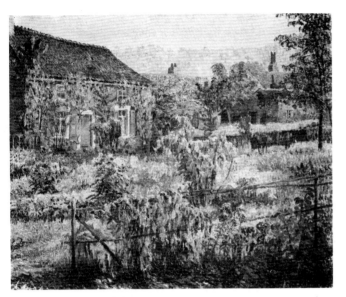

Juliette Wytsman, *Landscape*

A sustained love of flowers gave rise to Juliette Wytsman's first artistic efforts and remained her primary inspiration. Wytsman was already painting floral motifs when she entered formal training with Henri Hendrickx in Brussels. She perfected her interest through further studies with botanical painter Jean Capeinick. Influenced by his highly objective approach, she worked in a disciplined, exacting manner that resulted in images of almost scientific clarity.

Her mature style, however, was not based upon the teaching of Capeinick, but upon the insights of her fellow classmate—and future husband—Rodolphe Wytsman. A founding member of Les Vingt, Rodolphe introduced Juliette to *plein-air* painting and to Impressionist concerns with light and color. Composed swiftly in front of the subject, her works of the late 1880s lost all traces of detailed rigidity and were characterized by airy luminosity, bright colors, and broken strokes. Wytsman now depicted flowers within their natural settings, but landscape elements were still secondary.

Although Wytsman hardly altered her Impressionist style, after 1890 she enlarged her view to include the full landscape. Culling most of her motifs from the countryside and gardens surrounding her home near Linkebeek, Wytsman created paintings in which the floral elements were integrated with other natural features and with rustic buildings. Wytsman painted steadily during extensive trips through Europe, and while involved in the war relief effort in Holland, found time to depict the banks of the Meuse. Although she never consented to a one-man show, Juliette Wytsman was included in major group exhibitions beginning in 1882, not only in Belgium, but also in France, Italy, and the United States.

Landscape
oil on canvas, 23¾ x 28⅝ (60.3 x 72.7)
signed lower right: Juliette Wytsman
signed and inscribed on upper stretcher bar: Madame Juliette Wytsman/Bruxelles/ Petites Fermes (illegible)[1]
The Holliday Collection 79.300

Juliette Wytsman was a solid member of Belgium's Impressionist contingent, and her landscapes of the Brabant countryside fall squarely into the naturalistic painting tradition. Wytsman never aspired to pointillism, but according to her biographer, she did favor applying pigments directly to the canvas without blending them on the palette.[2]

The Holliday landscape is typical of Wytsman's attraction to lonely rural settings with "their gardens adorably neglected."[3] The flowers are delicately encrusted with impasto, while a flatter texture prevails in the distant sky. A silver-gray tonality permeates the landscape, icing the variations of green, rose, and violet that comprise the color scheme. The composition, with its cottage securely planted in the background, is similar to many of Wytsman's landscapes of the early 1900s.

Notes
[1] The inscription on the stretcher has not been conclusively assigned to the artist's hand. It refers to "Little Farms" before becoming illegible.

[2] L. Jottrand, *Juliette Wytsman, 1860-1925*, Brussels, 1926, p. 27 (trans).

[3] Ergaste, "Au Salon, Paysages—M. et Mme. Wytsman," *Petit bleu*, Brussels, August 8, 1897, p. 3 (trans).

Provenance: Purchased from the artist's nephew, Charles Dehoy, by Marcel Bas, Brussels; Paris, Guy Pogu (Galerie de l'Institut); W. J. Holliday, 1965.

Exhibition: HC 1968-69.

Literature: G. Pogu, *Néo-impressionnistes étrangers et influences néo-impressionnistes*, Paris, 1963 (reprod.).

Anonymous
late 19th-early 20th century

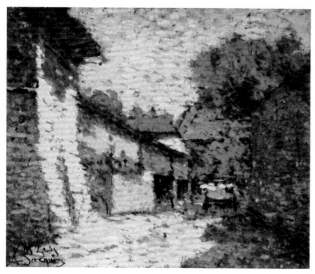

Anonymous, *Village Street*

Village Street
gouache and pencil on gray paper mounted to cardboard,
 7 x 8⁹⁄₁₆ (17.8 x 21.8), irregular
inscribed lower left: L M Zay (?)/A Jacques
The Holliday Collection 79.313

Provenance: Basel, Tcherkinsky Collection; W. J. Holliday, 1969.

Bibliography

General Bibliography

This bibliography is drawn from the twentieth-century literature on Neo-Impressionism, with the exception of the writings of Paul Signac and Félix Fénéon, which were reprinted in the 1960s. For contemporary critical literature, such as reviews in French and Belgian periodicals, the reader is advised to consult the bibliographies of Robert Herbert, ed., *Neo-Impressionists and Nabis in the Collection of Arthur G. Altschul* and John Rewald, *Post-Impressionism from van Gogh to Gauguin*, listed below.

Angrand, P. *Naissance des Artistes Indépendants 1884.* Paris, 1965.

L'Aube du XXe siècle, de Renoir à Chagall. 2 vols. Geneva: Petit Palais, [1968].

Well-illustrated catalogue that includes many of the artists represented in the Holliday Collection.

Belgian Art: 1880-1914. Brooklyn: The Brooklyn Museum, 1980. (Exhibit. cat.)

With excellent individual texts and essays on Les Vingt, Neo-Impressionism, Symbolism, and the decorative arts. General and individual artists' bibliographies. Particularly strong on Lemmen and Van Rysselberghe.

Bock, C. C. *Henri Matisse and Neo-Impressionism. 1898-1908.* Studies in the Fine Arts: The Avant-Garde. Ann Arbor, Michigan, 1981.

Very useful study of later Neo-Impressionism that includes excellent chapter-by-chapter analysis of Signac's *D'Eugène Delacroix au néo-impressionnisme.*

Cachin, F. "Les Néo-Impressionnistes et le Japonisme, 1885-1893," in *Japonisme in Art.* An International Symposium. Tokyo, 1980, pp. 225-237.

Cachin, F., ed. *Félix Fénéon, Au-delà de l'impressionnisme.* Miroirs de l'Art series. Paris, 1966.

Selected writings of Félix Fénéon, with introduction, biography, and catalogue of articles by Françoise Cachin.

Colin, P. *La peinture belge depuis 1830.* Brussels, 1930.

Le Groupe des XX et son temps. Brussels: Musées Royaux des Beaux-Arts de Belgique and Otterlo: Rijksmuseum Kröller-Müller, 1962. (Exhibit. cat.)

Biographies with numerous citations from contemporary criticism and Octave Maus archives.

Herbert, R. L. *Neo-Impressionism.* New York: The Solomon R. Guggenheim Museum, 1968. (Exhibit. cat.)

Exhibition catalogue that has become basic reference book on the subject. Documents the French, Belgian, and Dutch practitioners, as well as the role of Neo-Impressionism in Fauve and Cubist periods. With excellent essay, artists' biographies, exhibition history/chronology spanning 1881-1967, and individual and general bibliographies.

Herbert, R. L., ed. *Neo-Impressionists and Nabis in the Collection of Arthur G. Altschul.* New Haven: Yale University Art Gallery, 1965. (Exhibit. cat.)

Catalogue of important American private collection. Very useful bibliography that is exceptionally strong in contemporary literature by Neo-Impressionism's most important critics. Also contains essay, artists' biographies with individual bibliographies and exhibition lists, roster of group shows, and chronology.

Herbert, R. L. and Herbert, E. W. "Artists and Anarchism, Unpublished Letters of Pissarro, Signac and others," *Burlington Magazine,* CII, 692, November 1960, pp. 473-482, and CII, 693, December 1960, pp. 517-522.

Kahn, G. "Au temps du pointillisme," *Mercure de France,* CLXXI, April 1, 1924, pp. 5-23.

Lemonnier, C. *L'école belge de peinture, 1830-1905.* Brussels, 1906.

Maus, M. O. *Trente années de lutte pour l'art, 1884-1914.* Brussels, 1926, rept. 1980.

Basic source on the activities of Les Vingt and La Libre Esthétique, Brussels' progressive exhibition groups, written by the wife of the group's secretary, Octave Maus. Numerous references to French as well as Belgian artists.

Post-Impressionism: Cross-Currents in European Painting. London: Royal Academy of Arts, 1979. (Exhibit. cat.)

Useful catalogue entries on major French, Belgian, Dutch, and Italian divisionists. Survey of Post-Impressionism includes very helpful essays on French Post-Impressionism, Italian Divisionism, Les Vingt, and La Libre Esthétique. Detailed exhibition history/chronology.

Rewald, J., ed., with Pissarro, L. *Camille Pissarro: Letters to His Son Lucien.* New York and London, 1943; rev. ed. Mamaroneck, New York, 1972.

Rewald, J. *Post-Impressionism from van Gogh to Gauguin.* New York: Museum of Modern Art, 3rd ed., 1978.

The indispensable, authoritative source on the Post-Impressionist era. Documents Seurat and his friends through the artist's death in 1891. Rigorously thorough annotated bibliography of Neo-Impressionism from 1886 to 1970 and individual bibliographies for several French and Belgian Neo-Impressionists. Chronology.

Schurr, G. *Les petits maîtres de la peinture, valeur de demain, 1820-1920.* 4 vols. Paris, 1969, 1972, 1976, 1979.

Passing references to many little-known artists, geared to the marketplace.

Signac, P. *D'Eugène Delacroix au néo-impressionnisme.* Miroirs de l'Art series. Edited by F. Cachin. Paris, 1964.

Signac's treatise on Neo-Impressionist practice and its artistic precedent. First published in serial form in 1898.

Sutter, J., ed. *The Neo-Impressionists.* Translated by C. Deliss. Neuchâtel, London, and Greenwich, Conn., 1970.

One of the fundamental books on the subject, with chapters on various artists written by several different authors. Material on French artists more comprehensive than on Belgian. A brief general bibliography and individual artists' bibliographies.

Thorold, A., ed. *Artists, Writers, Politics: Camille Pissarro and his Friends (An Archival Exhibition).* Oxford: Ashmolean Museum, 1980. (Exhibit. cat.)

Rich documentary source of information on the artistic, literary, and political climate of late nineteenth-century France, based largely on well-annotated correspondence in the Pissarro Family Archive.

Trente ans d'Art Indépendant 1884-1914. Paris: Société des Artistes Indépendants, 1926. (Exhibit. cat.)

Retrospective of exhibition society in which Neo-Impressionists played such a large role. Many Holliday Collection artists represented.

Webster, J. C. "The Technique of Impressionism: a Reappraisal," *College Art Journal,* IV, 4, November 1944, pp. 3-22.

Selected Bibliography for Individual Artists

List of sources compiled by Tracy E. Smith

The references for each artist are listed chronologically. An asterisk* indicates that the source contains a substantial bibliography. In addition to the references cited below each artist's name, nearly all the painters in the Holliday Collection are represented in one or more of the following encyclopedias. Artists for whom there are no additional sources of information do not appear in this bibliography.

Bénézit, E., ed. *Dictionnaire critique et documentaire des peintres, sculpteurs, dessinateurs et graveurs.* 10 vols. Paris, new edition, 1976.

Edouard-Joseph, R., ed. *Dictionnaire biographique des artistes contemporains, 1910-1930.* 4 vols. Paris, 1930-1936.

Thieme, U. and Becker, F., ed. *Allgemeines Lexikon der bildenden Künstler, von der Antike bis zur Gegenwart.* 37 vols. Leipzig, 1907-1950.

Vollmer, H., ed. *Allgemeines Lexikon der bildenden Künstler des XX. Jahrhunderts.* 6 vols. Leipzig, 1953-1962.

Louis Abel-Truchet
 b. December 29, 1857 Versailles, France
 d. September 9, 1918 Auxerre, France

"Abel-Truchet." *Art et décoration,* X, November 1901, pp. 125-128.

Merio Ameglio
 b. October 4, 1897 San Remo, Italy
 d. July 29, 1970 Paris, France

Espiau, M. *Merio Ameglio, le paysagiste de Paris.* Paris, [n.d.].

Charles Angrand
 b. April 19, 1854 Criquetot-sur-Ouville, France
 d. April 1, 1926 Rouen, France

Welsh-Ovcharov, B. *The Early Work of Charles Angrand and his Contact with Vincent van Gogh.* Utrecht and The Hague, 1971.

Charles Angrand, 1854-1926. Dieppe: Musée de Dieppe, 1976. (Exhibit. cat.)

Lespinasse, F. *Charles Angrand, 1854-1926.* Rouen, 1982.

Paul Baum
 b. September 22, 1859 Meissen, Germany
 d. May 18, 1932 San Gimignano, Italy

Hitzeroth, C. *Paul Baum, ein deutsher Maler.* Dresden, 1937.

Kramm, W. *Paul Baum (1859-1932).* Ausstellungshefte der Städtischen Kunstsammlungen zu Kassel, heft 6. Kassel: Städtische Kunstsammlung, 1959. (Exhibit. cat.)

Anna Boch
 b. February 10, 1848 La Louvière, Belgium
 d. 1936 Brussels, Belgium

Colin, P. *Anna Boch.* Brussels, 1928.

Anna et Eugène Boch. La Louvière: Musée des Arts et Métiers, 1958. (Exhibit. cat.)

Faider-Thomas, T. "Anna Boch." *Miscellanea Josef Duverger,* I. Ghent, 1968.

*Anna Boch und Eugène Boch, Werke aus den Anfangen der modernen Kunst. Saarbrucken: Saarland Museum, 1971. (Exhibit. cat.)

Ernest-Lucien Bonnotte
 b. February 21, 1873 Dijon, France
 d. 1954 Dijon, France

Fyot, E. "L'art, salons et expositions." *La Revue de Bourgogne,* VI, 1918-1919, p. 376.

Gaston-Gérard. *E.-L. Bonnotte, 1873-1954.* Dijon: Musée des Beaux-Arts, 1956. (Exhibit. cat.)

Bernard Boutet de Monvel
 b. August 4, 1881 Paris, France
 d. 1949 The Azores

Vauxcelles, L. "Bernard Boutet de Monvel." *Art et décoration,* XXIV, December 1908, pp. 185-194.

Valotoire, M. "Bernard Boutet de Monvel." *Creative Art,* I, November 1927, pp. 307-314.

Bernard Boutet de Monvel. Paris: Galerie Luxembourg, 1975. (Exhibit. cat.)

Louvet, J. "Vie, oeuvre, et art du peintre Bernard Boutet de Monvel, 1884 [sic]-1949." Master's thesis, Paris, 1979.

Louis-Gustave Cambier
 b. June 13, 1874 Brussels, Belgium
 d. May 23, 1949

Exposition de M' et M^me Louis G. Cambier. Preface by P. Signac. Nice: l'Artistique de Nice, 1918.

Crooy, F. "Louis-G. Cambier, portraitiste." *Gand Artistique,* IV, 2, February 1925, pp. 27-31.

Hellens, F. *L.-G. Cambier.* Brussels, 1929.

Le peintre Louis-G. Cambier. Preface by R. Dupierreux. Brussels: Galerie Giroux, 1949. (Exhibit. cat.)

Eugène Chigot
 b. November 22, 1860 Valenciennes, France
 d. July, 1923 Paris, France

Eugène Chigot. Preface by F. Jourdain. Paris: Galeries Georges Petit, 1905. (Exhibit cat.)

Merlet, J. F. L. *Eugène Chigot, Peintre.* Paris, 1910.

Exposition rétrospective du peintre Eugène Chigot. Preface by C. Kunstler. Paris: Musée Galliera, 1954.

Eugène Chigot, 1860-1923. London: Kaplan Gallery, 1964. (Exhibit. cat.)

Lucie Cousturier
 b. December 19, 1876 Paris, France
 d. June 16, 1925 Paris, France

Maus, M. O. *Evocation de Lucie Cousturier.* Paris, 1930.

Bunoust, M. *Quelques Femmes Peintres.* Paris, 1936.

Cogniat, R. "Lucie Cousturier." *Arts, beaux-arts, littérature, spectacles.* October 10, 1947, p. 1.

Rewald, J. *Seurat and His Friends.* New York: Wildenstein & Co., 1953. (Exhibit. cat.)

Henri Delavallée
 b. 1862 Rheims, France
 d. 1943 Quimper, France

Chassé, C. *Gauguin et son temps.* Paris, 1955.

Chassé, C. *Gauguin sans légendes.* Paris, 1965.

L'école de Pont-Aven dans les collections publiques et privées de Bretagne. Quimper: Musée de Quimper, 1978. (Exhibit. cat.)

Le mouvement impressionniste dans l'école de Pont-Aven. Pont-Aven: Musée de Pont-Aven, 1978. (Exhibit. cat.)

Maurice Denis
 b. November 25, 1870 Granville, France
 d. November 13, 1943 Paris, France

Cousturier, L. "Maurice Denis." *L'art décoratif*, XXIX, January-June 1913, pp. 205-220.

Fosca, F. *Maurice Denis*. Paris, 1924.

Denis, M. *Journal 1884-1943*. I, II, Paris, 1957; III, Paris, 1959.

**Maurice Denis*. Paris: Orangerie des Tuileries, 1970. (Exhibit. cat.)

**Jaworska, W. Paul Gauguin et l'école de Pont-Aven*. Neuchâtel, 1971.

Maurice Denis. Bremen: Kunsthalle Bremen, 1971. (Exhibit cat.)

Mauner, G. *The Nabis, Their History and Their Art, 1888-1896*. New York, 1978.

Welsh-Ovcharov, B. *Vincent van Gogh and the Birth of Cloisonism*. Toronto: Art Gallery of Ontario, 1981. (Exhibit. cat.)

René Durey
b. March 16, 1890 Paris, France
d. November, 1959 Paris, France

Vauxcelles, L. "René Durey." *L'amour de l'art*, II, October 1921, p. 305.

Bazin, G. "René Durey." *L'amour de l'art*, XV, 2, February 1934, p. 302.

René Durey. Preface by A. Chamson. Paris: Musée Galliera, 1960. (Exhibit. cat.)

Jean vanden Eeckhoudt
b. 1875 Brussels, Belgium
d. 1946 Bourgeois-Rixensart, Belgium

Lambotte, P. *Jean vanden Eeckhoudt*. Brussels, 1934.

**Hommage à Jean vanden Eeckhoudt*. Preface by M.-J. Chartrain-Hebbelinck. Brussels: Musées Royaux de Belgique, 1973. (Exhibit. cat.)

Hommage à Jean vanden Eeckhoudt. Brussels: Galerie L'Ecuyer, 1978. (Exhibit. cat.)

Edouard Fer
b. 1887 Nice, France
d. 1959

Fer, E. "Les Principes scientifiques du néo-impressionnisme." *Pages d'Art*, December 1917 and May 1918.

Fer, E. *Solfège de la couleur*. Paris, 1954.

Edouard Fer 1887-1959. Introduction by J. Forneris. Nice: Galerie des Ponchettes, 1975.

Julien-Gustave Gagliardini
b. March 1, 1846 Mulhouse, France
d. November 28, 1927 Paris, France

Uzanne, J. *Figures contemporaines, tirées de l'album Mariani*. 11 vols. Paris, 1896-1908.

Lestrange, R. "Gagliardini." *Gazette des Beaux-Arts*, 5th ser., XVIII, September-October 1928, pp. 192-196.

Dardenne, R. "Aux galeries Georges Petit: La Rétrospective Gagliardini." *Le Figaro*. November 1, 1928.

Exposition rétrospective des peintres foréziens. Saint-Etienne: Musée de Saint-Etienne, 1945.

Léo Gausson
b. February 14, 1860 Lagny-sur-Marne, France
d. October 27, 1944 Lagny-sur-Marne, France

Fénéon, F. "Léo Gausson." *La Revue Blanche*, X, April 1896, p. 336.

Léo Gausson, 1860-1944. Paris: Hôtel Drouot, December 3, 1979. (Auction cat.)

Paul-Elie Gernez
b. January 27, 1888 Onnaing, France
d. September 6, 1948 Honfleur, France

Klingsor, T. "P. E. Gernez." *L'amour de l'art*, X, 5, May 1929, pp. 167-171.

Leblond, M.-A. "Gernez." *Art et décoration*, LXII, February 1933, pp. 39-46.

Rey, R. *Paul-Elie Gernez*. Paris, 1947.

Gernez. Paris: Galerie J. C. Bellier, 1970. (Exhibit. cat.)

Ferdinand Hart Nibbrig
b. April 5, 1866 Amsterdam, The Netherlands
d. October 12, 1915 Laren, The Netherlands

Gosschalk, J. C. "Hart-Nibbrig." *Onze Kunst*, XVIII, 1910, pp. 165-180.

Loosjes-Terpstra, A. B. *Moderne Kunst in Nederland 1900-1914*, Utrecht, 1959.

Vom Licht zur Farbe: Nachimpressionistische Malerei zwischen 1886 und 1912. Düsseldorf: Städtische Kunsthalle, 1977. (Exhibit. cat.)

Louis Hayet
b. August 29, 1864 Pontoise, France
d. December 27, 1940 Cormeilles-en-Parisis, France

Papers of Jean Sutter. New Haven: Beinecke Rare Book Library, Yale University.

Auguste Herbin
b. April 29, 1882 Quiévy, France
d. January 31, 1960 Paris, France

Jakovski, A. *Auguste Herbin*. Paris, 1933.

Auguste Herbin. Introduction by G. Claisse. London: Arthur Tooth and Sons, 1972. (Exhibit. cat.)

**Herbin: The Plastic Alphabet*. New York: Galeries Denise René, 1973. (Exhibit. cat.)

Kennedy, J. "Auguste Herbin's Early Geometrical Compositions (1917-1921)." *Arts Magazine*, LVI, 7, March 1982, pp. 66-71.

Claisse, G. *Catalogue raisonné Auguste Herbin*. Paris, forthcoming.

Adrien-Joseph Heymans
b. June 11, 1839 Antwerp, Belgium
d. December, 1921 Belgium

Verhaeren, E. *A.-J. Heymans*. Brussels, 1885.

Adrien-Joseph Heymans. Brussels: Galerie Giroux, 1922. (Exhibit. cat.)

Rétrospective A.-J. Heymans. Schaerbeek: Maison des Arts de Schaerbeek, 1954. (Exhibit. cat.)

Modest Huys
b. October 25, 1875 Olsene, Belgium
d. January, 1932 Zulte, Belgium

Chabot, G. and D'Aconit, G. "Modest Huys." *Gand Artistique*, VII, July 1928, pp. 122-140.

Rétrospective Modest Huys. Deinze: Museum voor schone Kunsten van Latem en Leiestreek, 1974. (Exhibit. cat.)

Jules Arthur Joëts
b. September 1, 1884 Saint-Omer, France
d. January 19, 1959 Viry-Châtillon, France

Schneeberger, A. *Le peintre Jules Joëts*. Lille and Paris, 1933.

**Bernard, M.-A. Jules Joëts*. Les cahiers d'art-documents, no. 68. Geneva, 1957.

**Jules Joëts*. Geneva: Galerie des Granges, 1974. (Exhibit. cat.)

Georges Lacombe
b. 1868 Versailles, France
d. July 29, 1916 Alençon, France

Vignaud, J. "Georges Lacombe." *L'art et les artistes*, June 1908, pp. 127-130.

Exposition rétrospective des oeuvres de Georges Lacombe. Preface by J. Vignaud. Paris: Galerie Balzac, 1924.

Hepp, P. "Georges Lacombe." *L'art et les artistes*, October 1924, pp. 8-15.

Humbert, A. *Les nabis et leur temps*. Geneva, 1954.

Ansieau, J. "Georges Lacombe, peintre et sculpteur." Master's thesis, Ecole du Louvre, 1969.

Georges Lacombe, le nabi sculpteur. Paris: Galerie André Pacitti, 1969. (Exhibit. cat.)

Chastel, A. "Nabi oublié: Georges Lacombe, sculpteur fin de siècle." *Le Monde*, March 27, 1969.

Georges Lacombe: Drawings. New York: Shepherd Gallery, 1974. (Exhibit. cat.)

Het Symbolisme in Europa. Rotterdam: Museum Boymans-van Beuningen, 1975. (Exhibit. cat.)

Art Nouveau Belgium/France. Houston: Rice Museum, 1976. (Exhibit. cat.)

L'école de Pont-Aven dans les collections publiques et privées de Bretagne. Quimper: Musée de Quimper, 1978. (Exhibit cat.)

Le Mouvement impressionniste dans l'école de Pont-Aven. Pont-Aven: Musée de Pont-Aven, 1978. (Exhibit. cat.)

Gaston La Touche
b. October 29, 1854 Saint Cloud, France
d. July 12, 1913 Saint Cloud, France

Mourey, G. "The Work of Gaston La Touche." *The Studio*, XVI, 72, March 15, 1899, pp. 77-90.

Vaillet, L. "Gaston La Touche." *L'art et les artistes*, VII, June 1908, pp. 117-126.

Frantz, H. *Gaston La Touche 1854-1913*. London, 1914.

Mauclair, C. "L'art de Gaston La Touche." *La revue de l'art*, XXXV, 1914, pp. 241-252.

de Ganey, E. "Gaston La Touche, peintre de jardins." *Le figaro artistique*, October 29, 1925, pp. 35-37.

Achille Laugé
b. April 29, 1861 Arzens, France
d. June 2, 1944 Cailhau, France

Achille Laugé. Preface by G. Geoffroy. Paris: Achille Astre, 1907. (Exhibit. cat.)

Achille Laugé. Preface by G. Geoffroy. Paris: Nunès et Fiquet, 1919. (Exhibit. cat.)

Achille Laugé et ses amis Bourdelle et Maillol. Toulouse: Musée des Augustins, 1961. (Exhibit. cat.)

Achille Laugé. New York: Hammer Galleries, 1967. (Exhibit. cat.)

Achille Laugé. Paris: Galerie Marcel Flavian, 1969.

Atelier Achille Laugé. Paris: Drouot-Rive Gauche, March 5, 1976. (Auction cat.)

Atelier Achille Laugé. Paris: Drouot-Rive Gauche, March 11, 1977. (Auction cat.)

Ernest-Joseph Laurent
b. June 8, 1859 Paris, France
d. June 25, 1929 Bièvres, France

Jamot, P. "Ernest Laurent." *Gazette des Beaux-Arts*, 4th ser., V, February 1911, pp. 173-203.

Rosenthal, L. "Ernest Laurent." *Art et décoration*, March 1911, pp. 65-76.

Martin, H. "Ernest Laurent, peintre." *Académie des Beaux-Arts Bulletin*, V, 9, January 1929, pp. 49-53.

Jamot, P. "Ernest Laurent, 1859-1929." *Gazette des Beaux-Arts*, 6th ser., II, October 1929, pp. 232-238.

Le Sidaner, H. *Notice sur la vie et les travaux de M. Ernest Laurent*. Paris, 1930.

Exposition Ernest Laurent. Paris: Orangerie des Tuileries, 1930.

Homer, W. "Seurat's Formative Period, 1880-1884." *Connoisseur*, CXLII, 571, August 1958, pp. 58-62.

Georges Lemmen
b. November 25, 1865 Brussels, Belgium
d. June 5, 1916 Brussels, Belgium

Elslander, J. F. *Figures et souvenirs d'une belle époque*. Brussels, 1950.

Nyns, M. *Georges Lemmen*. Antwerp, 1954.

Art Nouveau Belgium/France. Houston: Rice Museum, 1976. (Exhibit. cat.)

Georges Lemmen. Brussels: Musée Horta, 1980. (Exhibit. cat.)

Alfred Marie Le Petit
b. December 12, 1876 Fallencourt, France
d. 1953 La Frette, France

Rétrospective A. M. Le Petit. Preface by J. Cassou. Paris: Galerie Creuze, 1954.

A. M. Le Petit. Paris: Hôtel Drouot, May 10, 1971. (Auction cat.)

Henri Le Sidaner
b. August 7, 1862 Port Louis, Mauritius Island
d. July 16, 1939 Paris, France

Uzanne, J. *Figures contemporaines, tirées de l'album Mariani*. 11 vols. Paris, 1896-1908.

Mourey, G. "The Work of M. Le Sidaner." *International Studio*, XV, November 1901, pp. 30-36.

Marcel, H. "Henri Le Sidaner." *Gazette des Beaux-Arts*, 4th ser., II, August 1909, pp. 121-134.

Le Sidaner. Preface by C. Mauclair. Paris: Galeries Georges Petit, 1927. (Exhibit. cat.)

Mauclair, C. *Henri Le Sidaner*. Paris, 1928.

Henri Le Sidaner. Preface by Y. Bizardel. Paris: Musée Galliera, 1948. (Exhibit. cat.)

Henri Le Sidaner. Dunkerque: Musée de la ville de Dunkerque, 1974. (Exhibit. cat.)

Het Symbolisme in Europa. Rotterdam: Museum Boymans-van Beuningen, 1975. (Exhibit. cat.)

André Léveillé
b. May 9, 1880 Lille, France
d. 1962 Paris, France

Rey, R. "Les expositions Ladureau-Léveillé." *Beaux-Arts*, I, March 15, 1923, pp. 78-79.

Fegdal, C. "André Léveillé." *L'art et les artistes*, XVI, June 1928, pp. 299-303.

Cinquantenaire de l'exposition de 1925. Paris: Musée des Arts Décoratifs, 1976. (Exhibit. cat.)

Maximilien Luce
b. March 13, 1858 Paris, France
d. February 7, 1941 Paris, France

Christophe, J. "Maximilien Luce." *Les Hommes d'Aujourd'hui*, VIII, 376, 1890.

Exposition Maximilien Luce. Preface by F. Fénéon. Paris: Galerie Druet, 1904.

Exposition Luce. Preface by G. Geoffroy. Paris: Bernheim-Jeune, 1907.

Exposition Luce. Preface by E. Verhaeren. Paris: Bernheim-Jeune, 1909.

Tabarant, A. *Maximilien Luce*. Paris, 1928.

Maximilien Luce. Charleroi: Palais des Beaux-Arts, 1966. (Exhibit. cat.)

Luce, un pointilliste. Albi: Musée Toulouse-Lautrec, 1977. (Exhibit. cat.)

Marevna (Maria Stebelska Rosanovick)
b. February 14, 1892 Cheboksary, Russia

Marevna. *Life in Two Worlds*. Translated by B. Nash. London, 1962.

Marevna. Preface by G. Peillex. Geneva: Petit Palais, 1971. (Exhibit. cat.)

Marevna. *Life with the Painters of La Ruche*. New York, 1974.

Reginald Saint Clair Marston
b. January 15, 1886 Willenhall, Staffordshire, England
d. April 25, 1943 Langport, Somerset, England

Johnson, J. and Greutzner, A., compilers, *The Dictionary of British Artists 1880-1940*. Woodbridge, England: Antique Collectors' Club, 1980.

Henri-Jean-Guillaume Martin
b. August 5, 1860 Toulouse, France
d. November 1943 La Bastide-du-Vert, France

Henri Martin. Preface by A. Alexandre. Paris: Galeries Georges Petit, 1910. (Exhibit. cat.)

Segard, A. *Les décorateurs*, Vol. II of *Peintres d'aujourd'hui*. Paris, 1914.

Segard, A. "Henri Martin." *L'art et les artistes*, January 1921, pp. 139-150.

Fajol, A. "Henri Martin et son oeuvre." *Art Méridional*, 41, January 1939, pp. 8-11.

Gilet, J.-L. "A Marquayrol." *Art Méridional*, 41, January 1939, pp. 11-12.

*Martin-Ferrières, J. *Henri Martin, sa vie, son oeuvre*. Preface by E. Souriau. Paris, 1967.

Henri Martin. London: Kaplan Gallery, 1971. (Exhibit. cat.)

Het symbolisme in Europa. Rotterdam: Museum Boymans-van Beuningen, 1975. (Exhibit. cat.)

Jac Martin-Ferrières
b. August 6, 1893 Saint-Paul-Cap-de-Joux, France
d. 1974

Kahn, G. "Jac Martin-Ferrières." *L'art et les artistes*, XV, March 1927, pp. 200-204.

Vildrac, C. *Martin-Ferrières*. Paris, 1962.

Jac Martin-Ferrières. London: Wally Findlay Galleries, 1965. (Exhibit. cat.)

Thomas Buford Meteyard
b. November 12, 1865 Rock Island, Illinois, United States
d. March 17, 1928 Temtet, Switzerland

Pointillists and Their Period. Preface by H. E. Bates. London: Redfern Gallery, 1950. (Exhibit. cat.)

T. B. Meteyard: The American Pointillist-Impressionist. Preface by H. E. Bates. London: Redfern Gallery, 1951. (Exhibit. cat.)

Alloway, L. "Art News from London." *Art News*, LIV, 7, November 1955, p. 12.

Jean Metzinger
b. June 24, 1883 Nantes, France
d. November, 1956 Paris, France

Apollinaire, G. *Les peintres cubistes*. Paris, 1913.

Hazan, F. *Dictionary of Modern Painting*. New York, 1955.

Golding, J. *Cubism: A History and an Analysis, 1907-1914*. London, 1959.

Habasque, G. *Cubism*. Geneva, 1959.

Metzinger: Pre-Cubist and Cubist Works 1900-1930. Preface by S. E. Johnson. Chicago: International Galleries, 1964. (Exhibit. cat.)

Georges Daniel de Monfreid
 b. March 14, 1856 Paris, France
 d. November 26, 1929 Corneilla-de-Conflent, France

The Letters of Paul Gauguin to Georges Daniel de Monfreid. Translated by R. Pielko, foreword by F. O'Brien. New York, 1922.

Gauguin, P. *My Father, Paul Gauguin*. Translated by A. G. Chater. New York, 1937.

Hanson, L. and Hanson, E. *Noble Savage: the Life of Paul Gauguin*. New York, 1955.

Puig, R. *Paul Gauguin, G. D. de Monfreid et leurs amis*. Perpignan, 1958.

Dalevèze, J. "Un ami de Gauguin: Daniel de Monfreid." *L'Oeil*, XXV, 250, May 1976, pp. 34-37.

Georges Daniel de Monfreid, 1856-1929. Preface by R. Cogniat. Paris: Galerie Art Moderne Jaubert, 1976. (Exhibit. cat.)

George Morren
 b. July 28, 1868 Hoogboom, Belgium
 d. November 21, 1941 Brussels, Belgium

Buyssens, M. P. *George Morren*. Brussels: Palais des Beaux-Arts, 1942. (Exhibit. cat.)

Bernard, C. *George Morren*. Brussels, 1950.

Charles Sprague Pearce
 b. October 13, 1851 Boston, Massachusetts, United States
 d. May 18, 1914 Auvers-sur-Oise, France

"Charles Sprague Pearce." *The Art Amateur*, X, 1, December 1883, pp. 5-7.

Earle, H. *Biographical Sketches of American Artists*. 4th ed., Lansing, Michigan, 1916.

Henri Person
 b. June 22, 1876 Amiens, France
 d. February 6, 1926 Paris, France

Henri Person. Preface by P. Signac. Paris: Bernheim-Jeune, 1913. (Exhibit. cat.)

Henri Person. Preface by A. D. de Segonzac. Paris: Galerie de Paris, 1961. (Exhibit. cat.)

de Perthuis, F. "Un village paisible, Saint-Tropez." *Gazette de l'Hôtel Drouot*, April 25, 1969.

Henri Person. Paris: Hôtel Drouot, May 8, 1969. (Auction cat.)

Hippolyte Petitjean
 b. September 11, 1854 Mâcon, France
 d. September 18, 1929 Necker, France

Klingsor, T. "Hippolyte Petitjean." *L'art et les artistes*, n. s. XIX, January 1930, pp. 138-139.

Catalogue de l'exposition du centenaire d'Hippolyte Petitjean (1854-1954). Paris: Galerie de l'Institut, 1955.

Aquarelle von Hippolyte Petitjean (1854-1929). Cologne: Gemälde-Galerie Abels, 1959. (Exhibit. cat.)

Hippolyte Petitjean, Watercolors. New York: David B. Findlay Galleries, 1959. (Exhibit. cat.)

Georges Manzana Pissarro
 b. November 20, 1871 Louveciennes, France
 d. January 20, 1961 Menton, France

Manzana-Pissarro. Paris: Galerie Hébrard, 1912. (Exhibit. cat.)

Janneau, G. "Manzana Pissarro." *Art et décoration*, XXXIII, January 1913, pp. 13-17.

Manzana-Pissarro. Preface by A. Alexandre. Paris: Musées des Arts Décoratifs, 1914. (Exhibit. cat.)

Manzana-Pissarro. Introduction by J. Bailly-Herzberg. Andelys: Musées des Andelys, 1972. (Exhibit. cat.)

Manzana Pissarro. Paris: Galerie Dario Boccara, 1973. (Exhibit. cat.)

Rewald, J., ed., with Pissarro, L. *Camille Pissarro: Letters to His Son Lucien*. New York and London, 1943; rev. ed. Mamaroneck, New York, 1972.

Lucien Pissarro
 b. February 20, 1863 Paris, France
 d. July 10, 1944 Hewood, Somerset, England

Manson, J. "Some Notes on the Paintings of Lucien Pissarro." *Studio*, LX, 238, December 1916, pp. 57-66.

Clement-Janin. "Peintres-Graveurs contemporains, Lucien Pissarro." *Gazette des Beaux-Arts*, 4th ser., XV, October-December 1919, pp. 337-351.

Rewald, J., ed., with Pissarro, L. *Camille Pissarro: Letters to His Son Lucien*. New York and London, 1943; rev. ed. Mamaroneck, New York, 1972.

Rothenstein, J. *Modern English Painters, I: Sickert to Smith*. London, 1952.

Lucien Pissarro. Preface by V. Abul-Huda. London: O'Hana Gallery, 1955. (Exhibit. cat.)

Meadmore, W. *Lucien Pissarro: Un coeur simple*. London, 1962.

Lucien Pissarro: A Centenary Exhibition of Paintings, Watercolors, Drawings, and Graphic Work. Introduction by R. Pickvance. London: Arts Council of Great Britain, 1963.

Easton, M. "Lucien Pissarro and His Friends at Rye, 1913: A Group of Post-Impressionists on Holiday." *Gazette des Beaux-Arts*, 6th ser., LXXII, November 1968, pp. 237-248.

Baron, W. *The Camden Town Group*. London, 1979.

Three on Holiday at Rye 1913: A Group of Post-Impressionists: Lucien Pissarro, James Bolivar Manson, James Brown. London: Parkin Gallery, 1980. (Exhibit. cat.)

*Thorold, A. *Catalogue of Oil Paintings by Lucien Pissarro*. Preface by C. Lloyd. London, 1983.

Ferdinand Loyen du Puigaudeau
 b. April 4, 1864 Nantes, France
 d. September 19, 1930 Choisic (?), France

Le mouvement impressionniste dans l'école de Pont-Aven. Pont-Aven: Musée de Pont-Aven, 1978. (Exhibit. cat.)

Enrico Reycend
 b. November 3, 1855 Turin, Italy
 d. 1928 Turin, Italy

Biancale, M. *Il pittore Enrico Reycend*. Introduction by M. Bernardi. Turin, 1955.

Valsecchi, M. *Landscape Painting of the Nineteenth Century*. Greenwich, Connecticut, 1971.

Christian Rohlfs
 b. December 22, 1849 Niendorf, Germany
 d. January 8, 1938 Hagen, Germany

Niemeyer, W. *Malerische Impression und koloristischer Rhythmus*. Düsseldorf, 1920.

Selz, P. *German Expressionist Painting*. Berkeley, 1957.

Keiler, M. "Christian Rohlfs, Pioneer of German Expressionism." *Art Journal*, XVIII, Spring 1959, pp. 200-209.

Myers, B. *The German Expressionists: A Generation in Revolt*. New York, 1963.

Christian Rohlfs. Introduction by P. Vogt. San Francisco: San Francisco Museum of Art, 1966. (Exhibit. cat.)

*Vogt, P. *Christian Rohlfs, Oeuvre-Katalog der Gemälde*. Catalogue raisonné by U. Köcke. Recklinghausen, Germany, 1978.

Expressionism: A German Intuition, 1905-1920. New York: The Solomon R. Guggenheim Museum, 1980.

Jane Rouquet
 b. late 19th century Carcassonne, France
 d. ?

Roches, F. "A propos d'un livre: *La ville du Passé*." *L'art décoratif*, November 5, 1912, pp. 249-256.

Théo van Rysselberghe
 b. November 28, 1862 Ghent, Belgium
 d. December 13, 1926 Saint-Clair, France

Théo van Rysselberghe. Introduction by M. Denis. Brussels: Galerie Giroux, 1927. (Exhibit. cat.)

Fierens, P. *Théo van Rysselberghe*. Brussels, 1937.

Maret, F. *Théo van Rysselberghe*. Antwerp, 1948.

Théo van Rysselberghe. Introduction by P. Eeckhout. Ghent: Musée des Beaux-Arts, 1962. (Exhibit. cat.)

Chartrain-Hebbelinck, M.-J., ed. "Les lettres de van Rysselberghe à Octave Maus." *Bulletin*, Musées Royaux des Beaux-Arts de Belgique, 1966, 1-2, pp. 55-112.

Paul Saïn
b. December 5, 1853 Avignon, France
d. March 6, 1908 Paris, France

Uzanne, J. *Figures contemporaines, tirées de l'album Mariani.* 11 vols. Paris, 1896-1908.

Exposition des tableaux et études par Paul Saïn. Preface by E. Arène. Paris: Galeries Georges Petit, 1904.

Claude-Emile Schuffenecker
b. December 8, 1851 Fresnes Saint-Manes, France
d. July, 1934 Paris, France

Ranft, R. "E. Schuffenecker." *Les Hommes d'Aujourd'hui,* XVIII, 389, 1896.

Deverin, Edouard. "Un ami de Gauguin: Schuffenecker." *Les marges,* LV, 215, January 1935, pp. 12-16.

Emile Schuffenecker. New York: Hirschl and Adler Galleries, Inc., 1958. (Exhibit. cat.)

Emile Schuffenecker. Paris: Galerie les Deux-Iles, 1963. (Exhibit. cat.)

Jaworska, W. *Paul Gauguin et l'école de Pont-Aven.* Neuchâtel, 1971.

Monneret, S. *L'impressionnisme et son époque.* 2 vols. Paris, 1978.

Le mouvement impressionniste dans l'école de Pont-Aven. Pont-Aven: Musée de Pont-Aven, 1978. (Exhibit. cat.)

Le Paul, C.-G. "Gauguin et Schuffenecker." *Bulletin des amis du Musée de Rennes,* Summer 1978, pp. 48-60.

**Claude-Emile Schuffenecker, 1851-1934.* Essay by J. Grossvogel. Binghamton: State University of New York Art Gallery, 1980. (Exhibit. cat.)

Arthur Segal
b. July 13, 1875 Jassy, Rumania
d. June 23, 1944 London, England

Behne, A. "Arthur Segal: A Personality of Importance in Contemporary German Art." *Studio,* August 1930, pp. 126-139.

Dada: Ausstellung zum 50-jahrigen Jubiläum/Exposition Commémorative du cinquantenaire. Cahiers de l'association internationale pour l'étude de Dada et du surréalisme, no. 2. Zurich: Kunsthaus and Paris: Musée d'Art Moderne, 1966. (Exhibit. cat.)

Lynton, N. "Arthur Segal and German Cubism." *Studio International,* July/August 1969, pp. 22-24.

Arthur Segal, 1875-1944: A Selection of Paintings. London: The Alpine Club, 1973. (Exhibit. cat.)

Whitford, F. "Arthur Segal in German Expressionism." *Arthur Segal, A Collection of Woodcuts: ca. 1910-1918.* Oxford: Ashmolean Museum, 1977. (Exhibit. cat.)

**Lynton, N. *Arthur Segal.* London: Fischer Fine Art, 1978. (Exhibit. cat.)

Georges Seurat
b. December 2. 1859 Paris, France
d. March 29, 1891 Paris, France

Christophe, J. "Georges Seurat." *Les Hommes d'Aujourd'hui,* VIII, 368, 1890.

Coustudier, L. *Seurat.* Paris, 1921.

**Rewald, J. *Georges Seurat.* New York, 1946.

Seurat: Paintings and Drawings. Chicago: Art Institute of Chicago, 1958. (Exhibit. cat.)

Schapiro, M. "New Light on Seurat." *Art News,* LVII, 2, April 1958, pp. 22-24, 44-46.

Herbert, R. L. "Seurat in Chicago and New York." *Burlington Magazine,* C, 662, May 1958, pp. 146-155.

Homer, W. I. "Seurat's Formative Period: 1880-1884." *Connoisseur,* CXLII, 571, August 1958, pp. 58-62.

**Dorra, H. and Rewald, J. *Seurat: L'oeuvre peint, biographie, et catalogue critique.* Paris, 1959.

de Hauke, C. M. *Seurat et son oeuvre.* 2 vols. Paris, 1961.

**Herbert, R. L. *Seurat's Drawings.* New York, 1962.

**Homer, W. I. *Seurat and the Science of Painting.* Cambridge, Massachusetts, 1970.

Broude, N., ed. *Seurat in Perspective.* Artists in Perspective series. Englewood Cliffs, New Jersey, 1978.

Herbert, R. L. "'Parade de cirque' de Seurat et l'esthétique scientifique de Charles Henry." *Revue de l'art,* 50, 1980, pp. 9-23.

Paul Signac
b. November 11, 1863 Paris, France
d. August 15, 1935 Paris, France

Fénéon, F. "Paul Signac." *Les Hommes d'Aujourd'hui,* VIII, 373, 1890.

Coustudier, L. *Paul Signac.* Paris, 1922.

Rewald, J., ed. "Extraits du journal inédit de Paul Signac." I (1894-1895), *Gazette des Beaux-Arts,* 6th ser., XXXVI, 1949, pp. 97-128 (trans. pp. 166-174); II (1897-1898), *Gazette des Beaux-Arts,* 6th ser., XXXIX, 1952, pp. 265-284 (trans. pp. 298-304); III (1898-1899), *Gazette des Beaux-Arts,* 6th ser., XLII, 1953, pp. 27-57 (trans. pp. 72-80).

**Signac.* Catalogue notes by M.-T. Lemoyne de Forges. Paris: Musée du Louvre, 1963. (Exhibit. cat.)

**Cachin, F. *Paul Signac.* Paris, 1971.

Léon de Smet
b. July 20, 1881 Ghent, Belgium
d. September 9, 1916 Deurle, Belgium

*Haesaerts, P. *L'école de Laethem St. Martin.* Brussels, 1945.

*de Morel Boucle, P. *Léon de Smet.* Brussels, 1949.

Langui, E. *Expressionism in Belgium.* Brussels, 1974.

Josep Balasch Tataret
b. 1888 Barcelona, Spain
d. ?

Rafols, J. F., ed. *Diccionario biográfico de artistas de Cataluña desde la época romana hasta nuestros dias.* Barcelona, 1951-54.

Henry van de Velde
b. April 3, 1863 Antwerp, Belgium
d. October 15, 1957 Oberageri, Switzerland

Niemeyer, W. *Malerische Impression und Koloristischer Rythmus.* Düsseldorf, 1920.

Van de Velde, H. *Geschichte meines Lebens.* Munich, 1962.

Henry van de Velde. Brussels: Palais des Beaux-Arts, 1963. (Exhibit. cat.)

**Hammacher, A. M. *Le monde de Henry van de Velde.* Catalogue raisonné by E. Billeter. Antwerp and Paris, 1967.

Ollinger-Zinque, G. "'La fille qui remaille' ou 'La ravadeuse' d'Henry van de Velde." *Bulletin,* Musées Royaux des Beaux-Arts de Belgique, 1-4, 1973, pp. 165-169.

Art Nouveau Belgium/France. Houston: Rice Museum, 1976. (Exhibit. cat.)

Henry van de Velde Archives. Brussels: Bibliothèque Royale de Belgique.

Médard Verburgh
b. February 16, 1886 Roulers, Belgium
d. 1957

de Bendère, R. "Médard Verburgh." *Gand Artistique,* VII, 4, April 1928, pp. 61-75.

Exhibition of Paintings of Médard Verburgh. New York: Newhouse Galleries, 1930.

Fernand Verhaegen
b. 1884 Marchienne-au-Pont, Belgium
d. 1975 Belgium

Delevoy, R.-L. *Fernand Verhaegen.* Brussels, 1936.

Jan Vijlbrief
b. June 3, 1868 Leiden, The Netherlands
d. July 9, 1895 Leiden, The Netherlands

de la Faille, J.-B. *Les Faux Van Gogh.* Paris and Brussels, 1930, p. 24.

Franz Waldraff
b. April 14, 1878 Tuttlingen, Germany
d. ?

Sedeyn, E. "Clément Mere et Franz Waldraff." *Art et décoration,* XXXII, December 1912, pp. 161-172.

Juliette Wytsman
b. July 14, 1860 Brussels, Belgium
d. March 8, 1925 Brussels, Belgium

Jottrand, L. *Juliette Wytsman, 1860-1925.* Brussels, 1926.

Index

Artists

Titles

Titles

Production Credits

Typesetting and Composition:
Weimer Typesetting Co., Inc., Indianapolis

Color Separations:
Loxley Color Separations, Inc., Dayton, Ohio

Printing: Design Printing Co., Inc., Indianapolis

Distributed in cooperation with Indiana
University Press, Bloomington

Photography Credits

Essay

Courtesy of The Art Institute of Chicago, p. 14.

Catalogue

Helga Photo Studio, New York; courtesy of Hirschl & Adler
Galleries, Inc., New York, p. 55.

Courtesy of Rosenthal & Rosenthal, Inc., New York, p. 69.

Rijksmuseum Kröller-Müller, Otterlo, figs. 1 and 2, p. 78.

Roger Viollet, Paris, p. 98.

Conservation Laboratory, Indianapolis Museum of Art,
p. 126.

Courtesy of Louis Le Sidaner, Paris, p. 132.

Service de Documentation Photographique de la Réunion des
Musées Nationaux, Paris, p. 148.

Roger Viollet, Paris, fig. 1, p. 159.

Courtesy of Galerie G. Paffrath, Düsseldorf, p. 164.

Robert Wallace and the Conservation Laboratory, Indianapo-
lis Museum of Art, p. 172.

Robert Wallace, Indianapolis Museum of Art, p. 183.